MW00618754

ART AFRICA

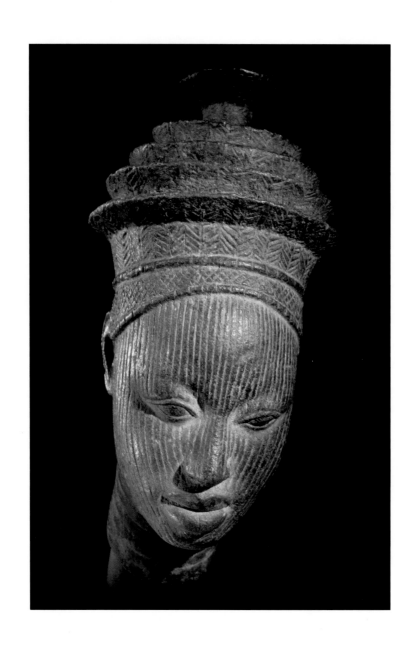

FRANZISKA BOLZ

AFRICAN ART
ART AFRICAIN
AFRIKANISCHE KUNST
ARTE AFRICANO
ARTE AFRICANA
AFRIKAANSE KUNST

ÉDITIONS
PLACE DES
VICTOIRES

KÖNEMANN

p. 2

Benin

Miniature head of an ancestry shrine

Tête miniature provenant d'un autel des ancêtres

Miniaturkopf eines Ahnenschreins

Cabeza en miniatura de un altar de antepasados

Testa in miniatura di un santuario per gli antenati

Miniatuurkop van een voorouderschrijn

Brass/Laiton

KÖNEMANN

© 2018 koenemann.com GmbH

www.koenemann.com

© Éditions Place des Victoires

6, rue du Mail – 75002 Paris

www.victoires.com

ISBN : 978-2-8099-1687-4

Dépôt légal : 2ᵉ trimestre 2019

Concept, Project Management: koenemann.com GmbH

Text: Franziska Bolz

Editing: Petra Böttcher

Translations:

info@textcase.nl

textcase.de textcase.eu

Layout: Oliver Hessmann

Picture credits: akg-images gmbh

ISBN: 978-3-7419-2412-5

Printed in China by Shenzen Hua Xin Colour-printing & Platemaking Co., Ltd

Contents Sommaire Inhalt Índice Indice Inhoud

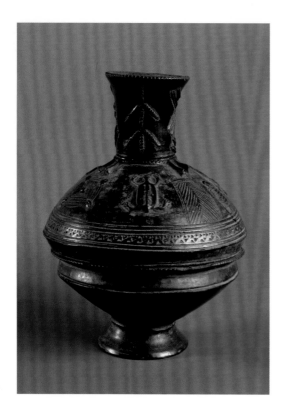

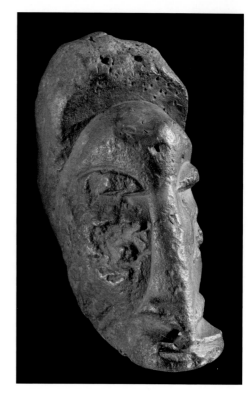

Baule	Sapi
Drinking vessel for drinking offerings	Head
Récipient pour les libations	Tête
Gefäß für Trankopfer	Kopf
Recipiente para libaciones	Cabeza
Vaso per libagioni	Testa
Kruikje voor drankoffer	Kop
1875, Clay fired/Terre cuite, 22,5 × 16,5 cm	1864–66, Soap stone/Stéatite

Introduction

After Asia, Africa is the second-largest continent on the planet and approximately three times as big as Europe. Roughly one billion people live here, speaking more than 2000 languages and local dialects. Various trade relationships have been in place between Europe and Africa since many years, intensifying from the 15th century onwards. Later, European countries advanced to more power, developing colonial structures. The former view of Africa changed: the colonial view was an Africa without history, which needed conquering and discovering and, of course, civilisation. The objects in this book give an overview of multiple centuries and are separated in cultural-geographic regions, from the West to the East. This categorisation reflects the concept of "Black Africa". This term encompasses the area below the Sahara Desert as its own, homogeneous area. The people living there were sorted into "tribes" by the colonial administrations, often without considering lingual groups or ethnical background.

All cultures create art. However, every culture, maybe every person, looks at culture in a different way. "African Art" as an umbrella term for art from Africa has been impacted by many economic, political and social processes. In the 18th and 19th century, Europe was obsessed with collecting artefacts. Objects from nature, artefacts and art pieces were imported

Introduction

Le continent africain est le second plus grand au monde après l'Asie et sa surface est à peu près trois fois celle de l'Europe. Environ un milliard de personnes vivent ici, parlant plus de 2000 langues et dialectes locaux. Les multiples liens commerciaux qui existent depuis fort longtemps entre l'Europe et l'Afrique se sont intensifiés à partir du 15e siècle. Plus tard, les pays européens ont développé des infrastructures coloniales afin d'avoir une plus grande puissance économique. L'image jusqu'alors positive de l'Afrique s'est modifiée : dans l'esprit colonial, l'Afrique était un continent sans passé historique qu'il fallait découvrir et civiliser.

Les objets de ce livre datent de différentes époques et sont classés par régions géographiques présentées d'ouest en est. Ce classement est conforme au concept «d'Afrique noire». Les zones situées sous le désert du Sahara sont rassemblées sous ce terme comme un seul et même espace homogène. L'administration coloniale a divisé les populations vivant ici en «tribus», souvent sans tenir compte des groupes linguistiques ou des origines ethniques.

La création artistique est commune à toutes les cultures. Mais ce que l'on entend par art diffère d'une culture à une autre et peut-être même d'une personne à l'autre. «L'art africain» – comme appellation générique désignant l'art provenant d'Afrique – est né dans un contexte de processus économiques,

Einführung

Der afrikanische Kontinent ist nach Asien der zweitgrößte der Erde und damit etwa dreimal so groß wie Europa; hier leben rund eine Milliarde Menschen, über 2000 verschiedene Sprachen und Dialekte werden gesprochen. Seit Menschengedenken bestehen zwischen Europa und Afrika vielfältige Handelsbeziehungen, die sich ab dem 15. Jahrhundert intensivierten. Später fingen die europäischen Staaten an, größere wirtschaftliche Macht anzustreben und Kolonien zu bilden. Das bisher positive Afrika-Bild veränderte sich: Afrika wurde in der kolonialen Vorstellung zu einem geschichtslosen Kontinent, den es einerseits zu entdecken und andererseits zu zivilisieren galt.

Die Objekte dieses Buches stammen aus mehreren Jahrhunderten und werden in kulturgeografische Regionen unterteilt, dargestellt von West nach Ost. Diese Unterteilung entspricht der Vorstellung von „Schwarzafrika". Mit diesem Begriff werden die Gebiete unterhalb der Wüste Sahara als ein eigener, homogener Raum zusammengefasst. Die dort lebenden Menschen wurden durch die Kolonialverwaltungen in „Stämme" eingeteilt, zum Teil ungeachtet von Sprachgruppen oder ethnischen Zuordnungen.

Kunstschaffen ist allen Kulturen gemeinsam. Was allerdings jeweils unter Kunst verstanden wird, ist von Kultur zu Kultur, vielleicht auch von Mensch

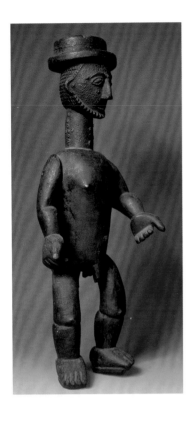

Akye

Sculpture of a man with hat
Sculpture d'un homme avec chapeau
Skulptur eines Mannes mit Hut
Escultura de hombre con sombrero
Scultura di un uomo con cappello
Beeldje van man met hoed

1878, Wood/Bois, 65 × 23,5 × 19,7 cm

Akan

Small mask
Petit masque
Kleine Maske
Pequeña máscara
Piccola maschera
Klein masker

1879, Gold/Or

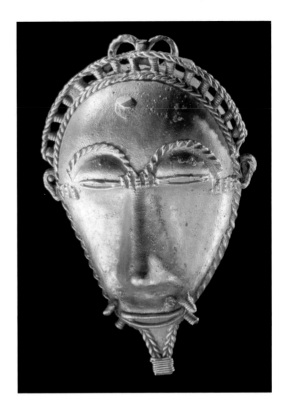

Introducción

El continente africano es, después de Asia, el
segundo más grande del planeta con unas tres
veces el tamaño Europa; allí viven mil millones de
personas y se hablan más de 2000 lenguas y dialectos
diferentes. Desde tiempos inmemoriales, han existido
relaciones comerciales entre África y Europa, que se
intensificaron a partir del siglo XV. Más tarde, los
estados europeos comenzaron a perseguir un mayor
poder económico y empezaron a formar colonias. En
ese momento cambió la visión, previamente positiva,
de África: en el imaginario colonial, África se convirtió
en un continente sin historia, que debía ser por una
parte conquistado y por otra civilizado.

Los objetos de este libro provienen de diversos siglos
y se subdividen en regiones geográfico-culturales,
presentadas de oeste a este. Esta distribución se
corresponde con la concepción del "África negra" o
"África subsahariana". Siguiendo este concepto, se
agrupa a las regiones meridionales del desierto del
Sáhara como un espacio homogéneo y propio. Sus
habitantes fueron clasificados por las administraciones
coloniales en "tribus", en ocasiones sin tener en cuenta
grupos lingüísticos o étnicos.

La creación de arte es común a todas las culturas.
Sin embargo lo que cada cultura, o tal vez cada
persona, entienda por arte es diferente. El concepto de
"arte africano" como herramienta de categorización

Introduzione

Il continente africano è il secondo più grande del
mondo dopo l'Asia. Con una superficie pari a circa
tre volte quella dell'Europa, è popolato da circa un
miliardo di persone che parlano oltre 2000 lingue
e dialetti differenti. Sin dai tempi remoti, Europa e
Africa hanno stretto numerosi rapporti commerciali,
che si sono intensificati a partire dal XV secolo. Più
tardi, i paesi europei iniziarono a perseguire un
maggiore potere economico e a fondare delle colonie,
determinando un cambiamento dell'immagine
positiva dell'Africa che si aveva sino ad allora:
nell'immaginario coloniale, l'Africa era infatti un
continente privo di storia, da un lato da scoprire e
dall'altro da civilizzare.

Gli oggetti descritti in questo libro risalgono a
numerosi secoli e sono catalogati in base alla regione
geografica, da ovest a est. Questa suddivisione
riflette all'idea di "Africa nera", concetto con il quale
viene indicata la regione africana situata a sud del
Deserto del Sahara come uno spazio omogeneo
a sé stante. Gli abitanti di questa regione furono
divisi dalle amministrazioni coloniali in "tribù",
in parte a prescindere dai gruppi linguistici o dalle
origini etniche.

La produzione artistica è comune a tutte le culture,
tuttavia il concetto di arte varia da cultura a cultura,
forse addirittura da persona a persona. L'"arte

Inleiding

Het Afrikaanse continent is op Azië na de grootste
landmassa op aarde en ongeveer driemaal zo groot
als Europa; hier leven rond één miljard mensen en
worden ruim tweeduizend verschillende talen en
dialecten gesproken. Sinds mensenheugenis bestaan
tussen Europa en Afrika talloze handelsbetrekkingen,
die vanaf de vijftiende eeuw intensiever werden.
Later begonnen de Europese grootmachten hun
economische aanspraken uit te breiden en koloniën
te stichten, waarna het tot dan toe positieve beeld van
Afrika veranderde: vanuit koloniaal perspectief werd
het continent een wereld zonder geschiedenis, die nog
ontdekt moest worden maar ook beschaving moest
worden bijgebracht.

De voorwerpen in dit boek bestrijken meerdere
eeuwen en zijn ingedeeld naar cultureel geografische
regio's, van West- naar Oost-Afrika. Deze indeling
sluit aan op het idee van 'zwart Afrika', een begrip
dat verwijst naar de culturen ten zuiden van de
Saharawoestijn als een afzonderlijk, homogeen gebied.
De mensen die hier wonen, werden onder koloniaal
bestuur in 'stammen' onderverdeeld, vaak zonder dat
daarbij rekening werd gehouden met taalgroepen of
etnische origines.

Alle culturen kenmerken zich door de creatie
van kunstvoorwerpen. Maar wat onder kunst
wordt verstaan, verschilt van cultuur tot cultuur en

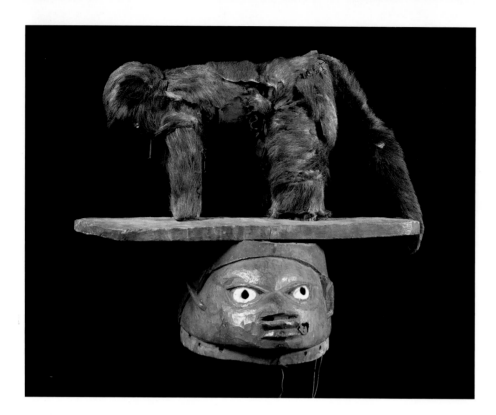

Yoruba

Head piece with monkey figurine
Coiffe avec figure de singe
Kopfaufsatz mit Affenfigur
Tocado con figura de mono
Copricapo con figura di scimmia
Hoofdtooi met apenfiguur
1882, Wood, fur, painted/Bois, fourrure, peint

from countries all over the world and were placed in museums and private collections. The objects came from different sources. Sometimes they were stolen in the country of origin, sometimes traded, seen as pieces of low or no value. Occasionally, pieces were manufactured as predecessor of the so-called "tourist souvenirs" for collectors, while modern pieces determined the local scene. The field "African art" was established by neo-classical artists, the label "art" was a condition to appreciate and value the objects. The so-called primitive art was thought to have direct access to the unknown, and an almost holy authenticity. This attractive mystification still has an influence these days. Popular movies contain many quotes from the—assumed or real—African wealth of forms, relating to distant cultures or extra-terrestrial worlds. The contexts in which African art is perceived constantly change. This way the objects receive new meaning all the time. The perception of what a "picture" should resemble differs between cultures as well. Our idea of a "picture" is that it is a resemblance of something, shows something and is a proof of visualisation: A "picture" shows us an illustration. Picture and meaning are often perceived as a unit, the picture being a powerful or living unit.

This idea has been known in Europe and Asia since the Middle Ages, e.g. pictures of the Virgin Mary or orthodox icon drawings from Russia—or *nkisi*-power

politiques et sociaux complexes. Aux 18ᵉ et 19ᵉ siècles, il y avait en Europe une véritable obsession : on faisait venir des objets de la nature et des œuvres d'art du monde entier pour les placer dans des musées et des collections privées. Les objets avaient été obtenus de diverses façons. Ils pouvaient avoir volés dans leur pays d'origine, ou négociés, considérés comme n'ayant que peu ou pas de valeur. Parfois, telles des précurseurs de l'art dit « touristique », les œuvres étaient fabriquées spécialement pour les collectionneurs, alors que localement on se tournait vers des créations modernes. Le champ « Art africain » a été créé par les artistes de la modernité classique, l'étiquette « Art » étant une condition pour l'appréciation et la valorisation des objets. On pensait que l'art dit primitif avait un accès direct à l'inconscient et une authenticité presque sacrée. Cette mystification attrayante persiste encore aujourd'hui. Les films populaires regorgent de citations faisant référence à la – supposée ou réelle – richesse africaine des formes, par exemple lorsqu'il est question de cultures lointaines ou de mondes extra-terrestres. Les contextes dans lesquels les œuvres d'art africaines sont perçues changent également constamment. Ainsi, les œuvres ont-elles toujours de nouvelles significations. De la même façon, ce que l'on entend par « image » varie d'une culture à l'autre. Nous connaissons la conception selon laquelle une « image » est une reproduction qui représente quelque chose

zu Mensch, verschieden. „Afrikanische Kunst" als Wahrnehmungsfolie von Kunst aus Afrika entstand vor dem Hintergrund von vielschichtigen ökonomischen, politischen und sozialen Prozessen. Im 18. und 19. Jahrhundert herrschte in Europa ein wahrer Sammelwahn: Objekte aus der Natur, Artefakte und Kunstwerke wurden aus „aller Herren Länder" importiert und in Museen und Privatsammlungen gebracht. Die Objekte stammten aus den unterschiedlichsten Zusammenhängen: Im Herkunftsland wurden sie manchmal geraubt, manchmal getauscht, als geheim oder wertlos angesehen. Gelegentlich, als Vorläufer der sogenannten Touristenkunst, stellte man die Dinge eigens für die Sammler her, während man sich vor Ort modernen Schöpfungen zuwandte. Das Feld „afrikanische Kunst" wurde von den Künstlern der klassischen Moderne etabliert, dabei war das Etikett „Kunst" eine Bedingung für die Wertschätzung der Objekte. Den sogenannten Primitiven wurde ein direkter Zugang zum Unbewussten zugesprochen, eine fast schon heilige Ursprünglichkeit unterstellt. Diese attraktive Mystifizierung wirkt noch heute nach. In populären Filmen etwa finden sich viele Zitate aus dem – angenommenen oder realen – afrikanischen Formenschatz, wenn es etwa um ferne Kulturen oder außerirdische Welten geht. Die Kontexte, in denen afrikanische Kunstwerke wahrgenommen werden,

Punu

Female figurine
Figure féminine
Weibliche Figur
Figura femenina
Figura femminile
Vrouwenfiguur
Wood/Bois, 46 cm

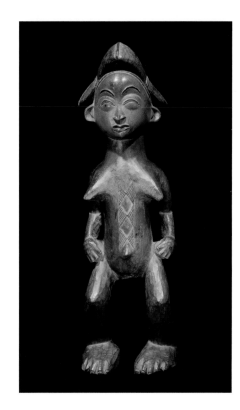

para el arte proveniente de África, surgió en medio de procesos sociales, políticos y económicos de gran complejidad. En los siglos XVIII y XIX, existía en Europa una verdadera fiebre de coleccionismo. Especímenes naturales, artefactos y obras de arte se importaron desde "todos los rincones del mundo" a museos y colecciones privadas. Estos objetos provenían de los contextos más variopintos: en ocasiones fueron robados de sus países de origen, o intercambiados, o se los consideraba secretos o carentes de valor. Ocasionalmente, como antecedente del llamado "arte para turistas", los objetos se fabricaban expresamente para los coleccionistas, recurriendo en los lugares a creaciones modernas. El área del "arte africano" fue establecida por los artistas de las vanguardias, donde la etiqueta de "arte" era una condición para valorar los objetos. A estos presuntos salvajes se les atribuía un contacto más directo con el inconsciente, y una condición natural casi sagrada. Esta mistificación tan atractiva persiste hoy en día. En las películas se recogen muchos guiños a la –real o supuesta– geología africana, por ejemplo cuando se trata de culturas extrañas o mundos extraterrestres. Los contextos en los que se presentan las obras de arte africanas son siempre distintos. Así, las obras adquieren un nuevo significado. También el concepto de qué es una "imagen" difiere entre culturas. Estamos familiarizados con la idea de que una "imagen" es

africana" come espressione della produzione artistica originata in Africa è stata influenzata da numerosi processi economici, politici e sociali. Nel XVIII e XIX secolo l'Europa fu presa da una vera e propria febbre del collezionismo: oggetti naturali, manufatti e opere d'arte furono importati da ogni parte del mondo e conservati in musei e collezioni private. Gli oggetti provenivano da fonti diverse: nel paese di origine, venivano a volte rubati, a volte scambiati, visti come poveri o privi di valore. Occasionalmente, nell'ambito di una prassi precorritrice della cosiddetta arte turistica, gli oggetti venivano prodotti espressamente per i collezionisti che si recavano sul posto alla ricerca di creazioni moderne. Il nome di "arte africana" fu coniato dagli artisti del modernismo classico, che con l'etichetta "arte" mostravano il loro apprezzamento per gli oggetti designati con tale termine. Si riteneva che le persone cosiddette primitive godessero dell'accesso diretto all'inconscio e di un'originalità quasi sacra; un'attraente mistificazione che conserva ancora oggi tutto il suo fascino. In noti film vengono utilizzati numerosi richiami al repertorio formale africano (supposto o reale) per rappresentare culture lontane o mondi extraterrestri. I contesti in cui vengono percepite le opere d'arte africane sono sempre diversi, per cui vengono attribuiti loro sempre nuovi significati. Allo stesso modo, il concetto di "immagine" è diverso da una cultura all'altra. Conosciamo l'idea secondo

misschien zelfs van mens tot mens. De 'Afrikaanse kunst' als overkoepelend begrip ontstond tegen de complexe achtergrond van economische, politieke en sociale processen. In de achttiende en negentiende eeuw woedde in Europa een ware verzamelkoorts: vondsten uit de natuur, fraai gevormde voorwerpen en kunstwerken uit alle windstreken werden naar Europa verscheept en in musea en privécollecties bijeengebracht. De voorwerpen stamden uit de meest uiteenlopende contexten: in de landen van herkomst waren ze vaak geroofd, geruild of als raadselachtig of juist waardeloos beschouwd. Als voorlopers van de toeristische souvenirs van tegenwoordig werden sommige voorwerpen speciaal voor verzamelaars gecreëerd, terwijl men zich ter plekke liever op moderne kunstwerken richtte. Het gebied van de 'Afrikaanse kunst' werd voor het eerst serieus genomen door de kunstenaars van het klassiek modernisme, waarbij het etiket 'kunst' werd gebruikt als waardebepaling van deze voorwerpen. Zo werden aan de zogenaamde primitieve kunst eigenschappen toegeschreven die een directe toegang tot het onderbewuste en daarmee een bijna heilige authenticiteit veronderstelden. Deze mythevorming laat tot op heden haar sporen na. In populaire films wordt vaak verwezen naar – aangenomen of reële – Afrikaanse vormen als het om afgelegen of zelfs buitenaardse werelden gaat. Afrikaanse

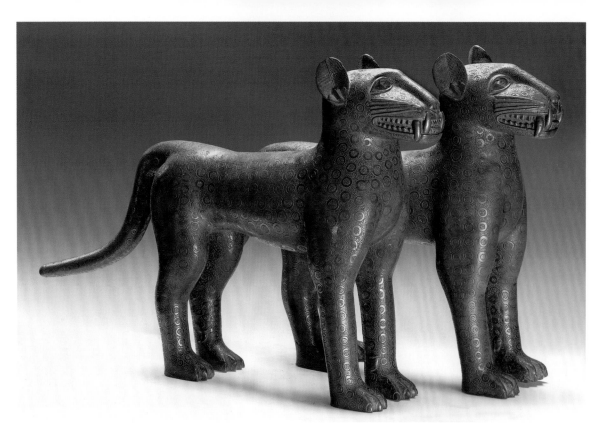

Benin

Leopards
Léopards
Leoparden
Leopardos
Leopardi
Luipaarden

Bronze, Nigerian National
Museum, Lagos

states from Congo. Art pieces from Africa took on many functions, were used in religion, science, medicine, art and entertainment. When collecting these pieces, these former functions are usually labelled as "magic" of the artefact. Today, we have an excellent documentation of individual objects from field studies and in archives. Scientists from Africa and other parts of the world are dedicated to various areas, such as old art, design or photography. However, considering the vast volume of expressions there are still big gaps in knowledge. Often little is known about the ideals of beauty and art of individual societies; in each case it is different who manufactured the pieces, men or women, the youngest or eldest of a group, friends or strangers, occasionally or exclusively.

The illustrations in this book have one thing in common: they are considered to be "African Art".

The art pieces are only partially present; we only see the object that was selected as collectable artefact. Intangible aspects or temporary elements have often not been considered; often the documentation of the meaning lacks content. Furthermore, we do not see the artefact in its original environment, but in a special photographic production: on cloth, hanging on a wall, or placed in front of a neutral background. This way it is possible to study the looks of an object in detail; however, the way of the presentation provides

et sert de preuve visuelle. Une « image » nous montre une représentation. Mais image et signification sont souvent perçues comme une seule unité, l'image étant considérée comme une unité puissante ou vivante. En Europe et en Asie, cette conception remonte au Moyen-Âge, avec, par exemple les images de la Vierge Marie et les icônes orthodoxes russes – ou les statues fétiches *nkisi* du Congo. Les œuvres d'art d'Afrique avaient en outre de nombreuses fonctions. Elles étaient utilisées dans la religion, la science, la médecine, l'art et le divertissement. Lors des collectes, ces nombreuses fonctions ont souvent été réduites à la seule «magie» de l'objet. Grâce à des études comparatives et aux recherches sur le terrain et dans les archives, nous disposons aujourd'hui d'une bonne documentation sur les différents objets. Des chercheurs du monde entier, d'Afrique comme d'autres continents, se consacrent aux différentes branches de l'art ancien, comme la conception ou la photographie. Pourtant, au regard de l'immense variété des formes d'expression, nos connaissances sont encore très lacunaires. On en sait souvent bien peu sur l'idéal esthétique et artistique des différentes sociétés. Car de l'une à l'autre, ce n'étaient pas les mêmes personnes qui fabriquaient les objets : les femmes ou les hommes, les plus jeunes ou les plus vieux membres de la communauté, des familiers ou des étrangers, occasionnellement ou régulièrement.

sind also immer wieder andere. So erhalten die Werke stets neue Bedeutungen. Ebenso unterscheiden sich die Auffassungen, was eigentlich ein „Bild" ist, von Kultur zu Kultur. Wir kennen die Vorstellung, dass ein „Bild" eine Abbildung von etwas ist, eben etwas darstellt und als Beweis oder Visualisierung dient: Ein „Bild" zeigt uns das Dargestellte. Bild und Bedeutung werden aber oft als Einheit aufgefasst, das Bild als machtvolle oder lebendige Einheit gesehen. Diese Vorstellung ist in Europa und Asien seit mittelalterlicher Zeit bekannt, etwa bei Marienbildern oder orthodoxen Ikonenbildern aus Russland – oder den *nkisi*-Kraftfiguren aus dem Kongo. Kunstwerke aus Afrika übernahmen darüber hinaus viele Funktionen, waren Gegenstand von Religion, Wissenschaft, Medizin, Kunst und Unterhaltung. Im Sammeln rezipiert werden diese vielen Funktionen oft nur als „Magie" eines Gegenstandes. Durch Vergleichsstudien, Feldforschungen vor Ort und in Archiven gibt es mittlerweile gute Dokumentationen der einzelnen Objekte. Forscher aus aller Welt, aus Afrika wie aus anderen Erdteilen, widmen sich den unterschiedlichsten Bereichen, alter Kunst etwa, Design oder Fotografie. In Anbetracht der schieren Anzahl von Ausdrucksformen gibt es jedoch nach wie vor große Wissenslücken. Oft ist wenig bekannt über das Schönheits- und Kunstideal der einzelnen

Nok
Figurine
Figure
Figur
Figura
Figura
Figuur
Clay fired/Terre cuite

una ilustración, que representa algo y que sirve como prueba o visualización: una "imagen" nos muestra lo representado. La imagen y su significado se entienden a menudo como una unidad, y la imagen se considera una unidad viva o poderosa. Esta idea se conoce en Europa y Asia desde la Edad Media, por ejemplo en las representaciones marianas o los iconos ortodoxos rusos –o las figuras de fuerza *nkisi* del Congo. Los objetos de arte africanos adoptaban, además de esta función, muchas otras: eran objetos de religión, ciencia, medicina, arte y entretenimiento. Al coleccionarnos, a menudo estas funciones se entendían simplemente como la "magia" del objeto. Gracias a estudios comparativos, investigaciones de campo y archivos, a día de hoy tenemos una buena documentación de los objetos individuales. Investigadores de todo el mundo, tanto de África como de otras partes del globo, se dedican a las áreas más diversas, desde arte antiguo a diseño o fotografía. Sin embargo, vista la enorme variedad de formas de expresión, sigue habiendo grandes lagunas en la investigación. A menudo se conoce muy poco sobre los ideales artísticos o de belleza de las diferentes sociedades; estos son distintos en función de quién ha producido los diversos objetos, de si eran hombres o mujeres, miembros jóvenes o los más ancianos de una sociedad, conocidos o desconocidos, en trabajo social o individual.

la quale un'"immagine" è la rappresentazione di un oggetto, una raffigurazione, e funge da prova o illustrazione: un'"immagine" ci mostra ciò che è raffigurato. L'immagine e il significato sono spesso considerati come un unico elemento, essendo l'immagine ritenuta una potente entità vivente. Questa idea è diffusa in Europa e in Asia sin dal Medioevo, come testimoniano le raffigurazioni della Madonna e l'iconografia ortodossa russa, o ancora le sculture *nkisi* del Congo. Le opere d'arte africane svolgevano inoltre numerose funzioni: erano oggetti religiosi, scientifici, medici, artistici e ludici. Queste molteplici funzioni sono state spesso etichettate nelle collezioni semplicemente come "magia" di un oggetto. Mediante studi comparativi e ricerche sul campo in loco e in archivio, è ora disponibile una documentazione di buona qualità sui singoli oggetti. Ricercatori di tutto il mondo, sia dall'Africa che da altri continenti, si dedicano allo studio di diversi campi, dall'arte antica al design e alla fotografia. Tuttavia, a causa della vastità del patrimonio, sono ancora molte le lacune. Spesso si sa poco dell'ideale di arte e bellezza delle singole popolazioni; è diverso di caso in caso, a seconda di chi ha prodotto i singoli oggetti, se l'autore era un uomo o una donna, se era un membro giovane o anziano della comunità, se era un familiare o un estraneo, e se si trattava di un lavoro occasionale o esclusivo.

kunstvoorwerpen worden dus in telkens verschillende contexten waargenomen, waardoor ze telkens andere betekenissen krijgen. Zo verschillen ook de opvattingen over wat nu eigenlijk een 'beeld' is van cultuur tot cultuur. Wij gaan uit van het idee dat een 'beeld' een afbeelding van iets is, zelfs iets voorstelt en als bewijs of visualisering dient: het 'beeld' toont ons een afbeelding van iets. Maar beeld en betekenis worden vaak als eenheid opgevat, waarbij het beeld als een machtige en levende eenheid wordt beschouwd. Dit idee is in Europa en Azië sinds de Middeleeuwen bekend, vooral met betrekking tot Mariabeelden of de orthodoxe iconen van Rusland – maar ook bij de *nkisi*-krachtfiguren uit Kongo. Kunstwerken uit Afrika namen vele functies aan, als uitingen van religie, wetenschap, geneeskunde, kunst of vermaak. Al deze functies werden in verzamelingen vaak kort samengevat als de 'magie' van een kunstvoorwerp. Maar dankzij vergelijkende studies, veldwerk ter plaatse en archiefonderzoek zijn veel afzonderlijke objecten inmiddels goed gedocumenteerd. Onderzoekers uit Afrika en de rest van wereld wijden zich aan zeer uiteenlopende gebieden, waaronder de oude kunst, het design en de fotografie. Maar gezien de enorme hoeveelheid scheppingsvormen vertoont onze kennis nog altijd grote hiaten. Vaak is er weinig bekend over het schoonheids- en kunstideaal van de diverse

11

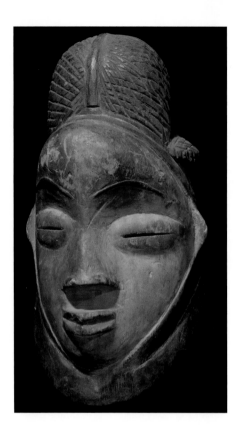

Punu

Mask

Masque

Maske

Máscara

Maschera

Masker

Wood painted/Bois peint, 31 cm

information on the spirit of the times. People from Africa developed many ways of expression, just as people everywhere else in the world. Their visual language is often surprising to our eyes, but also inspiring and exciting. This underlines the creativity of the artists to create pieces of art that are perceived as important throughout the centuries.

Les œuvres de cet ouvrage ont en commun d'être considérées comme de « l'art africain ». Elles ne sont toutefois présentées que partiellement : nous ne voyons l'objet qu'en tant que pièce de collection. Bien souvent, les éléments immatériels ou temporaires n'ont pas été pris en compte, de même que la documentation sur les significations manque également de contenu. En outre, nous ne voyons pas les œuvres d'art dans leur contexte d'origine, mais dans une mise en scène photographique spécifique : posées sur du tissu, accrochées au mur ou se détachant sur un fond neutre. Cela permet d'étudier avec précision l'aspect d'une œuvre d'art ; la présentation des objets nous donne toutefois des informations sur l'esprit de l'époque. Les peuples d'Afrique ont, comme ailleurs, développé des formes d'expressions diverses. Leur langage visuel est souvent surprenant pour notre œil, mais il est également stimulant et source d'inspiration. Cela souligne la capacité des artistes à créer des œuvres considérées comme importantes à travers les siècles et les cultures.

Gesellschaften; es unterscheidet sich von Fall zu Fall, wer die einzelnen Gegenstände hergestellt hat, ob es Frauen oder Männer waren, die jüngsten oder ältesten Mitglieder einer Gesellschaft, Vertraute oder Fremde, in gelegentlicher oder ausschließlicher Arbeit.

Gemeinsam ist den Bildwerken dieses Buches, dass sie als „afrikanische Kunst" gelten. Jedoch liegen die Kunstwerke gewissermaßen nur in Ausschnitten vor: Wir sehen nur das Objekt, das als Sammelgegenstand ausgewählt wurde. Nicht physisch verbundene oder temporäre Bestandteile wurden oftmals nicht berücksichtigt, ebenso bruchstückhaft blieb die Dokumentation der Bedeutungen. Darüber hinaus sehen wir die Kunstwerke nicht in ihrem Ursprungskontext, sondern in einer besonderen fotografischen Inszenierung: auf Stoff präsentiert, lieblos an die Wand gehängt oder freigestellt vor neutralem Hintergrund. So wird es möglich, das Aussehen der Kunstwerke genau zu studieren; dabei verrät uns die Präsentation der Objekte etwas über den Geist der Zeit. Die Menschen aus Afrika haben, genau wie anderswo, vielfältige Ausdrucksformen entwickelt. Ihre visuellen Sprachen wirken für unser Auge oft überraschend, aber auch inspirierend und anregend. Das zeigt die Fähigkeit der Kunstschaffenden, Werke zu kreieren, die quer durch die Jahrhunderte und Kulturen als bedeutungsvoll wahrgenommen werden.

House painting in
Old Dongola

Peinture d'une maison
dans le vieux Dongola

Hausbemalung in
Alt Dongola

Casa pintada en
Vieja Dongola

Pitture di una casa
ad Antica Dongola

Woningbeschildering
in Oud Dongola

Las obras plásticas de este libro tienen en común su consideración como "arte africano". Sin embargo, las obras aparecen hasta cierto punto únicamente como fragmentos: solo vemos el objeto que se escogió como elemento de coleccionista. Partes que no estuvieran físicamente unidas al mismo, o que lo estuvieran de forma temporal, a menudo no se tuvieron en cuenta, e igual de fragmentada quedó la documentación de sus significados. Además, no vemos los objetos en su contexto original, sino en una escenificación fotográfica especial: presentados sobre telas, colgados de manera aséptica en la pared o aislados delante de un fondo neutral. Esto nos permite estudiar con precisión el aspecto de las obras; pero también nos revela algo sobre el espíritu de la época. Los africanos, al igual que en otros lugares, han desarrollado múltiples formas de expresión. Su lenguaje visual resulta a menudo sorprendente a nuestros ojos, pero también inspirador y estimulante. Esto demuestra la capacidad de los creadores de generar obras que pueden ser percibidas como significativas a través de varios siglos y culturas.

Tutte le opere incluse in questo libro hanno in comune l'appartenenza all'"arte africana". Tuttavia, esse sono presentate, in certo qual modo, solo in parte: vediamo infatti solo quelle selezionate come oggetti da collezione. Gli oggetti temporanei o privi di legame fisico venivano spesso tralasciati, pertanto la documentazione relativa al loro significato resta frammentaria. Inoltre, non vediamo le opere nel loro contesto originale, bensì in una speciale messa in scena fotografica: appoggiate su una tela, appese freddamente al muro o esposte su uno sfondo neutro. Tuttavia, in questo modo è possibile studiare con precisione l'aspetto delle opere, e la presentazione degli oggetti ci fornisce informazioni circa lo stato dell'arte. Come in altri luoghi, i popoli africani hanno sviluppato molte forme di espressione diverse. I loro linguaggi visivi sono spesso sorprendenti, ma al contempo interessanti e stimolanti. Questo dimostra la capacità degli artisti di creare opere atemporali, significative attraverso i secoli e in diverse culture.

samenlevingen; dat hangt van geval tot geval af van de vraag hoe afzonderlijke voorwerpen zijn vervaardigd, of ze door vrouwen of mannen zijn gemaakt, door de jongste of de oudste leden van een gemeenschap, door ingewijden of vreemdelingen, als bijverdienste of als ambachtelijk werk.

De kunstwerken in dit boek hebben gemeen dat ze als 'Afrikaanse kunst' kunnen worden gezien. Maar in zekere zin worden slechts details van deze kunstwerken getoond: wij zien alleen het voorwerp dat als verzamelobject werd uitgekozen. Vaak is geen rekening gehouden met immateriële aspecten of tijdelijke elementen, terwijl ook het inzicht in de betekenissen gefragmenteerd blijft. Daarnaast zien we de kunstwerken niet in hun oorspronkelijke context, maar in een fotografische opzet: op een vilten ondergrond, aan de muur hangend of tegen een neutrale achtergrond. Weliswaar kunnen we zo het uiterlijk van de kunstwerken nauwkeurig bestuderen, maar deze presentatievorm zegt ook iets over de tijdgeest. Zoals overal hebben ook de mensen in Afrika veelzijdige uitdrukkingsvormen gecreëerd. Hun visuele talen zijn in onze ogen vaak verrassend, maar ook inspirerend en fascinerend. Daarmee toont de scheppende kunstenaar dat hij werken kan creëren waarvan de betekenis eeuwen en culturen kan overbruggen.

CÔTE D'IVOIRE
GUINÉ-BISSAU
GUINÉE
LIBERIA
SIERRA LEONE

GUINÉ-BISSAU

BIDYOGO

BAGA

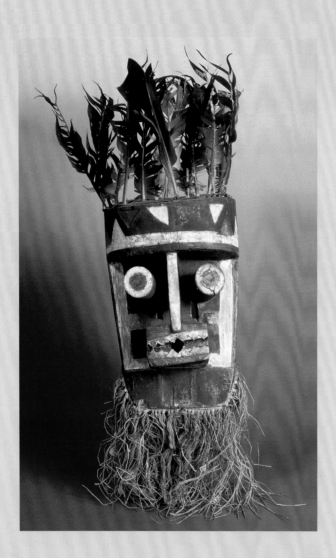

Kru
Mask
Masque
Maske
Máscara
Maschera
Masker
1865, wood painted, plant fibres, feathers/Bois peint, fibres végétales, plumes, 29 cm

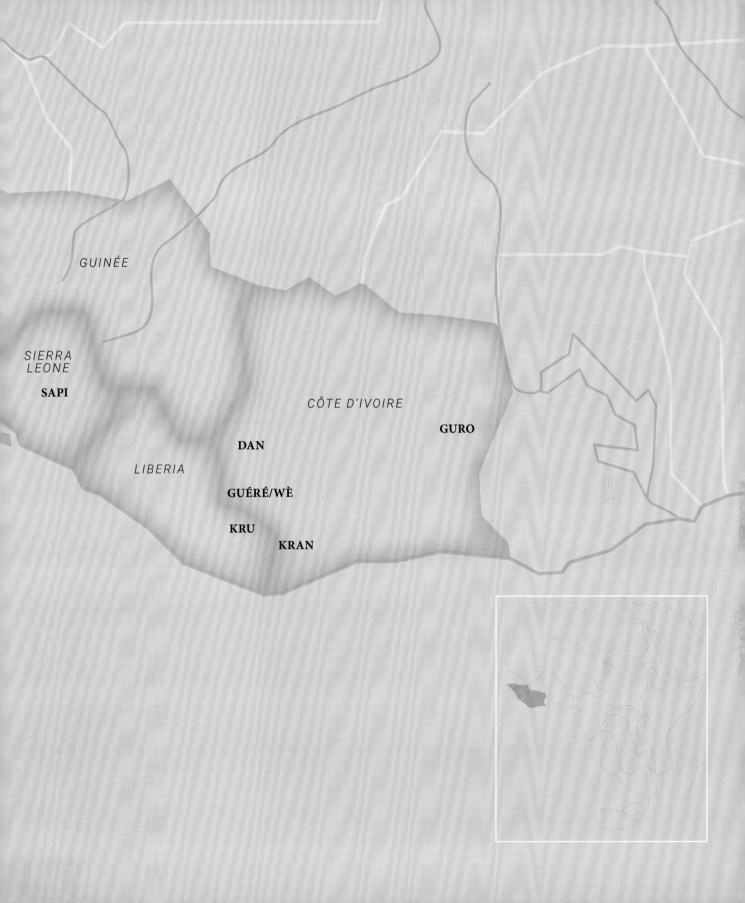

GUINÉE

SIERRA
LEONE

SAPI

CÔTE D'IVOIRE

GURO

DAN

LIBERIA

GUÉRÉ/WÈ

KRU

KRAN

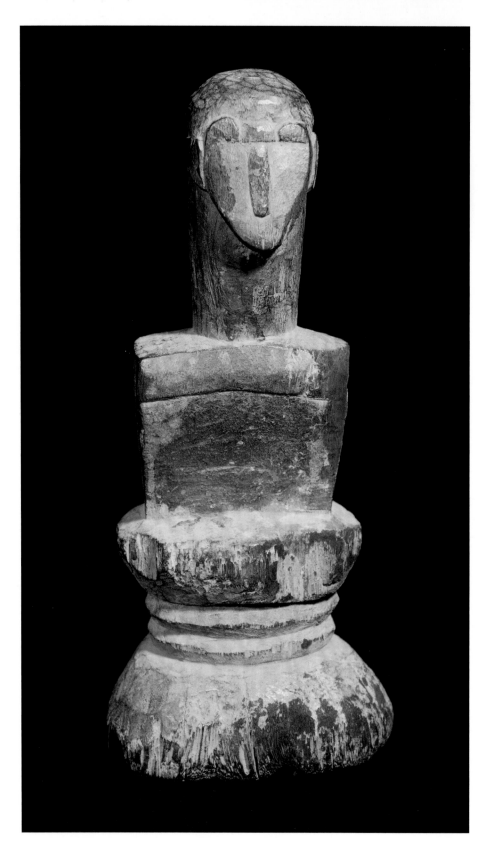

Bidyogo

Spiritual death sculpture
Sculpture spirituelle de la mort
Spirituelle Skulptur des Todes
Escultura espiritual de la muerte
Scultura spirituale della morte
Spiritueel beeldje van de dood
1873, Wood/Bois, 34,8 cm

Social diversity is large in Africa. The Bijago, to take an example, live on the Bissagos Islands in front of Guinea-Bissau. They have a long seafaring tradition. Therefore the Bijago were able to resist colonialisation from the Portuguese and remain independent for a long time. Many pieces of daily use are designed three-dimensionally. Iran-figures are seen as vessels for the souls of ancestors, however, they are not ancestor figurines. The deceased only reside in the aura of these spiritual figurines. According to their origin and destiny, Iran-figurines are made in figures or in abstract.

Les territoires géographiques africains sont très variés. Les Bijago, par exemple, vivent sur l'archipel des Bissagos au large de la Guinée-Bissau. Ils ont une tradition maritime très ancienne. Cela a permis aux Bijago de préserver longtemps leur indépendance vis-à-vis de la puissance coloniale portugaise. De nombreux objets du quotidien sont sculptés. Les statuettes Iran contiennent l'esprit des ancêtres, mais ne sont pas des figures ancestrales pour autant. Les défunts restent plutôt dans l'aura de ces entités. En fonction de leur origine et de leur usage, les Iran sont représentés de façon figurée ou abstraite.

Afrikanische Lebensräume sind sehr vielfältig. Die Bijagos etwa leben auf der Bissagos-Inselgruppe vor Guinea-Bissau. Sie haben eine lange Tradition der Seefahrt. Lange konnten sich die Bijagos daher ihre Unabhängigkeit von der portugiesischen Kolonialmacht bewahren. Viele Alltagsgegenstände sind plastisch gestaltet. Iran-Figuren werden als Behälter für die Seele der Vorfahren angesehen, sind jedoch keine Ahnenfiguren. Die Verstorbenen halten sich vielmehr in der Aura dieser Geistwesen auf. Gemäß ihrer Herkunft und Bestimmung werden Iran-Figuren figürlich oder abstrahiert dargestellt.

Bidyogo
Cover mask
Masque casque
Stülpmaske
Máscara tipo casco
Maschera ad elmo
Stulpmasker

1886, weaved, copper, horn,
cowry shells/Vannerie,
cuivre, corne, cauris, 35 cm

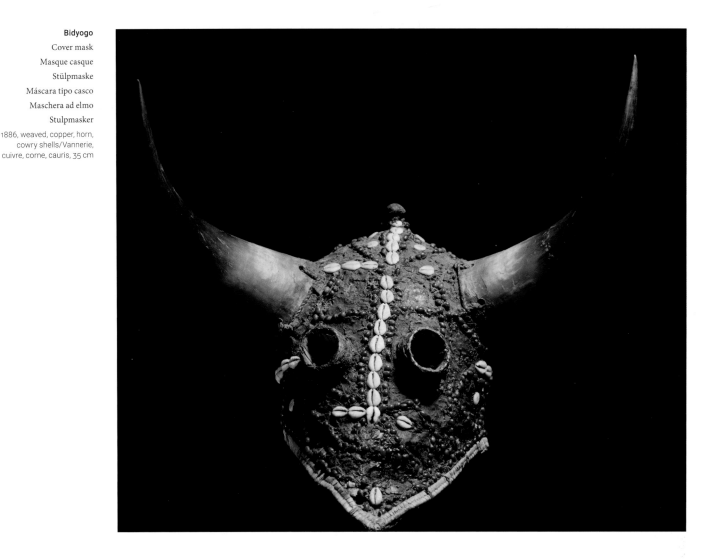

Los hábitats africanos son muy variados. Los Bijagó, por ejemplo, viven en el archipiélago Bijagós, en Guinea-Bisáu. Tienen una larga tradición como navegantes, que permitió a los Bijagó mantener su independencia del poder colonial portugués. Muchos objetos cotidianos están diseñados de forma muy plástica. Las figuras iran se consideran recipientes para el alma de los ancestros, pero no son figuras de antepasados. Más bien, los muertos residen en el aura de estos seres espirituales. Dependiendo de su origen y función, las figuras iran pueden ser figurativas o abstractas.

Gli habitat africani sono molto variegati. I Bijago vivono sulle Isole Bijagos, al largo della Guinea-Bissau, e vantano una lunga tradizione marinara. Storicamente, furono in grado di preservare la loro indipendenza dal potere coloniale portoghese. Molti oggetti di uso quotidiano presentano un design plastico. Le figure Iran, ad esempio, erano utilizzate come urne per l'anima degli antenati, sebbene non siano figure ancestrali. I defunti, infatti, risiedono solo nell'aura di questi spiriti. A seconda della loro origine e del loro scopo, le figure Iran erano rappresentate in modo figurativo oppure astratto.

De Afrikaanse sociale diversiteit is zeer groot. Zo wonen de Bidjogo op de Bissagoseilanden, voor de kust van Guinee-Bissau, en kennen zij een oude zeevaarttraditie, waardoor ze gedurende lange tijd hun onafhankelijkheid tegenover de koloniale macht Portugal konden handhaven. Veel alledaagse voorwerpen zijn plastisch vormgegeven. De iran-figuren worden als bewaarders van de voorouderlijke ziel gezien, maar het zijn echter geen voorouderfiguren. Veeleer huizen de overledenen in het aura van deze spirituele figuren; afhankelijk van hun herkomst en gebruik worden iran-figuren naturalistisch of meer abstract uitgebeeld.

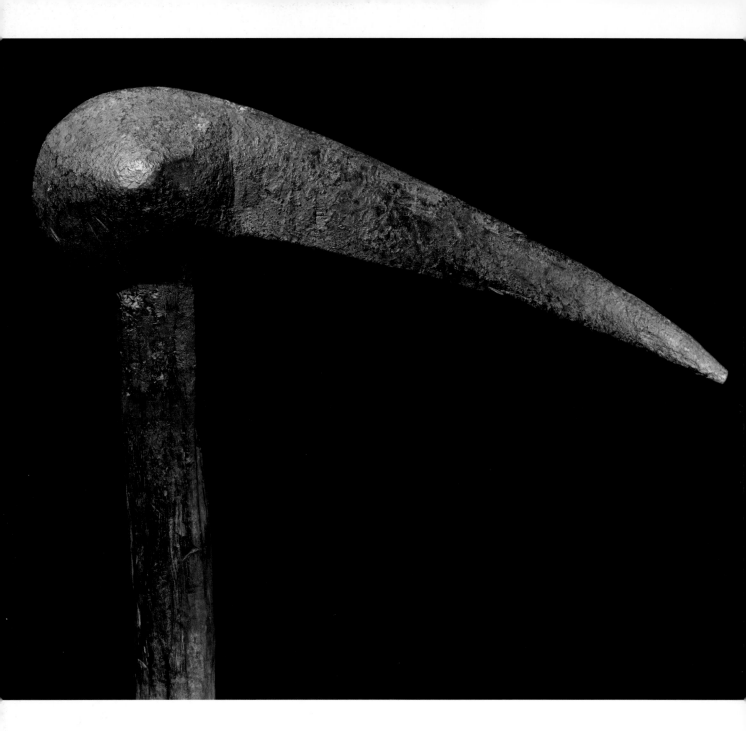

Baga

Figurine of a bird's head

Tête d'oiseau

Figur eines Vogelkopfes

Figura de cabeza de ave

Figura della testa di un uccello

Figuur van een vogelkop

1875, wood/Bois, 38 cm

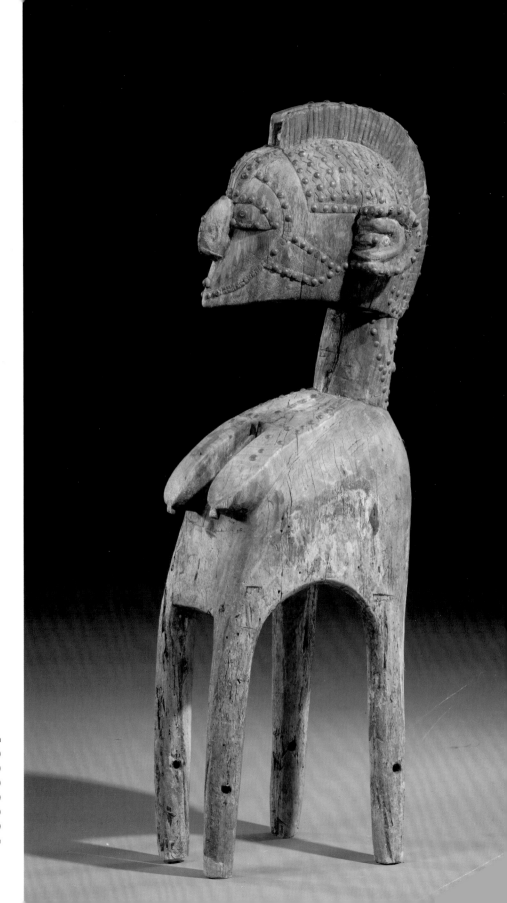

Baga

Nimba-shoulder mask (goddess of fertility)

Masque d'épaule Nimba (déesse de la fertilité)

Nimba-Schultermaske (Göttin der Fruchtbarkeit)

Máscara de hombros Nimba (diosa de la fertilidad)

Maschera da spalle raffigurante Nimba (dea della fertilità)

Nimba-schoudermasker (vruchtbaarheidsgodin)

1864, wood, nails/Bois, clous, 122 × 43 × 38 cm

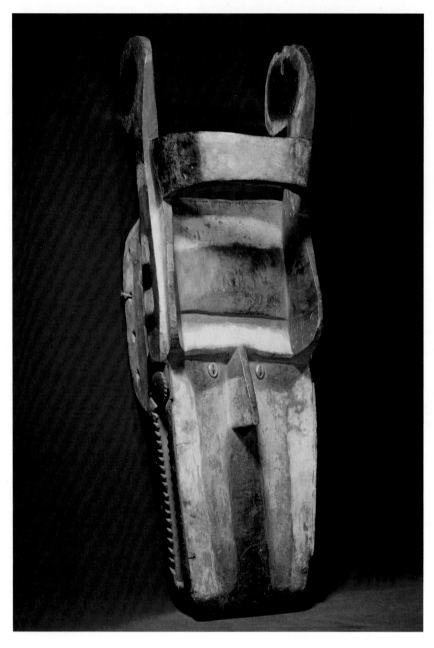

Baga

Dance mask

Masque de danse

Tanzmaske

Máscara de danza

Maschera di danza

Dansmasker

1858, wood/Bois, 90 cm

Baga

Head cover shaped like a snake

Coiffe en forme de serpent

Kopfaufsatz in Form einer Schlange

Tocado con forma de serpiente

Copricapo a forma di serpente

Hoofdtooi in de vorm van een slang

1864, wood painted, mirror/Bois peint, miroir, 193 cm

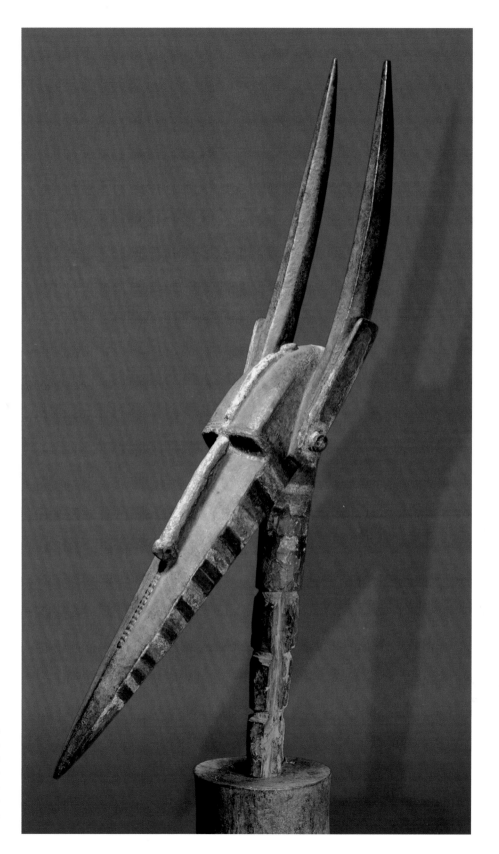

Baga
Figurine of goddess Kakilambe
Représentation du dieu Kakilambe
Figur der Gottheit Kakilambe
Figura de la diosa Kakilambe
Figura della divinità Kakilambe
Figuur van de godheid Kakilambe
1861, wood painted/Bois peint, 141 cm

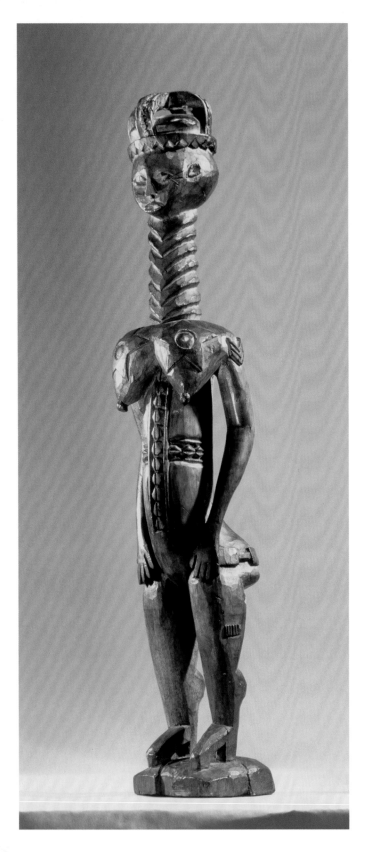

Mende	**Mende**
Statue from the possessions of a fortune teller	Sowei-Mask
Statue ayant appartenu à une voyante	Masque Sowei
Statue aus dem Besitz einer Wahrsagerin	Sowei-Maske
Estatua posesión de una vidente	Máscara Sowei
Statua appartenente al patrimonio di un indovino	Maschera Sowei
Beeld uit het bezit van een waarzegster	Sowei-masker
1866, wood/Bois	1866, wood/Bois, 33 cm

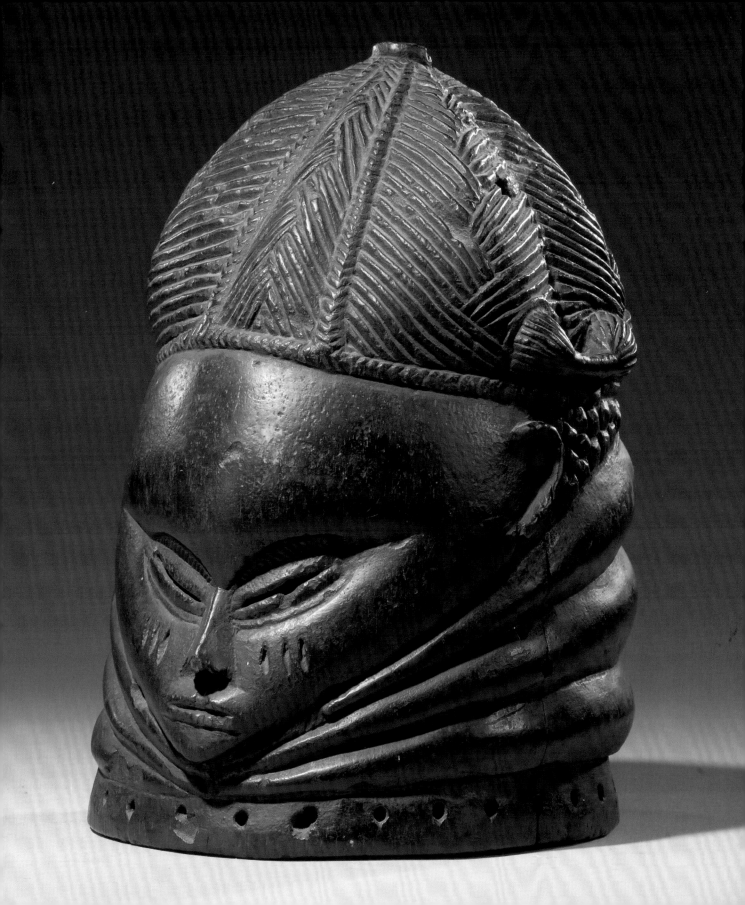

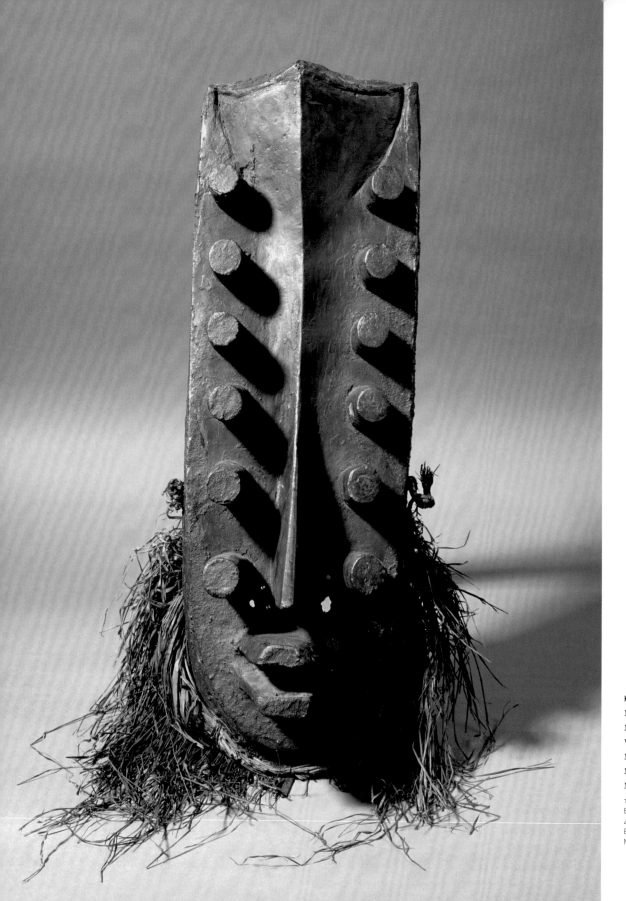

Kru

Multi-eye mask

Masque aux multiples yeux

Vieläugige Maske

Máscara de muchos ojos

Maschera dai molti occhi

Masker met rijen ogen

1865, wood, plant fibres/
Bois, fibres végétales,
42 × 16 cm,, Musée
Ethnographique Théodore-
Monod d'art africain, Dakar

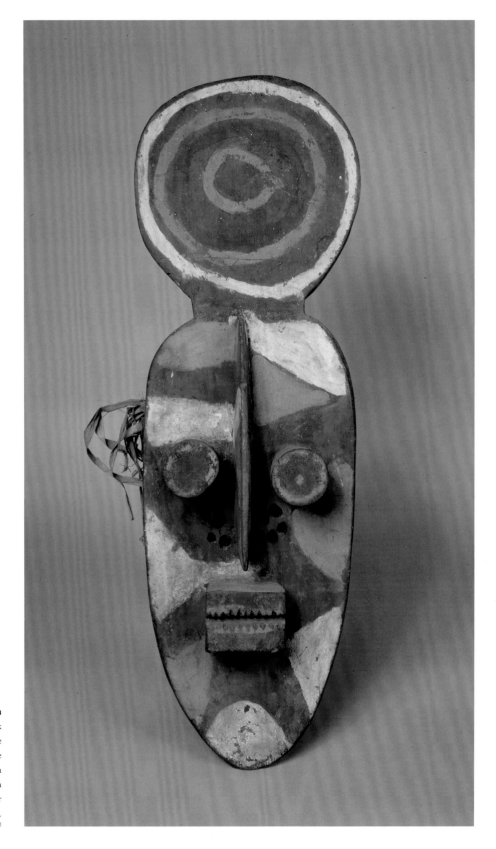

Kru

Mask

Masque

Maske

Máscara

Maschera

Masker

1865-66, wood painted, plant fibres/Bois peint,
fibres végétales, 57 × 20 × 14,5 cm

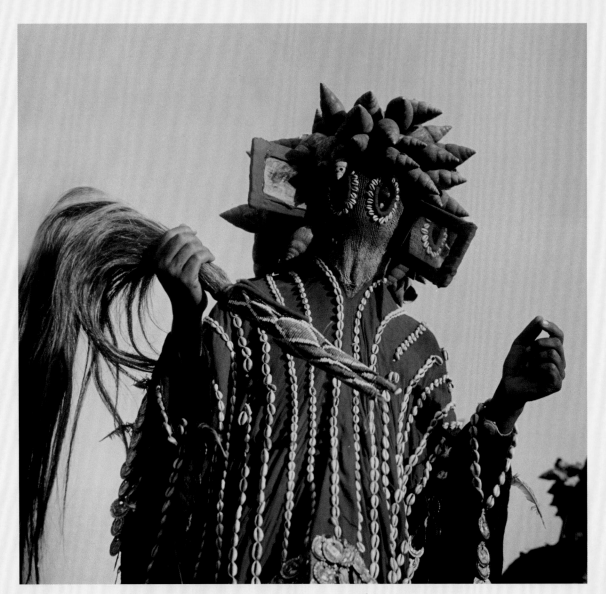

Bamileke

Masked dancer
Danseur masqué
Maskierter Tänzer
Bailarín enmascarado
Ballerino mascherato
Gemaskerde danser
1869

Context

In addition to paintings and sculpture, Africa has a rich tradition of architecture, literature and scenic arts. Like everywhere else, different types of art are interconnected. Motives can be found on many different objects, such as literary references to cooking equipment. A thorough knowledge of culture is required to understand the object. Merchants and collectors (including exhibition in museums) reduce the object to its pure aesthetic qualities; often there is no relation to its original meaning. This underlines how impressive these pieces are in a formal setting, let alone in their original setting.

Contexte

En plus des peintures et des sculptures, l'Afrique a une riche tradition architecturale, littéraire et des arts de la scène. Ici comme ailleurs, les différentes formes d'art sont étroitement liées. Les motifs se retrouvent dans de nombreux domaines différents. C'est par exemple le cas des références littéraires aux ustensiles de cuisine. Il faut une connaissance approfondie de la culture pour comprendre l'objet. Les marchands et les collectionneurs (mais aussi le fait d'être exposé dans les musées) réduisent l'objet à ses qualités esthétiques pures ; il est souvent coupé de son sens originel. Cela montre à quel point ces pièces sont impressionnantes dans un cadre formel, donc a fortiori dans leur contexte original.

Kontext

Neben Malerei und Skulptur gibt es in Afrika reiche Traditionen von Architektur, Literatur und szenischen Künsten. Wie anderswo auch sind die Künste eng miteinander verbunden. Motive finden sich auf vielen unterschiedlichen Gegenständen wieder, etwa literarische Anspielungen auf Küchengeräten. Um das Kunstwerk zu verstehen, ist eine tiefere Kenntnis der Kulturen wichtig. Die Praxis der Händler und Sammler, wie etwa das Ausstellen im Museum, reduziert den Gegenstand meist auf eine rein ästhetische Qualität; von der ursprünglichen Bedeutung wird oft nichts vermittelt. Das zeigt, wie eindrucksvoll die formale Gestaltung der Stücke ist.

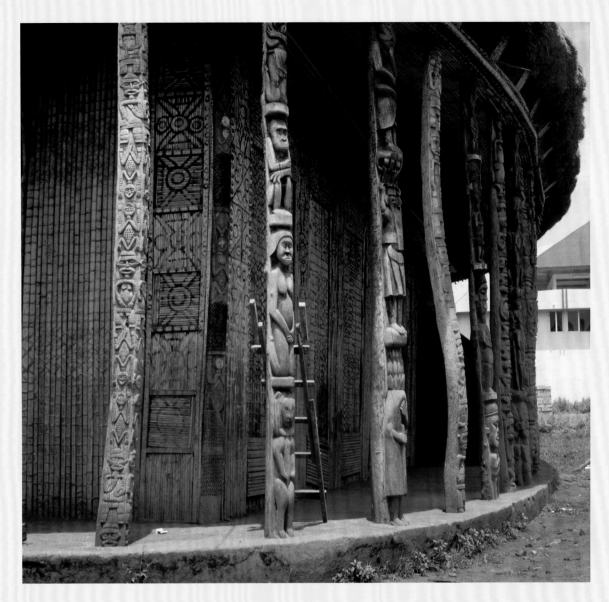

Bamileke

Wooden house of a chief

Maison en bois d'un
chef de tribu

Holzhaus eines Häuptlings

Casa de madera de un jefe

Casa di legno di
un capotribù

Houten huis van
stamhoofd

1869

Contexto

Además de en pintura y escultura, África tiene una
rica tradición en arquitectura, literatura y artes
escénicas. Como en otros lugares, las artes están
estrechamente vinculadas entre sí. Algunos motivos
pueden encontrarse en objetos diferentes, por
ejemplo alusiones literarias en utensilios de cocina.
Para entender la obra de arte, es necesario tener un
conocimiento profundo de la cultura. La práctica de
los comerciantes y coleccionistas, como el caso de su
exposición en un museo, reduce el objeto a su simple
cualidad estética; a menudo no se transmite nada de
su significado original. Esto muestra lo impresionante
del trabajo formal de las obras.

Contesto

Oltre alla pittura e alla scultura, l'Africa possiede
anche una ricca tradizione architettonica, letteraria
e scenica. Come altrove, le arti sono strettamente
interconnesse. Lo stesso motivo può essere rinvenuto
in oggetti molto diversi tra loro, da allusioni letterarie
a utensili da cucina. Per comprendere l'arte, è
fondamentale avere una conoscenza culturale molto
profonda. La pratica dello scambio commerciale e
del collezionismo, come ad esempio l'esposizione
in musei, riduce l'oggetto puramente alle sue qualità
estetiche, facendo perdere spesso ogni legame con il
significato originale. Risultano pertanto estremamente
importanti la decorazione formale e il posizionamento
di questi pezzi.

Context

Naast schilder- en beeldhouwkunst kent Afrika een
rijke traditie op het gebied van architectuur, literatuur
en podiumkunsten. Zoals elders in de wereld zijn deze
kunstvormen nauw met elkaar verbonden. Motieven
worden op talloze verschillende voorwerpen toegepast,
zoals literaire verwijzingen naar keukengerei. Om het
kunstwerk te begrijpen is een dieper inzicht in deze
culturen van belang. De praktijk van de kunsthandelaar-
en verzamelaar, waaronder het exposeren in musea,
beperkt het voorwerp doorgaans tot zijn esthetische
kwaliteit; van de oorspronkelijke betekenis wordt
daarbij weinig tot niets overgebracht. Hieruit blijkt hoe
indrukwekkend de puur formele uitvoering van deze
kunstvoorwerpen op zichzelf al is.

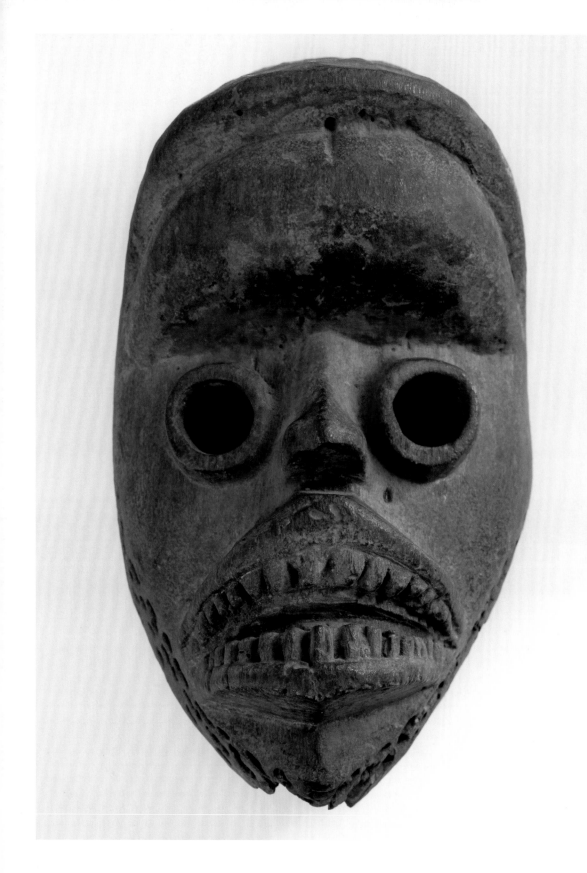

Kran

Mask

Masque

Maske

Máscara

Maschera

Masker

1865, wood/Bois, 24 cm

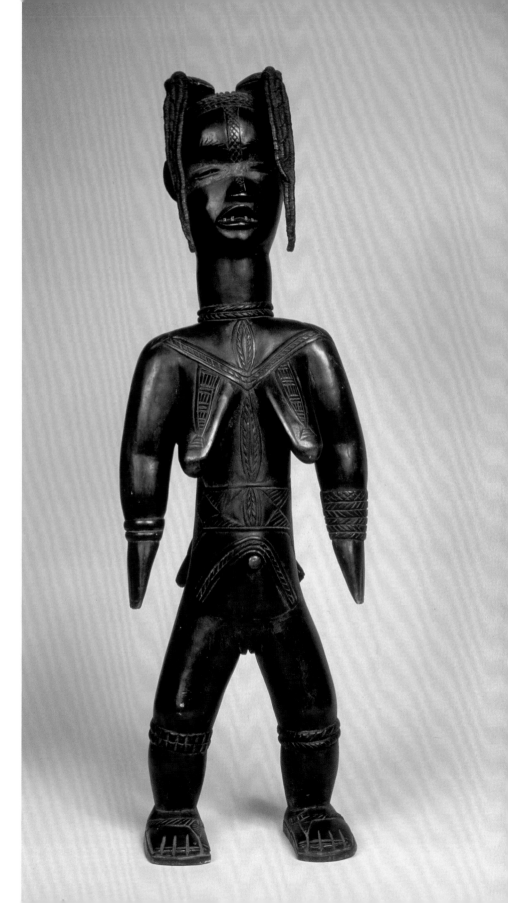

Dan

Women with child on back

Femme portant un enfant sur son dos

Frau mit Kind auf dem Rücken

Mujer con niño a la espalda

Donna con bambino sulla schiena

Vrouw met kind op de rug

1867, wood/Bois, 63 × 20,5 cm

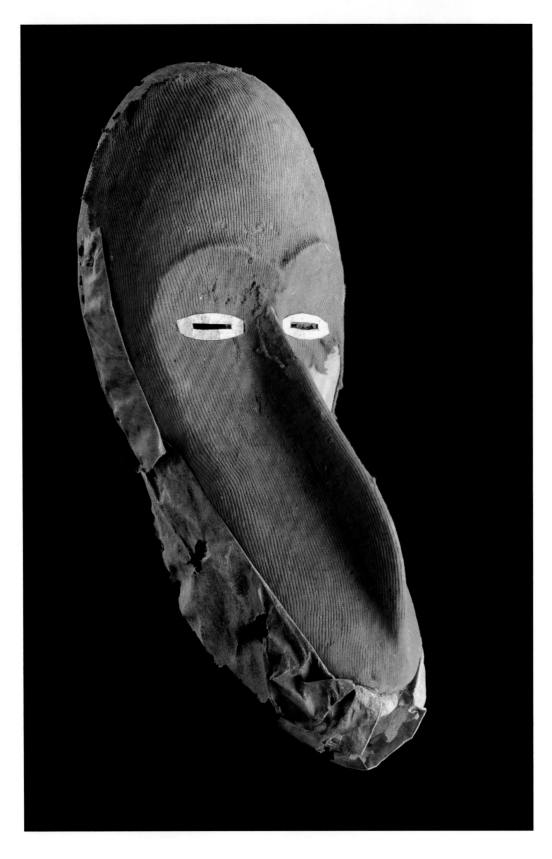

Dan

Mask

Masque

Maske

Máscara

Maschera

Masker

1866, wood, cloth, aluminium/
Bois, tissu, aluminium, 39 cm

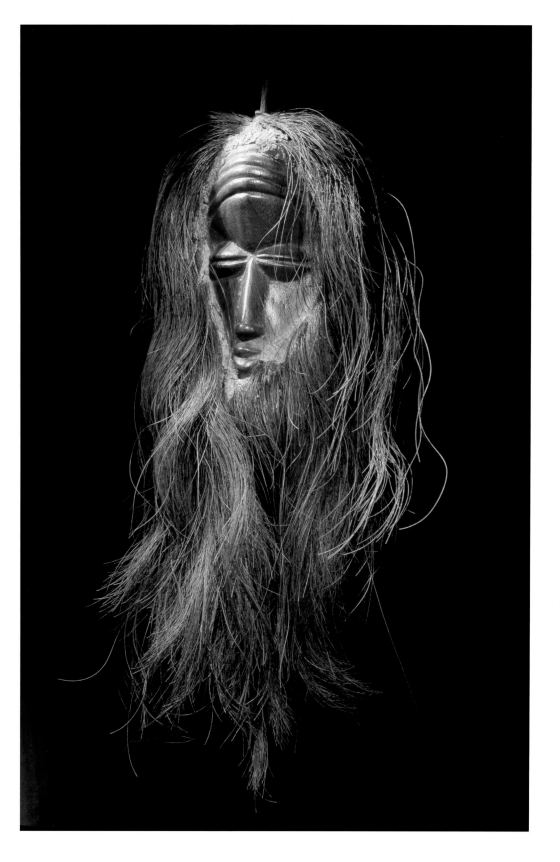

Dan
Mask
Masque
Maske
Máscara
Maschera
Masker
1867, wood/Bois

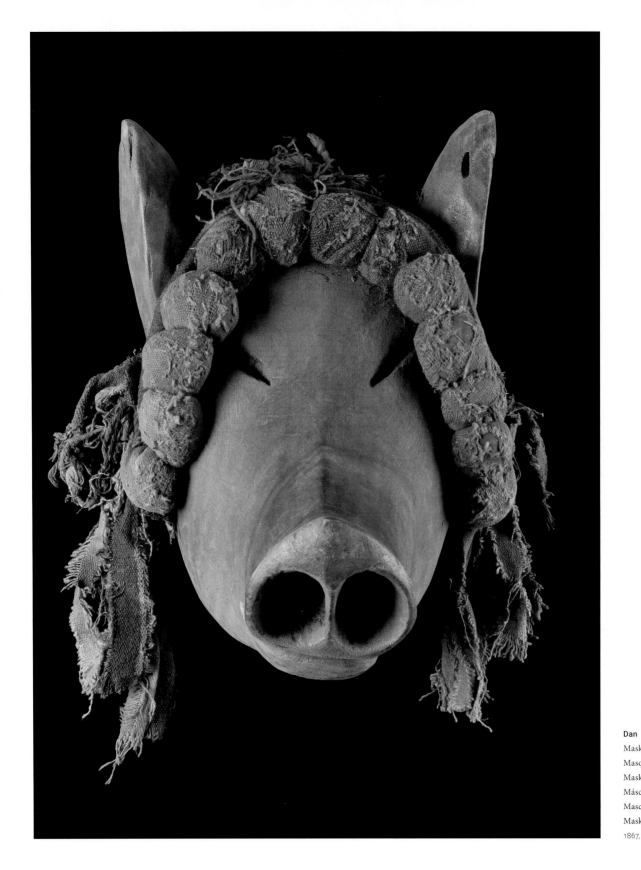

Dan

Mask

Masque

Maske

Máscara

Maschera

Masker

1867, wood/Bois

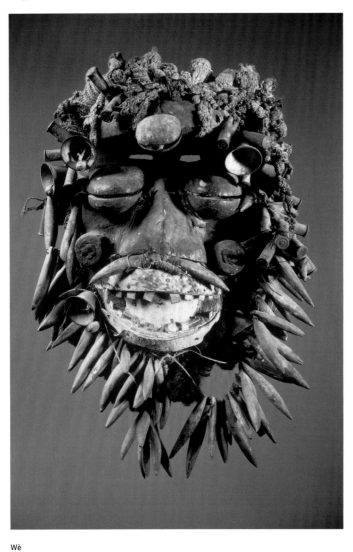

Wè

Mask
Masque
Maske
Máscara
Maschera
Masker

1868–69, wood/Bois, 47 × 43 × 19 cm

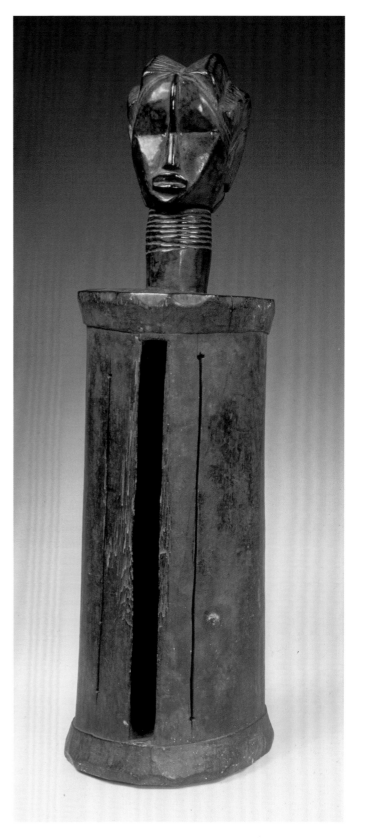

Dan

Drum with large split and anthropomorphic handle
Tambour à grande fente et poignée anthropomorphe
Trommel mit großer Spalte und anthropomorphem Griff
Tambor con hendidura grande y asa antropomórfica
Tamburo con grande fenditura e manico antropomorfo
Trommel met verticale spleet en antropomorf handvat

1867, wood/Bois, 59 × 19,5 cm

Masks are typical for the culture of the Wè. These masks distinguish themselves by expressive facial characteristics, such as eyes and a beard. They are manifestations of spirits, which are brought alive by the users during presentations. They can be of male, female or animalistic nature. Europeans collected only the masks—therefore this is the only tradition reported. The entire meaning of a mask can only be comprehended by understanding the relation between the mask and decorations and articles of clothing, ritual actions or body expressions—or even a certain time of the day.

Les masques sont typiques de la culture des Wè. Ces masques se caractérisent par l'accentuation expressive des attributs du visage, comme les yeux ou la barbe. Ils sont considérés comme les manifestations d'êtres spirituels dont le pouvoir social s'exerce par l'intermédiaire de celui qui les porte lors des représentations. Ils peuvent être masculins, féminins ou de nature animale. Les Européens n'ont rapporté que les masques, c'est donc la seule tradition rapportée. La signification d'un masque ne peut se comprendre qu'en relation avec des éléments associés : décorations ou vêtements, actes rituels ou certaines expressions corporelles, voire même un moment précis de la journée.

Masken sind typisch für die Kultur der Wè. Die Masken sind gekennzeichnet durch die expressiv betonten Merkmale eines Gesichtes, wie Augen oder Bart. Sie gelten als Manifestationen von Geistwesen, die durch Träger und Aufführungen gesellschaftlich wirksam werden. Sie treten in weiblichen, männlichen oder animalischen Formen auf. Von Europäern gesammelt und damit materiell überliefert wurde jedoch nur die eigentliche Maske. Zum Bedeutungszusammenhang einer Maske gehören allerdings Umhänge oder andere Kleidungen, rituelle Handlungen und eine bestimmte Art der Bewegung – oder auch eine bestimmte Tageszeit.

Las máscaras son típicas de la cultura de los Wè. Se caracterizan por la expresiva exageración de algunos rasgos de la cara, como los ojos o la barba. Se consideran manifestaciones de seres espirituales, que actúan en la sociedad a través de portadores y de actuaciones. Pueden tener forma femenina, masculina o animal. Sin embargo, lo único que los coleccionistas europeos trajeron fue la máscara en sí. El contexto de significación de una máscara está también definido por las capas u otras vestimentas, acciones rituales y una determinada forma de moverse −o una determinada hora del día− que la acompañan.

Le maschere sono un elemento tipico della cultura dei Wè. Sono caratterizzate da tratti del viso molto accentuati, come ad esempio gli occhi o la barba, e sono considerate manifestazioni di esseri spirituali che agiscono sulla società tramite intermediari e rappresentazioni. Si presentano in forme femminili, maschili o animali. Gli europei collezionavano soltanto le maschere, che sono pertanto l'unica tradizione riportata. Tuttavia, il loro vero significato può essere colto solo se si comprende la loro relazione con i mantelli o altri capi d'abbigliamento, rituali e movimenti specifici, persino con una determinata ora del giorno.

Maskers zijn typerend voor de cultuur van de Wè. De maskers worden gekenmerkt door de expressieve nadruk op bepaalde gelaatstrekken, zoals de ogen of de baard. Ze gelden als manifestaties van geesten die hun rol in de samenleving spelen door middel van dragers en opvoeringen. Ze komen in vrouwelijke, mannelijke of animistische gedaante voor. Alleen de maskers zelf werden door Europeanen verzameld en daarmee fysiek overgeleverd. Maar tot de complexe samenhang van betekenissen horen ook versieringen en kledingstukken, rituele handelingen, een specifieke vorm van bewegen en zelfs bepaalde tijdstippen van de dag.

Guéré (Wè)
Mask for initiation ritual
Masque pour rituel d'initiation
Maske für Initationsritual
Máscara para ritual de iniciación
Maschera per rito di iniziazione
Initiatiemasker
1868, wood painted, fur, natural fibres/Bois peint, cheveux, fibres naturelles

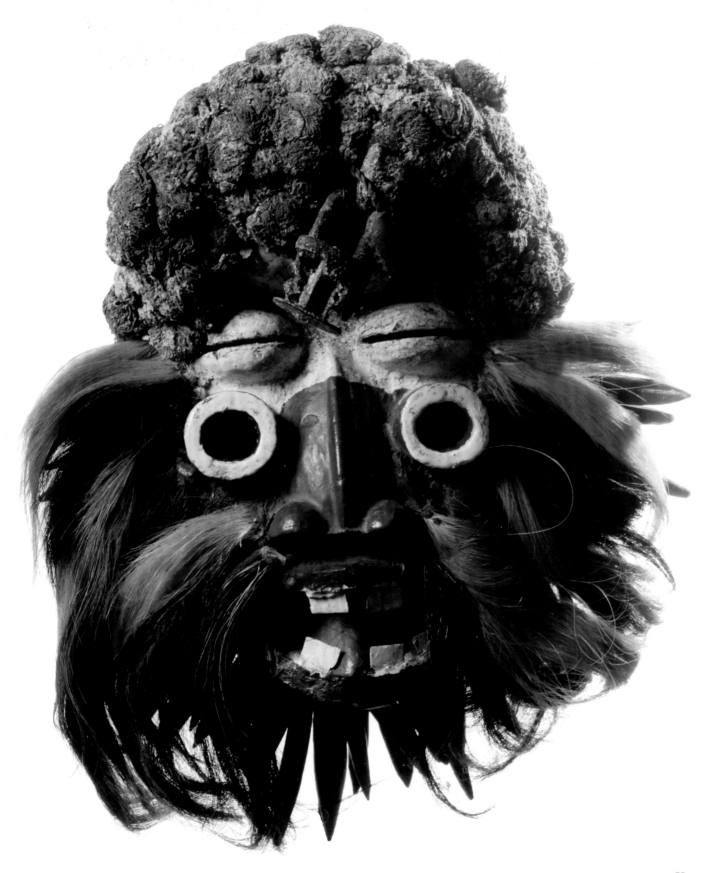

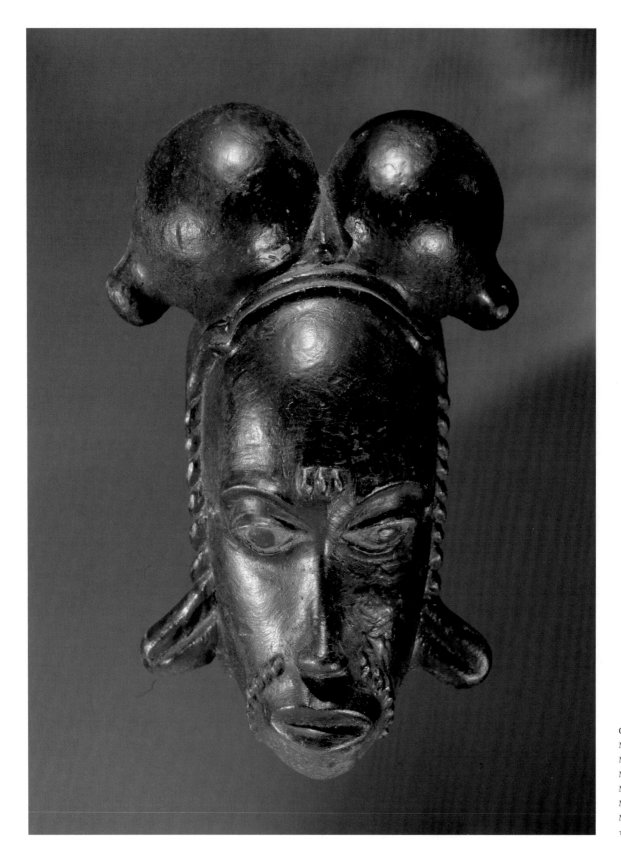

Guro
Mask
Masque
Maske
Máscara
Maschera
Masker
1868, wood/Bois

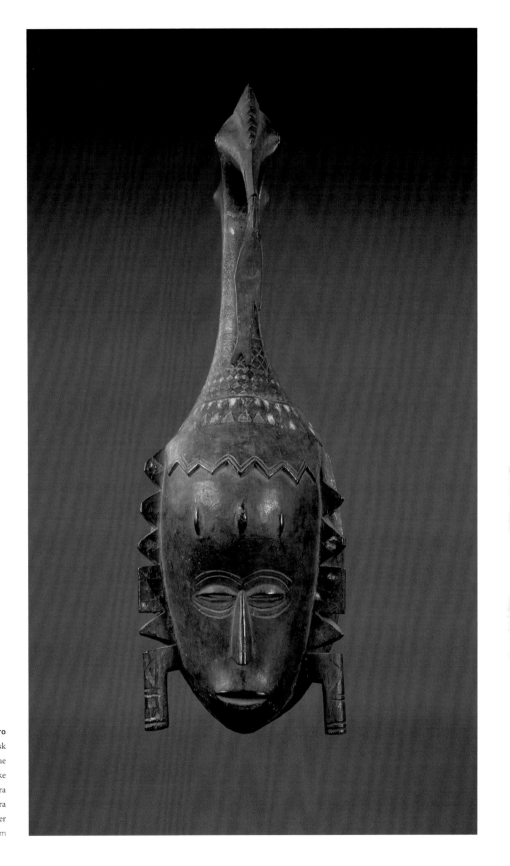

Guro
Mask
Masque
Maske
Máscara
Maschera
Masker

1869, wood/Bois, 43 × 14 × 13,5 cm

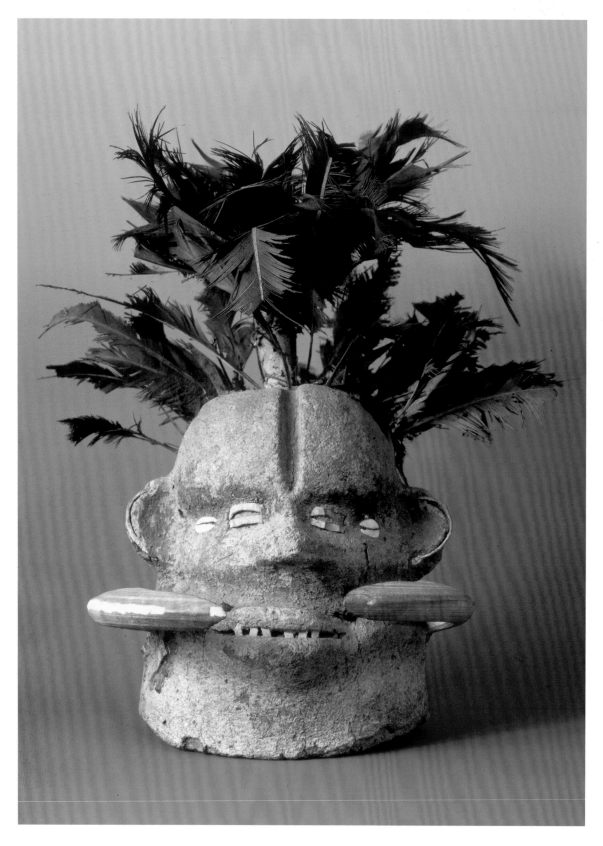

Wè

Mask

Masque

Maske

Máscara

Maschera

Masker

1869, clay, pig's teeth,
feathers, cowry shells,
wood/Argile, dents de porc,
plumes, cauris, bois

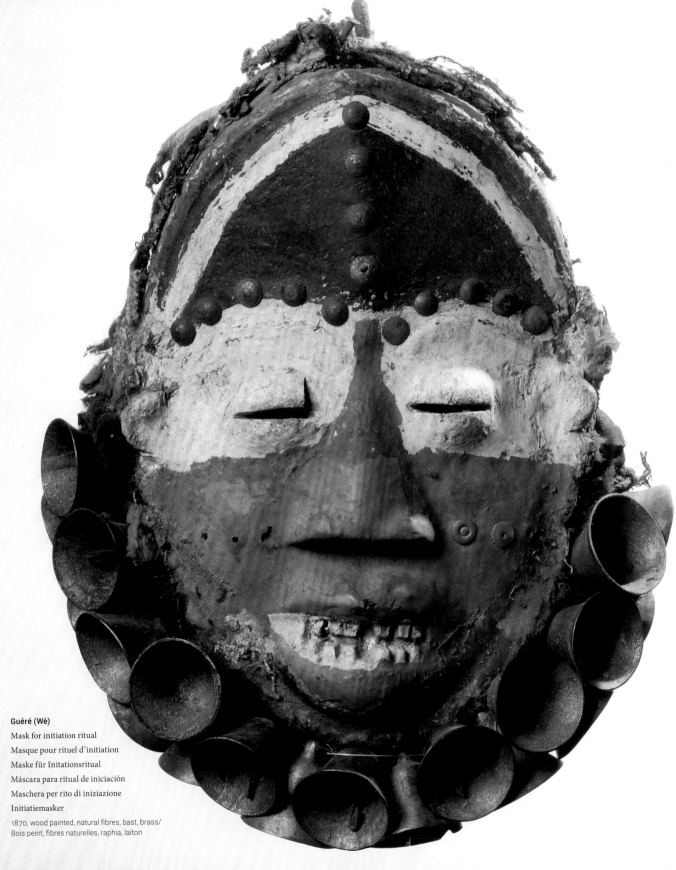

Guéré (Wè)

Mask for initiation ritual

Masque pour rituel d'initiation

Maske für Initationsritual

Máscara para ritual de iniciación

Maschera per rito di iniziazione

Initiatiemasker

1870, wood painted, natural fibres, bast, brass/
Bois peint, fibres naturelles, raphia, laiton

39

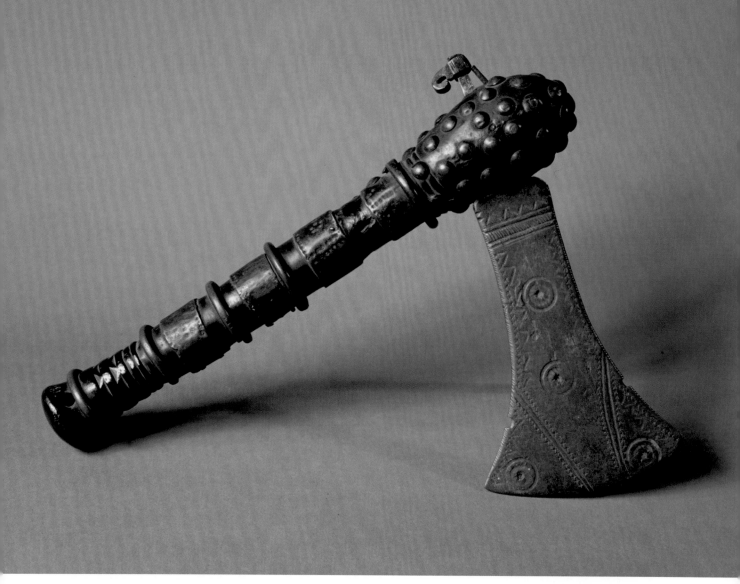

Wè

Ceremonial axe

Hache de cérémonie

Zeremonialaxt

Hacha ceremonial

Ascia cerimoniale

Ceremoniële bijl

1869, wood, copper/Bois, cuivre, 32 × 23,5 × 5,5 cm

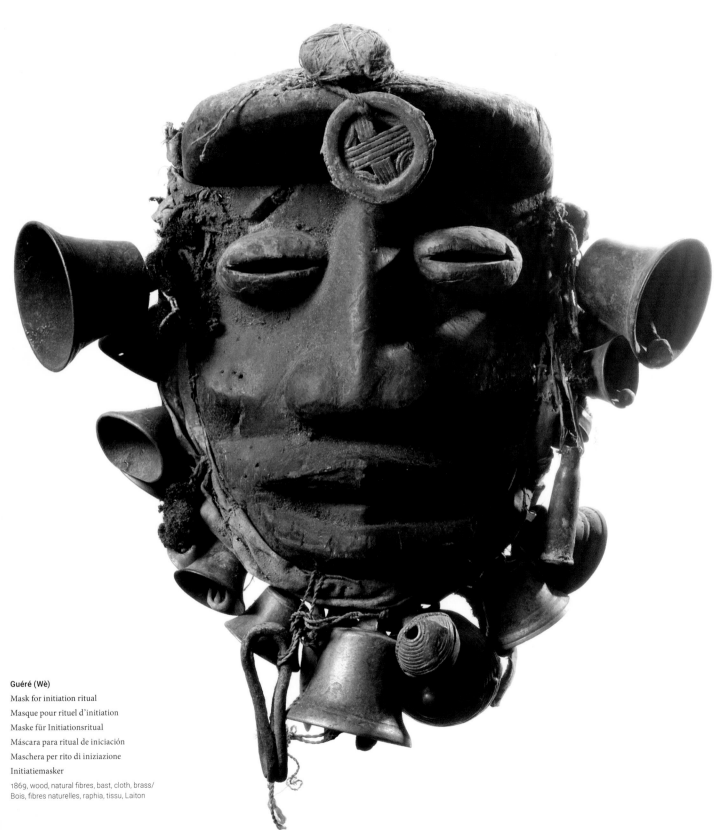

Guéré (Wè)

Mask for initiation ritual

Masque pour rituel d'initiation

Maske für Initiationsritual

Máscara para ritual de iniciación

Maschera per rito di iniziazione

Initiatiemasker

1869, wood, natural fibres, bast, cloth, brass/
Bois, fibres naturelles, raphia, tissu, Laiton

BÉNIN
CÔTE D'IVOIRE
GHANA
NIGERIA
TOGO

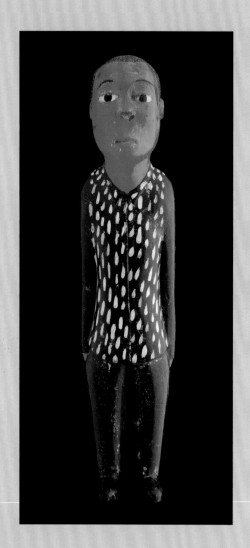

Akan

Male colon figurine

Figurine de colon masculin

Männliche Colon-Figur

Figura de hombre colono

Figura Colon maschile

Mannelijke 'colon'-figuur

1879, Wood painted/Bois peint, 29 cm

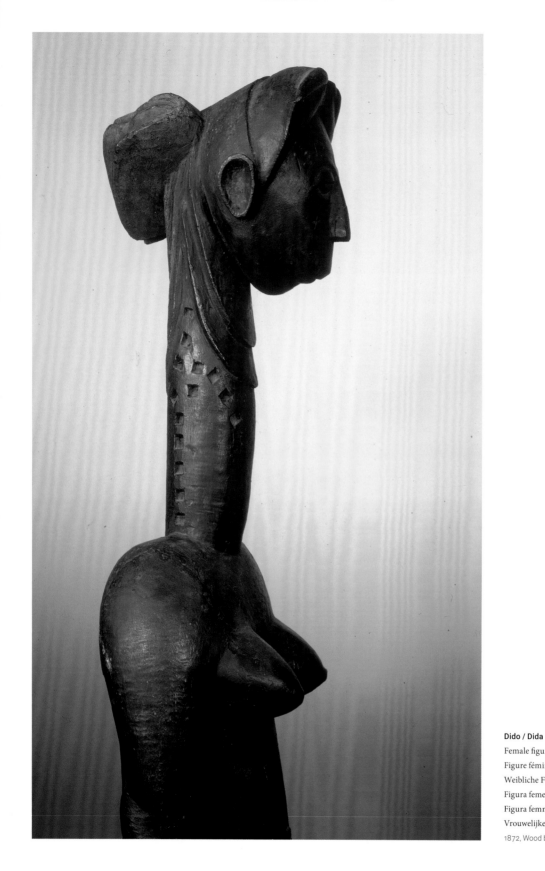

Dido / Dida

Female figurine

Figure féminine

Weibliche Figur

Figura femenina

Figura femminile

Vrouwelijke figuur

1872, Wood blackened/Bois noirci, 130 × 23 × 19,8 cm

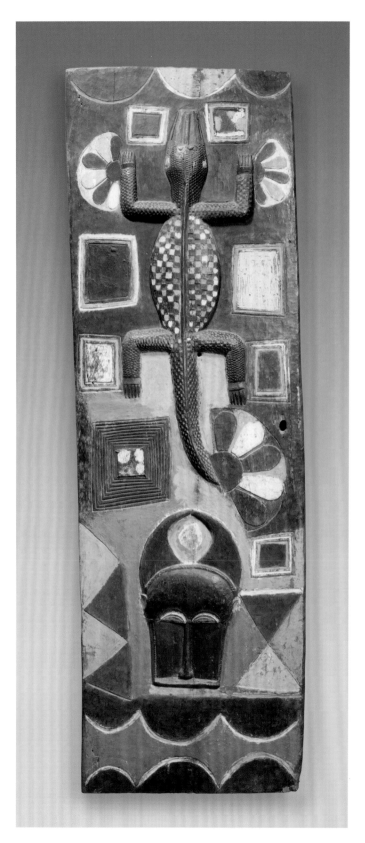

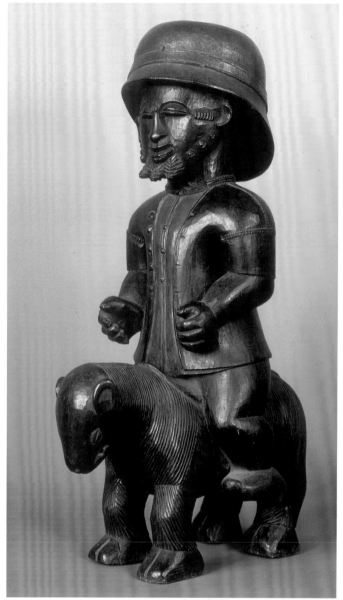

Baule
Rider with pith helmet
Figure de cavalier portant un casque colonial
Reiterfigur mit Tropenhelm
Figura ecuestre con casco
Figura equestre con casco coloniale
Ruiterfiguur met tropenhelm
1870-71, Wood/Bois, 39 × 14,5 × 23 cm

Baule
Door panel
Vantail de porte
Türflügel
Hoja de una puerta
Anta di una porta
Deurpaneel
1870, Wood painted/Bois peint, 162 × 52 cm

45

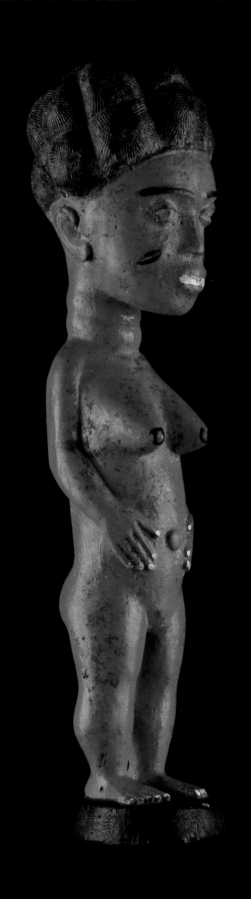

Baule

Female *colon* figurine
Figure de colon féminin
Weibliche Colon-Figur
Figura *colon* de mujer
Figura *colon* femminile
Vrouwelijke *colon*-figuur
1870, Wood painted/Bois peint, 31,5 cm

African artists have been inspired by the interaction
and exchange with the entire world over many
centuries. As an example, the *colon* statues from
Baule societies are decorated with European clothing.
Clothing is a sign of colonial wealth on figurines of
Western African cults: "European attributes" represent
a high social status. Today, *colon* statues are widely
spread around the continent as part of the souvenir
genre. This changed their meaning: They do not longer
represent local strategies to adapt to Europe, but rather
act as folklore relicts of a colonial past.

Au cours des siècles, les artistes africains ont été
inspirés par l'interaction et les échanges avec le
monde entier. À titre d'exemple, les personnages de
statuettes colon Baoulé sont représentés avec des
vêtements européens. L'habillement est un signe de
richesse coloniale sur les figurines de culte en Afrique
de l'est : les « attributs européens » traduisent un statut
social élevé. Aujourd'hui, les statuettes colon sont très
répandues sur le continent en tant que genre artistique
dit « touristique ». Cela a changé leur signification :
elles ne représentent plus des stratégies locales
d'adaptation à l'Europe, mais sont plutôt les reliques
folkloriques d'un passé colonial.

Künstler in Afrika ließen sich vom jahrhundertelangen
Austausch mit aller Welt inspirieren. Die Colon-
Figuren von Baule-Gesellschaften beispielsweise
sind mit europäischer Kleidung geschmückt. Auf
den Figuren westafrikanischer Kulte gilt die Kleidung
als Zeichen für kolonialen Reichtum: „Europäische"
Attribute repräsentieren hohen sozialen Status. Heute
sind Colon-Figuren als Genre der Touristenkunst
auf dem Kontinent verbreitet. Damit hat sich ihre
Bedeutung geändert: Diese verkörpern nicht mehr
lokale Strategien, sich Europa anzuzeigen, sondern
fungieren eher als folkloristische Relikte einer
kolonialen Vergangenheit.

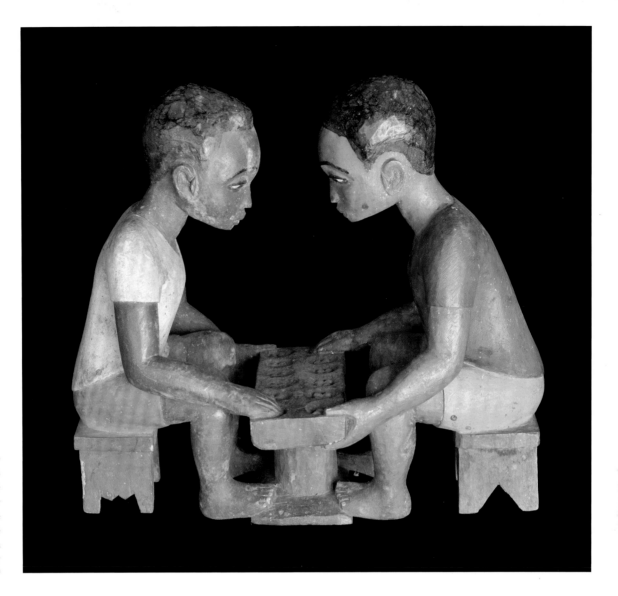

Baule
Awalé players
Joueurs d'Awalé
Awalé-Spieler
Jugadores Awalé
Giocatori di Awalé
Awalé-spelers
1870–71, Wood painted/
Bois peint, 48 cm

A lo largo de los siglos, los artistas africanos se dejaron inspirar por el intercambio con el resto del mundo. Las figuras *colon* de las sociedades Baule, por ejemplo, están decoradas con vestimentas europeas. En las figuras de cultos del África occidental estas vestimentas se consideran indicadores de riqueza colonial: os atributos "europeos" representan un estatus social elevado. Hoy en día, las figuras *colon* están expandidas por el continente como parte del género de arte para turistas. Por lo tanto, su significado ha cambiado: ya no simbolizan estrategias locales para adaptarse a Europa, sino que actúan como las reliquias folclóricas de un pasado colonial.

Gli artisti africani traevano ispirazione dallo scambio secolare con il mondo circostante. Le figure *colon* dei Baulé, ad esempio, sono decorate con abiti in stile europeo. Nelle figure impiegate nei culti dell'Africa occidentale, l'abbigliamento era un segno della ricchezza coloniale: attributi "europei" erano sinonimo di uno status sociale elevato. Oggigiorno, le figure *colon* sono diffuse nel continente come genere dell'arte turistica. Ciò ha determinato un cambiamento del loro significato: non incarnano più le strategie locali per adattarsi all'Europa ma sono piuttosto delle reliquie folcloriche del passato coloniale.

Eeuwenlang werden kunstenaars in Afrika geïnspireerd door de uitwisseling met de rest van de wereld. Zo zijn de *colon*-figuren van de Baule-volken met Europese kleding gedecoreerd. De kledij op deze figuren van West-Afrikaanse religies geldt als teken van koloniale rijkdom: de 'Europese' attributen staan voor een hoge sociale status. Vandaag de dag zijn de *colon*-figuren als een genre van souvenirkunst over het hele continent verspreid. En daarmee is hun betekenis veranderd: ze belichamen niet langer de plaatselijke strategie om zich iets Europees eigen te maken, maar fungeren veeleer als folkloristische overblijfselen van een koloniaal verleden.

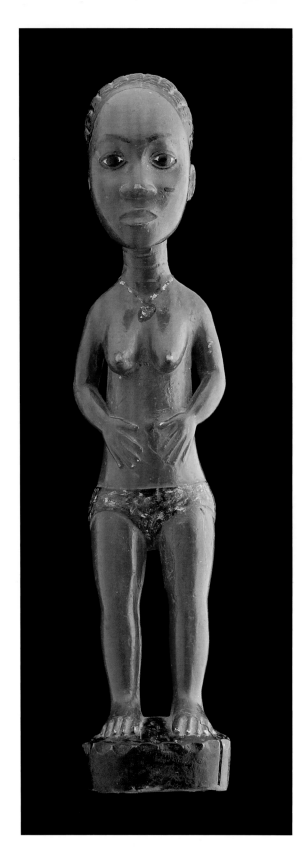

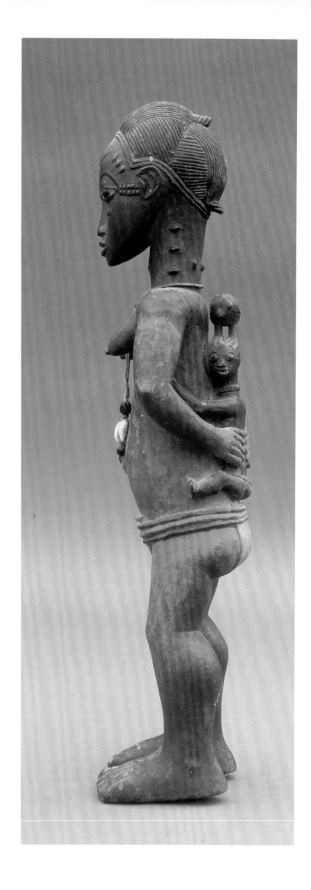

Baule

Female *colon* figurine

Figure colon féminin

Weibliche Colon-Figur

Figura *colon* de mujer

Figura *Colon* femminile

Vrouwelijke *colon*-figuur

1870, Wood painted/
Bois peint, 31,5 cm

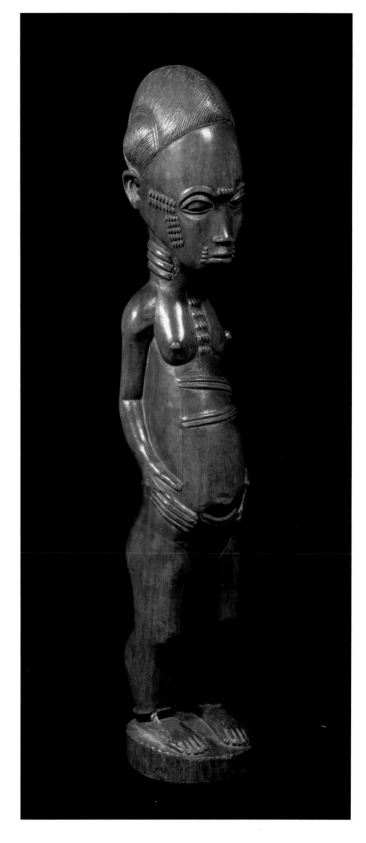

Baule

Mother with child and bird

Mère avec enfant et oiseau

Mutter mit Kind und Vogel

Madre con hijo y pájaro

Madre con bambino e un uccello

Moeder met kind en vogel

1871, Wood painted/Bois peint, 44 × 14 × 10,5 cm

Baule

Female figurine

Figure féminine

Weibliche Figur

Figura femenina

Figura femminile

Vrouwelijke figuur

1873, Wood patinised/Bois patiné, 43 cm

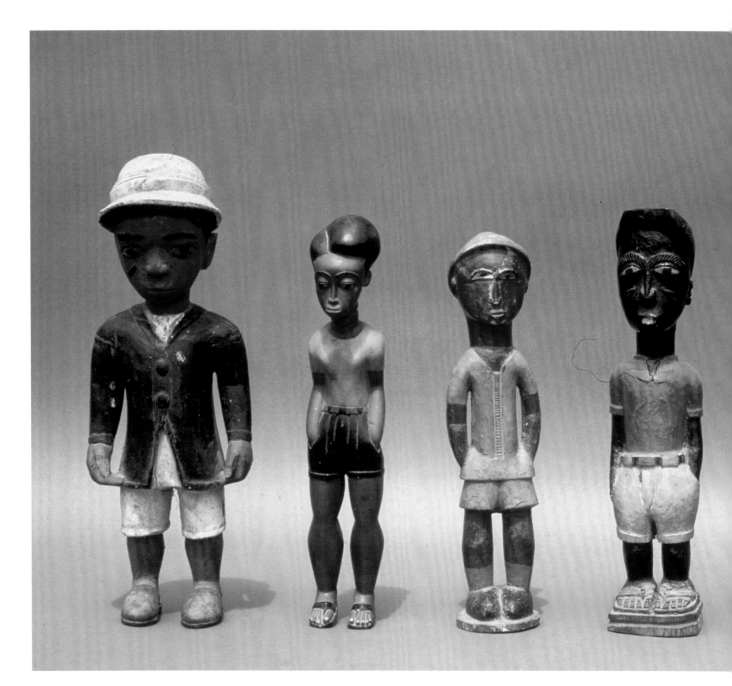

Baule

Statues in European clothing

Statuettes en vêtements européens

Statuetten in europäischer Kleidung

Estatuillas con vestimentas europeas

Statuette in abiti europei

Beeldjes met Europese kledij

1872, Wood painted/Bois peint

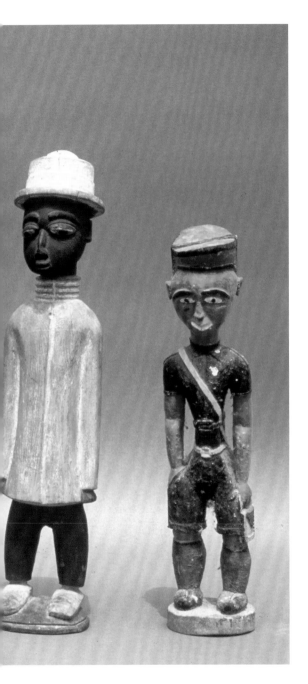

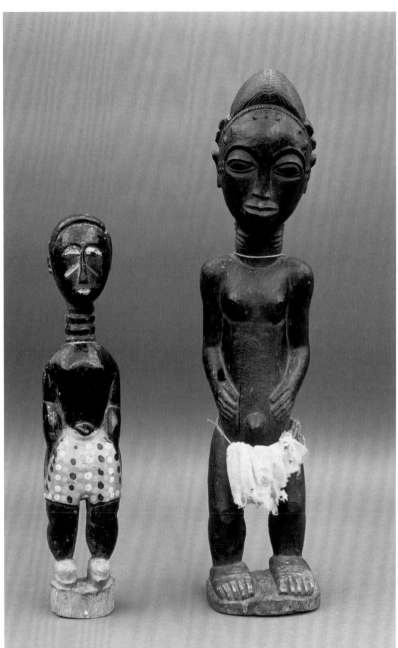

Baule

Two statues

Deux statuettes

Zwei Statuetten

Dos estatuillas

Due statuette

Twee beeldjes

1871, Wood painted/Bois peint

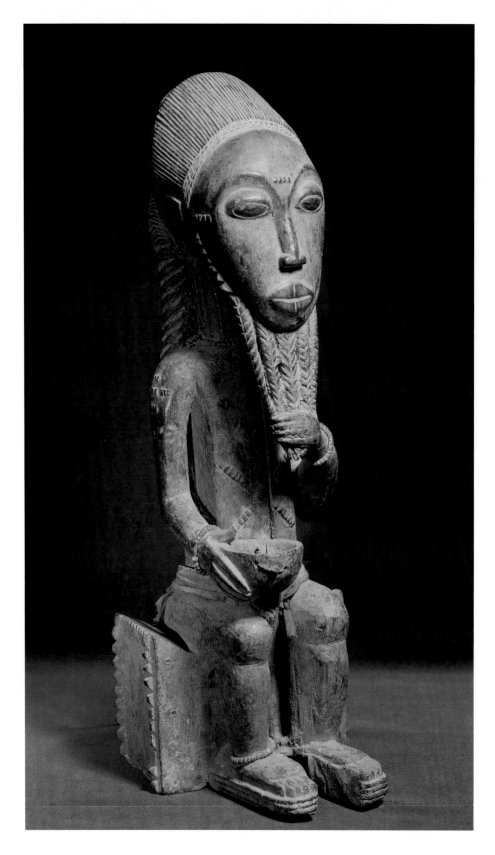

Baule

Sitting ancestor figurine

Figurine d'ancêtre assis

Sitzende Ahnenfigur

Figura de antepasado sedente

Figura di un antenato seduto

Zittende voorouderfiguur

1871, Wood/Bois, 42 cm

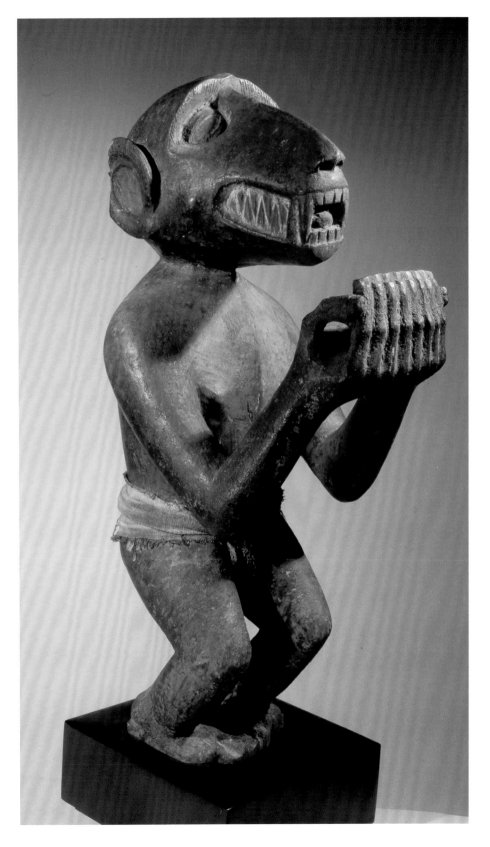

Baule

Monkey figurine for trance séances

Figurine de singe pour séances de transes

Affenfigur für Trance-Séancen

Figura de mono para sesiones de trance

Figura di scimmia per sedute spiritiche e trance

Apenfiguur voor trance-séances

1872–75

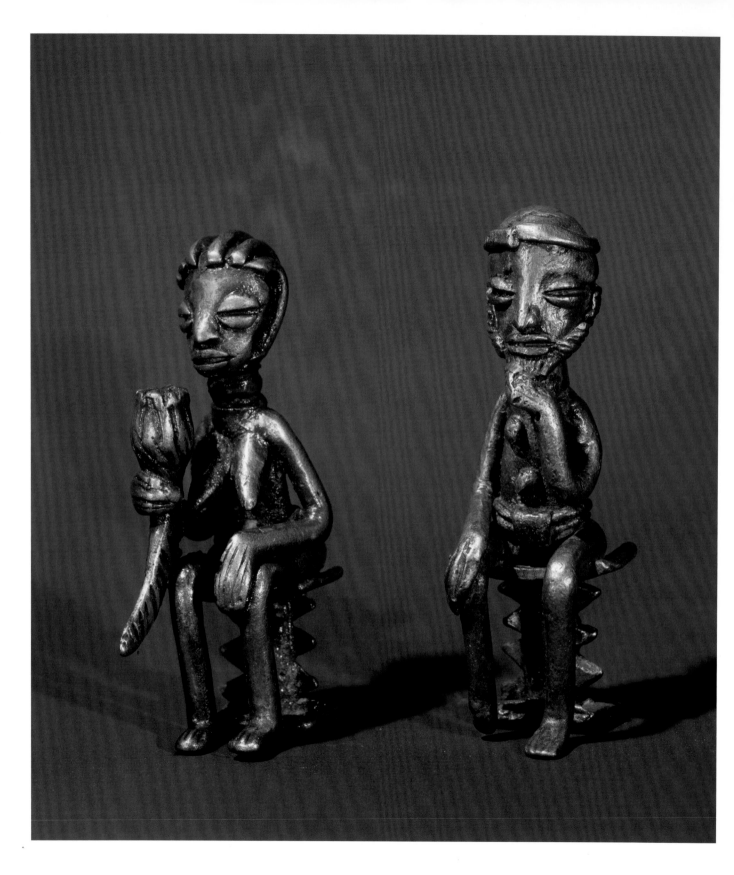

Baule

Sitting figurines

Figurines assises

Sitzfiguren

Figuras sedentes

Figure sedute

Zittende figuren

1872, Brass/Laiton, 6,8 cm

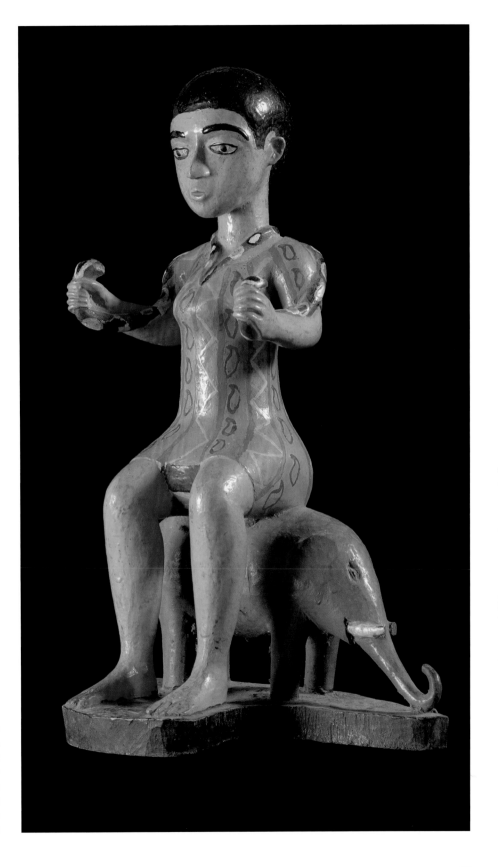

Baule

Figurine of a water spirit

Figurine d'un esprit de l'eau

Figur eines Wassergeistes

Figura de un espíritu del agua

Figura di uno spirito dell'acqua

Figuur van een watergeest

1872, Wood painted/Bois peint

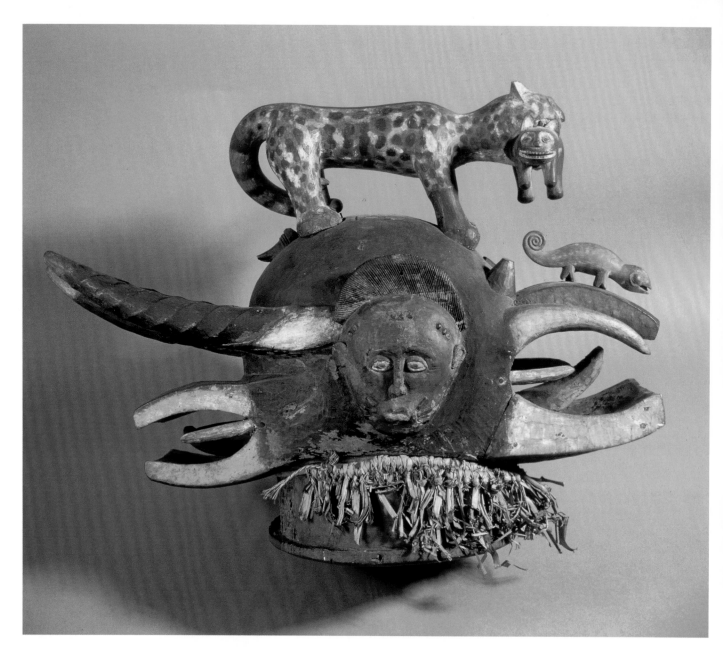

Baule

Mask

Masque

Maske

Máscara

Maschera

Masker

1872, Wood painted/Bois peint, 48 × 30 × 64,3 cm

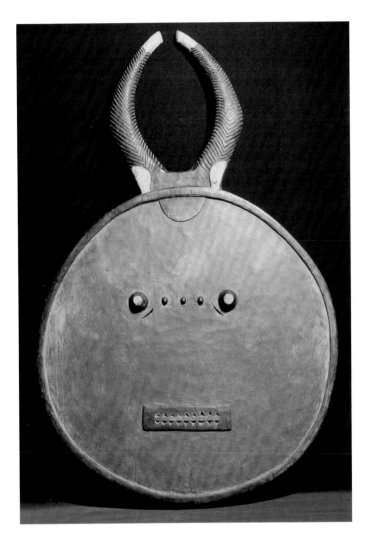

Baule

Mask

Masque

Maske

Máscara

Maschera

Masker

1872, Wood painted, metal/Bois peint, métal, 99,5 cm

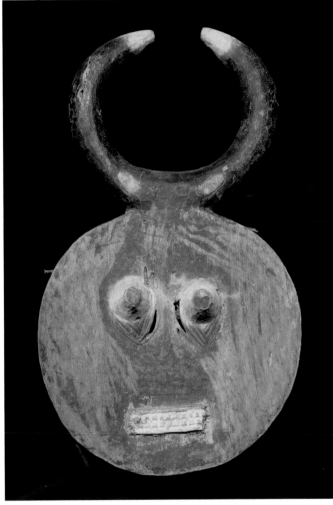

Baule

Mask

Masque

Maske

Máscara

Maschera

Masker

1873, Wood/Bois, 41 × 24,5 × 10,5 cm

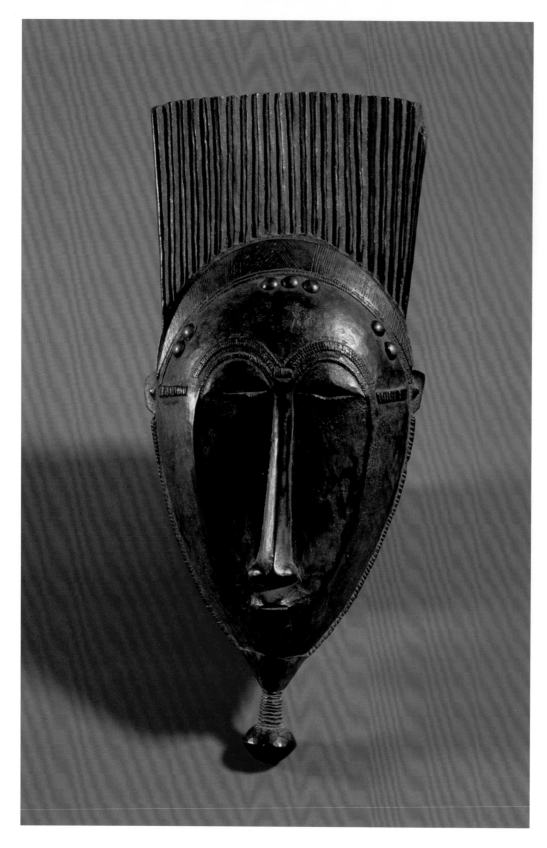

Baule
Mask
Masque
Maske
Máscara
Maschera
Masker
1871, Wood/Bois, 34 × 15 × 8 cm

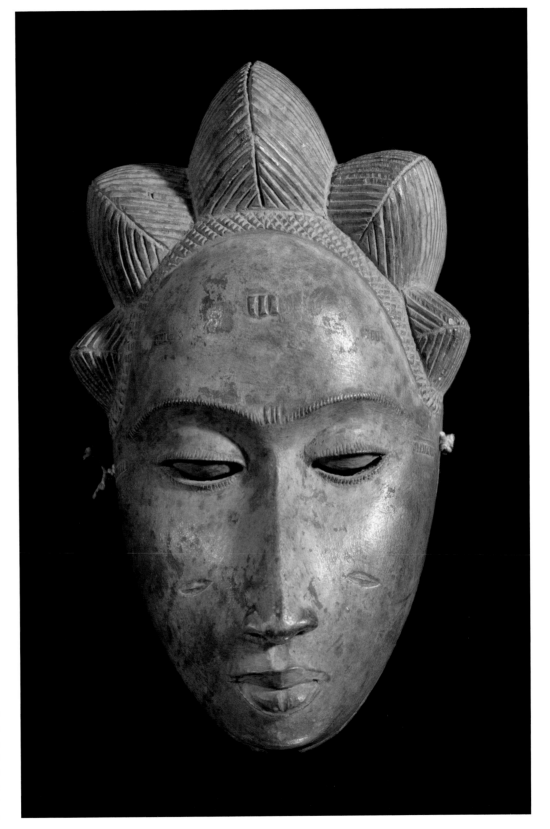

Baule
Mask
Masque
Maske
Máscara
Maschera
Masker
1872, Wood patinised/Bois patiné, 26,3 cm

59

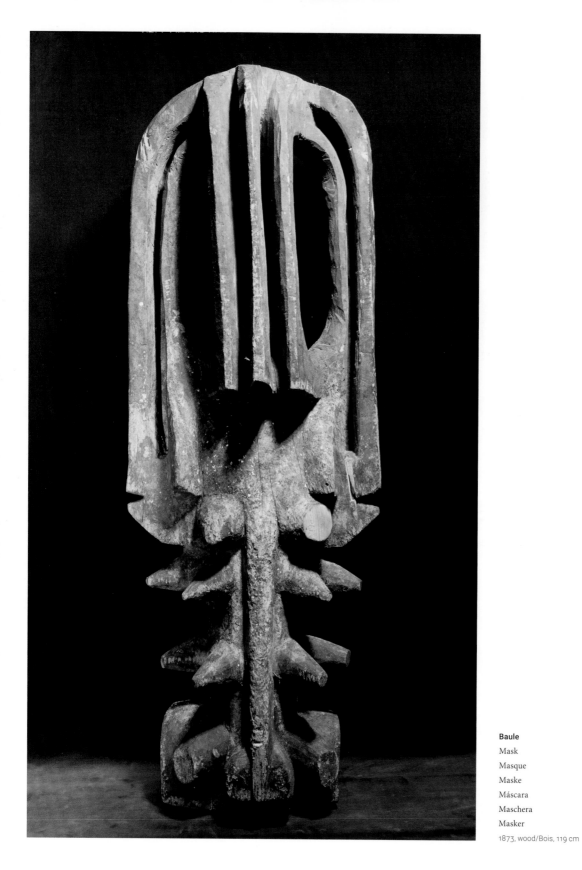

Baule

Mask

Masque

Maske

Máscara

Maschera

Masker

1873, wood/Bois, 119 cm

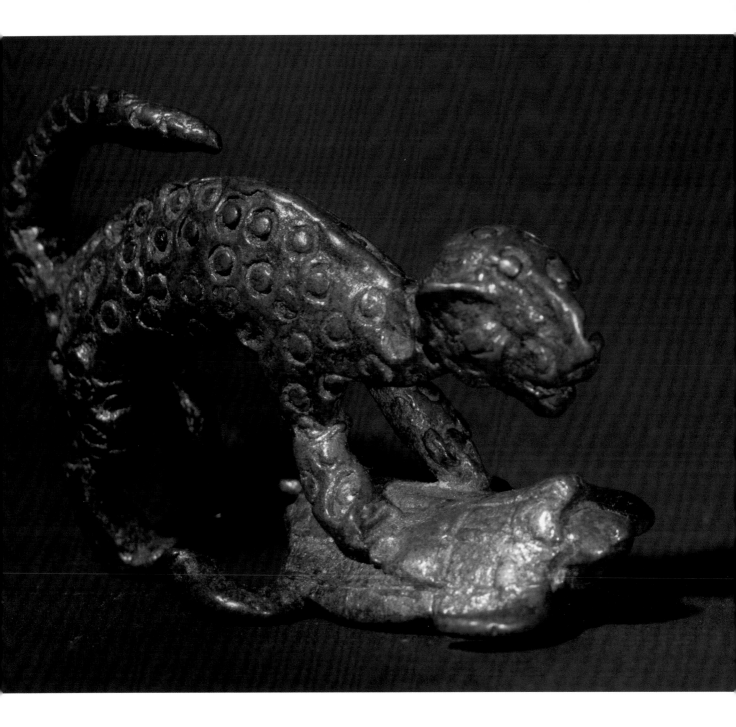

Baule

Golden weight in shape of leopard and turtle

Poids à peser l'or en forme de léopard et de tortue

Goldgewicht in Form von Leopard und Schildkröte

Pesa de oro en forma de leopardo y tortuga

Peso per oro a forma di leopardo e tartaruga

Goudgewicht in de vorm van luipaard en kikker

1874, Brass/Laiton, 7 cm

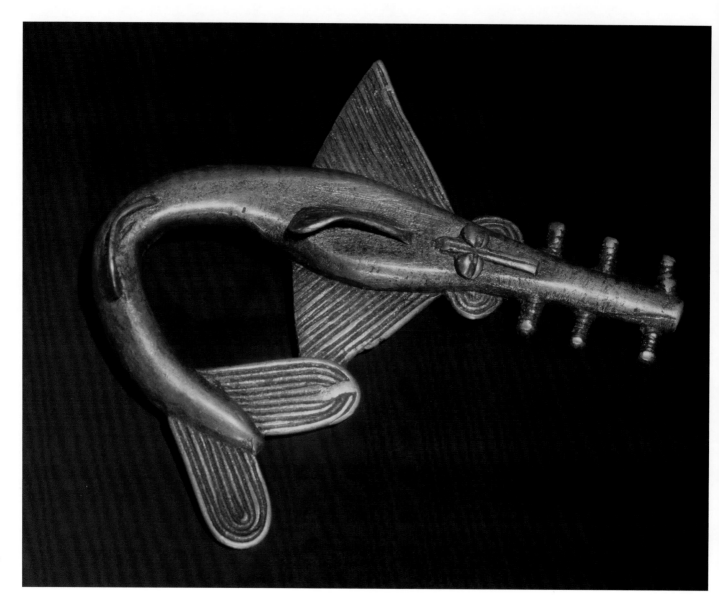

Baule

Golden weight in shape of a sawfish

Poids à peser l'or en forme d'espadon

Goldgewicht in Form eines Sägefisches

Pesa de oro en forma de pez sierra

Peso per oro a forma di pesce sega

Goudgewicht in de vorm van een zaagvis

1873, Bronze/Bronze, 9,4 cm

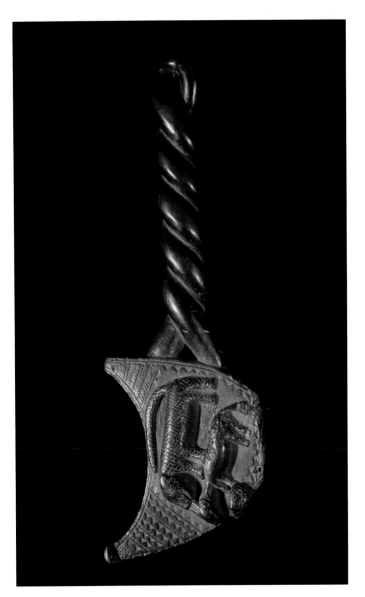

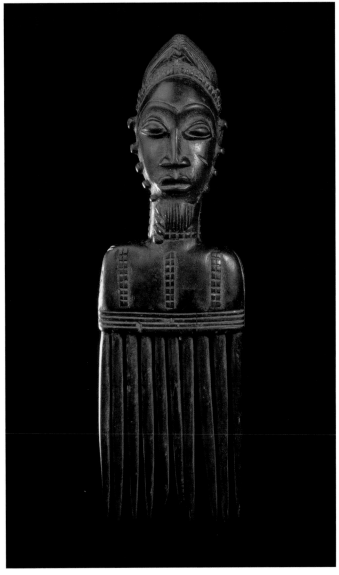

Baule

Bell with hunting scene

Maillet de cloche avec scène de chasse

Glockenschlegel mit Jagdszene

Baqueta de campana con escena de caza

Pendolo per campana con scena di caccia

Klepel met jachtscène

1874, Wood/Bois, 24,8 cm

Baule

Comb with male bust as handle

Peigne avec manche en forme de buste masculin

Kamm mit männlicher Büste als Griff

Peine con busto masculino como asa

Pettine con manico a forma di busto maschile

Kam met mannenbuste als handvat

1875, Wood/Bois, 27 cm

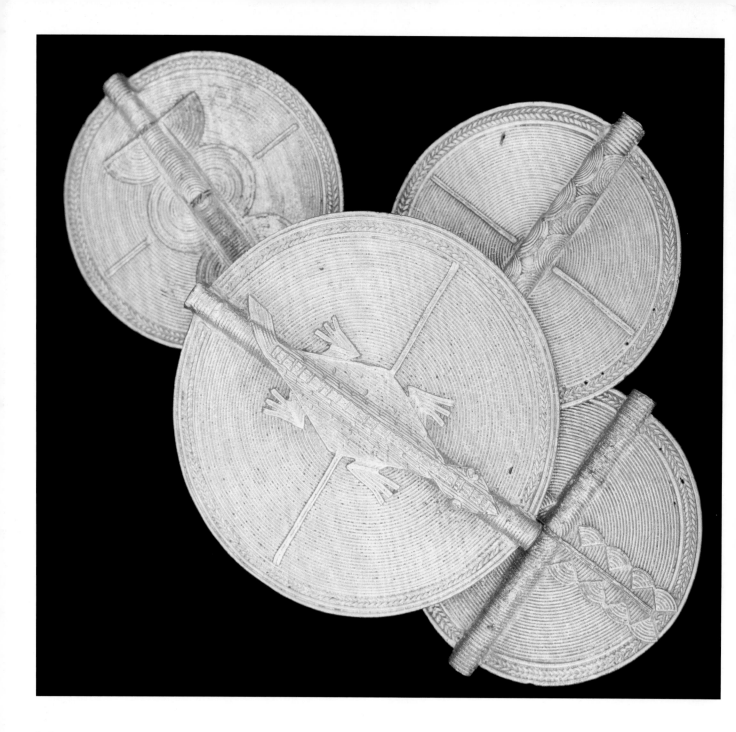

Baule

Jewellery

Bijoux

Schmuck

Joyería

Gioiello

Sieraden

1872, Gold/Or, Ø 6,5–9 cm

Baule

Pendant

Pendentif

Schmuckanhänger

Pendientes

Ciondoli

Sieraden

1877, Gold/Or, 4,4–8,2 cm

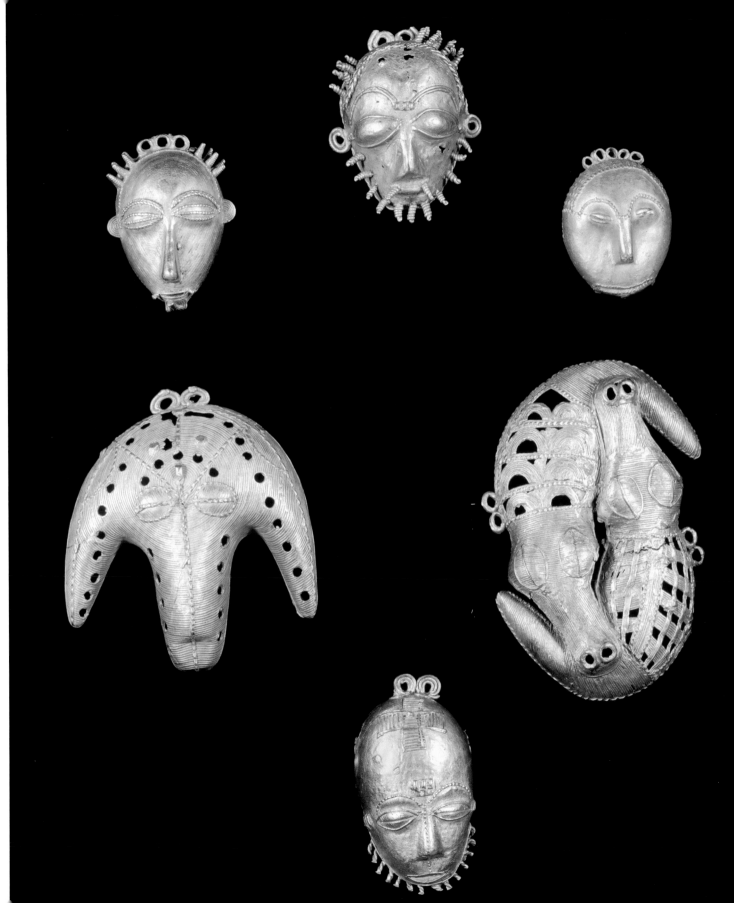

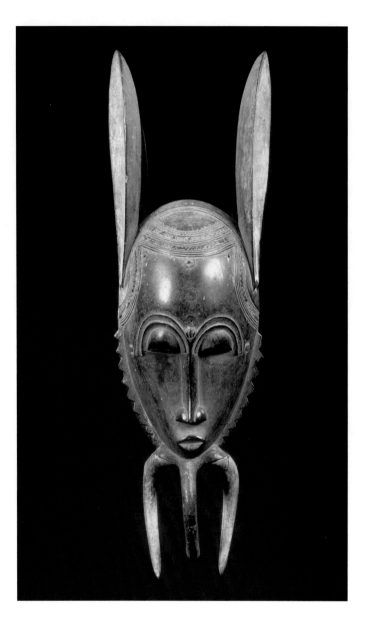

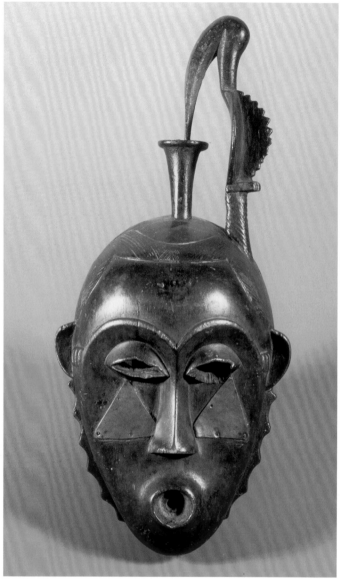

Yohure

Mask

Masque

Maske

Máscara

Maschera

Masker

1877, Wood/Bois, 39 × 13 × 8 cm

Yohure

Mask with bird

Masque avec oiseau

Maske mit Vogel

Máscara con pájaro

Maschera con uccello

Masker met vogel

1876-1877, Wood/Bois, 40 cm

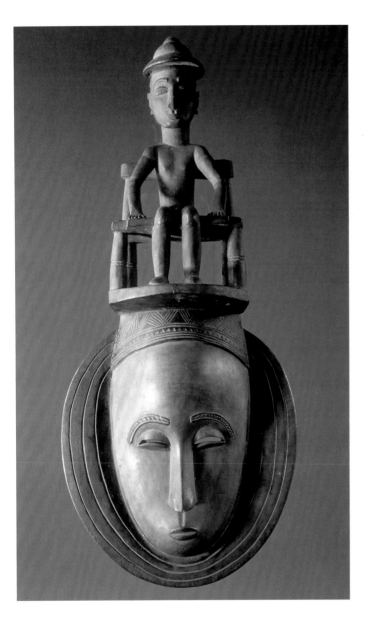

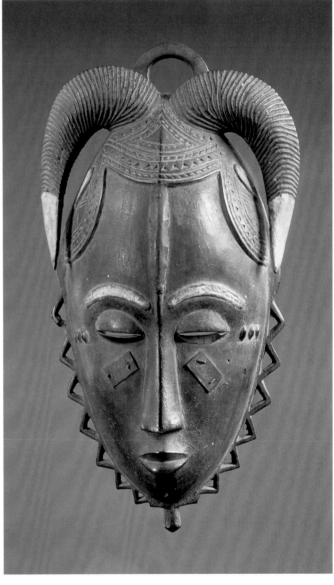

Yohure

Mask with sitting figurine

Masque avec personnage assis

Maske mit Sitzfigur

Máscara con figura sedente

Maschera con figura seduta

Masker met zittende figuur

1876, Wood/Bois, 49 × 21,5 × 11,5 cm

Yohure

Mask

Masque

Maske

Máscara

Maschera

Masker

1878, Wood painted/Bois peint, 29,2 × 17 × 10 cm

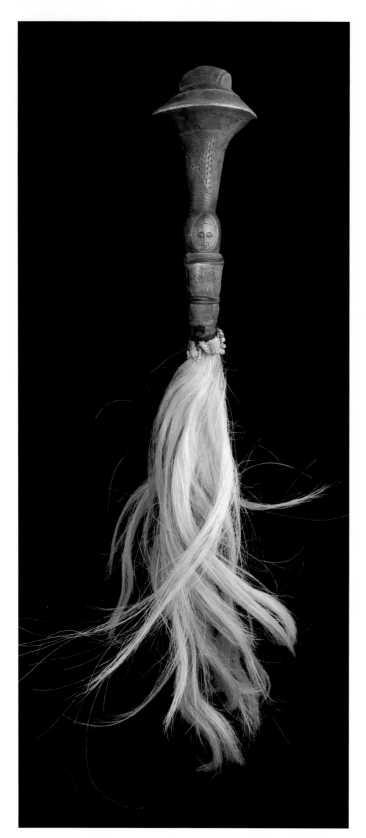

Akan

Fly swatter, decorated with two masks (souvereign insign)

Tapette à mouches ornée de deux masques (insigne de pouvoir)

Fliegenwedel, verziert mit zwei Masken (Herrscherinsignie)

Espantamoscas, decorado con dos máscaras (insignia de gobernantes)

Frusta per mosche, decorata con due maschere (emblema della dinastia)

Vliegenkwast, versierd met twee heersersmaskers

1878, Wood, cloth, horse hair/Bois, tissu, crin de cheval, 66 cm

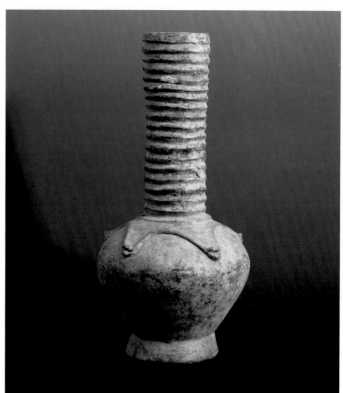

Akan

Ritual vessel

Récipient rituel

Rituelles Gefäß

Recipiente ritual

Vaso rituale

Rituele kom

1878-81, Clay fired/Terre cuite, 32 × 16 cm

Akan

Fly swatter, decorated with a head (souvereign insign)

Tapette à mouches ornée d'une tête (insigne de pouvoir)

Fliegenwedel, verziert mit einem Kopf (Herrscherinsignie)

Espantamoscas, decorado con una máscara (insignia de gobernantes)

Frusta per mosche, decorata con una testa (emblema della dinastia)

Vliegenkwast, versierd met heerserskop

1878, Wood, cloth, horse hair/Bois, tissu, crin de checal, 85 cm

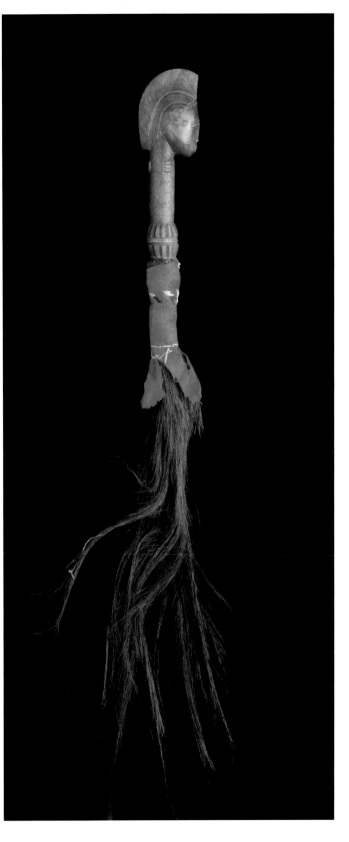

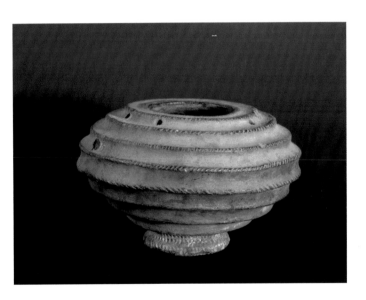

Akan

Ritual vessel

Récipient rituel

Rituelles Gefäß

Recipiente ritual

Vaso rituale

Rituele kom

1878, Clay fired/Terre cuite, 10 × 20 cm

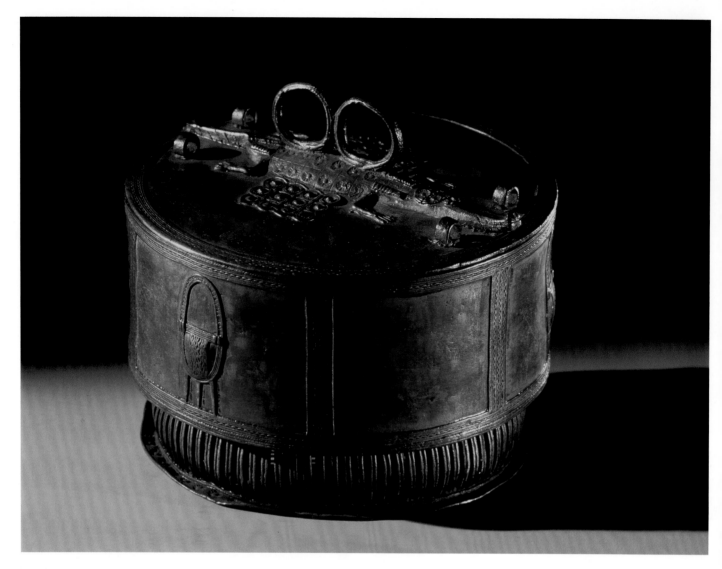

Ashanti

Vessel for valuables

Récipient pour les objets de valeur

Behälter zur Aufbewahrung von Wertgegenständen

Contenedor para guardar objetos de valor

Portaoggetti per oggetti di valore

Doosje voor waardevolle spullen

1883, Brass/Laiton

Ashanti

Fertility doll

Poupée de fécondité

Fruchtbarkeitspuppe

Muñeco de la fertilidad

Bambola della fertilità

Vruchtbaarheidspop

1879, Wood patinised/Bois patiné, 20 cm

This region had intensive contact with merchants from Europe for centuries and later Northern African merchants as well. The powerful empire of the Ashanti was founded on gold trade and later on, the slave trade. Gold dust was the official currency until the beginning of the 20th century. It was weighed using clamshells or metal weights. Metal weights are very versatile. Different motives tell stories from all areas of life. Figure-like illustrations have been circulated since the 18th century; they symbolise figures of speech or quotes from literature.

Cette région a eu des contacts intensifs avec les marchands d'Europe depuis des siècles, mais aussi, de façon plus tardive, avec les marchands d'Afrique du Nord. Le puissant empire Ashanti a été bâti sur le commerce de l'or et, plus tard, celui des esclaves. La poussière d'or était la monnaie officielle jusqu'au début du 20ᵉ siècle. On la pesait en utilisant par exemple des coquilles de moules ou des poids en métal. Les poids métalliques sont extrêmement variés. Les différents motifs racontent des histoires de tous les domaines de la vie. Des représentations figuratives circulent depuis le 18ᵉ siècle ; elles symbolisent par exemple des proverbes ou des passages littéraires.

Seit Jahrhunderten bestand in dieser Region ein intensiver Kontakt mit Händlern aus Europa und später auch aus Nordafrika. Das mächtige Reich der Ashanti etwa gründete sich vor allem auf den Handel mit Gold, später mit Sklaven. Goldstaub war bis Anfang des 20. Jahrhunderts offizielle Währung. Gewogen wurde er beispielsweise mit Muscheln oder Metallgewichten. Metallgewichte sind äußerst vielgestaltig. Unterschiedlichste Motive erzählen aus allen Lebensbereichen. Figürliche Darstellungen waren seit dem 18. Jahrhundert im Umlauf; sie versinnbildlichen beispielsweise Sprichwörter oder literarische Passagen.

Durante siglos, existió en esta región un contacto intenso con comerciantes europeos y más tarde norafricanos. El poderoso imperio de los Ashanti, por ejemplo, se fundó principalmente sobre el comercio con el oro y después con esclavos. El polvo de oro era, hasta principios del siglo XX, la moneda oficial. Se pesaba con conchas o con pesas de metal. Las pesas de metal son especialmente variadas. Sus motivos nos hablan de los más diversos ámbitos de la vida. Las representaciones figurativas estaban en circulación desde el XVIII, simbolizando por ejemplo proverbios o pasajes literarios.

Per secoli questa regione ha intrattenuto intensi rapporti con i commercianti provenienti dall'Europa e, successivamente, dal Nordafrica. Il potente regno di Ashanti prosperò soprattutto grazie agli scambi commerciali di oro e, più avanti, di schiavi. La polvere d'oro ne fu la moneta ufficiale fino agli inizi del XX secolo. Veniva pesata ad esempio con conchiglie o pesi in metallo, che sono estremamente versatili. I differenti motivi ci forniscono informazioni circa le varie sfere della vita. Le rappresentazioni figurative, in circolazione dal XVIII secolo, simboleggiano ad esempio proverbi o brani letterari.

Deze regio onderhield eeuwenlang intensieve contacten met handelaren uit Europa en later ook uit Noord-Afrika. Zo berustte het machtige rijk van de Ashanti vooral op de handel in goud en later in slaven. Tot aan het begin van de vorige eeuw was goudstof het officiële betaalmiddel. Het werd gewogen aan de hand van schelpen of metalen gewichten. Deze metalen gewichten hebben een veelheid van vormen. Zeer uiteenlopende motieven verwijzen naar alle mogelijke aspecten van het leven. Sinds de achttiende eeuw kwamen ook figuurlijke uitbeeldingen in omloop, waarmee bijvoorbeeld spreekwoorden of literaire passages werden gesymboliseerd.

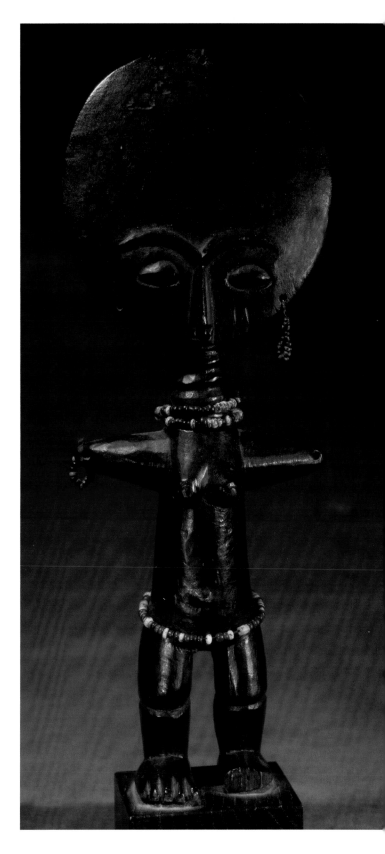

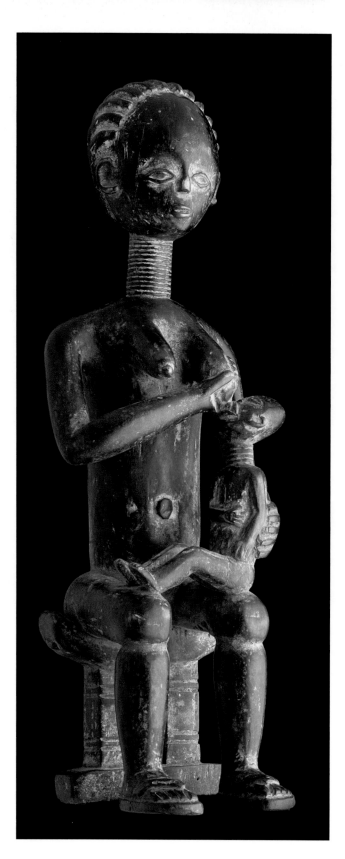

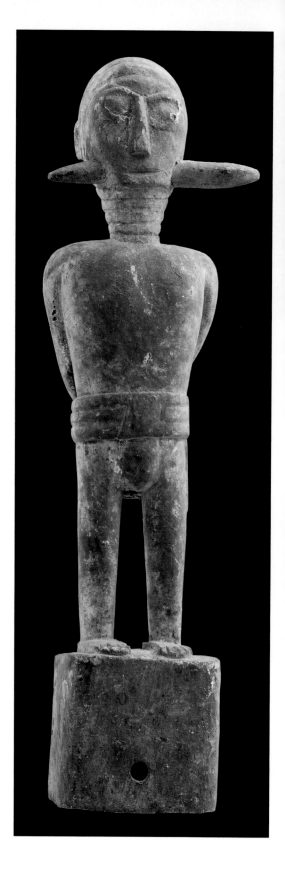

Ashanti

Mother with child
(motherhood)

Mère avec enfant
(maternité)

Mutter mit Kind
(Mutterschaft)

Mujer con hijo
(maternidad)

Madre e figlio
(maternità)

Moeder met kind
(moederschap)

1883, Wood painted,
clay/Bois peint, argile

Ashanti

Cult statue as
part of an altar

Statuette cultuelle,
élément d'un autel

Kultstatuette als
Teil eines Altars

Estatuilla de culto
(parte de un altar)

Statuetta di
culto come parte
di un altare

Cultusbeeldje als
deel van altaar

1884, Wood/Bois

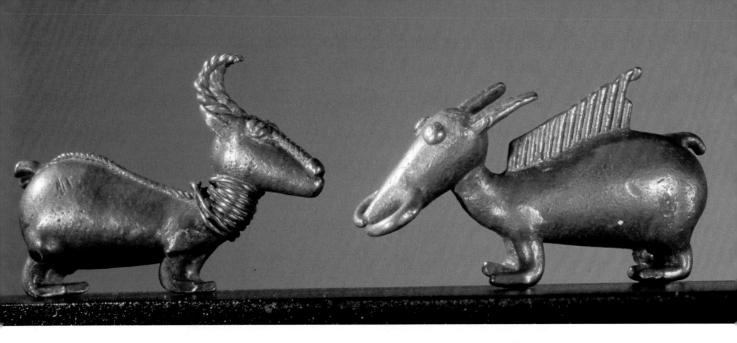

Ashanti

Golden weights in shape
of animal figurines

Poids à peser l'or en forme d'animal

Goldgewichte in Form
von Tierfiguren

Pesas de oro en forma de animales

Peso per oro a forma
di figure animali

Goudgewichten met dierenvormen

1880

Ashanti

Pendant with mask

Pendentif avec masque

Schmuckanhänger mit Maske

Pendiente con máscara

Ciondolo con maschera

Sieraad met masker

1883, Gold/Or, 7,6 × 8 cm

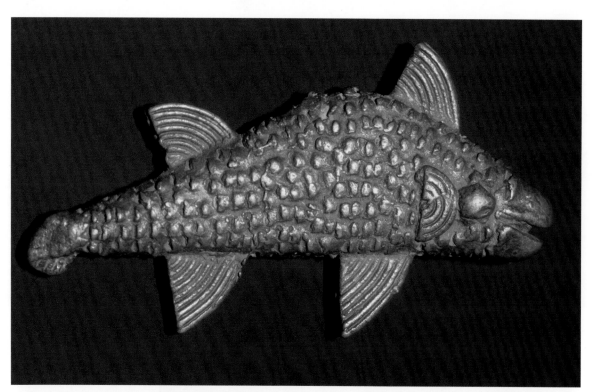

Ashanti

Golden weight in
shape of a fish

Poids à peser l'or en
forme de poisson

Goldgewicht in Form
eines Fisches

Pesa de oro en
forma de pez

Peso per oro a
forma di pesce

Goudgewicht in de
vorm van een vis

1880, Bronze/Bronze, 7,5 cm

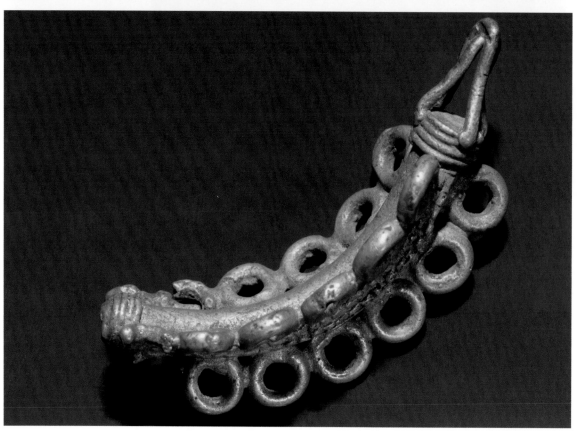

Ashanti

Golden weight in shape
of a fable animal

Poids à peser l'or en forme
d'animal mythique

Goldgewicht in Form
eines Fabeltiers

Pesa de oro en forma
de animal imaginario

Peso per oro a forma
di creatura mitica

Goudgewicht in de vorm
van een fabeldier

1880, Brass/Laiton, 6,3 cm

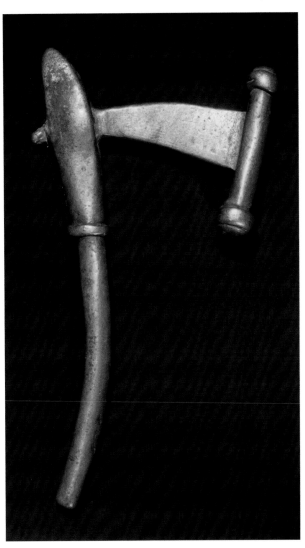

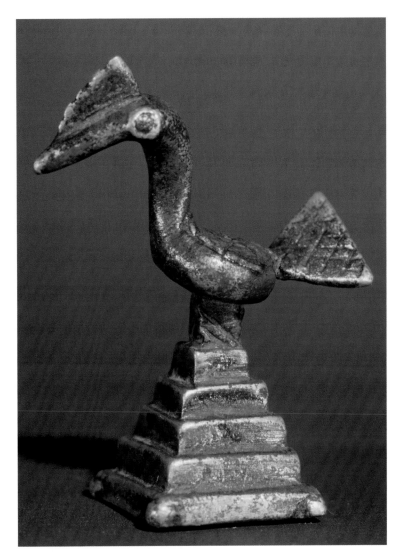

Ashanti

Golden weight in shape of an axe

Poids à peser l'or en forme de hache

Goldgewicht in Form einer Axt

Pesa de oro en forma d hacha

Peso per oro a forma di ascia

Goudgewicht in de vorm van een bijl

1880, Brass/Laiton, 5,9 cm

Ashanti

Golden weight in shape of a bird on a pyramid

Poids à peser l'or en forme d'oiseau sur une pyramide

Goldgewicht in Form eines Vogels auf einer Pyramide

Pesa de oro en forma de pájaro sobre una pirámide

Peso per oro a forma di uccello su una piramide

Goudgewicht in de vorm van een vogel op een piramide

1880, Brass/Laiton, 4,8 cm

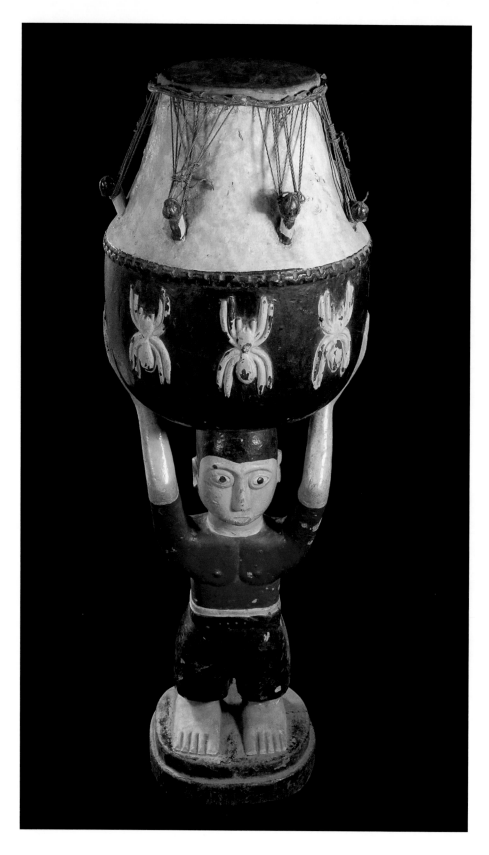

Fante

Drum with anthropomorphic foot

Tambour à pied anthropomorphe

Trommel mit anthropomorphem Fuß

Tambor con pies antropomórficos

Tamburo con piede antropomorfo

Trommel met antropomorf voetstuk

1880, Wood painted, leather/Bois peint, cuir, 70 cm

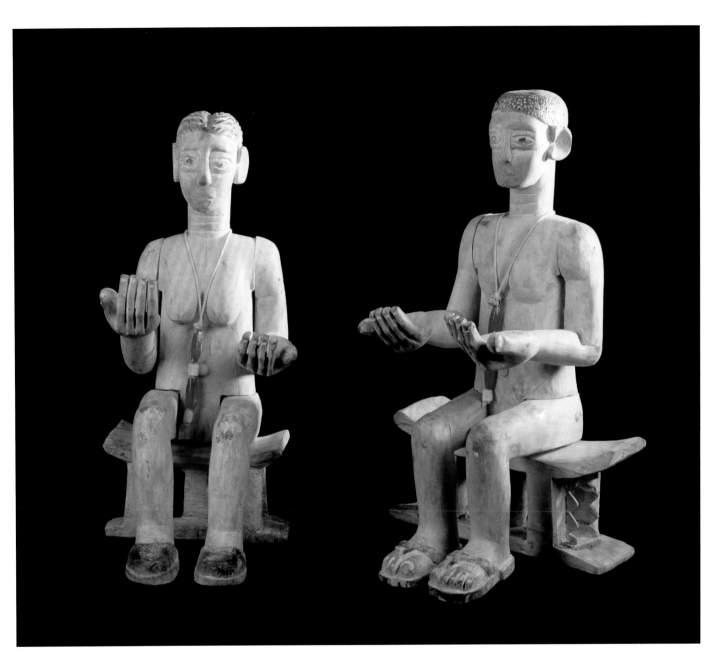

Ewe

The first human couple (Voodoo cult)

Le premier couple humain (culte vaudou)

Das erste Menschenpaar (Voodookult)

La primera pareja humana (culto vudú)

La prima coppia umana (culto vudù)

Het eerste mensenpaar (voodoocultus)

1888, Wood painted/Bois peint

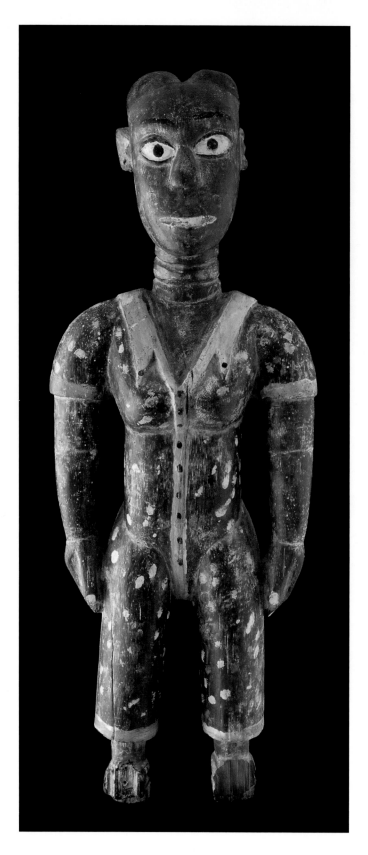

Ewe
Female *colon* figurine
Figurine *colon* féminin
Weibliche Colon-Figur
Figura *colon* de mujer
Figura *Colon* femminile
Vrouwelijke *colon*-figuur
1884, Wood painted/Bois peint, 42 cm

Ewe
Buffalo head
Tête de buffle
Büffelkopf
Cabeza de búfalo
Testa di bufalo
Buffelkop
Clay fired/Terre cuite, 22,8 cm

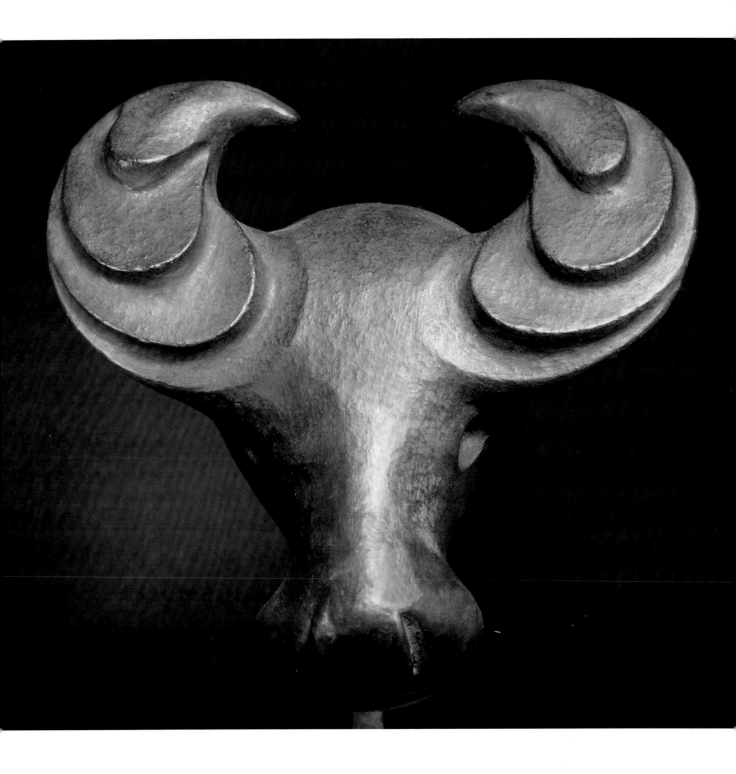

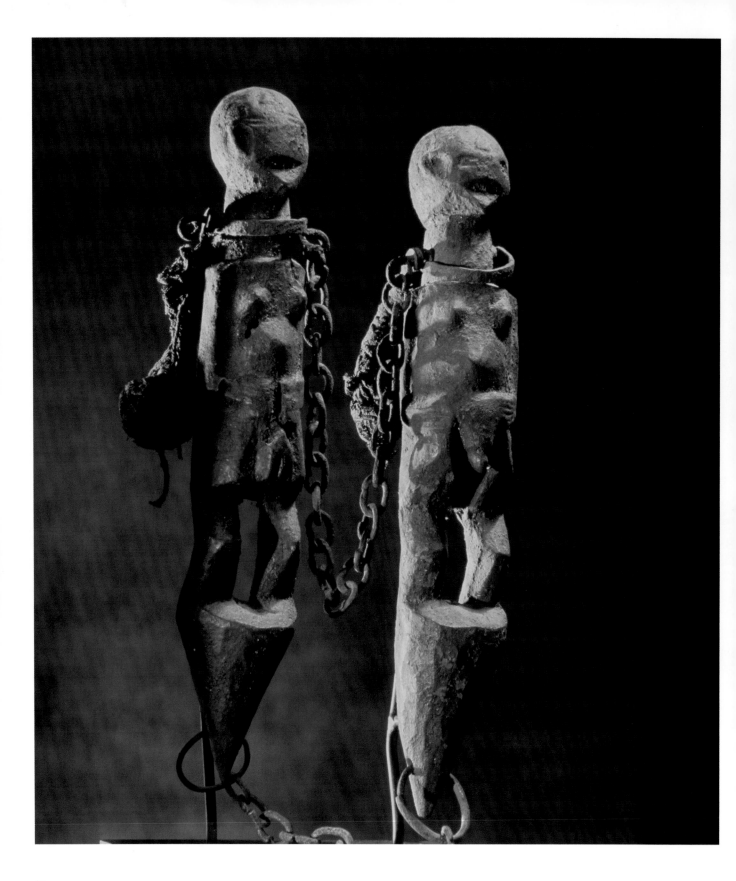

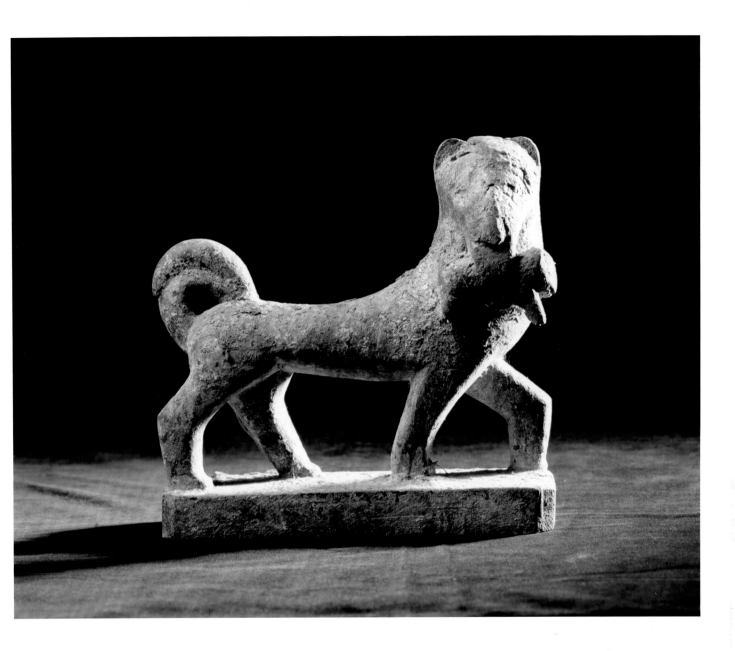

Fon

Figurines in chains (Voodoo cult)

Couple de figurines enchaîné (culte vaudou)

Figurenpaar in Ketten (Voodookult)

Pareja encadenada (culto vudú)

Coppia di figure in catene (culto vudù)

Paar figuren in ketens (voodoocultus)

1880, Wood, metal/Bois, métal

Fon

Lion figurine (Voodoo cut)

Figurine de lion (associé au culte vaudou)

Löwenfigur (Voodookult)

Figura de león (culto vudú)

Figura di leone (culto vudù)

Leeuwenfiguur (voodoocultus)

1881, Wood painted/Bois peint

Material

Wood is the most important material of African art in general; which cannot stand up against the usual climatic conditions in Africa over centuries. Almost all cultures developed metal-processing technologies. Mainly gold, iron and copper were used as raw material. The early European sequence of stone age, iron age and bronze age cannot be applied to the African continent: iron and copper processing started at the same time. Local and regional trade networks brought copper to Western Africa as well. This metal was common almost everywhere around 1000 AD.

Matériau

Le bois est le matériau le plus important de l'art africain en général ; mais avec les conditions climatiques que connait l'Afrique, le bois ne peut pas traverser les siècles en résistant aux dommages du temps. Les sociétés ont presque toutes développé des techniques de transformation des métaux. Les matières premières principalement utilisées étaient l'or, le fer et le cuivre. La succession préhistorique des âges – de pierre, de fer et de bronze – que l'on connait en Europe ne s'applique pas à l'Afrique : le travail du fer et du cuivre a commencé en même temps. Des réseaux commerciaux locaux et régionaux ont même apporté le cuivre en Afrique de l'Ouest. En 1000 apr. J.-C., le métal était déjà presque partout.

Material

Holz gilt als das wichtigste Material afrikanischen Kunstschaffens schlechthin; unter den üblichen klimatischen Bedingungen in Afrika kann Holz nicht die Jahrhunderte überdauern. Fast alle Gesellschaften haben allerdings Techniken zur Metallverarbeitung entwickelt. Als Ausgangsmaterial verwendete man vor allem Gold, Eisen und Kupfer. Die frühgeschichtliche Abfolge von Stein-, Eisen- und Bronzezeit in Europa lässt sich nicht auf den Kontinent anwenden: Eisen- und Kupferbearbeitung begannen gleichzeitig. Lokale und überregionale Handelsnetze brachten Kupfer auch nach Westafrika. Bereits um 1000 nach Christus war das Metall nahezu überall verbreitet.

Material

La madera se considera el material por excelencia de la creación artística africana. Dadas las condiciones climáticas de África, la madera no puede sobrevivir el paso de los siglos. Sin embargo, casi todas las sociedades han desarrollado técnicas de tratamiento de los metales. Como material de trabajo se utilizaban sobre todo el oro, el hierro y el cobre. La sucesión prehistórica de las edades de piedra, hierro y bronce en Europa no es aplicable a este continente: el tratamiento del hierro y del bronce comenzaron de manera simultánea. Las redes comerciales locales y suprarregionales trajeron el cobre también a África occidental. Ya alrededor del 1000 d.C., el metal se había expandido casi a todos los puntos del continente.

Materiale

Il legno è considerato il materiale africano per eccellenza nell'ambito della produzione artistica. Tuttavia, in condizioni climatiche normali, in Africa il legno non può sopravvivere per secoli, per cui quasi tutte le popolazioni hanno sviluppato tecniche per la lavorazione dei metalli. I materiali di partenza utilizzati erano principalmente oro, ferro e rame. La successione storica di pietra, ferro e bronzo che ebbe luogo in Europa non può essere applicata al continente africano: qui, infatti, la lavorazione del ferro e del rame ebbe inizio simultaneamente. Grazie alle reti commerciali locali e regionali il rame giunse anche nell'Africa occidentale. Già dal 1000 d.C. questo metallo veniva distribuito quasi in ogni angolo del territorio.

Materiaal

In de Afrikaanse kunsten is hout verreweg het belangrijkste materiaal; onder de kenmerkende klimatologische omstandigheden van Afrika kan hout de eeuwen niet doorstaan. Maar bijna alle Afrikaanse samenlevingen ontwikkelden ook metaalbewerkingstechnieken. Als bewerkingsmaterialen werden vooral goud, ijzer en koper gebruikt. De prehistorische opeenvolging van steen-, brons- en ijzertijd in Europa kan niet worden toegepast op het Afrikaanse continent: de bewerking van brons en ijzer viel namelijk samen. Dankzij plaatselijke en regionale handelsnetwerken werd ook koper in West-Afrika geïntroduceerd. Al rond het jaar 1000 was dit metaal wijdverbreid.

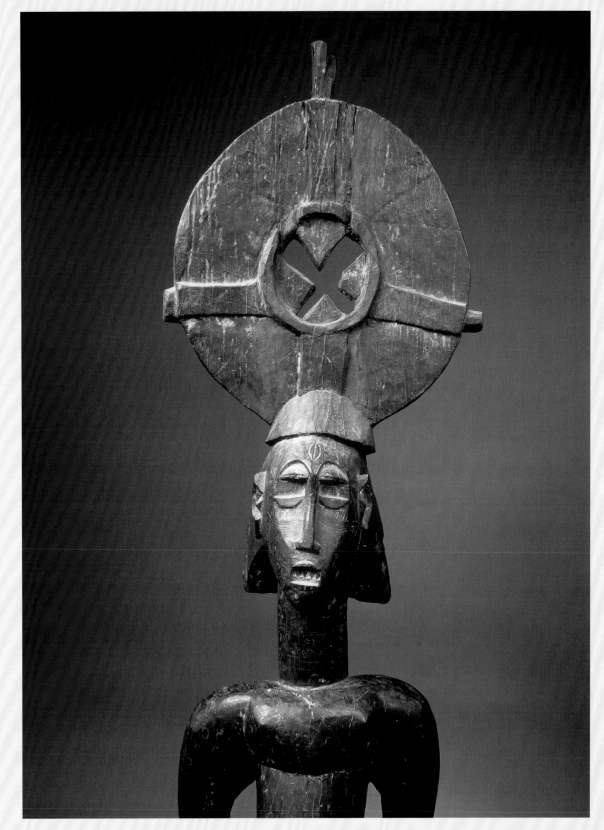

Senufo
Ritual pestle
Pilon rituel
Ritueller Stößel
Ariete ritual
Pestello rituale
Rituele stamper
1885, Wood/Bois,
182,5 × 34 × 35 cm

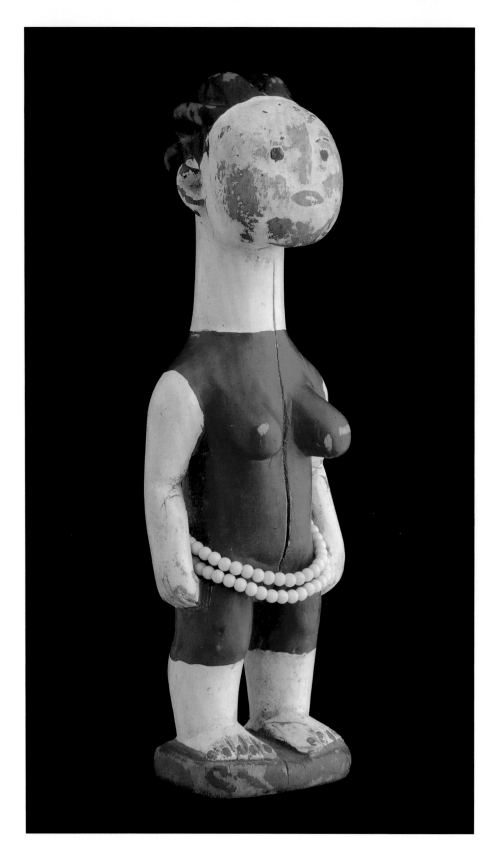

Fon

Female twin statue

Statuette de jumelle

Weibliche Zwillingsstatuette

Estatuilla de gemelas

Statuetta gemella femminile

Vrouwelijke tweelingfiguur

1882, wood painted/Bois peint, 15,5 cm

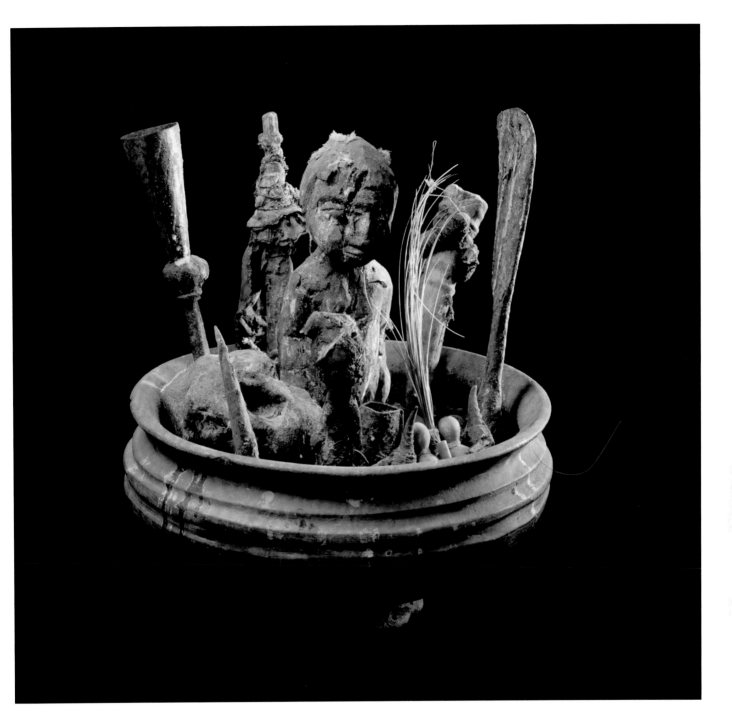

Fon

Vessel with fetishes (Voodoo cult)

Récipient avec fétiches (culte vaudou)

Gefäß mit Fetischen (Voodookult)

Recipiente con fetiches (culto vudú)

Vaso con feticci (culto vudù)

Kom met fetisjen (voodoocultus)

1881

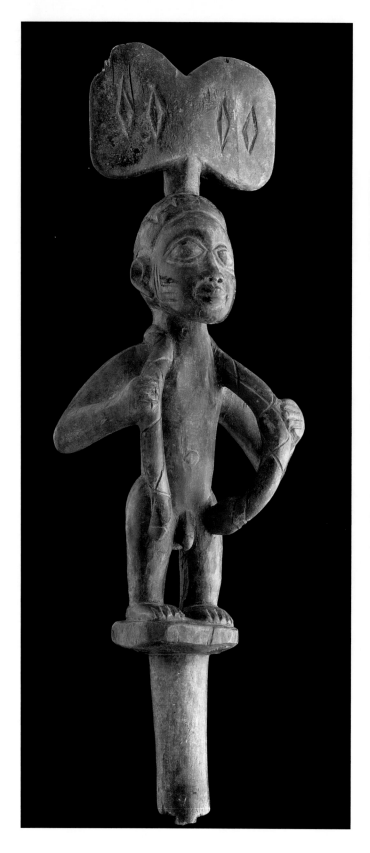

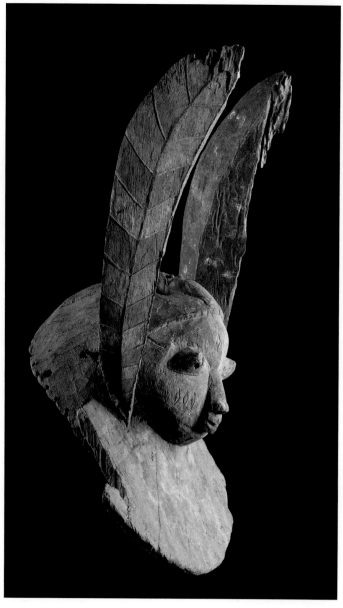

Yoruba

Sceptre or rattle (Voodoo cult)

Sceptre ou hochet (culte vaudou)

Zepter oder Klapper (Voodookult)

Cascabel o cetro (culto vudú)

Scettro o sonaglio (culto vudù)

Scepter of staf (voodoocultus)

1882, Wood painted/Bois peint

Yoruba

Mask

Masque

Maske

Máscara

Maschera

Masker

1882, Wood/Bois

Yoruba

Head piece with sitting figure of a
snake charmer and seer

Coiffe avec figurine assise de charmeur
de serpents et de voyant

Kopfaufsatz mit Sitzfigur eines
Schlangenbeschwörers und Wahrsagers

Tocado con figura sedente de un
encantador de serpientes y vidente

Copricapo con figura di un indovino e
incantatore di serpenti seduto

Hoofdtooi met zittende figuur van
slangenbezweerder en waarzegger

1883, Wood painted/Bois peint

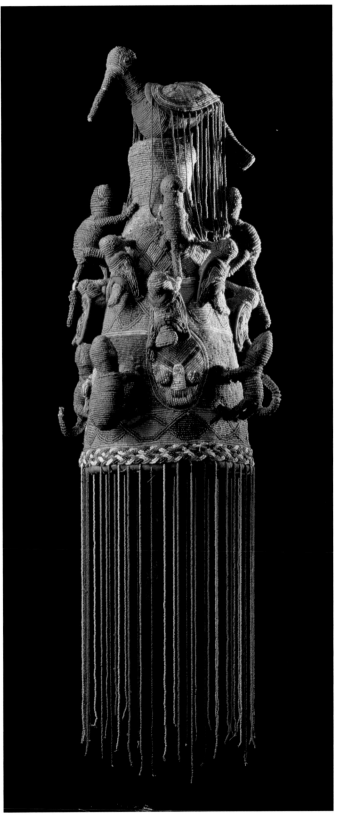

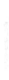

Yoruba

Crown with figurine jewelery

Couronne avec ornement figuratif

Krone mit figürlichem Schmuck

Corona con joyería figurativa

Corona con figure decorative

Kroon met figuratieve versiering

1880

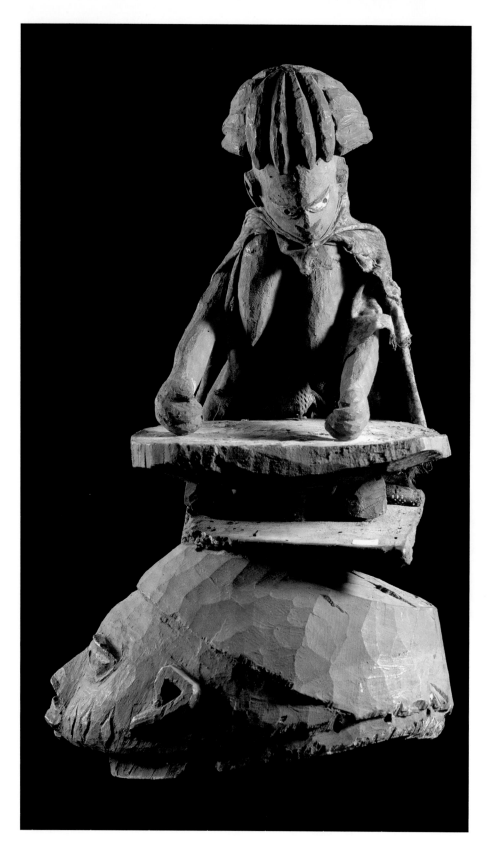

Yoruba

Head piece with female figurine

Coiffe avec personnage féminin

Kopfaufsatz mit weiblicher Figur

Tocado con figura femenina

Copricapo con figura femminile

Hoofdtooi met vrouwelijke figuur

1883, Wood painted/Bois peint

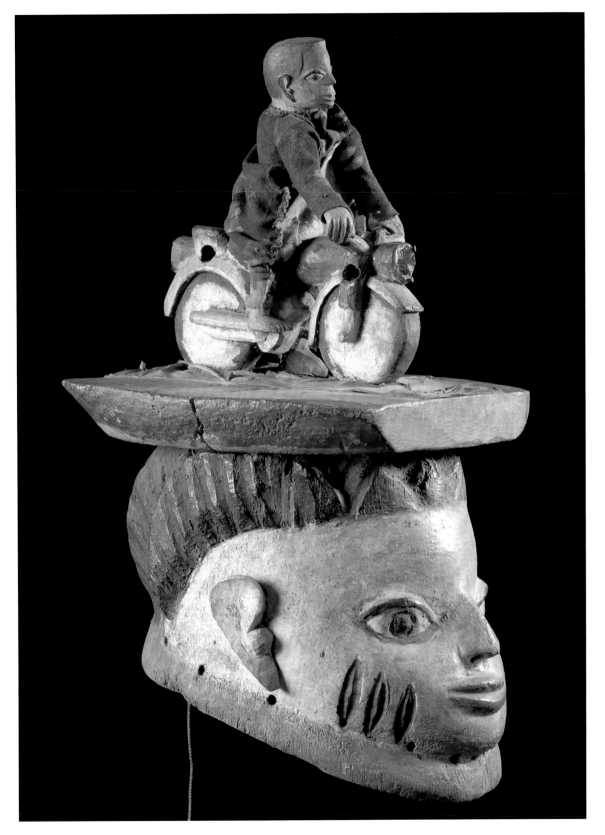

Yoruba

Head piece with biker

Coiffe avec motocycliste

Kopfaufsatz mit
Motorradfahrer

Tocado con motociclista

Copricapo con motociclista

Hoofdtooi met motorrijder

1884, Wood painted/
Bois peint

BÉNIN
BURKINA FASO
CAMEROUN
CÔTE D'IVOIRE
GHANA
NIGERIA

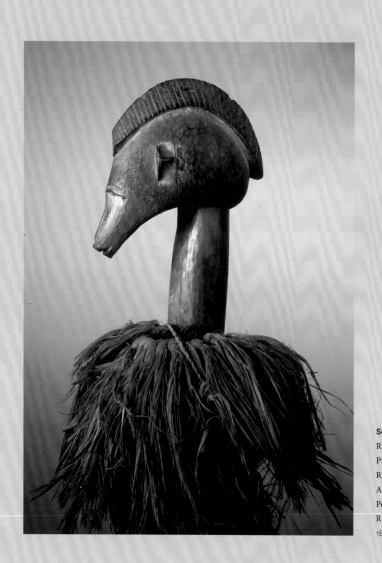

SENU

Senufo
Ritual pestle
Pilon rituel
Ritueller Stößel
Ariete ritual
Pestello rituale
Rituele stamper
1885, Wood, plant fibres/Bois, fibres végétales, 110 × 19 cm

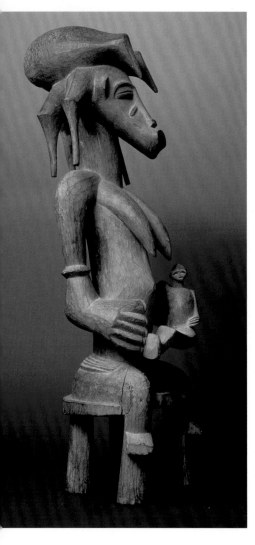

Senufo

Mother and child (motherhood)

Mère et enfant (maternité)

Mutter und Kind (Mutterschaft)

Madre e hijo (maternidad)

Madre e figlio (maternità)

Moeder en kind (moederschap)

1884, Wood/Bois, 68 × 20 × 21,5 cm

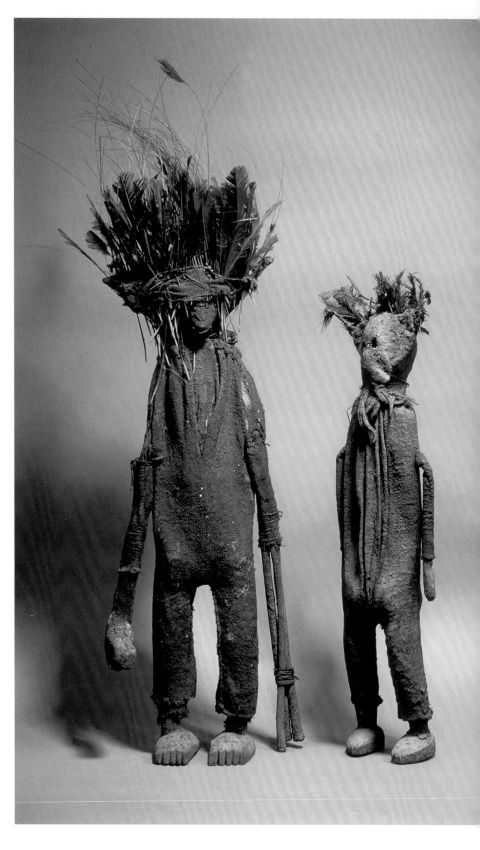

Senufo

Figurines

Figurines

Figuren

Figuras

Figure

Figuren

1884, Wood, cloth, plant fibres, hair, feathers/Bois, tissu,
fibres végétales, cheveux, plumes, 70–100 cm

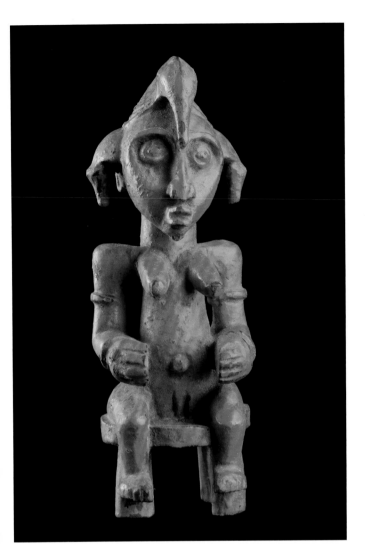

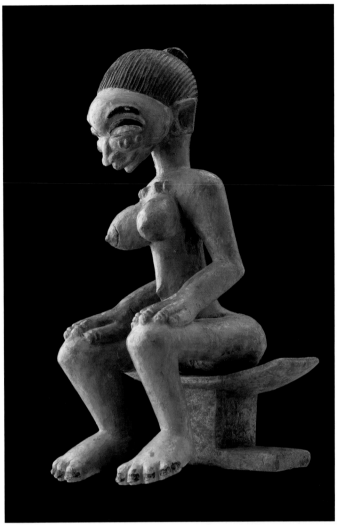

Senufo

Female sitting figure

Figurine féminine assise

Weibliche Sitzfigur

Figura femenina sedente

Figura femminile seduta

Zittende vrouwenfiguur

1884, Wood painted/Bois peint, 28 cm

Senufo

Female figurine of a secret society

Figure féminine en lien avec une société secrète

Weibliche Figur eines Geheimbundes

Figura femenina de una organización secreta

Figura femminile di una società segreta

Vrouwelijke figuur van een geheim verbond

1884, Wood painted/Bois peint

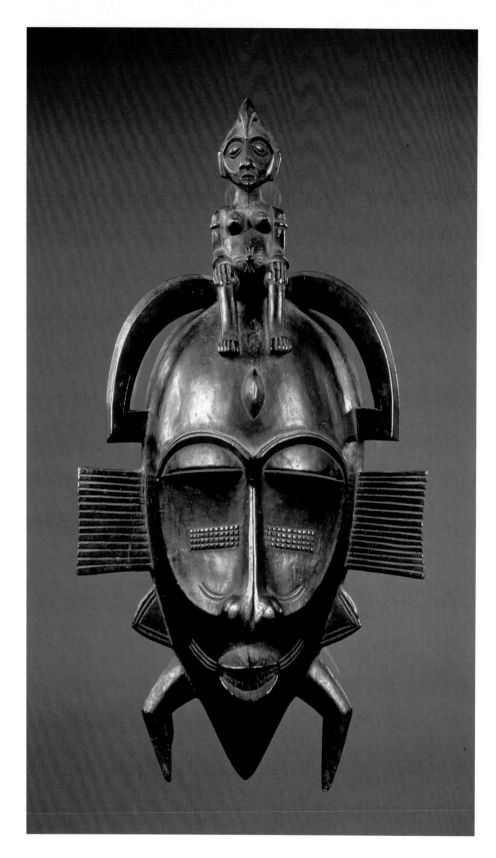

Senufo

Mask with sitting figurine

Masque avec personnage assis

Maske mit Sitzfigur

Máscara con figura sedente

Maschera con figura seduta

Masker met zittende figuur

1885, Wood patinised/Bois patiné

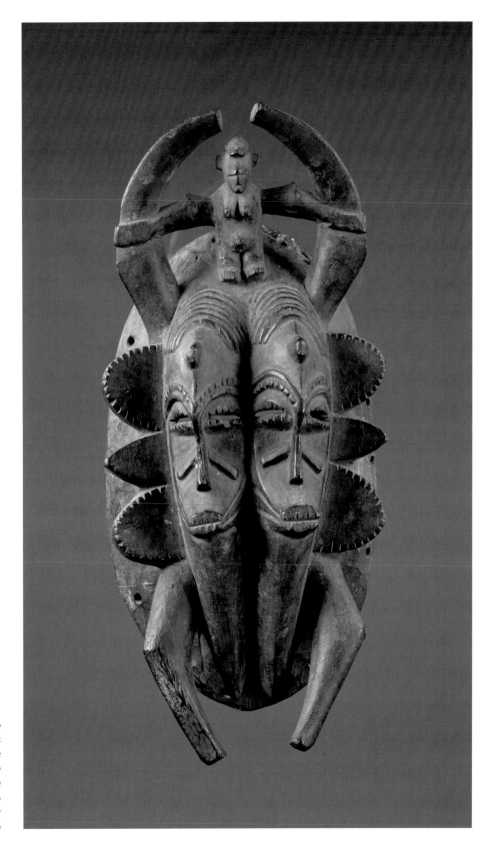

Senufo

Double mask

Masque double

Doppelmaske

Máscara doble

Maschera doppia

Dubbelmasker

1886, Wood/Bois, 30,5 × 14,4 × 7,5 cm

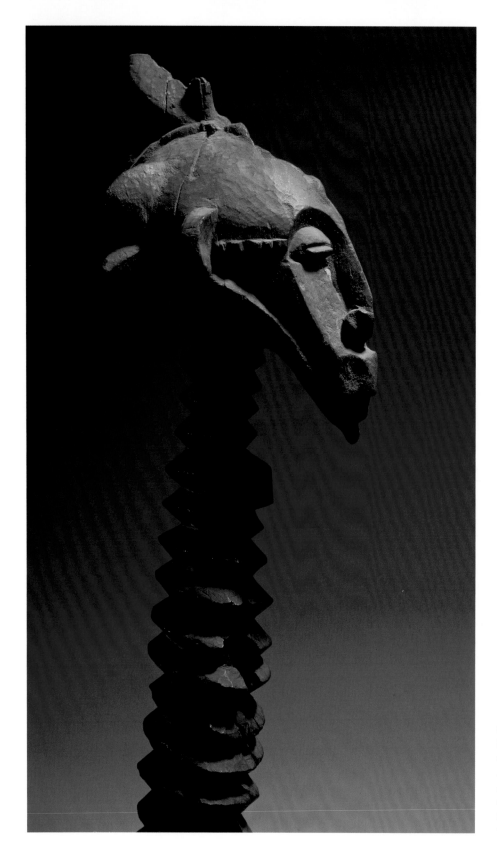

Senufo

Helmet mask extension

Cimier d'un masque casque

Aufsatz einer Helmmaske

Accesorio de una máscara-casco

Copricapo di una maschera ad elmo

Hoofdtooi met gehelmd masker

1886, Wood/Bois, 76,2 × 19 × 19 cm

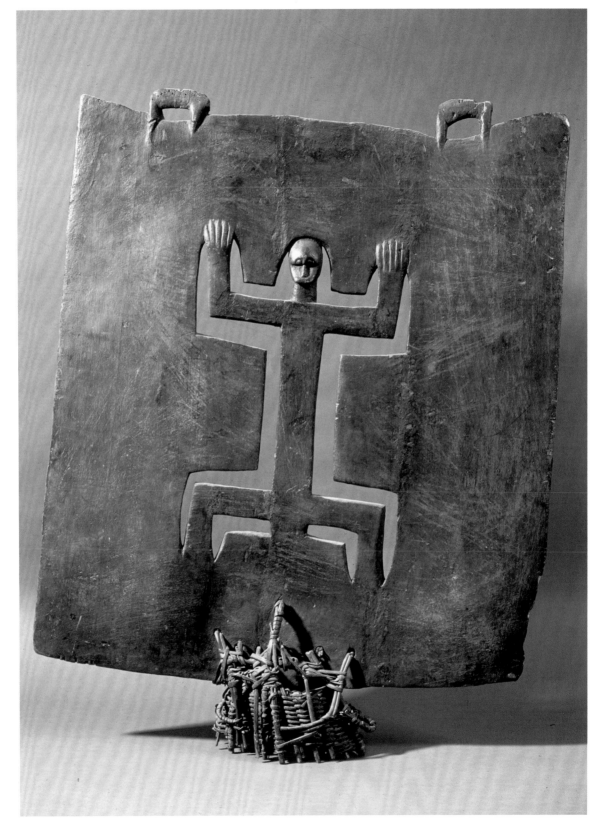

Senufo

Mask of a secret society
for initiation ritual

Masque pour rituel
d'initiation en lien avec
une société secrète

Maske eines
Geheimbundes für
Initationsritual

Máscara para un ritual
de iniciación de una
organización secreta

Maschera di una
società segreta per
rito di iniziazione

Masker van een geheim
verbond voor initiatierite

1886, Wood/Bois, 98 cm

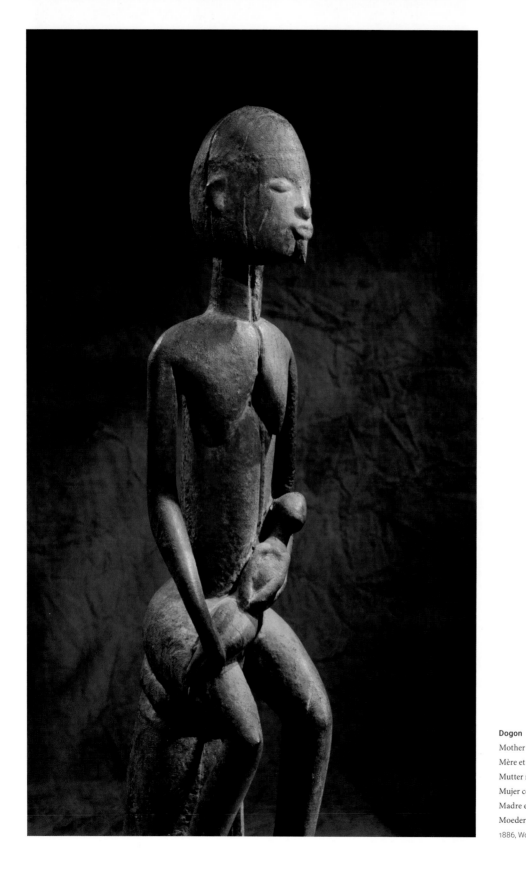

Dogon

Mother with child

Mère et enfant

Mutter mit Kind

Mujer con hijo

Madre e figlio

Moeder met kind

1886, Wood painted/Bois peint, 75 cm

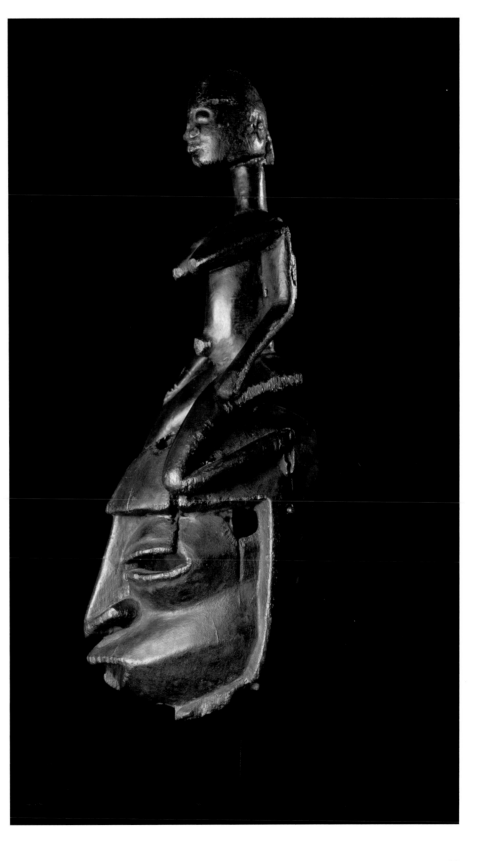

Dogon

Mask with kneeling female figurine

Masque avec figure féminine agenouillée

Maske mit knieender weiblicher Figur

Máscara con figura femenina arrodillada

Maschera con una figura femminile inginocchiata

Masker met knielende vrouwenfiguur

1886, Wood/Bois, 58 cm

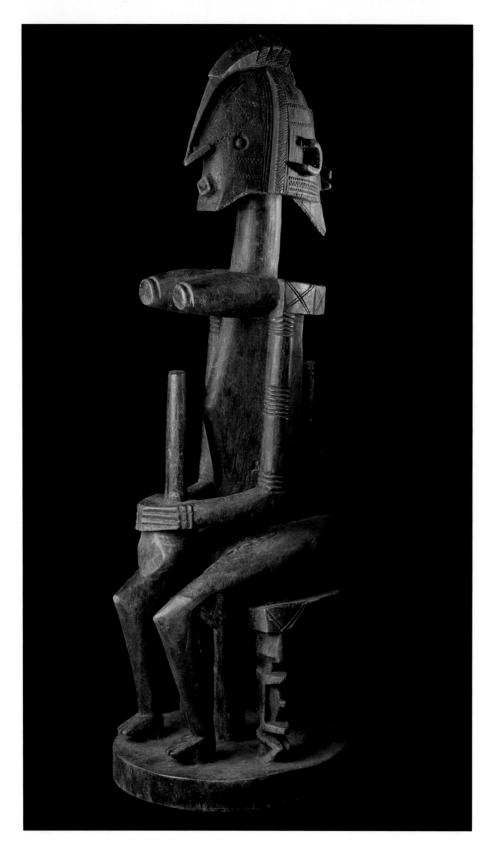

Dogon

Female ancestry figurine

Figurine d'ancêtre féminin

Weibliche Ahnenfigur

Figura de antepasado femenina

Figura femminile di antenata

Vrouwelijke voorouderfiguur

1885, Wood/Bois

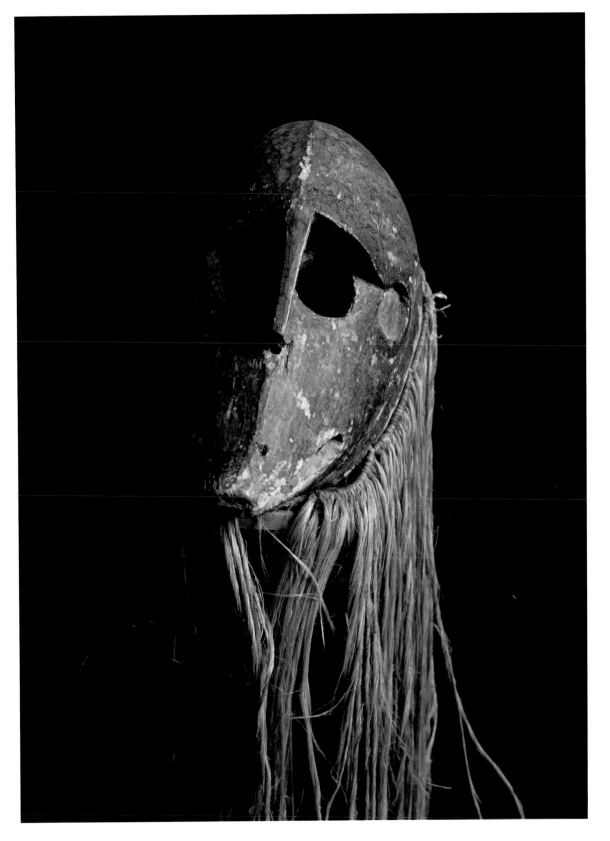

Dogon
Hyaena mask
Masque de hyène
Hyänenmaske
Máscara de hiena
Maschera a forma di iena
Hyenamasker
1885, Wood/Bois

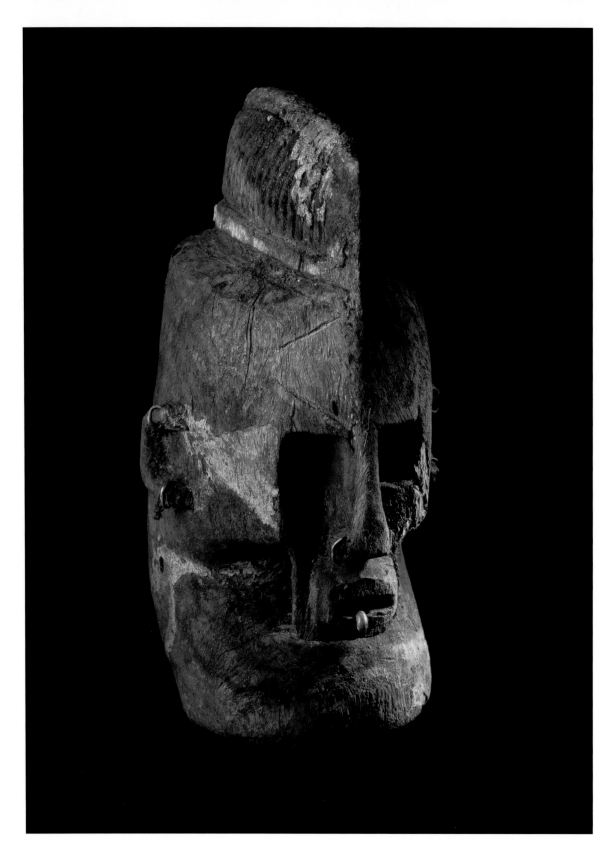

Dogon

Mask with canker

Masque avec goitre

Maske mit Kropf

Máscara con cresta

Maschera con gozzo

Masker met krop

1889–1890, Wood/Bois

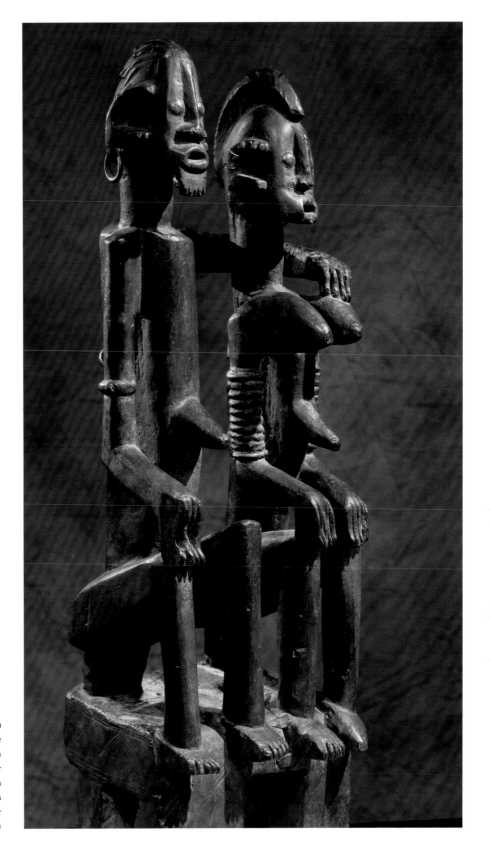

Dogon

The first human couple
Le premier couple humain
Das erste Menschenpaar
La primera pareja humana
La prima coppia umana
Het eerste mensenpaar

1889-1890, Wood, metal/Bois, métal, 66 cm

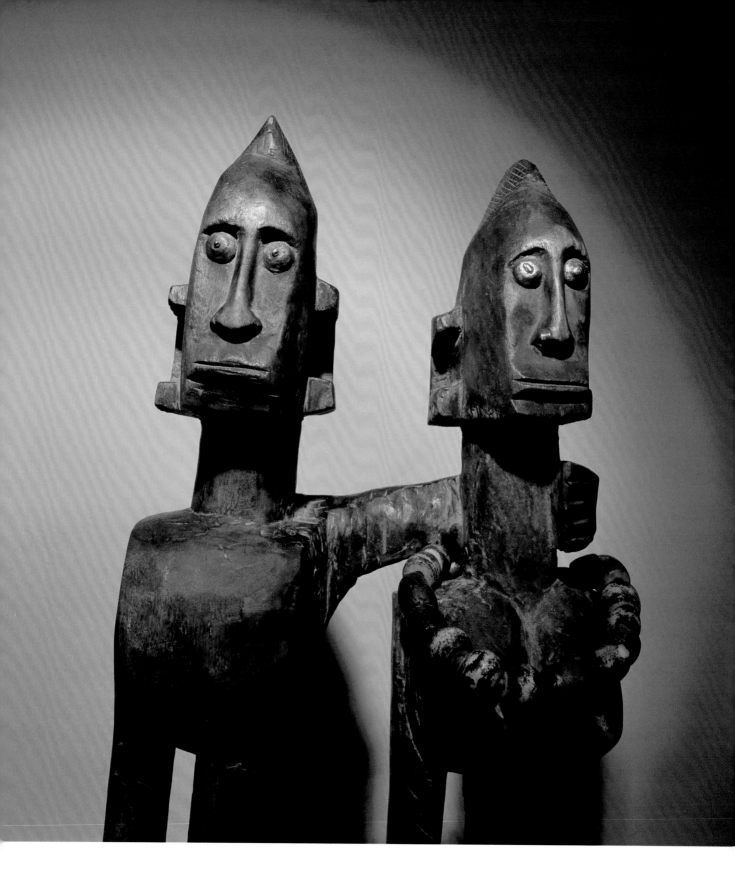

Dogon

Figurine pair, probably
for use in funerals

Figurine de couple,
sans doute pour une
utilisation lors des
cérémonies funéraires

Figurenpaar, vermutlich
für den Gebrauch bei
Begräbniszeremonien

Figura de pareja,
probablemente para el uso
en ceremonias funerales

Coppia di figure,
presumibilmente per
l'uso in funerali

Figurenpaar, vermoedelijk
voor begrafenisrituelen

1890, Wood/Bois, 86 cm

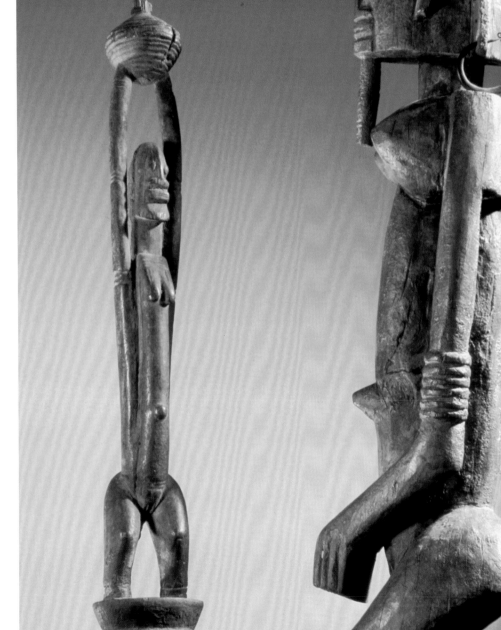

Dogon

Figurine pair, probably
for use in funerals

Deux statuettes, sans doute
pour une utilisation lors
des cérémonies funéraires

Zwei Figuren, vermutlich
für den Gebrauch bei
Begräbniszeremonien

Dos figuras,
probablemente para el uso
en ceremonias funerales

Due figure,
presumibilmente per
l'uso in funerali

Twee figuren, vermoedelijk
voor begrafenisrituelen

1891, Wood, metal/
Bois, métal, 59 cm

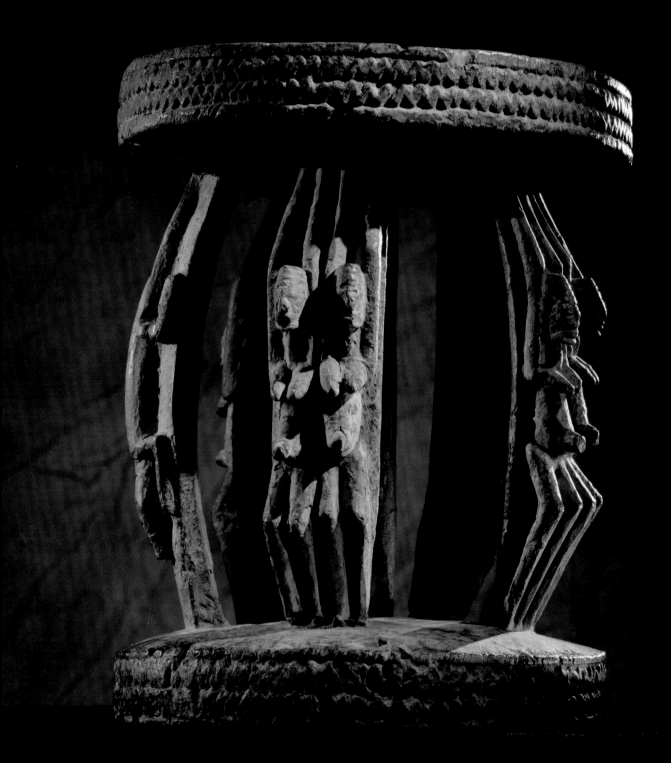

Dogon

Seat with figurine decor

Tabouret à motifs figuratifs

Hocker mit Figurenschmuck

Taburete con figuras decorativas

Sgabello con figure decorative

Krukje met figuratieve versiering

1891, Wood/Bois, 33 cm

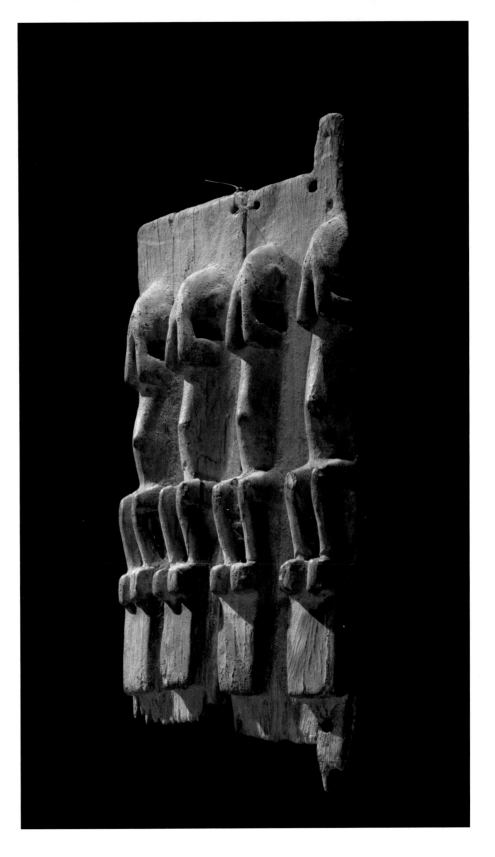

Dogon

Window panel of a grain storage with figurine decor

Vantail d'un volet avec figures décoratives

Fensterladen eines Speichers mit Figurenschmuck

Contraventana de almacén con figuras decorativas

Imposta di un granaio con figure decorative

Raamluik van opslagplaats met figuratieve versiering

1891, Wood, iron/Bois, fer, 45 cm

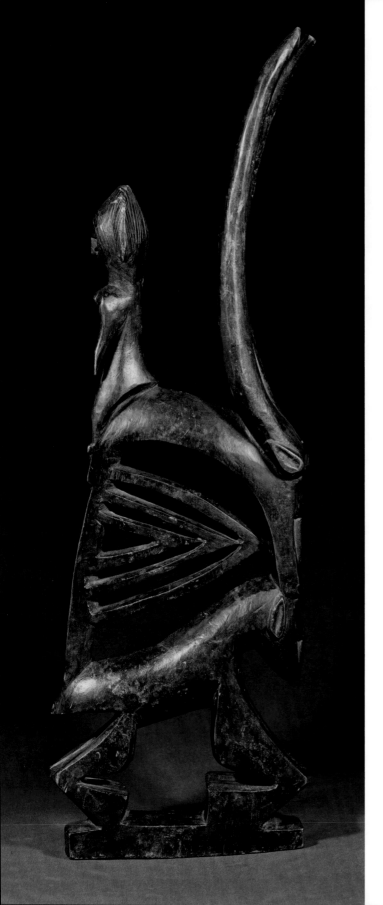

Chiwara are dance masks from Western Africa and are some of the best-known African sculptures. The main motive of the *chiwara* is the antelope, the tribal animal of the Bambara. The antelope is often paired with an aardvark or anteaters and armadillos. Mythology states that the antelope brought farming to humankind. It is therefore the connection to the cosmos. The antelope is the symbolic animal of the second to last of the six unifications a person is initiated to in life. Its display is very versatile: dissolved naturalistic or in geometric shapes. The *chiwara* motive can be found on bank notes and company logos in Mali.

Les *ciwara* sont des masques de danse d'Afrique de l'Ouest et ils comptent parmi les sculptures africaines les plus connues. Le principal motif des *ciwara* est l'antilope, l'animal tribal des Bambara. L'antilope est souvent complétée par un oryctérope (ou un fourmilier) et un pangolin. Selon la mythologie, l'antilope aurait apporté l'agriculture à l'humanité. Elle représente donc la connexion avec le cosmos. L'antilope est l'animal symbolique de l'avant-dernière des six unifications auxquelles une personne est initiée au cours de sa vie. Ses représentations sont très variées : naturalistes ou intégrées à des formes géométriques. Aujourd'hui, on retrouve le motif *ciwara* sur les billets de banque et certains logos d'entreprise au Mali.

Die *Tjiwara* genannten Tanzaufsätze aus Westafrika gehören zu den bekanntesten Skulpturen aus Afrika. Das Hauptmotiv der *Tjiwara* ist die Antilope, das Stammestier der Bambara. Die Antilope wird oft ergänzt durch Erdferkel beziehungsweise Ameisenbär und Schuppentier. In der Mythologie brachte die Antilope den Menschen den Ackerbau. Daher steht sie für die Verbindung zum Kosmos. Die Antilope ist das Symboltier der vorletzten von sechs Vereinigungen, in die ein Mensch im Laufe seines Lebens initiiert wird. Ihre Darstellung ist sehr vielfältig: naturalistisch oder in geometrische Formen aufgelöst. Das *Tjiwara*-Motiv findet sich heute auf Banknoten und Firmenlogos aus Mali.

Bambara (Bamana)
Tjiwara-Mask
Masque-coiffe Tjiwara
Tjiwara-Aufsatzmaske
Máscara Chi-wara
Copricapo Tjiwara
Chi Wara-hoofdtooi
1891, Wood/Bois, 70 cm

Las famosas figuras llamadas *chi-wara* del África occidental se cuentan entre las esculturas más famosas de África. El motivo principal de las *chi-wara* es el antílope, el animal de la tribu de los Bambara. El antílope se encuentra a menudo acompañado por un cerdo hormiguero, oso hormiguero o un pangolín. En la mitología, el antílope trae a los hombres la agricultura, por eso está conectado al cosmos. El antílope es el animal simbólico de la penúltima de seis organizaciones en las que una persona es iniciada a lo largo de su vida. Su representación es variada: naturalista, o bien abstraída en formas geométricas. El motivo *chi-wara* puede encontrarse hoy en día en billetes y logotipos de empresas en Malí.

I copricapi chiamati *ciwara*, che venivano indossati nell'Africa occidentale durante le danze, sono tra le sculture africane più celebri. Il motivo principale dei *ciwara* è l'antilope, l'animale simbolo dei Bambara, spesso accompagnata da un oritteropo, un formichiere o un pangolino. Nella mitologia, l'antilope donò agli uomini l'agricoltura, pertanto rappresenta un collegamento con il cosmo. L'antilope è l'animale simbolo della penultima delle sei unioni di una persona nel corso della sua vita: quella dell'iniziazione. Viene rappresentata in forme molto diverse, naturalistiche oppure geometriche. Il motivo dei *ciwara* lo si ritrova oggi su banconote e loghi del Mali.

De danstooien uit West-Afrika die chi wara worden genoemd, behoren tot de bekendste beeldhouwwerken uit Afrika. Het voornaamste motief van de *chi wara* is de antilope, het stamdier van de Bambara. Dit motief wordt vaak aangevuld met dat van het aardvarken of met de miereneter en het gordeldier. In de mythologie is het de antilope die de mensheid de landbouw bracht. Daarom staat het dier voor de verbondenheid met de kosmos. De antilope staat symbool voor het op één na laatste genootschap van een reeks van zes genootschappen waarin een mens in de loop van zijn leven door initiatie wordt opgenomen. De uitbeelding ervan is zeer divers: naturalistisch of tot geometrische vormen geabstraheerd. Het chi wara-motief is tegenwoordig in Mali terug te vinden op bankbiljetten en in bedrijfslogo's.

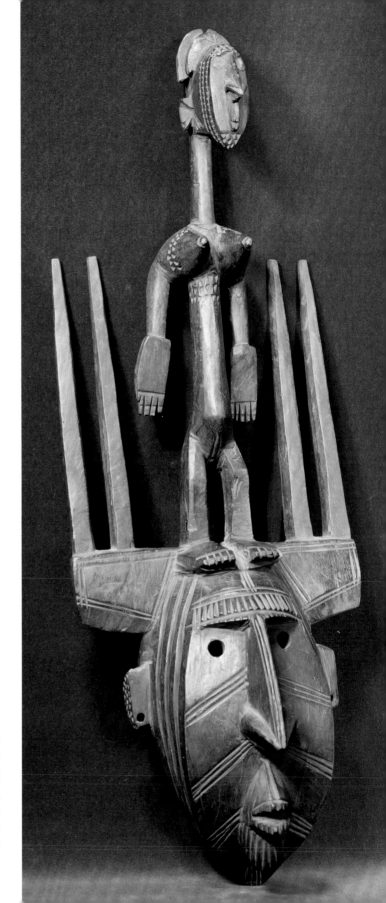

Bambara (Bamana)
Mask with demale figurine for initiation ritual
Masque avec figure féminine pour rituel d'initiation
Maske mit weiblicher Figur für Initationsritual
Máscara con figura femenina para ritual de iniciación
Maschera con figura femminile per rito di iniziazione
Masker met vrouwenfiguur voor initiatierite
1891, Wood/Bois, 68 cm

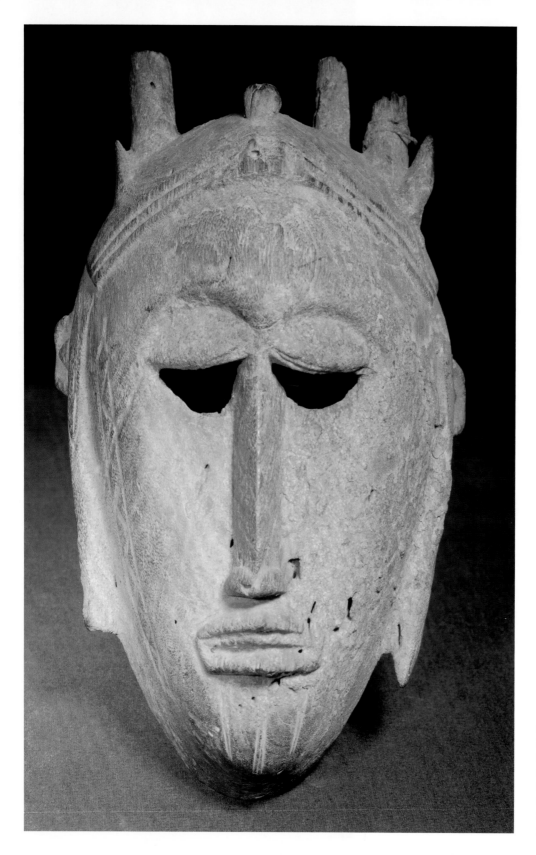

Bambara (Bamana)

Mask with horns

Masque à cornes

Maske mit Hörnern

Máscara con cuernos

Maschera con corna

Masker met hoorntjes

1891, Wood/Bois, 29 cm

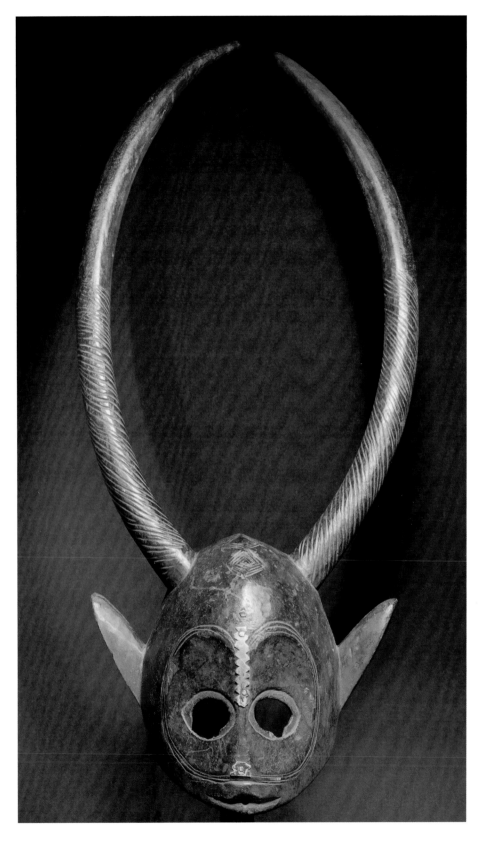

Bambara (Bamana)

Mask

Masque

Maske

Máscara

Maschera

Masker

1893, Wood, metal/Bois, métal, 79 cm

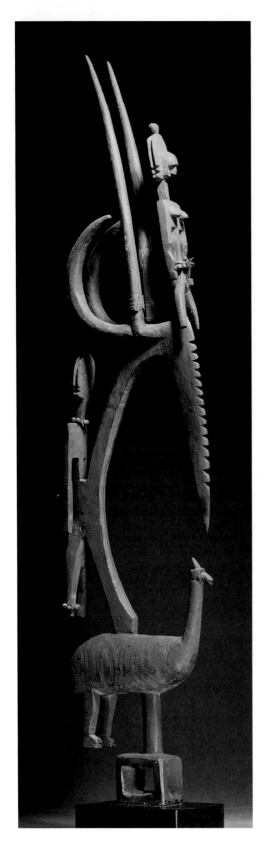

Bambara (Bamana)

Mask with antelope, ostrich and
anthropomorphic shapes

Masque-coiffe avec antilopes, autruches
et formes anthropomorphes

Aufsatzmaske mit Antilope, Strauß
und anthropomorphen Formen

Máscara con antílope, avestruz
y formas antropomórficas

Copricapo con antilope, struzzo
e forme antropomorfe

Hoofdtooi met antilope, struisvogel
en antropomorfe figuren

1892, Wood/Bois, 90 cm

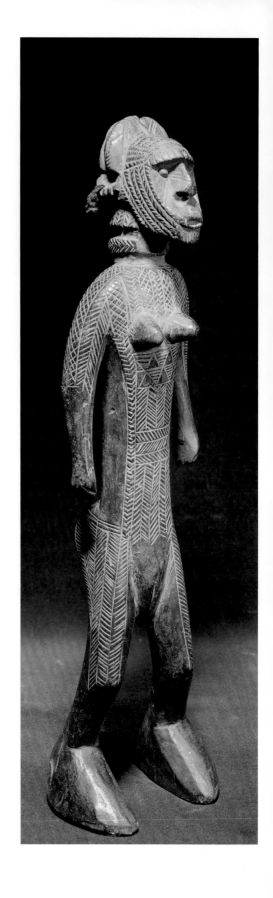

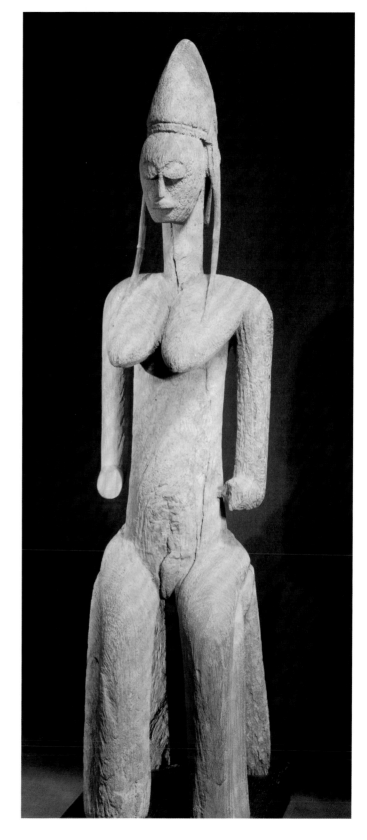

Bambara (Bamana)

Female figurine

Figure féminine

Weibliche Figur

Figura femenina

Figura femminile

Vrouwenfiguur

1894, Wood/Bois, 46,5 cm

Bambara (Bamana)

Female figurine

Figure féminine

Weibliche Figur

Figura femenina

Figura femminile

Vrouwenfiguur

1894, Wood/Bois, 87 cm

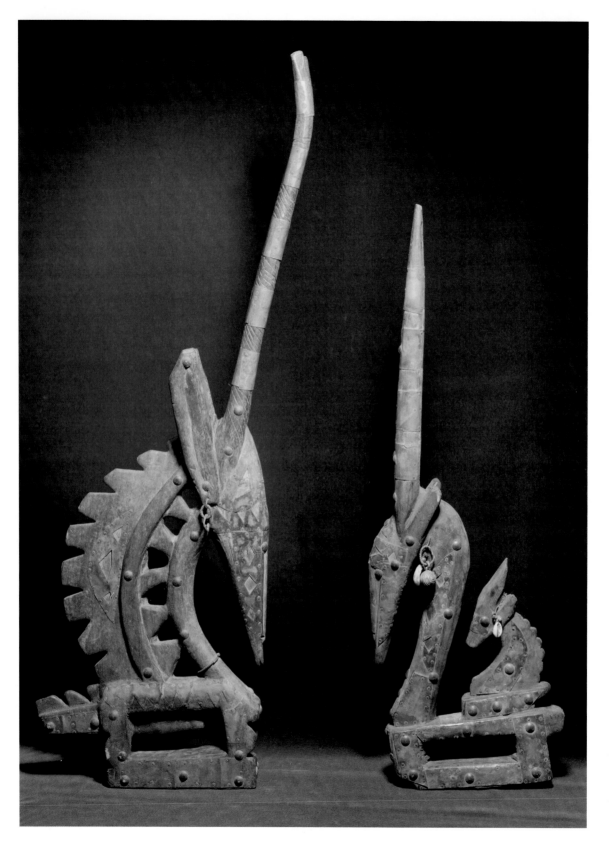

Bambara (Bamana)
Tjiwara-Mask
Masques-coiffes Tjiwara
Tjiwara-Aufsatzmasken
Máscaras Chi-wara
Copricapi Tjiwara
Chi Wara-hoofdtooien
1894, Wood, metal/
Bois, métal, 67–87 cm

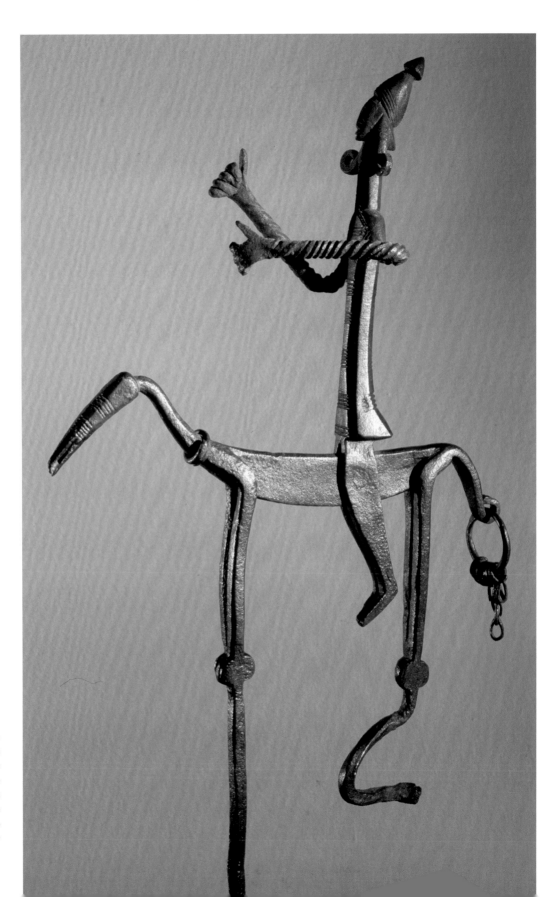

Bambara (Bamana)
Group of riders
Groupe de cavaliers
Reitergruppe
Grupo de figuras ecuestres
Gruppo equestre
Ruitergroep
1897, Iron/Fer

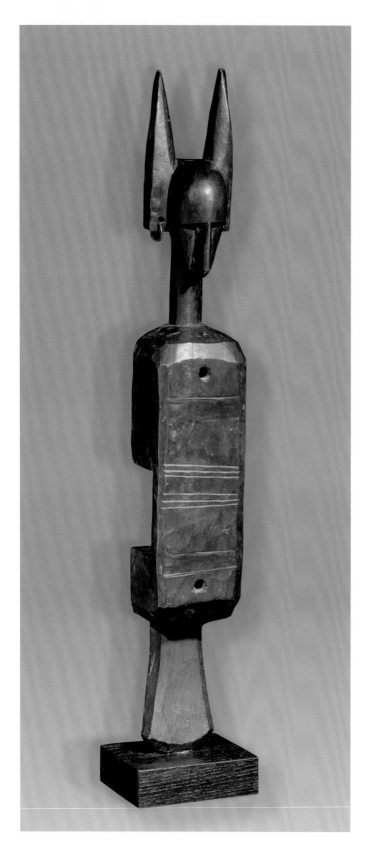

Bambara (Bamana)

Door lock

Serrure

Türschloss

Candado de puerta

Serratura

Deurslot

1897, Wood patinised/Bois patiné, 65,4 cm

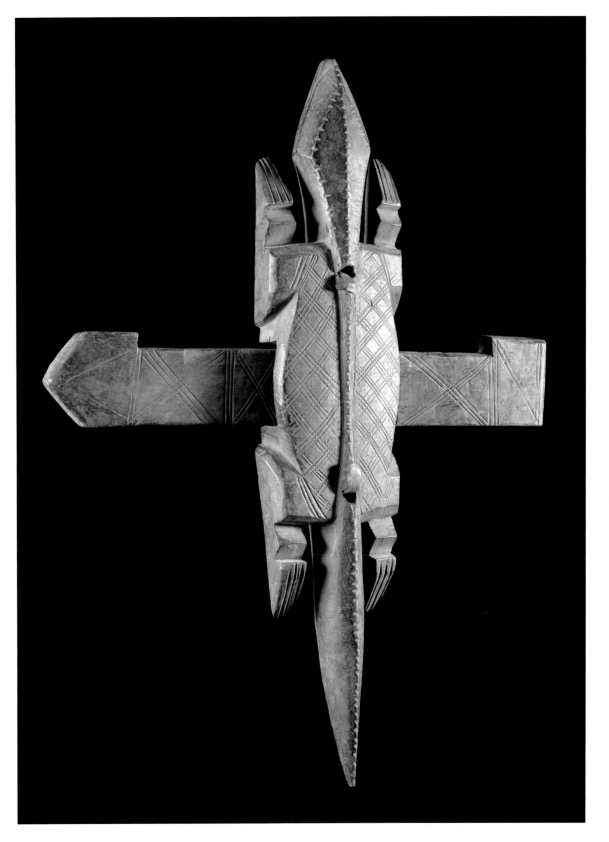

Bambara (Bamana)
Door latch
Verrou de porte
Türriegel
Cierre de puerta
Chiavistello
Deurklink
1897, Wood/Bois

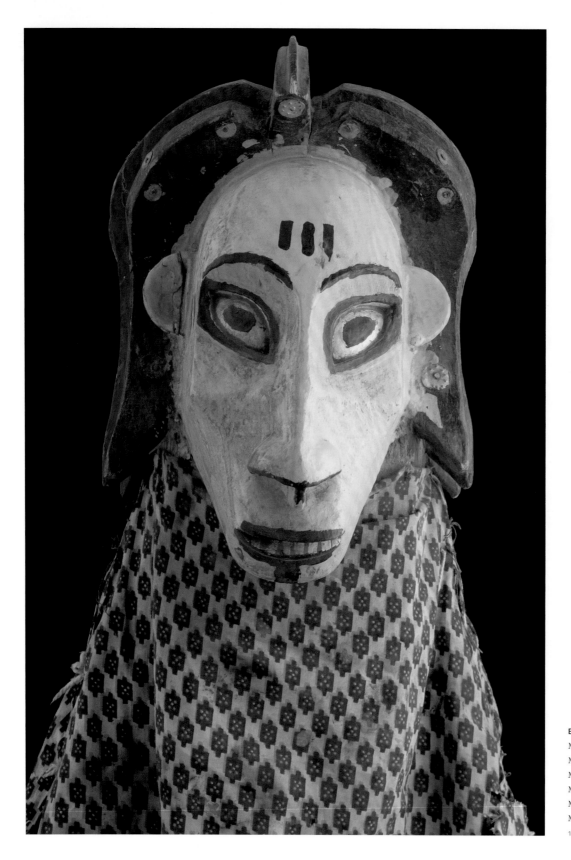

Bozo

Mask of a puppet

Masque d'une marionnette

Maske einer Marionette

Máscara de marioneta

Maschera di un burattino

Masker van een marionet

1919, Wood painted/Bois peint, 43 × 20 cm

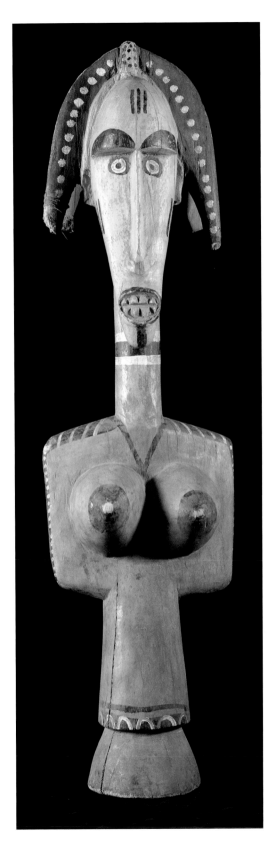

Bozo

Female bust

Buste féminin

Weibliche Büste

Busto femenino

Busto femminile

Vrouwenbuste

1899, Wood painted/
Bois peint

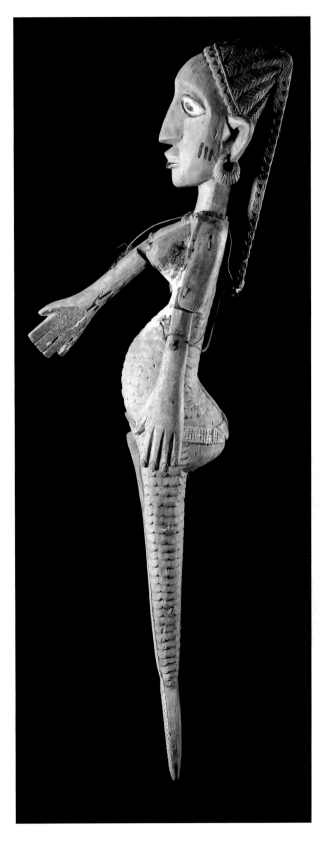

Bozo

Puppet (Sirene)

Marionnette (sirène)

Marionette (Sirene)

Marioneta (sirena)

Burattino (sirena)

Marionet (sirene)

1899, Wood painted/
Bois peint, 110 cm

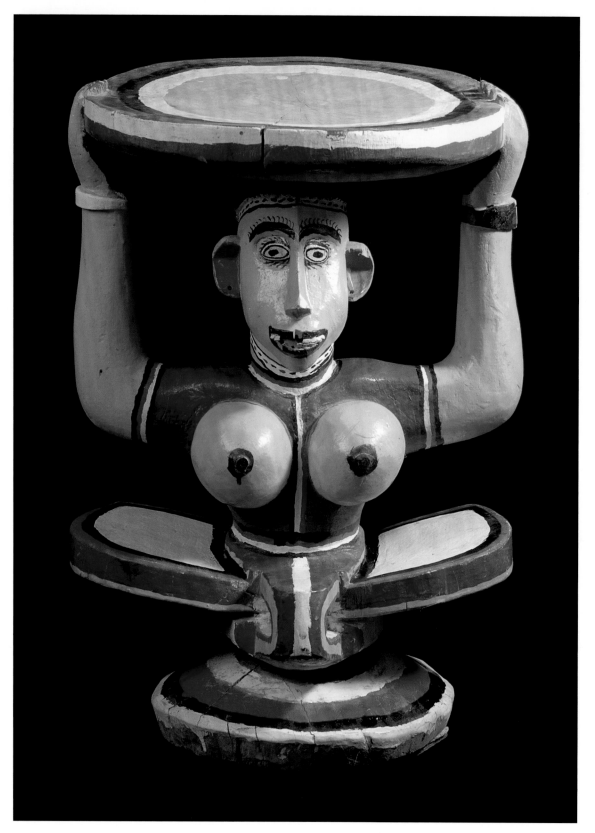

Bozo

Anthropomorphic seat

Tabouret anthropomorphe

Anthropomorpher Hocker

Taburete antropomórfico

Sgabello antropomorfo

Antropomorf krukje

1890, Wood painted/
Bois peint

Bozo
Head piece with fable animal
Coiffe avec animal mythique
Kopfaufsatz mit Fabeltier
Tocado con animal imaginario
Copricapo con creatura mitica
Hoofdtooi met fabeldier
1899, Wood painted/Bois peint

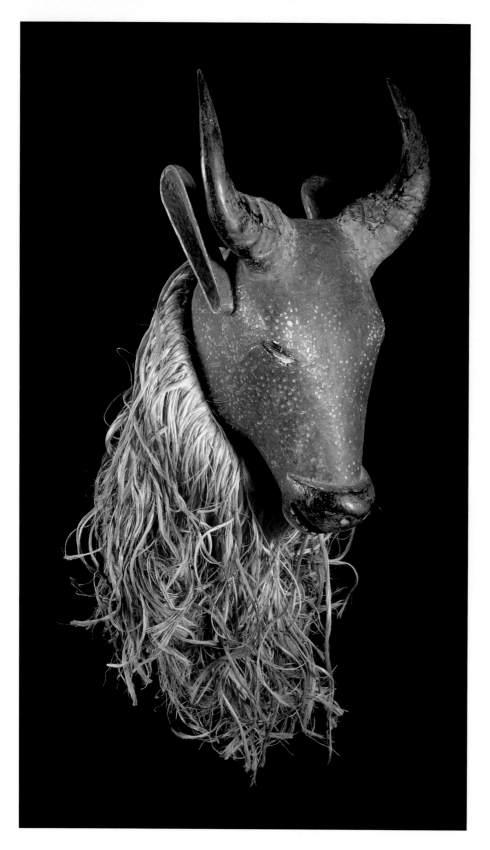

Bozo

Buffalo mask

Masque de buffle

Büffelmaske

Máscara de búfalo

Maschera a forma di bufalo

Buffelmasker

1900

Bozo

Anthropomorphic pestle (feeding mother)

Mortier anthropomorphe (mère nourricière)

Anthropomorpher Mörser (nährende Mutter)

Mortero antropomórfico (madre)

Mortaio antropomorfo (madre nutrice)

Antropomorfe vijzel (zogende moeder)

1900, Wood painted/Bois peint

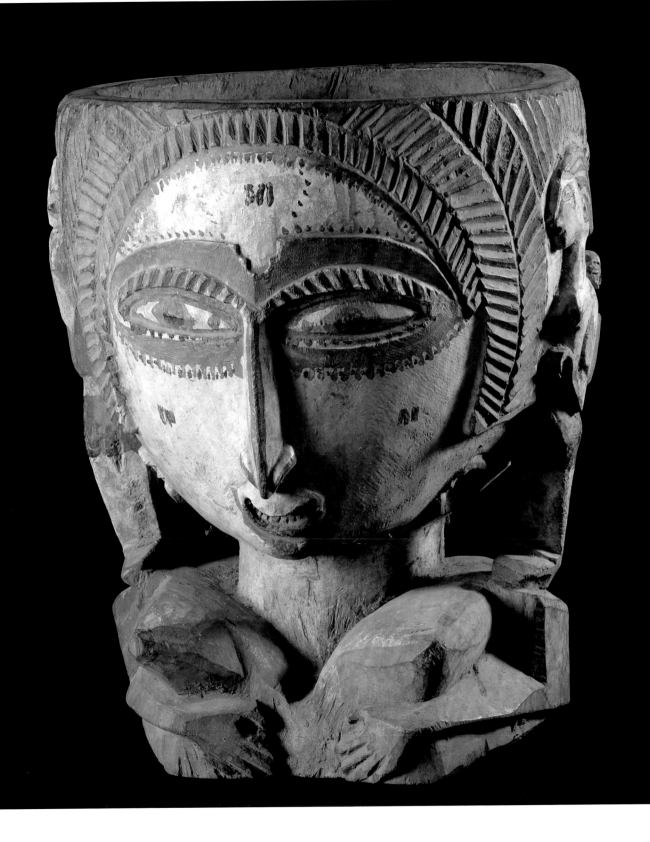

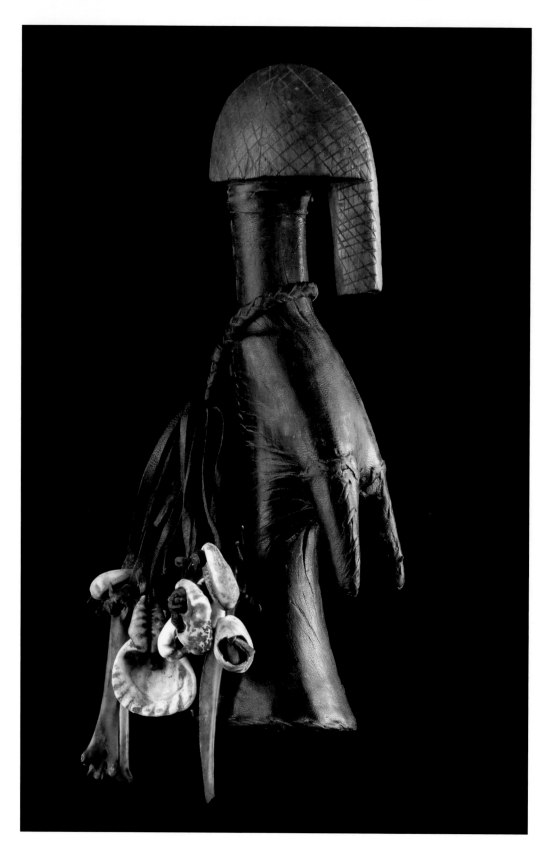

Mossi

Fertility doll

Poupée de fécondité

Fruchtbarkeitspuppe

Muñeco de la fertilidad

Bambola della fertilità

Vruchtbaarheidspop

1900, Wood, leather, clamshells, snails,
animal bones/Bois, cuir, moules,
coquilles d'escargots, os d'animaux

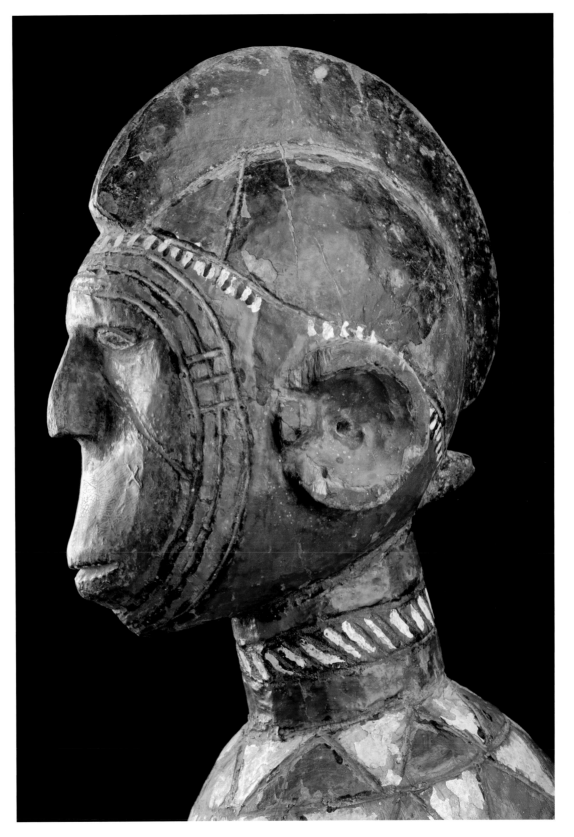

Mossi

Helmet decoration with
anthropomorphic head

Bijou de casque avec tête
anthropomorphe

Helmschmuck mit
anthropomorphem Kopf

Casco decorativo con
cabeza antropomórfica

Elmo decorativo con
testa antropomorfa

Helmsieraad met antropomorfe kop

1901, Wood painted/Bois peint, 32 cm

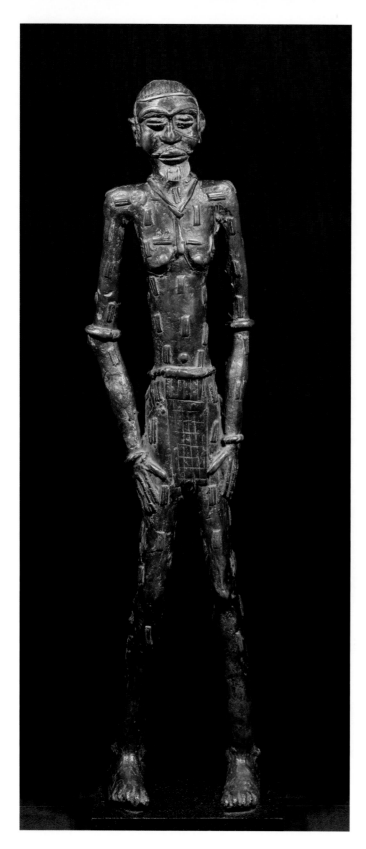

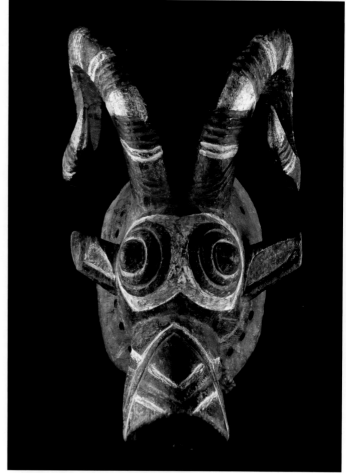

Gurunsi

Ram mask

Masque bélier

Widdermaske

Máscara de carnero

Maschera a forma di ariete

Ramsmasker

1902, Wood painted/Bois peint

Bobo

King figurine

Statuette de roi

Figur eines Königs

Figura de un rey

Figura di re

Koningsfiguur

1902, Bronze/Bronze, 55 cm

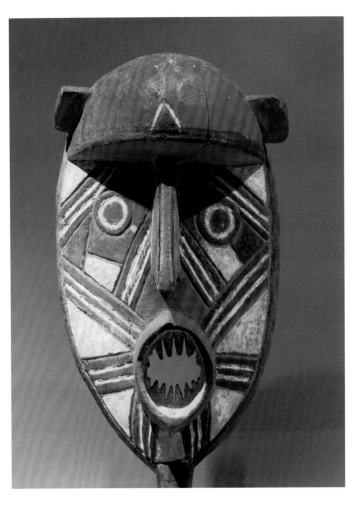

Nuna

Monkey mask

Masque de singe

Affenmaske

Máscara de mono

Maschera a forma di scimmia

Apenmasker

1902, Wood/Bois, 41 cm

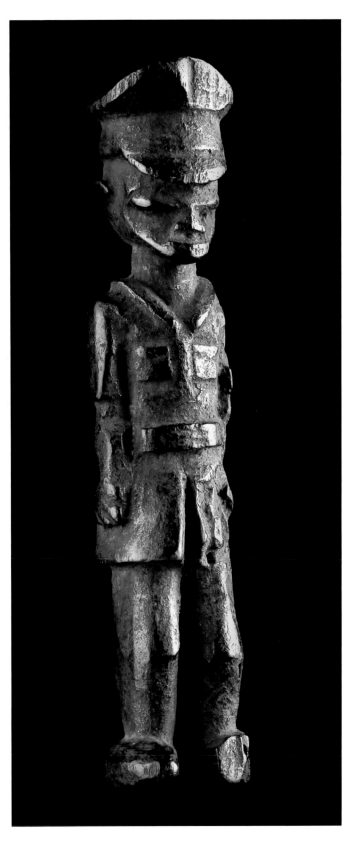

Lobi

Male colon figurine

Figurine de colon masculin

Männliche Colon-Figur

Figura de colono masculina

Figura Colon maschile

Mannelijke 'colon'-figuur

1904, Wood/Bois

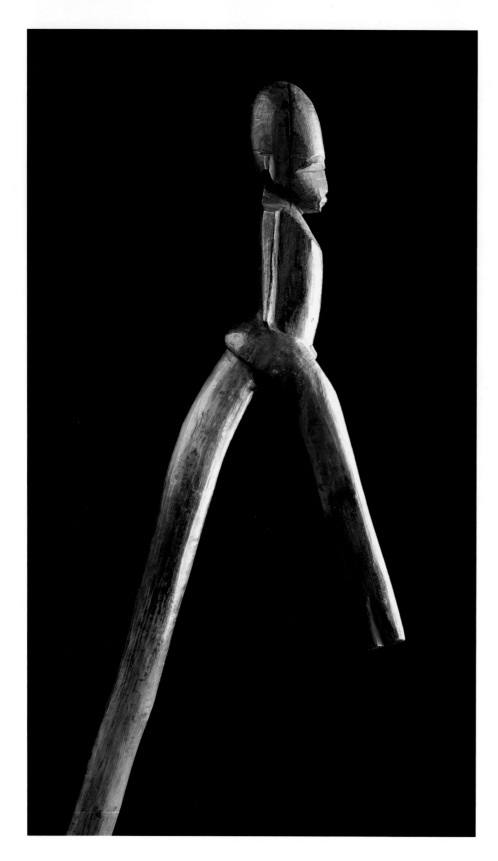

Lobi

Anthropomorphic cane

Canne anthropomorphe

Anthropomorpher Stock

Bastón antropomórfico

Bastone antropomorfo

Antropomorfe staf

1903, Wood/Bois, 55 cm

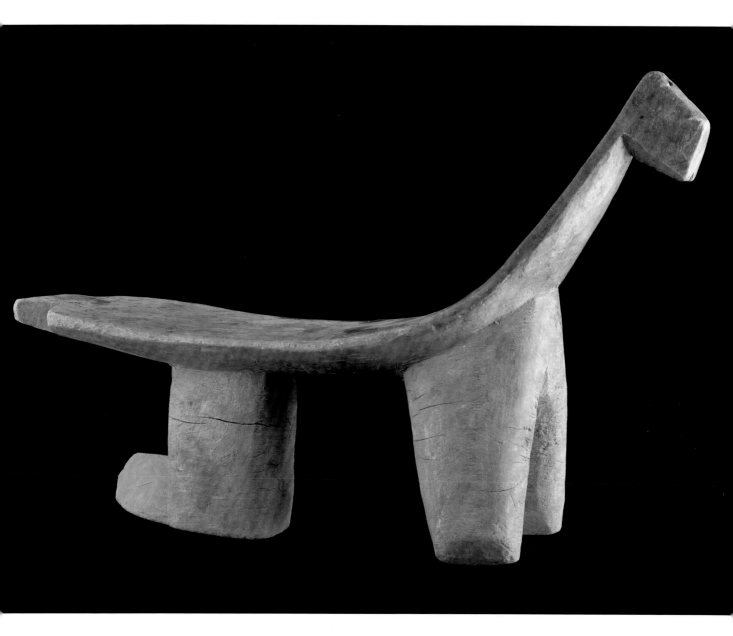

Lobi

Zoomorphic seat

Siège zoomorphe

Zoomorpher Sitz

Asiento zoomórfico

Seduta zoomorfa

Zoömorf krukje

1903, Wood / Bois , 66 cm

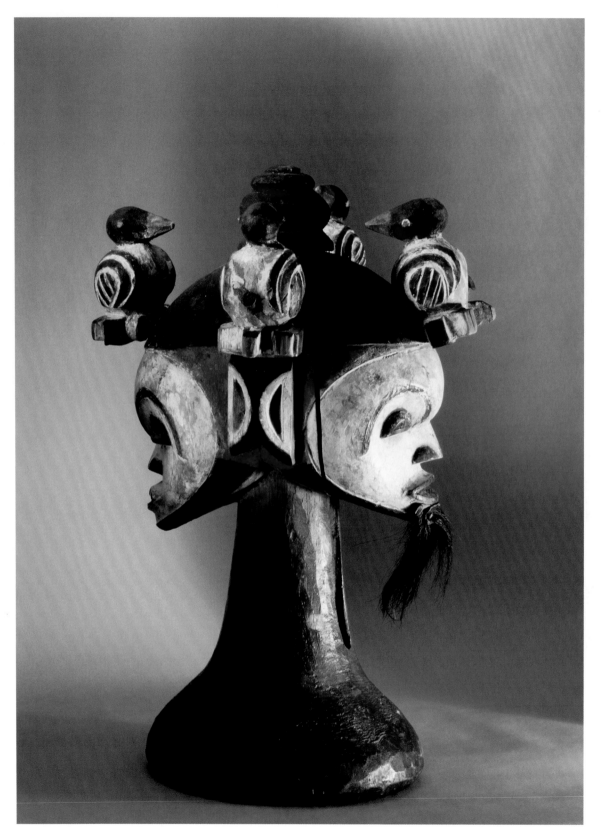

Idoma

Dual-face mask

Masque-coiffe à
double visage

Doppelgesichtige
Aufsatzmaske

Tocado de doble cara

Copricapo con due volti

Hoofdtooi met
twee maskers

1917, Wood painted,
human hair/Bois peint,
cheveux humains

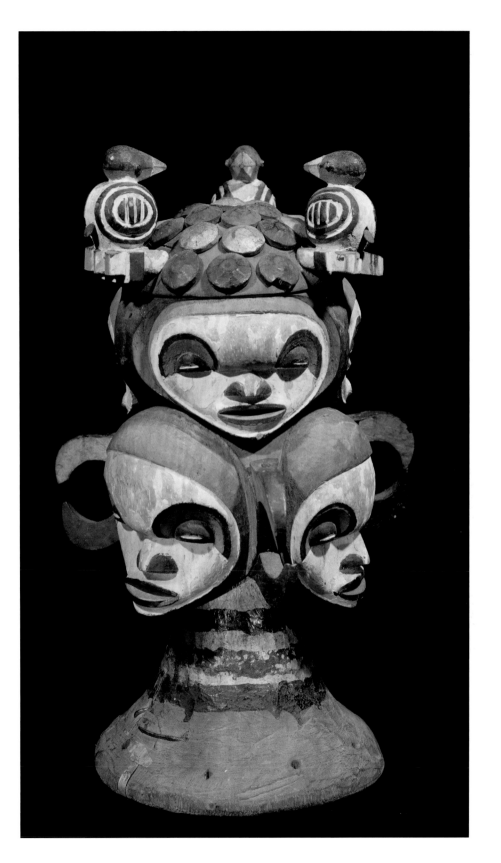

Idoma
Ochai (Otobi)
Triple-mask
Masque-coiffe triple
Dreimaskenaufsatz
Tocado de tres máscaras
Copricapo con 3 maschere
Hoofdtooi met drie maskers
1907, Wood painted/Bois peint, 35,5 cm

131

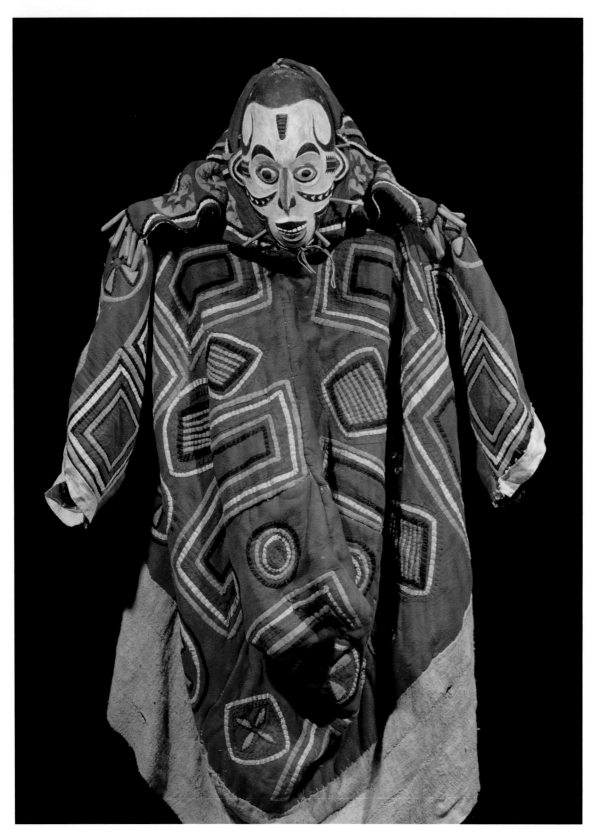

Ibo

Mask and funeral clothing

Masque et vêtements
funéraires

Maske und
Begräbniskleidung

Máscara y vestimentas
fúnebres

Maschera e abiti
di sepoltura

Masker en begrafeniskledij

1907, Wood painted, cloth/
Bois peint, tissu, 31 cm,,
National Museum, Lagos

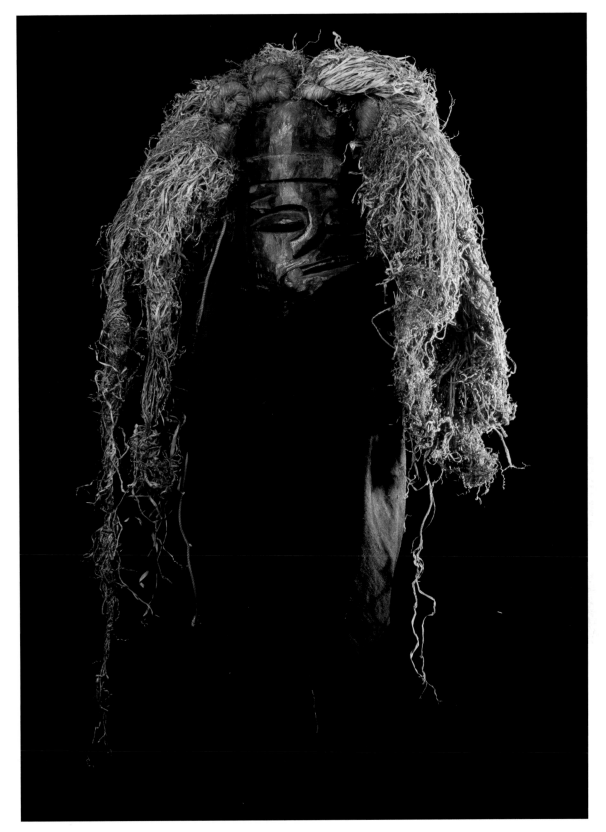

Igbo

Mask of a medicine man

Masque de guérisseur

Maske eines
Medizinmannes

Máscara de curandero

Maschera di sciamano

Masker van een
medicijnman

1907, Wood/Bois

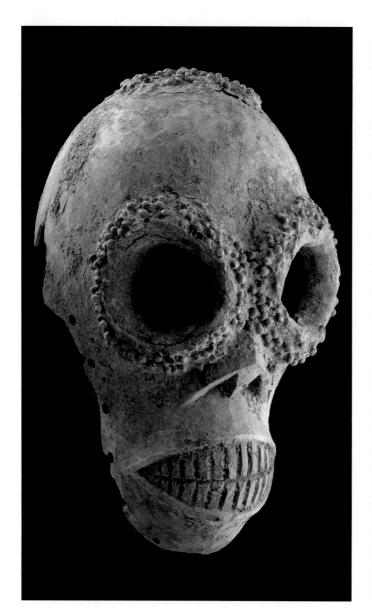

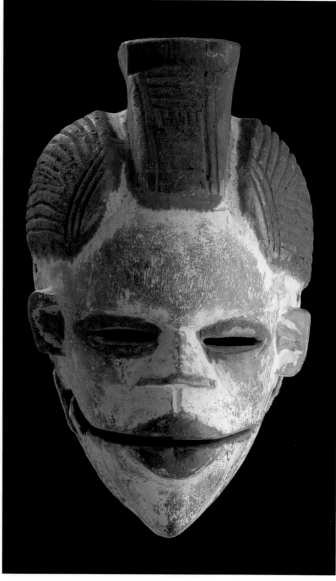

Igbo

Monkey mask or skull

Masque singe ou tête de mort

Affenmaske oder Totenschädel

Máscara de mono o calavera

Maschera a forma di scimmia o cranio

Apenmasker of doodskop

1908, Wood painted, grains/Bois peint, graines

Igbo

Mask for young women

Masque pour jeune femme

Maske für junge Frauen

Máscara para mujeres jóvenes

Maschera per giovani donne

Masker voor jonge vrouwen

1908, Wood painted/Bois peint

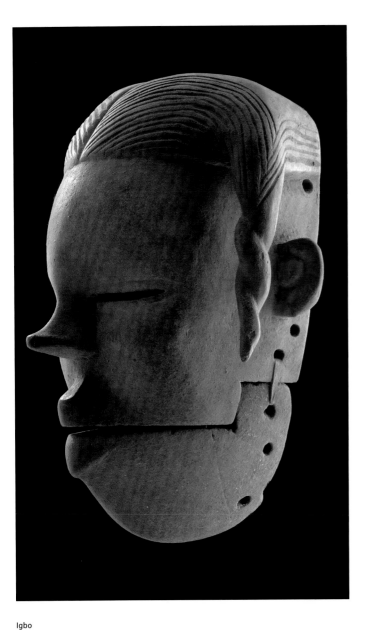

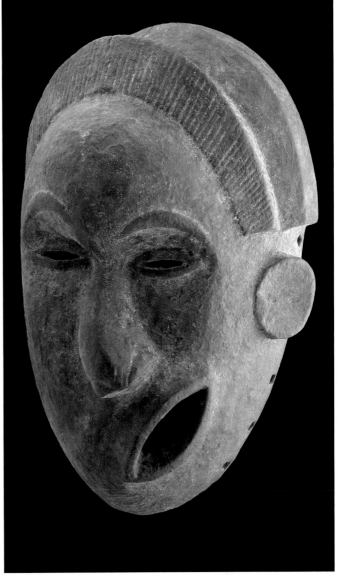

Igbo

Mask for young women

Masque pour jeune femme

Maske für junge Frauen

Máscara para mujeres jóvenes

Maschera per giovani donne

Masker voor jonge vrouwen

1908, Wood painted/Bois peint

Igbo

Mask

Masque

Maske

Máscara

Maschera

Masker

1908, Wood painted/Bois peint

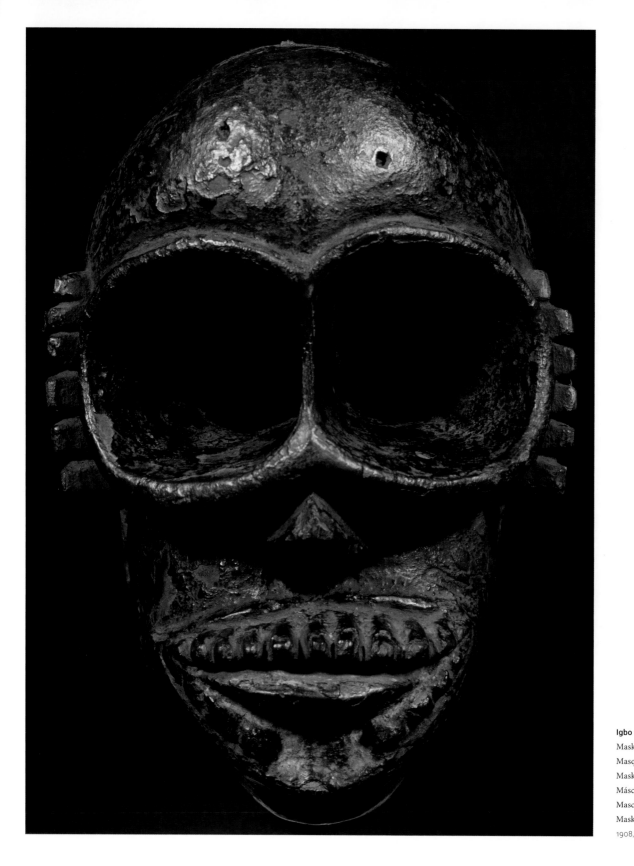

Igbo
Mask
Masque
Maske
Máscara
Maschera
Masker
1908, Wood/Bois, 25 cm

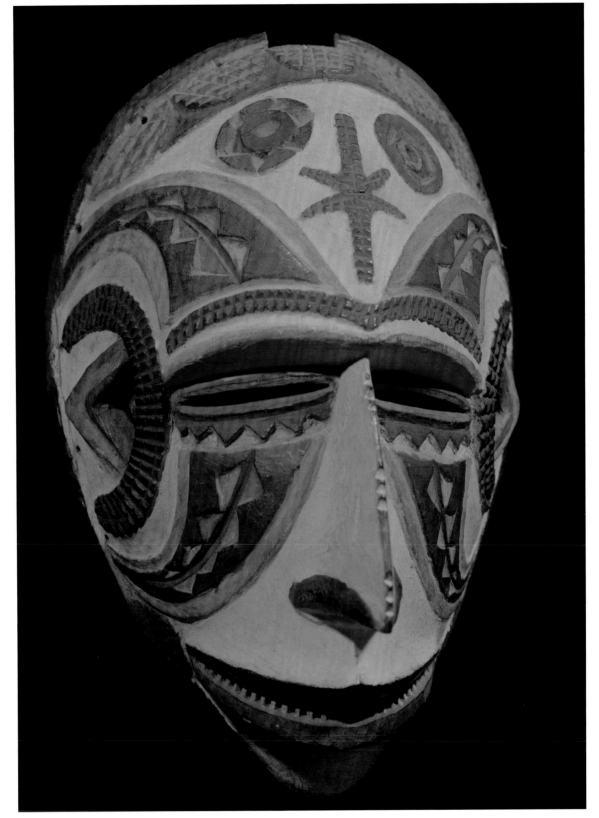

Igbo

Mask

Masque

Maske

Máscara

Maschera

Masker

1908, Wood/Bois, 20 cm

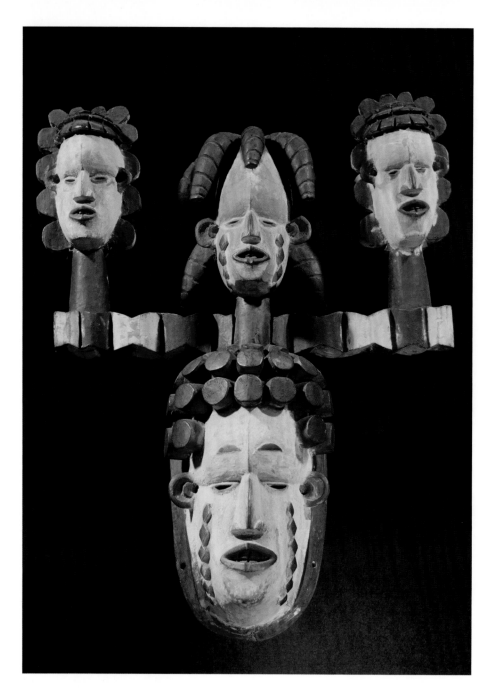

The Cross River and its tributary streams shape this region. The exceptionally wide river runs through today's Cameroon and leads to the Nigerian cost. The Cross River has always been an important trade route. Especially the Ibibio and Ibo cultures traded field fruits, goods and slaves. In the 18th and 19th century European merchants, colonialists and natives fought bitterly over these resources. Many people died in these fights. Only in this region people wore head masks during dances, resembling human heads. Reportedly, the Ekoi founded this tradition.

Le Cross et ses affluents façonnent la région. Le fleuve, incroyablement large, traverse l'actuel Cameroun et débouche sur la côte nigériane. Le Cross a toujours été une importante voie commerciale. Il était particulièrement utilisé par les cultures Ibibio et Ibo pour échanger des récoltes, des marchandises et des esclaves. Aux 18e et 19e siècles, marchands européens, colons et indigènes combattirent férocement pour ces ressources. De nombreuses personnes furent tuées. C'est la seule région où les habitants portaient des masques-coiffes ressemblant à des têtes humaines lors des danses. Le peuple Ekoi serait à l'origine de cette tradition.

Der Cross River und seine Nebenflüsse prägen dieses Gebiet. Der auffallend breite Fluss durchzieht das heutige Kamerun und mündet an der nigerianischen Küste. Seit jeher ist ist der Cross River ein bedeutender Handelsweg. Vor allem Ibibio- und Igbo-Gesellschaften tauschten hier Feldfrüchte, Waren und Sklaven. Europäische Händler, Kolonialherren und Einheimische kämpften besonders im 18. und 19. Jahrhundert erbittert um diese Ressourcen. Viele Menschen kamen dabei ums Leben. Nur in diesem Gebiet trugen die Menschen bei Tänzen Aufsatzmasken in Form menschlicher Köpfe. Den Ekoi schreibt man zu, diese Tradition begründet zu haben.

Igbo

Mask of a young girl's spirit

Masque de l'esprit d'une jeune fille

Maske des Geistes eines jungen Mädchens

Máscara del espíritu de una mujer joven

Maschera dello spirito di una giovane fanciulla

Masker van de geest van een jong meisje

1908, Wood painted/Bois peint, 41,9 cm

El río Cross y sus afluentes caracterizan a esta zona. Este río, extraordinariamente ancho, atraviesa el actual Camerún y desemboca en la cosa de Nigeria. Desde tiempo inmemorial, el río Cross ha sido una importante ruta de comercio. Especialmente las sociedades Ibibio e Igbo intercambiaban aquí frutas, mercancías y esclavos. Los comerciantes europeos, señores coloniales y los autóctonos, lucharon encarnizadamente en los siglos XVII y XIX por estos recursos y muchos perdieron la vida en esta lucha. Solo en esta zona, las personas llevaban máscaras con forma de cabeza humana mientras bailaban. Se le atribuye la creación de esta tradición a los Ekoi.

In questa regione scorrono il fiume Cross e i suoi affluenti. Sorprendentemente ampio in questa zona, il fiume attraversa l'odierno Camerun e sfocia sulla costa nigeriana. È da sempre un'importante rotta commerciale, utilizzata storicamente soprattutto dagli Ibibio e dagli Ibo per lo scambio di raccolti, merci e schiavi. I commercianti europei, i colonizzatori e gli abitanti autoctoni combatterono ferocemente nel XVIII e XIX secolo per queste risorse. Durante le battaglie persero la vita molte persone. Solo in questa regione, durante le danze venivano indossati copricapi a forma di teste umane, una tradizione la cui origine è attribuita agli Ekoi.

De rivier de Cross en zijn zijrivieren bepalen dit gebied. De opvallend brede rivier stroomt door het huidige Kameroen en mondt uit aan de Nigeriaanse kust. Sinds mensenheugenis is de Cross een belangrijke handelsroute. Vooral de Ibibio- en Ibo-culturen gebruikten de waterweg om handel te drijven in gewassen, koopwaar en slaven. In de achttiende en negentiende eeuw vochten Europese kooplui, koloniale machthebbers en inheemse stammen verbitterd om deze hulpbronnen, waarbij velen omkwamen. Uitsluitend in dit gebied droegen mensen bij rituele dansen hoofdtooien in de vorm van menselijke hoofden. De oorsprong van deze traditie wordt aan de Ekoi toegeschreven.

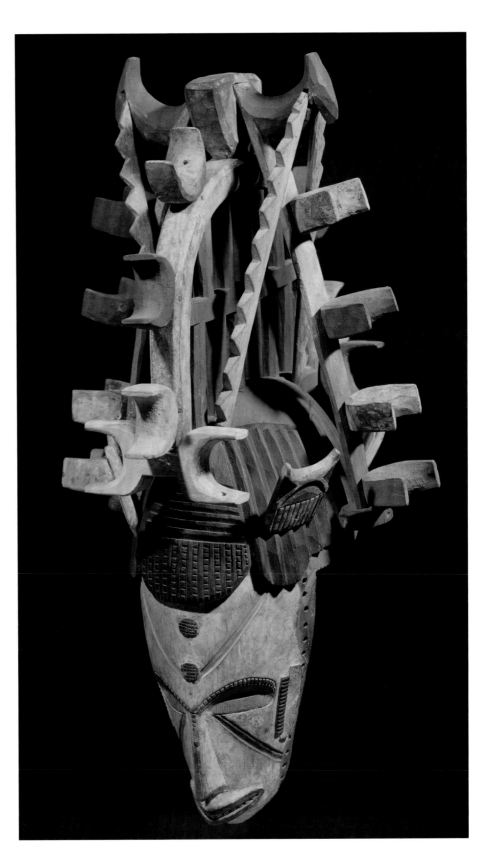

<div align="center">

Igbo

Ndie (Umingwedo)

Mask resembling female beauty

Masque représentant l'idéal de la beauté féminine

Maske, die das Ideal weiblicher Schönheit darstellt

Máscara que representa el ideal de belleza femenina

Maschera che rappresenta l'ideale della bellezza femminile

Masker dat het ideaal van vrouwelijke schoonheid uitbeeldt

1908, Wood/Bois, 37,5 cm

</div>

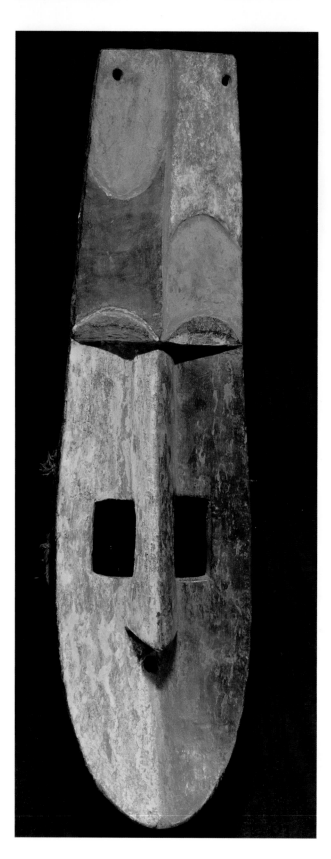

Igbo

Agu China
(Ndi Agha Nguzu)

Mask

Masque

Maske

Máscara

Maschera

Masker

1920, Wood/Bois, 43 cm

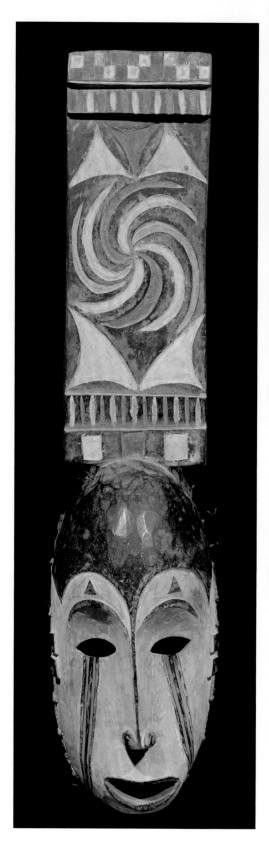

Igbo

Okoro (Mbom Afikpo)

Mask

Masque

Maske

Máscara

Maschera

Masker

1916–19, Wood painted/
Bois peint, 49 cm

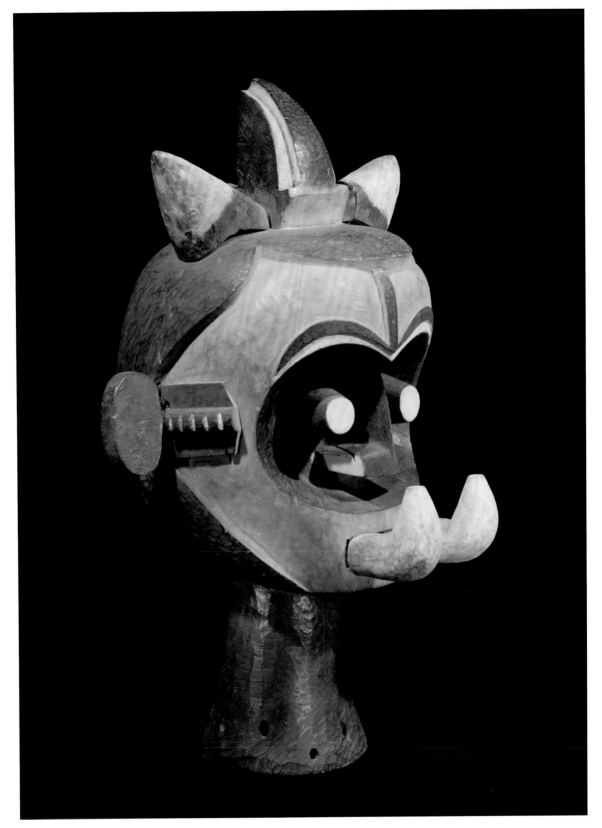

Igbo

Setting mask

Cimier

Aufsatzmaske

Máscara-tocado

Copricapo

Hoofdtooi met masker

1916–19, Wood painted/
Bois peint, 49 cm

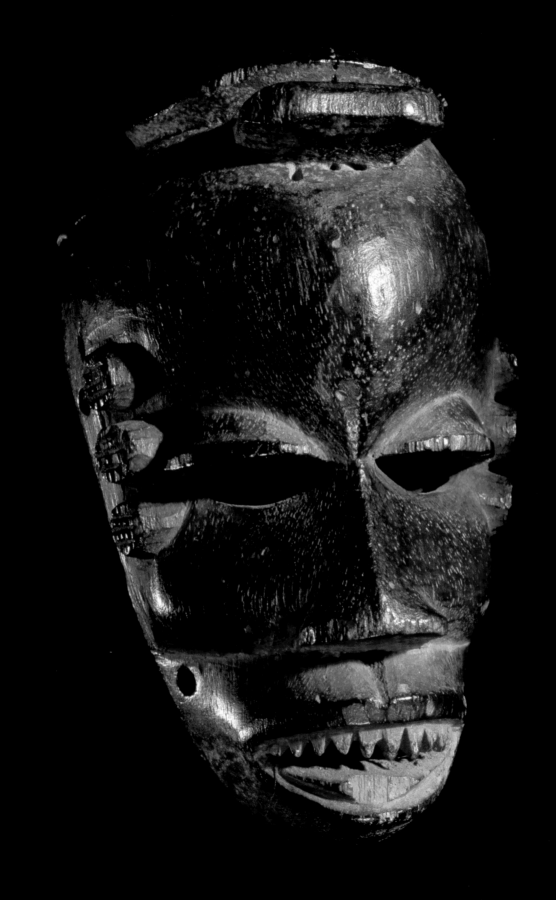

Ibibio

Dance mask

Masque de danse

Tanzmaske

Máscara de danza

Maschera di danza

Dansmasker

1919–20, Wood/Bois

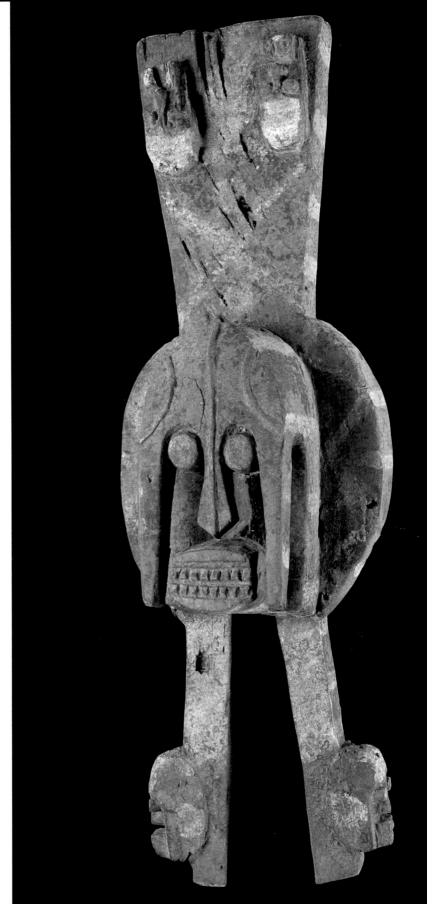

Ijo

Standing mask of an ancestor

masque debout d'un ancêtre

Standmaske eines Ahnen

Máscara-escultura de un antepasado

Maschera autoportante di un antenato

Standmasker van voorouder

1919–20, Wood painted/Bois peint

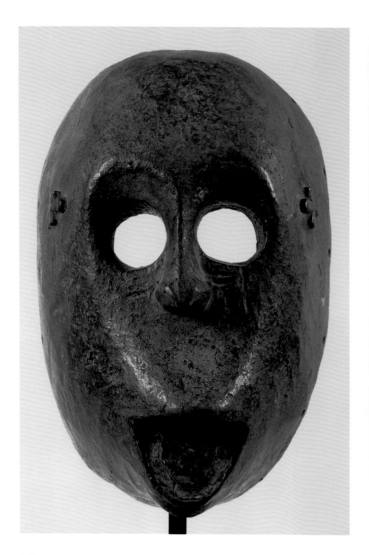

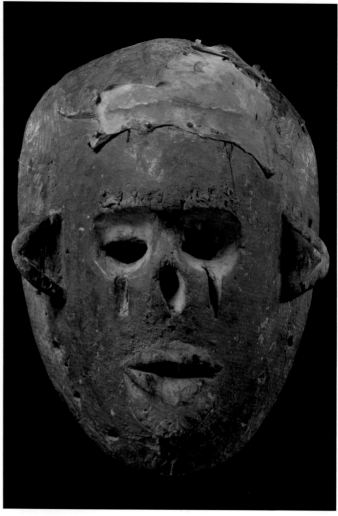

Ibibio

Mask

Masque

Maske

Máscara

Maschera

Masker

1919–22, Wood patinised/Bois patiné

Ibibio

Sickness mask

Masque de maladie

Krankheitsmaske

Máscara de enfermedad

Maschera di malattia

Masker bij ziekte

1920, Wood, leather/Bois, cuir, 33 × 14 cm

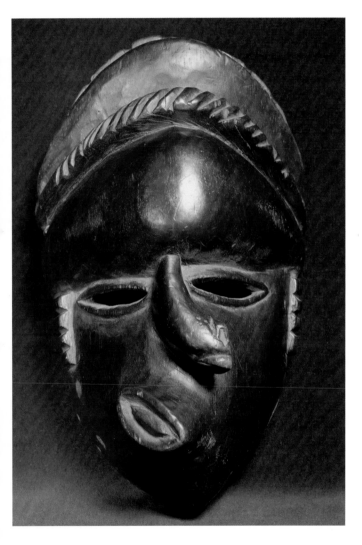

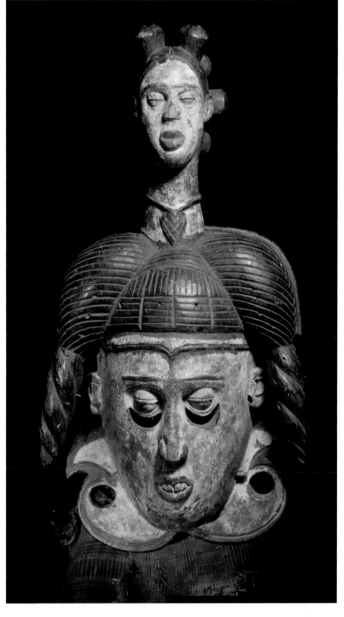

Ibibio

Mask

Masque

Maske

Máscara

Maschera

Masker

1922–24, Wood/Bois, 31,8 cm

Ibibio

Mask

Masque

Maske

Máscara

Maschera

Masker

1922, Wood painted, cloth/Bois peint, tissu, 57 cm

Ibibio

Mask with movable jaw (bearded man with large ears)

Masque avec mâchoire mobile (homme barbu avec de grandes oreilles)

Maske mit beweglichem Kiefer (bärtiger Mann mit großen Ohren)

Máscara con mandíbula móvil (hombre barbudo de grandes orejas)

Maschera con mascella mobile (uomo barbuto con grandi orecchie)

Masker met beweegbare kaak (man met baard en grote oren)

1922–24, Wood, leather/Bois, cuir, 51,5 × 107 cm

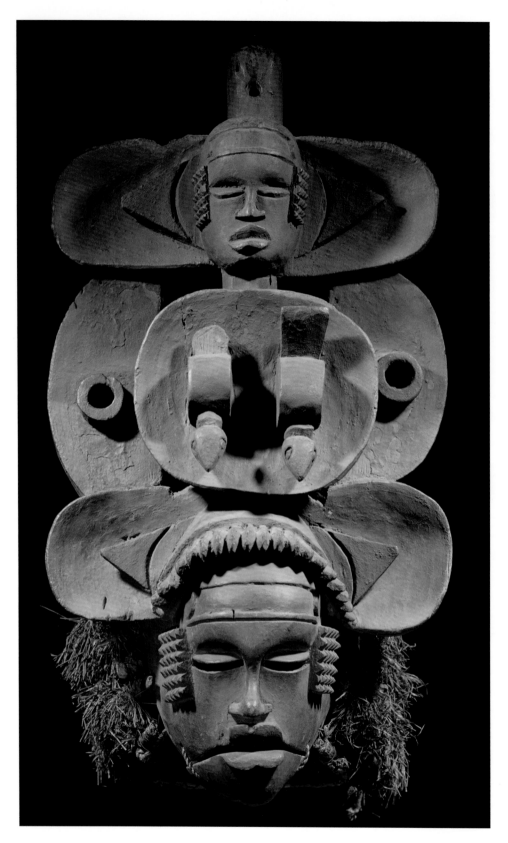

Ibibio

Mask with movable jaw

Masque avec mâchoire mobile

Maske mit beweglichem Kiefer

Máscara con mandíbula móvil

Maschera con mascella mobile

Masker met beweegbare kaak

1922–24, Wood, leather/Bois, cuir, 63 cm

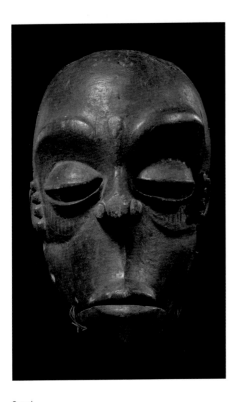

Ogoni

Mask
Masque
Maske
Máscara
Maschera
Masker

1918–25, Wood painted/Bois peint, 29 × 18 cm

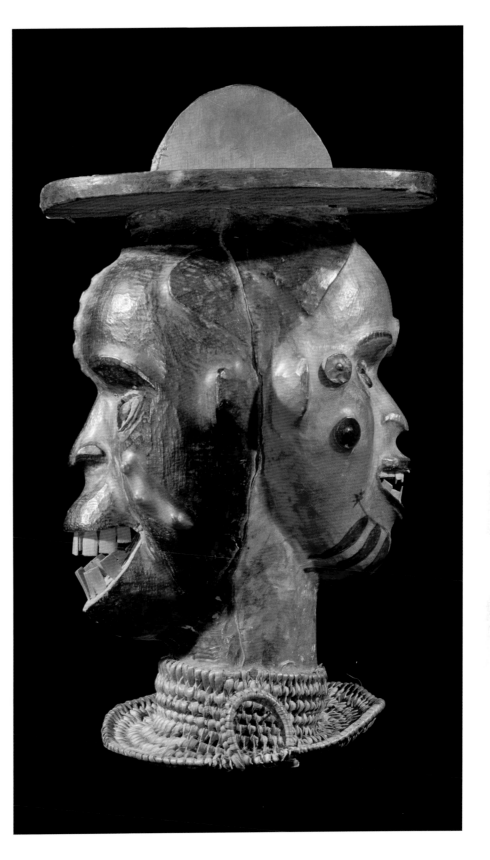

<div align="right">

Boki

Obi Bette (Ikom)

Dual face setting mask
Masque-coiffe à double visage
Doppelgesichtige Aufsatzmaske
Tocado de doble cara
Copricapo con due volti
Hoofdtooi met twee maskers

1925, Wood, leather/Bois, cuir, 33 cm

</div>

CAMEROUN
NIGERIA

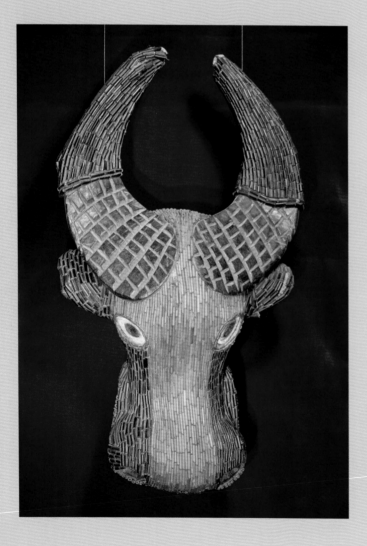

Bamileke

Buffalo mask

Masque de buffle

Büffelmaske

Máscara de búfalo

Maschera a forma di bufalo

Buffelmasker

1914–17, wood, glass pearls/Bois, perles de verre, 84 cm

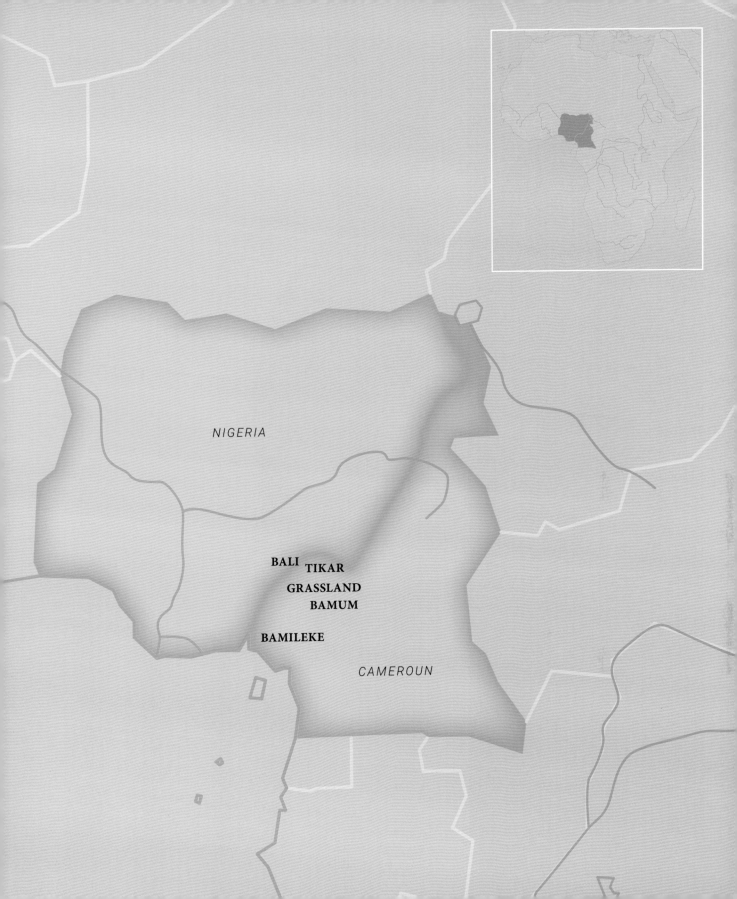

NIGERIA

BALI **TIKAR**
GRASSLAND
BAMUM

BAMILEKE

CAMEROUN

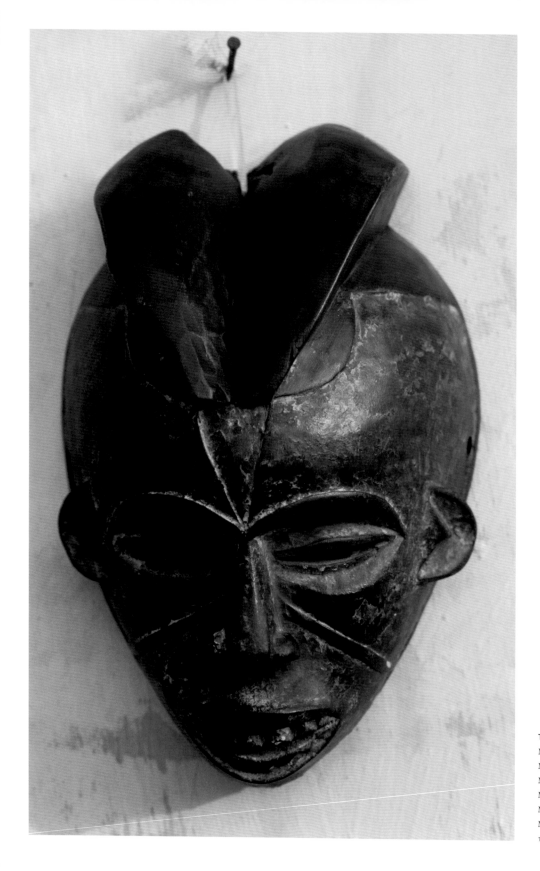

Tikar
Mask
Masque
Maske
Máscara
Maschera
Masker
1915, Wood/Bois

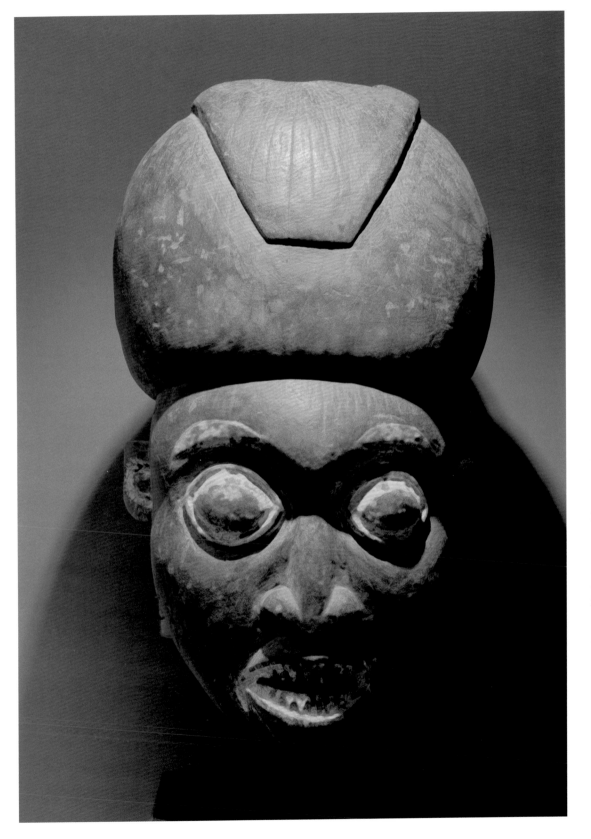

Grassland

Helmet mask

Masque casque

Helmmaske

Máscara-casco

Maschera ad elmo

Gehelmd masker

1914–18, Wood painted/
Bois peint, 50 cm

153

The Tikar of the Cameroon savannah organised themselves in chiefdoms. Various societies were called Tikar, no matter their language. The savannah was partially French and partially British. "Tribe" was an important category of colonial administration. This simplified the political organisation too much and historic dimensions and their respective dynamics were neglected. Although scientists already were present in the beginning of the 20th century, only a few historical facts are known of the Tikar. Any relation and link of today's politicians to the Tikar result in prestige due to history and tradition.

Les Tikar du Grassland au Cameroun étaient organisés en chefferies. De nombreuses sociétés ont été appelées Tikar sans que leur langue soit prise en compte. Le Grassland était une colonie en partie britannique et en partie française. La « tribu » était une catégorie importante de l'administration coloniale. À cause de cette simplification outrancière de l'organisation politique, la dimension historique et sa dynamique ont été totalement négligées. Bien que des chercheurs aient séjourné ici dès le début du 20ᵉ siècle, nous n'avons encore aujourd'hui que très peu d'éléments sur l'histoire des Tikar. Le lien actuel des politiciens locaux avec les origines Tikar correspond au prestige résultant de l'histoire et de la tradition.

Die Tikar des Kameruner Graslandes organisierten sich in Häuptlingstümern. Als Tikar wurde eine Vielzahl von Gesellschaften bezeichnet, ungeachtet ihrer Sprache. Das Grasland war teils britische, teils französische Kolonie. „Stamm" war eine wichtige Kategorie kolonialer Verwaltung. Damit wird die politische Organisation allerdings zu sehr vereinfacht und die historische Dimension und ihre Dynamiken vernachlässigt. Obwohl sich hier bereits Anfang des 20. Jahrhunderts Forscher aufhielten, sind bis heute nur wenige historische Fakten über die Tikar bekannt. Heutige Bezüge lokaler Politiker auf Tikar-Ursprünge versprechen Prestige durch Geschichte und Tradition.

Los Tikar de la meseta alta occidental de Camerún se organizaban alrededor de jefes. Se describía como Tikar a una multitud de sociedades, sin tener en cuenta su lengua. La meseta era en parte colonia británica, y en parte francesa. La "tribu" era una categoría importante para la administración de la colonia. También así se simplifica notablemente la organización política y se ignoraba la dimensión histórica y sus dinámicas. A pesar de que se realizaron investigadores en esta zona desde principios del XX, aún a día de hoy tenemos muy pocos datos históricos sobre los Tikar. Las alusiones actuales de políticos locales a sus orígenes Tikar, otorgan prestigio a través de la historia y la tradición.

L'etnia dei Tikar delle praterie del Camerun è organizzata in territori governati da un capotribù. Con il nome Tikar si identificano diversi gruppi etnici, indipendentemente dalla loro lingua. La prateria era una colonia in parte inglese e in parte francese, nella quale la "tribù" era un'importante categoria amministrativa coloniale. Tuttavia, si tratta di un'estrema semplificazione dell'organizzazione politica, che ne trascura la dimensione storica e le relative dinamiche. Anche se i ricercatori si installarono in questa regione già all'inizio del XX secolo, sono pochi i dati storici che si conoscono ancora oggi sui Tikar. Eventuali collegamenti con i Tikar dei politici locali attuali sono fonte di grande prestigio in virtù della loro storia e tradizione.

De Tikar van de Kameroense savanne organiseerden zich in dorpsgroepen onder één stamhoofd. Een groot aantal gemeenschappen werd ongeacht hun taal als Tikar aangeduid. De savanne was deels Brits en deels Frans gebied, waar het woord 'stam' als een belangrijke categorie van het koloniale bestuur werd gebruikt. Daarmee werden deze politieke organisaties zeer beperkt opgevat en werden hun historische dimensie en hun dynamiek genegeerd. Hoewel onderzoekers hier al vanaf het begin van de twintigste eeuw werkzaam zijn geweest, zijn er tot op heden nog maar weinig historische feiten over de Tikar bekend. Ook tegenwoordig nog beroepen plaatselijke politici zich op hun Tikar-afkomst om zich te associëren met prestige en tradities.

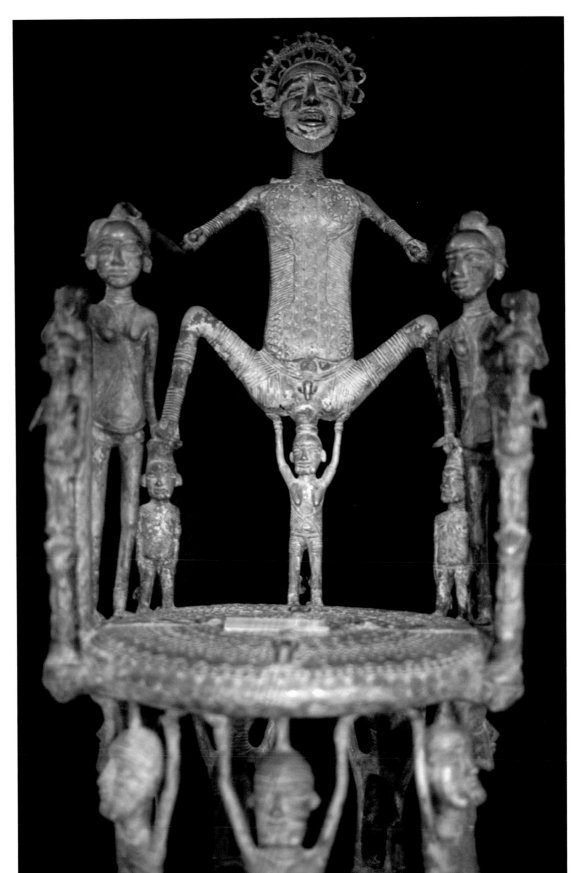

Tikar

King's throne with figurines

Trône avec représentations
figuratives

Königsthron mit figürlichen
Darstellungen

Trono real con
representaciones figurativas

Trono reale con
rappresentazioni figurative

Koningstroon met figuren

1925–26

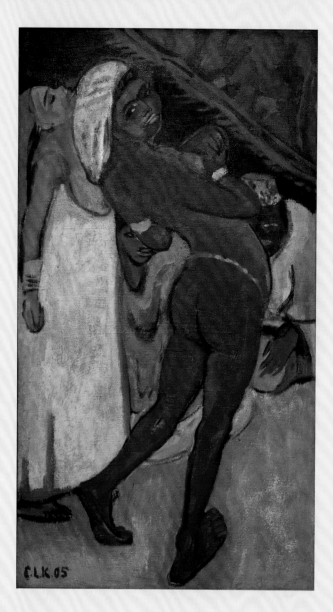

Ernst Ludwig Kirchner

Negro dancer

La danseuse nègre

Die Negertänzerin

La bailarina negra

Il ballerino di colore

De negerdanseres

1914–17, oil on canvas/Huile
sur toile, 170 × 94 cm

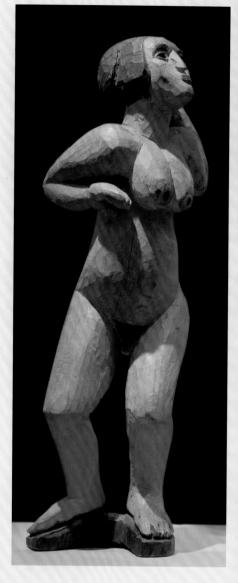

Ernst Ludwig Kirchner

Dancing woman

Femme dansant

Tanzende

Bailando

Donna danzante

Danseres

1918, wood painted/Bois peint,
87 × 35,5 × 27,5 cm,
Stedelijk Museum, Amsterdam

Inspiration

At least since the 15th century Europeans have appreciated African art culture. Albrecht Dürer reportedly bought ivory carvings. During the slave trade and the colonial empires this connection was forgotten; neo-classical artists were able to "rediscover African Art". However, all pieces from overseas were categorised as "art nègre". The artists were fascinated by the differentness, the seemingly archaic roughness and supposed distance from nature. In their own pieces they tried to convert the seen. They liked to show naked women.

Inspiration

Les Européens apprécient la création artistique africaine depuis le 15e siècle au moins. Albrecht Dürer aurait possédé des sculptures en ivoire. À l'époque de la traite des esclaves et des empires coloniaux, ce lien s'est distendu ; ce sont les artistes de la modernité classique qui ont redécouvert « l'art africain ». Cependant, les œuvres venant d'Afrique étaient qualifiées dans leur ensemble « d'art nègre ». Les artistes étaient fascinés par l'originalité, la rudesse archaïque apparente et la distance supposée avec la nature. Ils essayèrent d'intégrer ce qu'ils voyaient à leurs propres œuvres, et donc de représenter des femmes nues.

Inspiration

Mindestens seit dem 15. Jahrhundert schätzten Europäer afrikanisches Kunstschaffen. Albrecht Dürer etwa soll Elfenbeinschnitzereien erworben haben. Während der Zeit des Sklavenhandels und der Kolonialreiche geriet diese Verbindung in Vergessenheit; so konnten die Künstler der klassischen Moderne „afrikanische Kunst" neu „entdecken". Allerdings galten sämtliche Werke aus Übersee als „art nègre". Die Künstler waren fasziniert von der Andersartigkeit, der scheinbar archaischen Rohheit und angeblichen Naturferne. In ihren eigenen Werken versuchten sie, das Gesehene umzusetzen. Dabei zeigten sie gerne nackte Frauen.

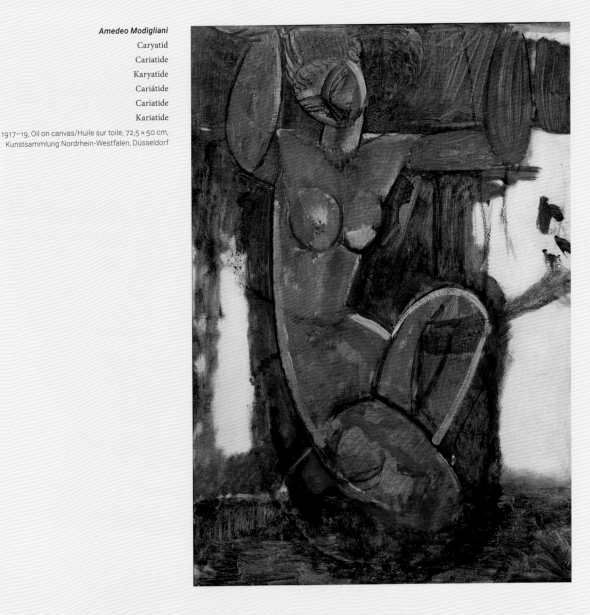

Amedeo Modigliani
Caryatid
Cariatide
Karyatide
Cariátide
Cariatide
Kariatide

1917–19, Oil on canvas/Huile sur toile, 72,5 × 50 cm,
Kunstsammlung Nordrhein-Westfalen, Düsseldorf

Inspiración

Al menos desde el siglo XV, los europeos aprecian la producción artística africana. Durero, por ejemplo, habría adquirido esculturas de marfil. Durante la época del comercio con esclavos y los imperios coloniales, esta relación cayó en olvido. Así, los artistas de las vanguardias pudieron "redescubrir" el "arte africano", si bien todas las obras llegadas de ultramar se consideraban "art nègre". Los artistas estaban fascinados por lo diferente de las obras, su crudeza aparentemente arcaica y una presunta falta de naturalidad. Intentaron, en sus propias obras, copiar lo observado, con una clara predilección por las mujeres desnudas.

Ispirazione

Gli europei iniziarono ad apprezzare la produzione artistica africana almeno a partire dal XV secolo. Si dice che Albrecht Dürer avesse acquisito sculture in avorio. Durante il periodo della tratta degli schiavi e degli imperi coloniali, però, questa relazione venne dimenticata, per cui gli artisti del modernismo classico "scoprirono" nuovamente quella che prese il nome di "arte africana". Tuttavia, tutte le opere provenienti dal continente africano venivano considerate "art nègre". Gli artisti erano affascinati dall'originalità, dall'apparentemente arcaica selvatichezza e dal presunto distacco dalla natura. Cercavano di riprodurre nelle loro opere ciò che avevano visto, e rappresentavano volentieri nudi femminili.

Inspiratie

Al sinds de vijftiende eeuw, en vermoedelijk nog eerder, waardeerden de Europeanen kunstschatten uit Afrika. Zo zou Albrecht Dürer ivoorsnijwerk hebben gekocht. In de tijd van de slavenhandel en het kolonialisme raakte deze band in vergetelheid, waarna de kunstenaars van het klassiek modernisme de 'Afrikaanse kunst' opnieuw 'ontdekten'. Overigens werd álle kunst van overzee in die tijd als *art nègre* ('negerkunst') aangeduid. De Europese kunstenaars waren gefascineerd door de andersoortige en schijnbaar archaïsche primitiviteit en verbondenheid met de natuur van deze objecten. In hun eigen werk probeerden ze deze indrukken te verwerken, waarbij ze graag naakte vrouwen uitbeeldden.

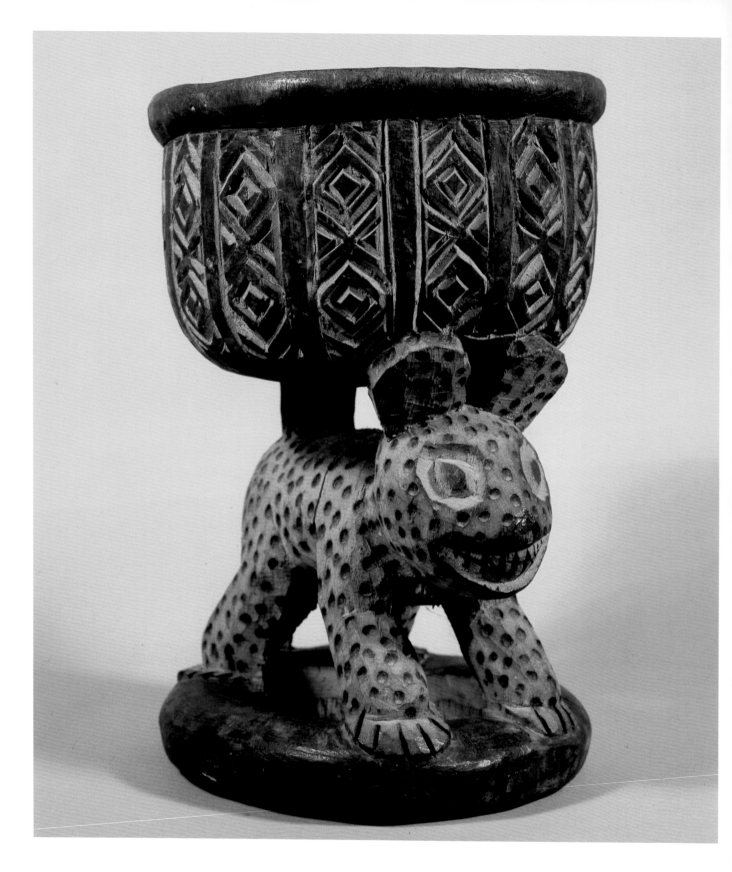

The Central Sudan region is shaped by a large artistic unity, as can be seen in the mask culture of secret societies. In these political organisations, the leaders of a society connect with each other. Masks are worn during various ceremonies, rituals or funerals and given as gifts during special occasions. Since artists change their working range at times, experts do often have problems dating and allocating masks in their respective periods.

La région du Soudan central se caractérise par une grande unité artistique, ainsi qu'on peut l'oberver avec la culture du masque des sociétés secrètes. Dans ces organisations politiques, les dirigeants d'une communauté s'associent les uns aux autres. Les masques sont portés au cours de diverses cérémonies, rituels ou funérailles, et sont offerts lors d'occasions particulières. Comme les artistes changeaient parfois de domaine d'activité, les experts ont souvent des problèmes de datation et d'affectation des masques à leurs périodes respectives.

Die Region Zentralsudan ist durch eine große künstlerische Einheit geprägt, wie am Maskenwesen der Geheimbünde zu erkennen. In diesen politischen Organisationen schließen sich die Führungspersonen einer Gemeinschaft zusammen. Masken werden bei unterschiedlichen Zeremonien, Ritualen oder Begräbnissen getragen und bei besonderen Gelegenheiten untereinander verschenkt. Da auch die Künstler gelegentlich ihren Wirkungskreis wechseln, haben die Experten häufig Schwierigkeiten bei der genauen Datierung und Zuordnung der Masken.

La región de Sudán central se caracteriza por una gran unidad artística, como puede observarse en las máscaras de sus sociedades secretas. En estas organizaciones políticas se congregaban los líderes de una sociedad. Las máscaras se visten en diversas ceremonias, rituales o entierros y en ocasiones especiales se regalan entre los miembros. Dado que también los artistas cambian ocasionalmente su campo de acción, los expertos tienen a menudo problemas a la hora de datar y catalogar estas máscaras.

La regione del Sudan centrale è caratterizzata da una grande unità artistica, come si può vedere dalle maschere delle società segrete, organizzazioni politiche in cui si riunivano i leader di una comunità. Le maschere venivano indossate in varie cerimonie, rituali o funerali e regalate in occasioni speciali. Poiché anche gli artisti cambiavano di tanto in tanto la loro sfera di attività, gli esperti incontrano spesso difficoltà nella datazione e l'attribuzione precisa delle maschere.

De cultuur- en taalregio Centraal-Soedan wordt gekenmerkt door een grote artistieke homogeniteit, zoals aan de maskerwezens van geheime genootschappen is te herkennen. In deze politieke organisaties sluiten de leidende figuren van een gemeenschap zich aaneen. De maskers worden bij verschillende ceremoniën, rituelen en begrafenissen gedragen en bij bijzondere gelegenheden als geschenken uitgewisseld. Omdat de kunstenaars vaak op verschillende plekken werkzaam waren, hebben experts moeite om de maskers nauwkeurig te dateren en toe te schrijven.

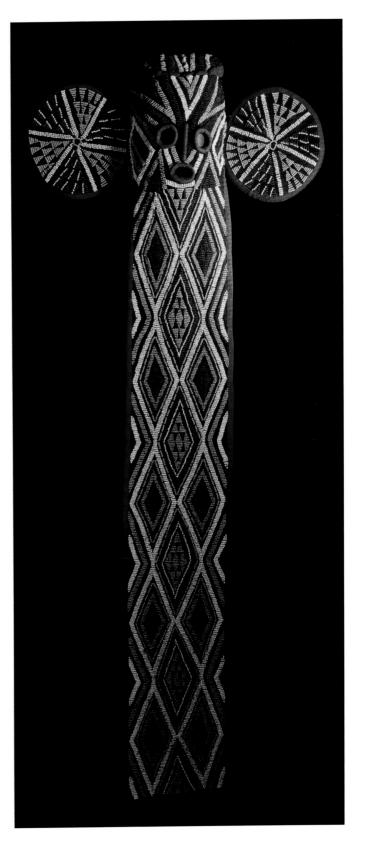

Grassland

Leopard with dish

Léopard avec bol pour la nourriture

Leopard mit Speiseschale

Leopardo con fuente de comida

Leopardo con ciotola per cibo

Luipaard met eetkom

1914–18, Wood/Bois, 26,5 cm

Bamileke

Elephant mask

Masque éléphant

Elefantenmaske

Máscara de elefante

Maschera a forma di elefante

Olifantsmasker

1914–18, Cloth, plant fibres, glass pearls/Tissu, fibres végétales, perles de verre, 137 cm

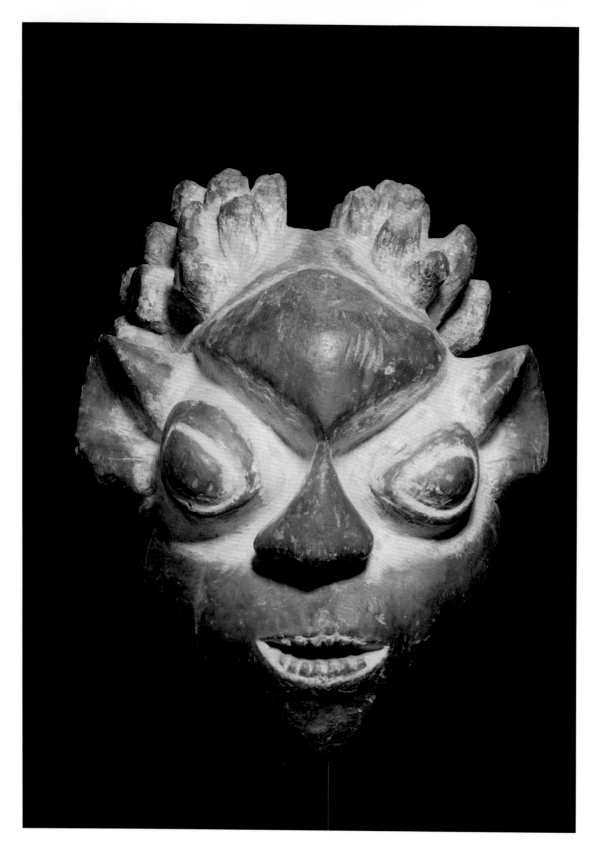

Bamileke

Mask

Masque

Maske

Máscara

Maschera

Masker

1914–18, Wood painted/
Bois peint, 26,2 cm

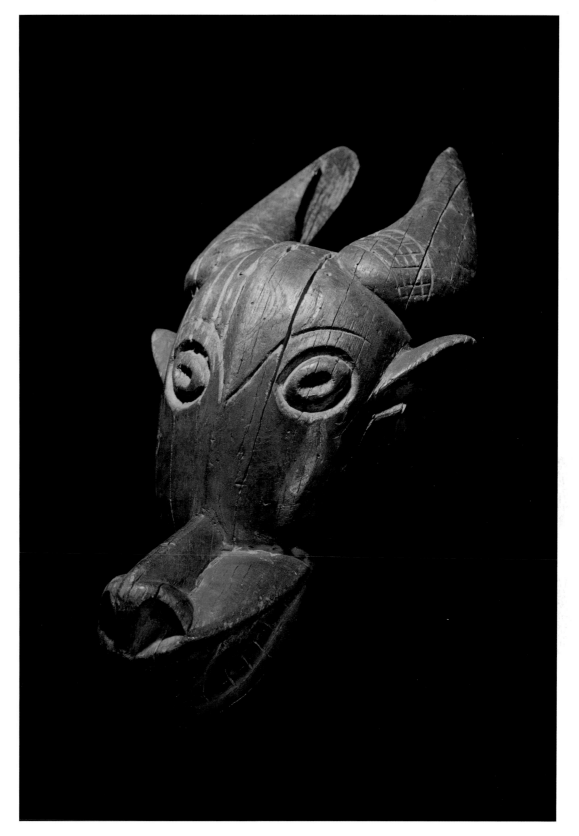

Bamileke
Mask
Masque
Maske
Máscara
Maschera
Masker
1914–17, Wood/Bois, 52 cm

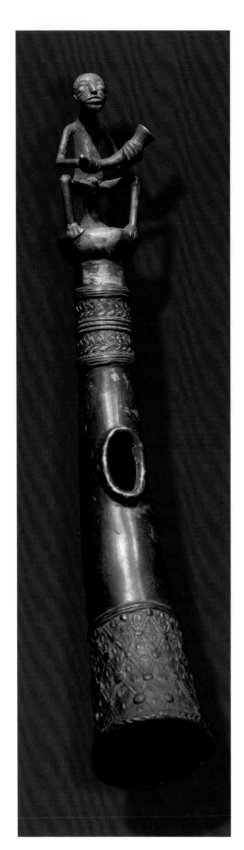

Bamileke

Horn with figurine
holding a horn

Corne avec personnage
tenant une corne

Horn mit Figur, die
ein Horn hält

Cuerno con figura
sosteniendo un cuerno

Corno con figura con
in mano un corno

Hoorn met figuur die
hoorn vasthoudt

1914–17, Bronze, 36 cm

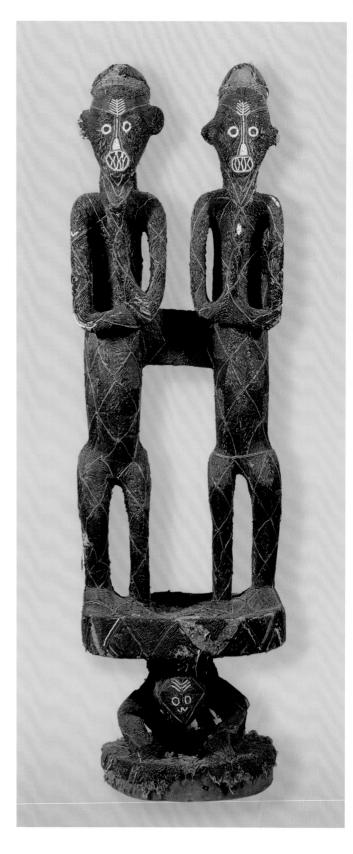

Bamileke

King's throne

Trône royal

Königsthron

Trono real

Trono reale

Koningstroon

1914–18, Wood, glass pearls/
Bois, perles de verre, 190 cm

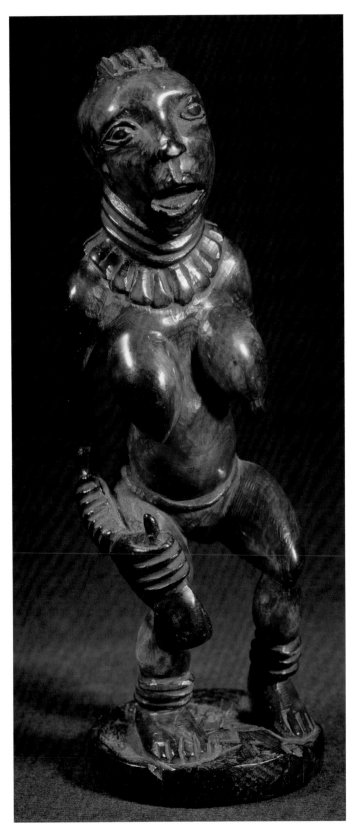

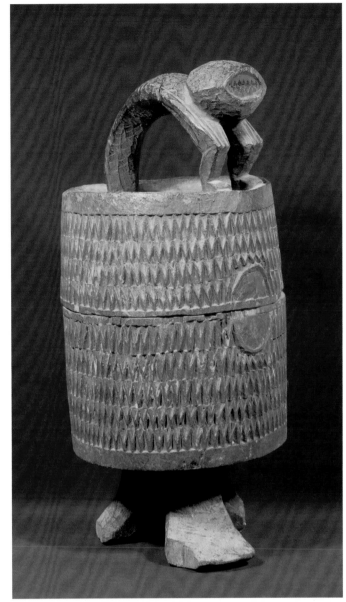

Bamileke

Tobacco pot

Pot à tabac

Tabaktopf

Recipiente de tabaco

Vaso per tabacco

Tabakspot

1915–26, Wood/Bois, 56 cm,, Museé du quai Branly, Paris

Bamileke

Standing female figurine

Figurine féminine debout

Stehende weibliche Figur

Figura de mujer

Figura femminile in posizione eretta

Staande vrouwenfiguur

1914–17, Wood/Bois

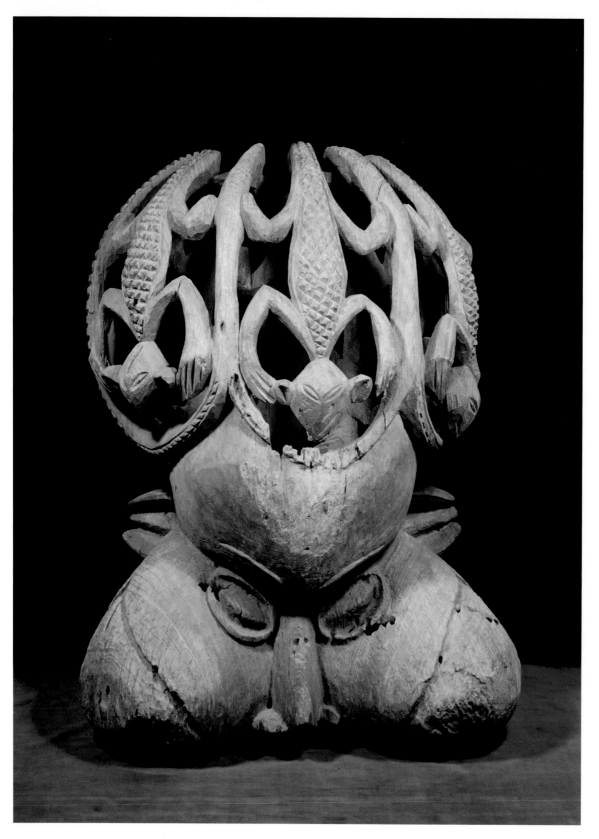

Bamileke

Royal mask of a society

Masque royal d'une société

Königliche Maske
eines Bundes

Máscara real de
una sociedad

Maschera reale di
una società

Koningsmasker van
een verbond

1915–26, Wood/Bois,
87,5 × 69,5 × 53,5 cm

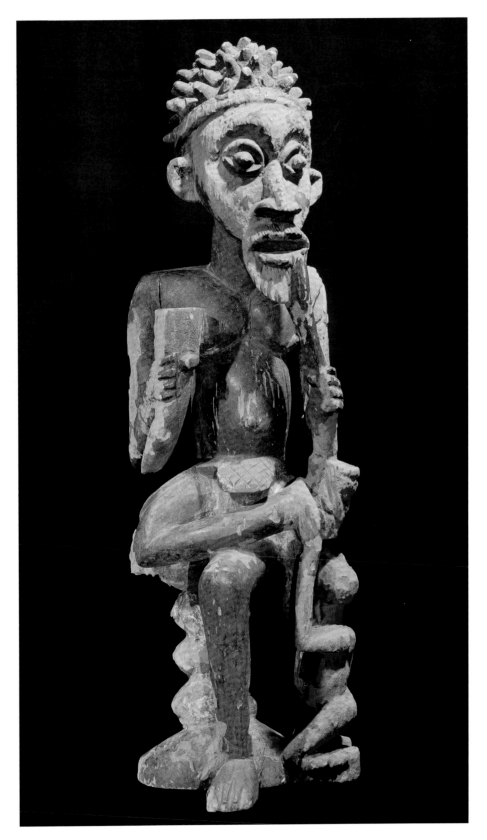

Bamileke
Ancestry figurine
Figurine d'ancêtre
Ahnenfigur
Figura de antepasado
Figura di antenato
Voorouderfiguur
1918–24, Wood patinised/Bois patiné, 85 cm

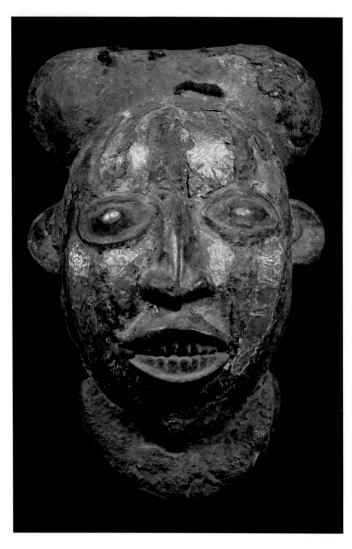

Bamum

Royal head

Tête royale

Königlicher Kopf

Cabeza real

Testa reale

Koningskop

1916–19, Wood painted, copper/ Bois peint, cuivre, 41 cm

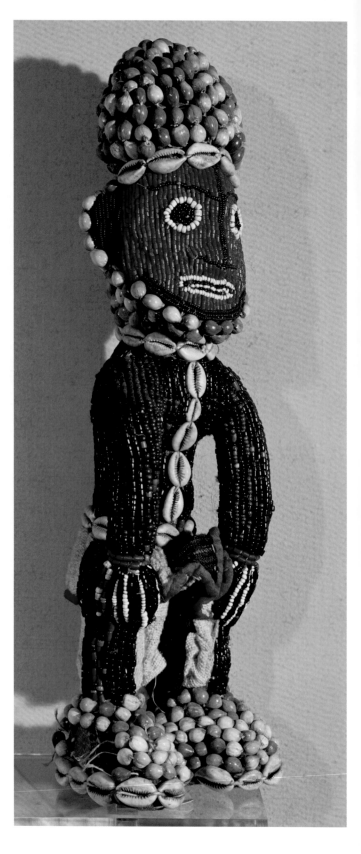

Bamileke

Standing male figurine

Personnage masculin debout

Stehende männliche Figur

Figura de mujer

Figura maschile in posizione eretta

Staande mannenfiguur

1915–26, Clamshells/Moules

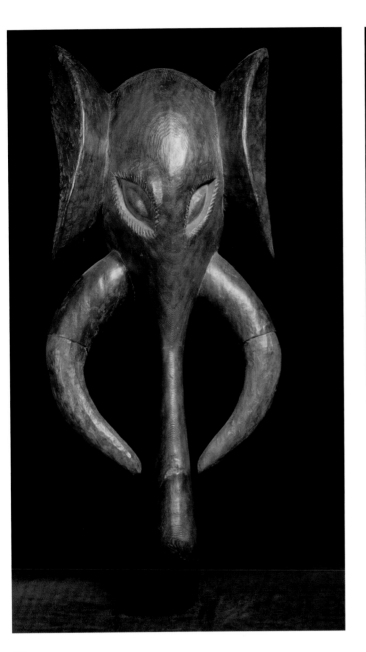

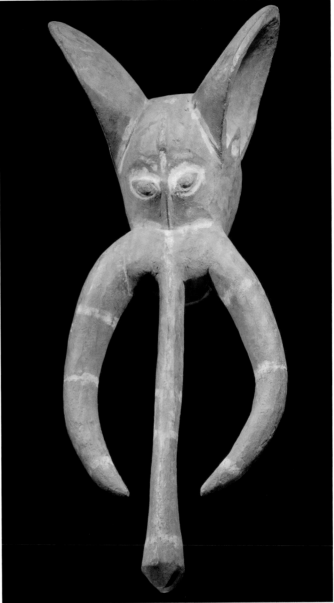

Bali

Elephant mask

Masque éléphant

Elefantenmaske

Máscara de elefante

Maschera a forma di elefante

Olifantsmasker

c. 1916, Wood /Bois , 71,5 cm

Bali

Elephant mask

Masque éléphant

Elefantenmaske

Máscara de elefante

Maschera a forma di elefante

Olifantsma

Wood patinised, painted/Bois patiné, peint, 97 cm

Kunduchi, Tanzania

Islamic grave with Chinese porcelain dishes (Ming dynasty)

Tombe islamique avec bols en porcelaine chinoise (dynastie Ming)

Islamisches Grabmal mit chinesischen Porzellanschalen (Ming-Dynastie)

Lápida islámica con cuencos de porcelana china (dinastía Ming)

Tomba islamica con ciotole di porcellana cinese (dinastia Ming)

Islamitisch grafmonument met schalen van Chinees porselein (Ming-dynastie)

1916–19

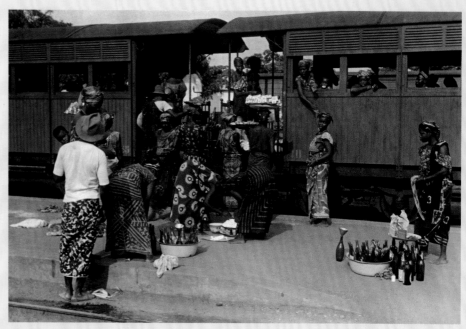

Thiaroye Station in Dakar, Senegal

À la gare de Thiaroye à Dakar (Sénégal)

Auf dem Bahnhof Thiaroye in Dakar, Senegal

En la estación Thiaroye en Dakar, Senegal

Alla stazione Thiaroye di Dakar, Senegal

Op het Thiaroye-station in Dakar, Senegal

1916–19

Exhibition in Limpopo, South Africa

Exposition à Limpopo (Afrique du Sud)

Ausstellung in Limpopo (Südafrika)

Exposición en Limpopo (Sudáfrica)

Mostra a Limpopo (Sudafrica)

Tentoonstelling in Limpopo (Zuid-Afrika)

2008

Passages

A rich exchange between Asia, Europe and Africa was present during Silk Road times in the early middle ages. Many Europeans travelled to Africa to explore all areas of the continent in the 18th and 19th century. These expeditions, which also served political functions, lead to the beginning of ethnology. Artistry of the population and its artefacts were not the focus of research. Merchants and scientists had versatile travel paths. They used traditional trade routes, but also new paths: railroads were built, some of which are still in operation today.

Passages

À l'époque de la Route de la soie, au début du Moyen-Âge, il y avait déjà d'importants échanges entre l'Asie, l'Afrique et l'Europe. Aux 18e et 19e siècles, de nombreux Européens se rendaient en Afrique pour explorer toutes les régions du continent. Ces expéditions, qui avaient également des objectifs politiques, sont à l'origine de l'ethnologie. La création artistique de la population et les œuvres d'art furent longtemps ignorées par la recherche. Marchands et scientifiques avaient des itinéraires très variés. Ils empruntaient les routes commerciales traditionnelles, mais aussi de nouvelles voies. On construisit des lignes de chemin de fer qui sont encore en partie en activité aujourd'hui.

Passagen

Schon in Zeiten der Seidenstraße in frühmittelalterlicher Zeit fand ein reger Austausch zwischen Asien, Afrika und Europa statt. Im 18. und 19. Jahrhundert reisten viele Europäer nach Afrika, um den Kontinent auf allen Gebieten zu erforschen. Aus diesen Expeditionen, die genauso machtpolitischen Zwecken dienten, entwickelte sich die Völkerkunde. Das künstlerische Schaffen der Bevölkerung und die Kunstwerke standen lange Zeit nicht im Fokus der Forschung. Die Reisewege der Händler und Forscher waren dabei vielfältig. Sie nutzten traditionelle Handelsrouten, aber auch neue Wege: Man errichtete Eisenbahnstrecken, die zum Teil heute noch in Betrieb sind.

Pasajes

Ya en tiempos de la ruta de la seda, en la temprana
Edad Media, existía un intercambio activo entre Asia,
África y Europa. En los siglos XVIII y XIX, muchos
europeos viajaron a África para investigar el continente
en todas sus áreas. De estas expediciones, que servían
igualmente a objetivos del poder político, se desarrolló
la etnología. La creación artística de los pueblos y las
obras de arte no constituyeron, durante largo tiempo,
el centro de interés de la investigación. Sin embargo,
los caminos de los comerciantes e investigadores
eran muy variados. Emplearon rutas comerciales
tradicionales, pero también nuevos caminos: se
construyeron vías férreas que siguen parcialmente
activas en la actualidad.

Passaggi

Già al tempo della Via della Seta, nell'Alto Medioevo,
aveva luogo un vivace scambio tra Asia, Africa ed
Europa. Nel XVIII e XIX secolo molti europei si recarono
in Africa con l'idea di esplorarne tutte le regioni. Da
queste spedizioni, che avevano altresì scopi politici,
nacque l'etnologia. La creazione artistica autoctona
e le opere d'arte non furono però per lungo tempo al
centro della ricerca. Gli itinerari dei commercianti e
dei ricercatori variavano molto: seguivano spesso le
rotte commerciali tradizionali, ma a volte prendevano
nuove vie. Fu in questo periodo che vennero costruite le
ferrovie, parte delle quali è ancora in funzione.

Routes

Al in tijden van de zijderoute in de vroege
Middeleeuwen vond een levendige uitwisseling plaats
tussen Azië, Afrika en Europa. In de achttiende en
negentiende eeuw reisden veel Europeanen naar
Afrika om het continent op alle mogelijke gebieden
te onderzoeken. Uit deze expedities, die evenzeer uit
machtspolitieke overwegingen werden ondernomen,
ontwikkelde zich de volkenkunde. Maar lange
tijd stonden daarbij de artistieke creaties van de
bevolking en de kunstwerken niet in het middelpunt
van de belangstelling. Handelaren en onderzoekers
kozen een groot aantal verschillende routes, niet
alleen traditionele handelswegen maar ook nieuwe
verbindingen: er werden spoorwegen aangelegd die
deels ook vandaag de dag nog in gebruik zijn.

CAMEROUN
CENTRAFRIQUE
CONGO
GABON

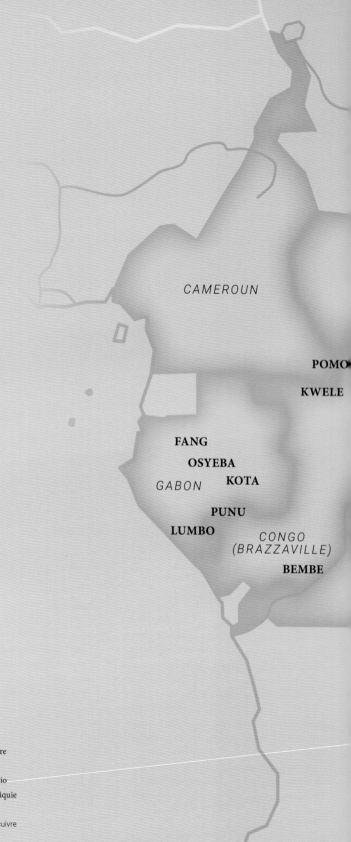

CAMEROUN

POMO

KWELE

FANG

OSYEBA

GABON KOTA

PUNU

LUMBO CONGO
(BRAZZAVILLE)

BEMBE

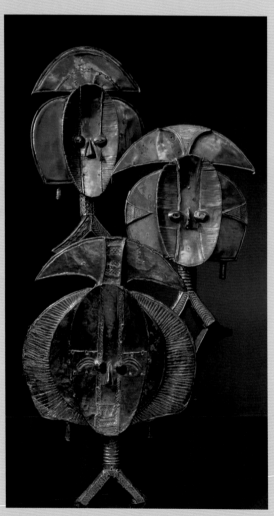

Kota

Reliquary guard

Gardien de reliquaire

Reliquarwächter

Guardián de relicario

Guardiano delle reliquie

Reliekwachter

Wood, copper/Bois, cuivre

CENTRAFRIQUE

AZANDE

MBOLE

CONGO
(KINSHASA)

LEGA

BEMBE

Osyeba

Reliquary guard

Gardien du reliquaire

Reliquarwächter

Guardián de relicario

Guardiano delle reliquie

Reliekwac

Wood, copper/Bois, cuivre, 64 cm

Osyeba
Reliquary guard
Gardien du reliquaire
Reliquiarwächter
Guardián de relicario
Guardiano delle reliquie
Reliekwachter
1920, Wood, copper/Bois, cuivre, 35 cm

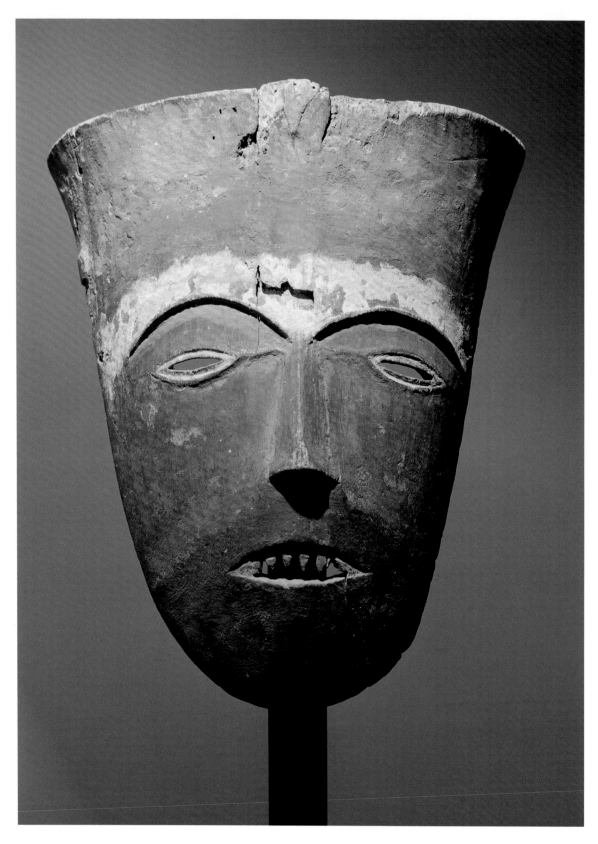

Pomo

Mask

Masque

Maske

Máscara

Maschera

Masker

1920, Wood painted/
Bois peint, 23,8 cm

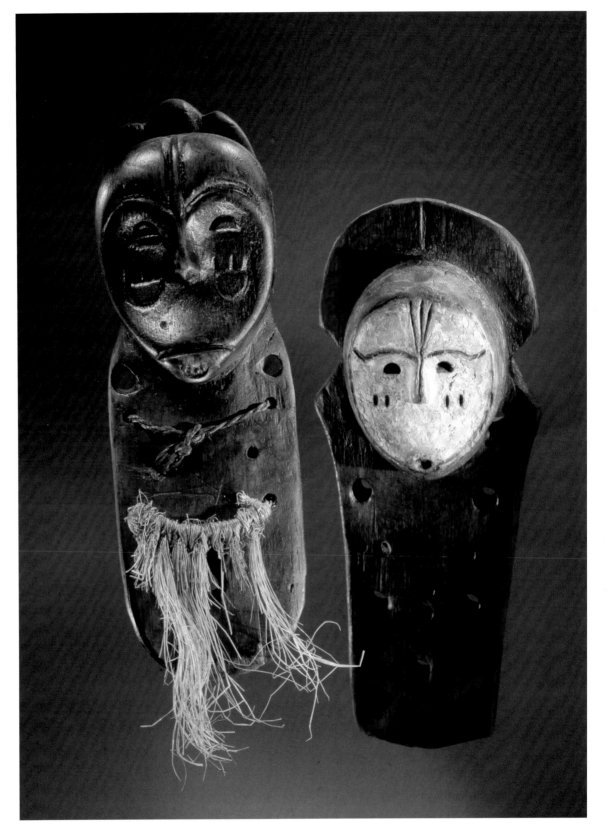

Fang
Small mask
Petit masque
Kleine Masken
Pequeñas máscaras
Piccole maschere
Kleine maskers
1908, Wood/Bois

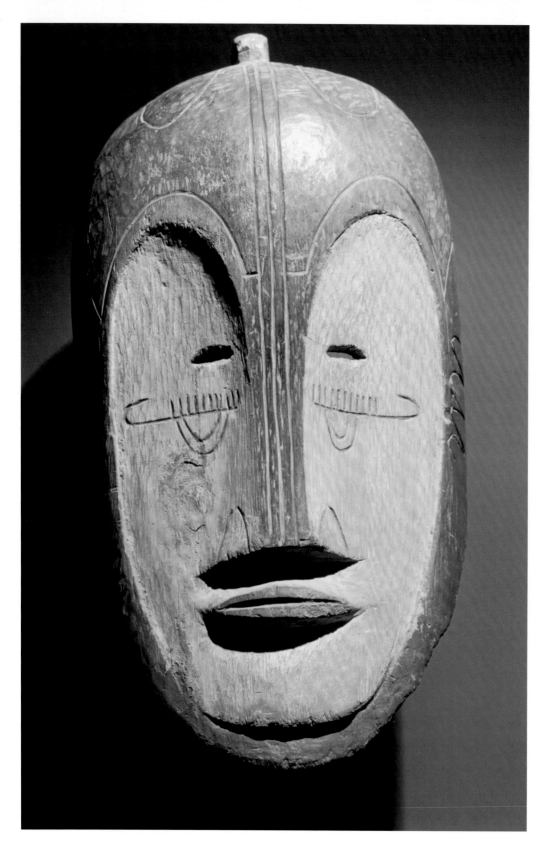

Fang

Mask

Masque

Maske

Máscara

Maschera

Masker

1901, Wood painted/Bois peint, 44 cm

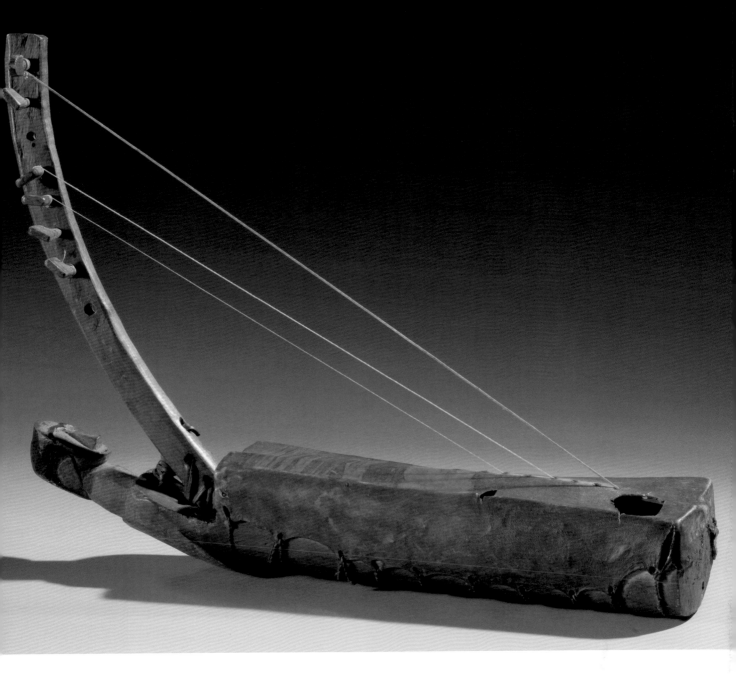

Fang

Ngombi (harp)

Ngombi (harpe arquée)

Ngombi (Bogenharfe)

Ngombi (arpa de arco)

Ngombi (arpa ad arco)

Ngombi (boogharp)

c. 1880, Wood, leather, strings/Bois, cuir, cordes, 70 × 11 cm

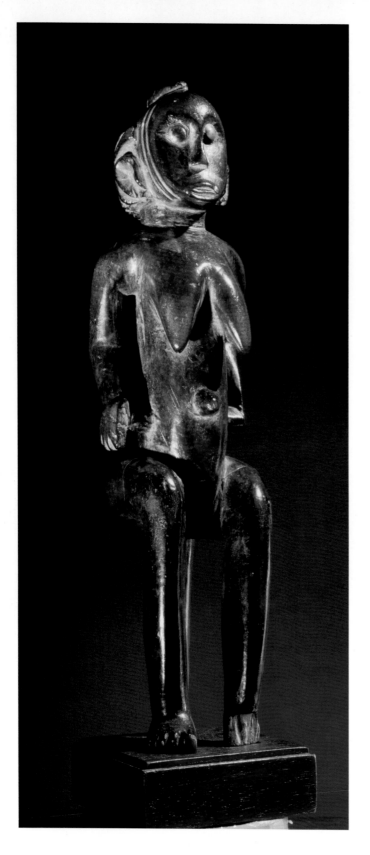

Fang

Reliquary guard

Gardien de reliquaire

Reliquiarwächter

Guardián de relicario

Guardiano delle reliquie

Reliekwachter

Wood/Bois

Punu

Fetish

Fétiche

Fetisch

Fetiche

Feticcio

Fetisj

Wood, plant fibres/Bois, fibres végétales, 36 cm

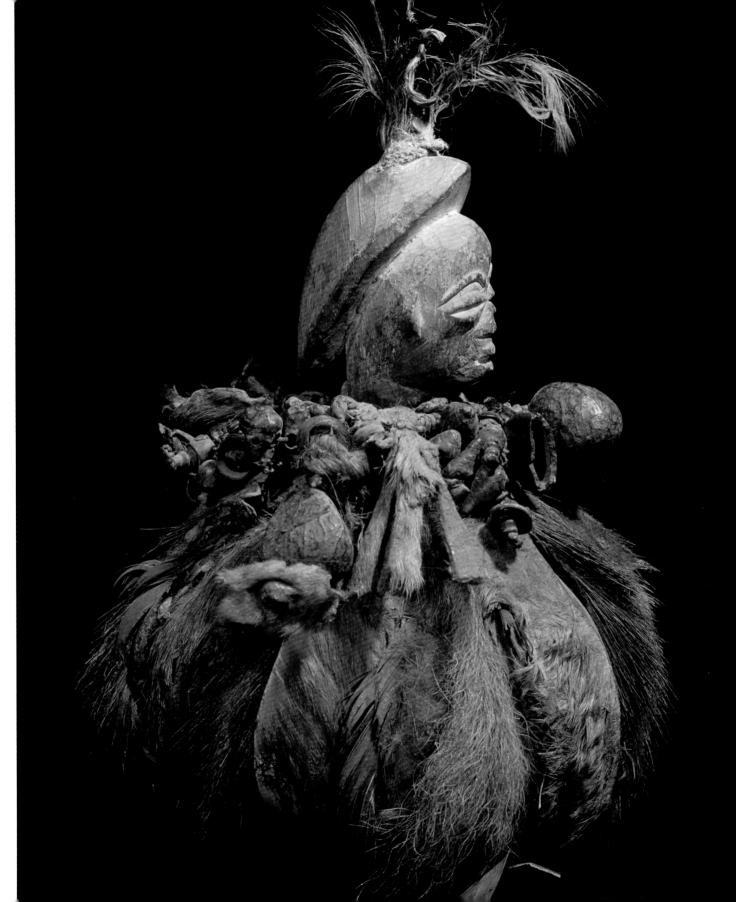

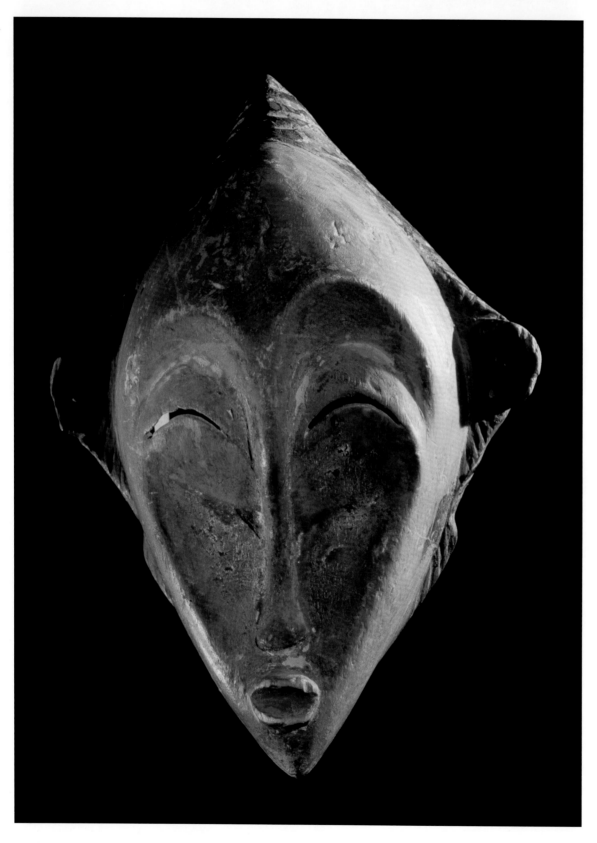

Punu

Dance mask for
funeral ceremonies

Masque de danse pour les
cérémonies funéraires

Tanzmaske für
Begräbniszeremonien

Máscara de baile para
ceremonias fúnebres

Maschera di danza
per funerali

Dansmasker voor
begrafenisrituelen

Wood/Bois, 27 cm

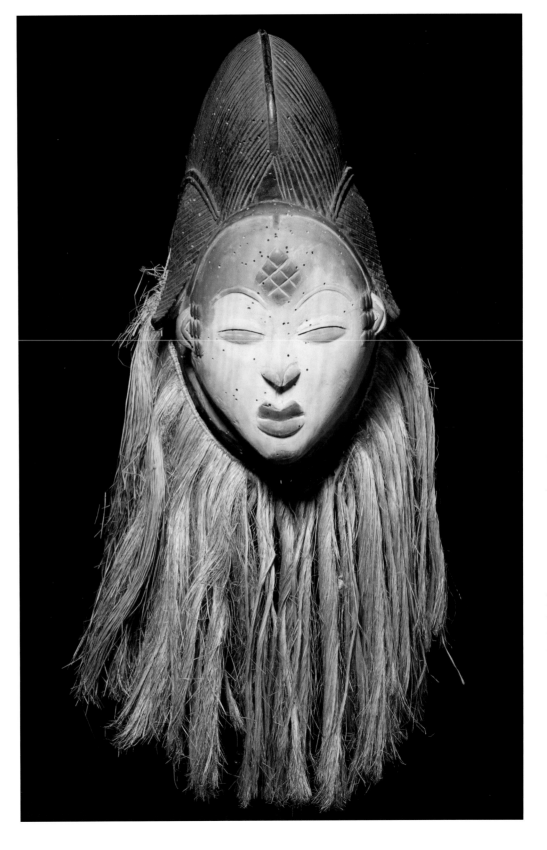

Punu

Mask

Masque

Maske

Máscara

Maschera

Masker

Wood painted, plant fibres/Bois
peint, fibres végétales, 29 cm

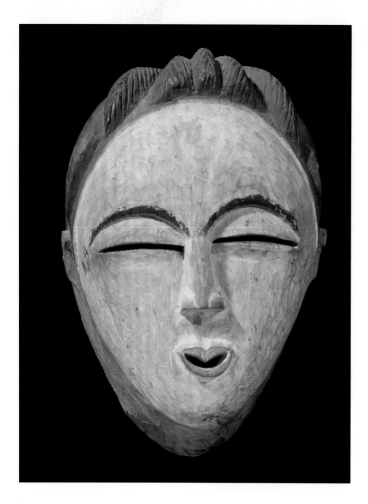

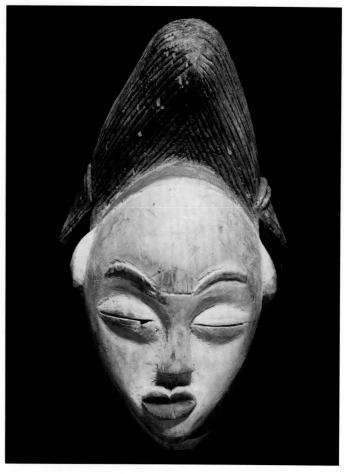

Punu

Mask

Masque

Maske

Máscara

Maschera

Masker

Wood painted/Bois peint, 29,5 cm

Punu

Mask

Masque

Maske

Máscara

Maschera

Masker

Wood painted/Bois peint, 20,5 cm

Only in the Ogooué River area, some cultures crafted white masks. The masks were stained with terra alba clay and presented a geometric scarification on the forehead. They represent the spirit of a beautiful, deceased girl. Due to the white stain and presentation of facial features they resemble the masks of the Japanese Noh theatre. Scientists have tried to prove their origin for some time. A resemblance may be purely coincidental. Since the masks are not used anymore, their origin remains unknown.

La région du fleuve Ogooué est la seule où certaines cultures fabriquaient des masques blancs. Les masques étaient teintés avec de l'argile blanche (ou kaolin) et portaient une scarification géométrique sur le front. Ils représentent l'esprit d'une belle jeune fille décédée. Avec cette couleur blanche et la représentation des traits du visage, ces masques ressemblent beaucoup à ceux du théâtre nô japonais. Les scientifiques ont longtemps essayé de prouver cette origine. Mais il se peut que cette similitude soit purement fortuite. Comme les masques ne sont plus utilisés, leur origine reste incertaine.

Allein im Bereich des Flusses Ogooué stellten einige Gesellschaften weiße Masken her. Die Masken wurden mit der Tonerde Kaolin gefärbt und tragen eine geometrische Skarifizierung auf der Stirn. Sie stellen den Geist eines verstorbenen, schönen Mädchens dar. Durch die weiße Farbe und die Darstellung der Gesichtszüge ähneln sie sehr den Masken des japanischen Nō-Theaters. Wissenschaftler versuchten lange Zeit, diese Herkunft zu beweisen. Eine Ähnlichkeit kann jedoch rein zufällig sein. Da die Masken nicht mehr aktiv verwendet werden, bleibt ihr Ursprung vorerst unklar.

Japan

Noh mask of a young women

Masque nô d'une jeune femme

Nō-Maske einer jungen Frau

Máscara nō de mujer joven

Maschera nō di una giovane donna

No-masker van jonge vrouw

Wood painted/Bois peint, 21,6 × 13,6 cm, National Museum, Tokyo

Japan

Noh mask of a young soldier

Masque nô d'un jeune soldat

Nō-Maske eines jungen Soldaten

Máscara nō de joven soldado

Maschera nō di un giovane soldato

No-masker van jonge soldaat

Wood painted/Bois peint, 20,3 × 14,2 cm, National Museum, Tokyo

Solo en la zona del río Ogowe, algunas sociedades crearon máscaras blancas. Las máscaras se pintaban con la arcilla caolín y tienen una escarificación en motivos geométricos en la frente. Representan el espíritu de una difunta, una bella muchacha. Por su color blanco y la forma de representar las facciones de la cara, recuerdan mucho a las máscaras del teatro nō japonés. Los investigadores intentan desde hace mucho tiempo demostrar esta procedencia. No obstante, el parecido puede ser pura coincidencia. Dado que las máscaras no se utilizan más de forma activa, de momento su origen continúa siendo desconocido.

Solo nella regione del fiume Ogooué alcune tribù fabbricavano maschere bianche, che venivano dipinte con caolino colorato e decorate con una scarificazione geometrica sulla fronte. Rappresentavano lo spirito di una bella fanciulla defunta. Il colore bianco e la raffigurazione dei tratti del viso le rendono molto simili alle maschere del teatro giapponese nō. I ricercatori hanno cercato per molto tempo di dimostrare questo legame, tuttavia la somiglianza potrebbe essere puramente casuale. Dal momento che le maschere non sono più utilizzate, la loro origine resta poco chiara.

In het stroomgebied van de rivier de Ogooué vervaardigden enkele gemeenschappen als enige ook blanke maskters. Deze werden beschilderd met kaolienaarde en tonen een geometrische littekenversiering op het voorhoofd, die de geest van een gestorven, mooi meisje symboliseert. Door hun witte kleur en weergave van de gelaatstrekken doen ze sterk denken aan de maskers van het Japanse no-theater. Wetenschappers hebben lange tijd geprobeerd een Japanse herkomst aan te tonen, omdat deze overeenkomsten niet toevallig konden zijn. Maar omdat de maskers niet meer actief worden gebruikt, is hun oorsprong vooralsnog onduidelijk.

Kota

Reliquary guard
Gardien de reliquaire
Reliquiarwächter
Guardián de relicario
Guardiano delle reliquie
Reliekwachter

Wood, brass/Bois, laiton

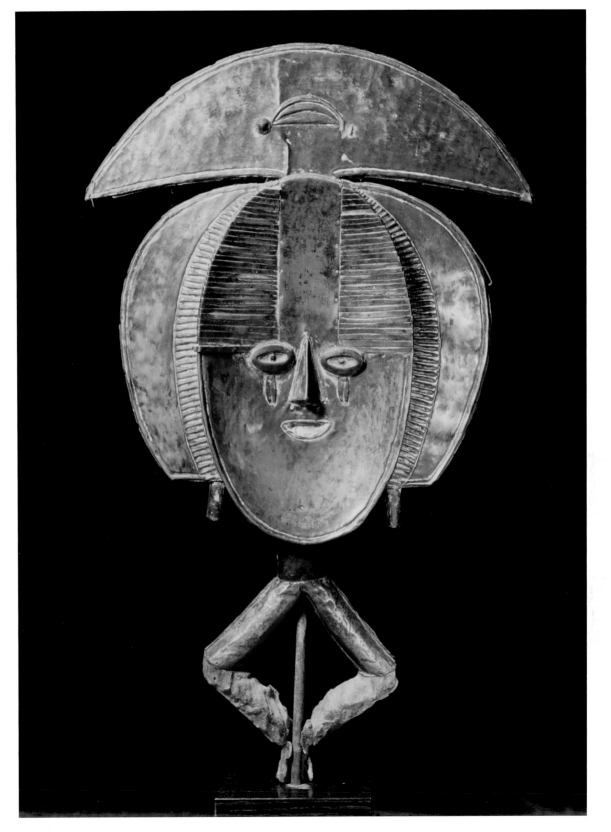

Kota

Dual-faced reliquary guard

Gardien de reliquaire
à deux visages

Doppelgesichtiger
Reliquiarwächter

Guardián de relicario
de dos caras

Guardiano delle
reliquie con due volti

Reliekwachter met
twee gezichten

Wood, brass/
Bois, laiton , 68,5 cm

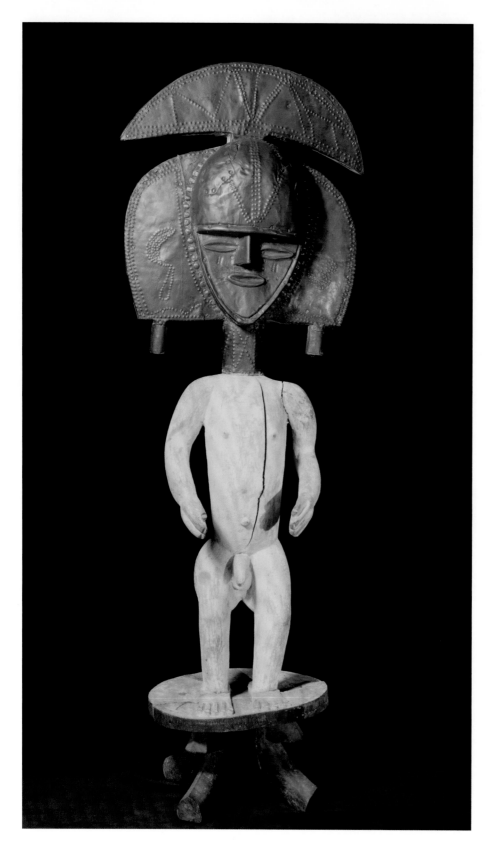

Kota

Reliquary figurine on seat

Reliquaire sur un tabouret

Reliquiarfigur auf Hocker

Figura de relicario sobre taburete

Figura di reliquiario su sgabello

Reliekfiguur op krukje

Wood, brass/Bois, laiton , 86 cm

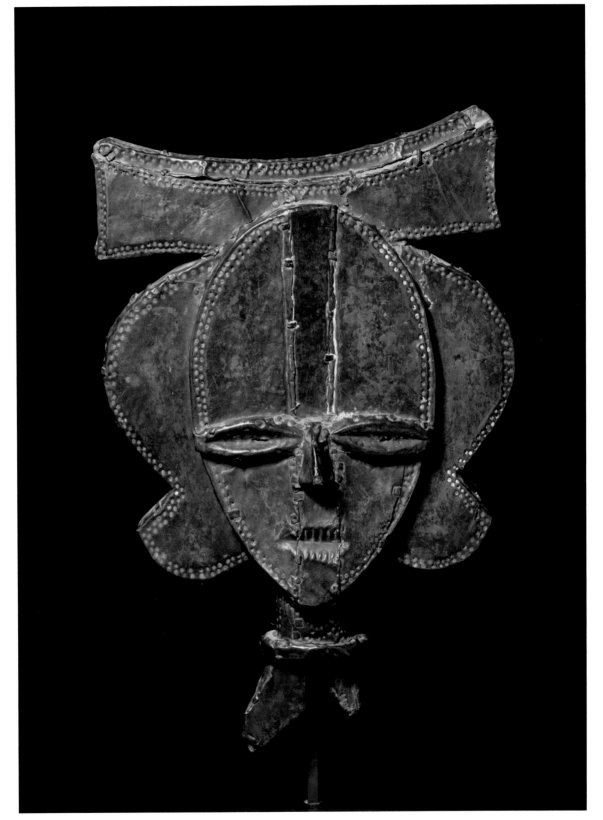

Kota

Reliquary head

Tête de reliquaire

Reliquiarkopf

Cabeza de relicario

Testa di reliquiario

Reliekkop

Wood, copper/
Bois, cuivre, 26 cm

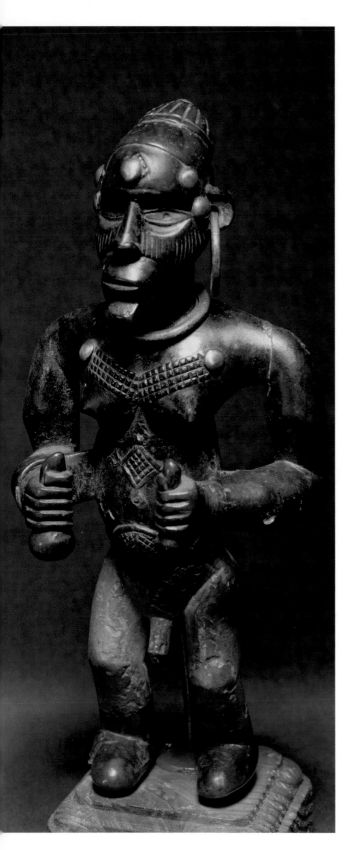

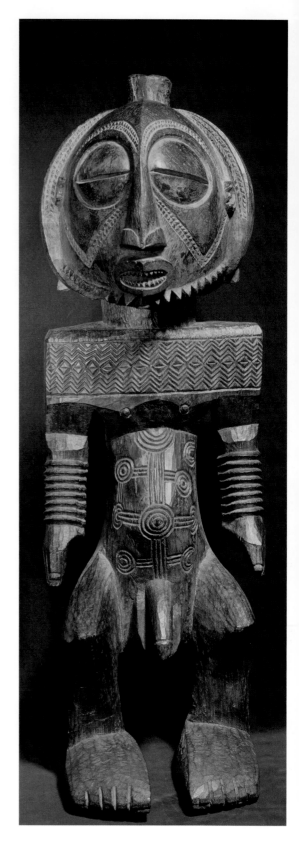

Bembe

Androgyneous statue

Statuette androgyne

Androgyne Statuette

Estatuilla andrógina

Statuetta androgena

Androgyn beeldje

Wood/Bois, 22,5 cm

Bembe

Ancestry figurine

Figurine d'ancêtre

Ahnenfigur

Figura de antepasado

Figura di antenato

Voorouderfiguur

Wood/Bois, 99,5 cm

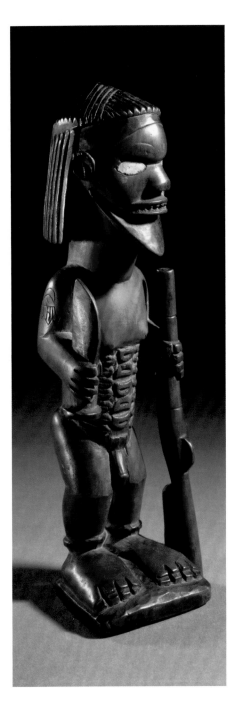

Bembe

Ancestry figurine

Figurine d'ancêtre

Ahnenfigur

Figura de antepasado

Figura di antenato

Voorouderfiguur

Wood/Bois, 26 cm

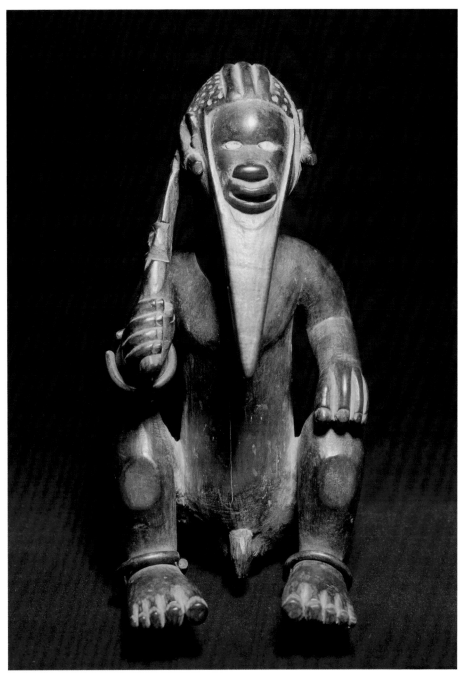

Bembe

Sitting figurine with sceptre

Personnage assis avec sceptre

Sitzende Figur mit Zepter

Figura sedente con cetro

Figura seduta con uno scettro

Zittende figuur met scepter

Wood, copper/Bois, cuivre, 20 cm

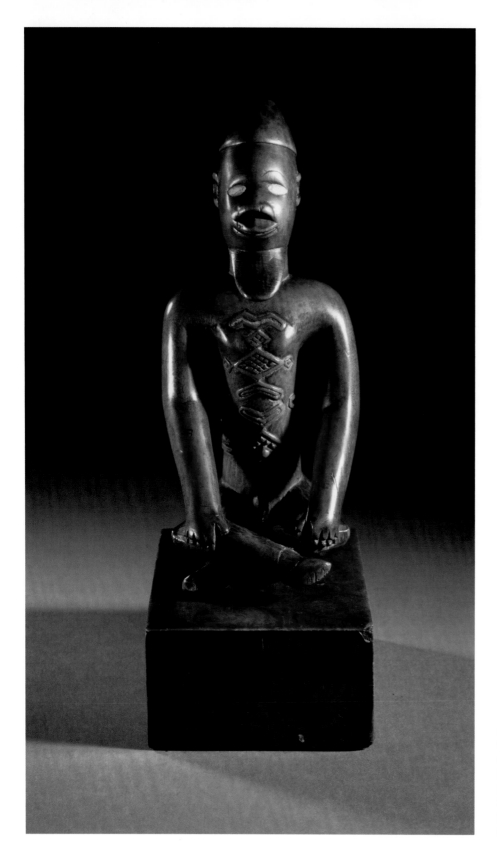

Bembe

Sitting ancestry figurine

Figurine d'ancêtre assis

Sitzende Ahnenfigur

Figura de antepasado sedente

Figura di un antenato seduto

Zittende voorouderfiguur

Wood/Bois, 18,5 cm

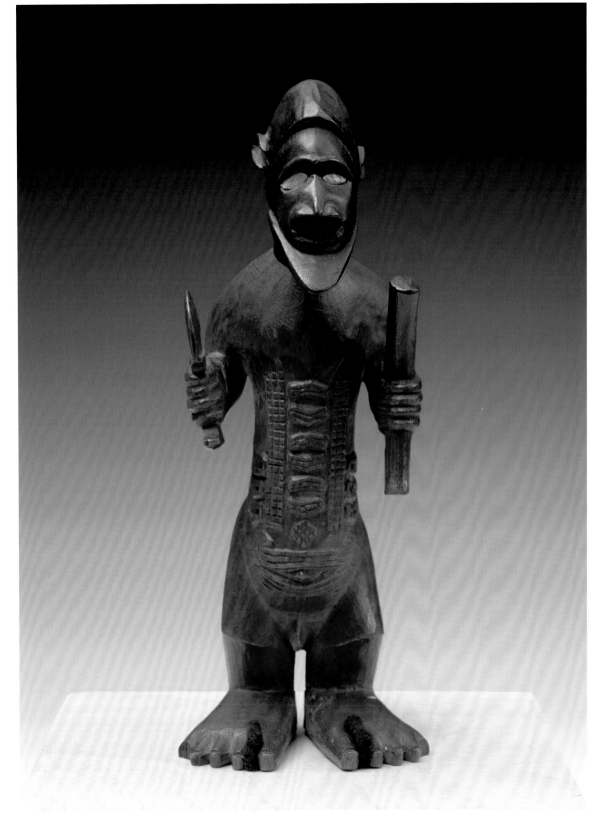

Bembe
Ancestry figurine
Figurine d'ancêtre
Ahnenfigur
Figura de antepasado
Figura di antenato
Voorouderfiguur
Wood, glass/
Bois, verre , 17 cm

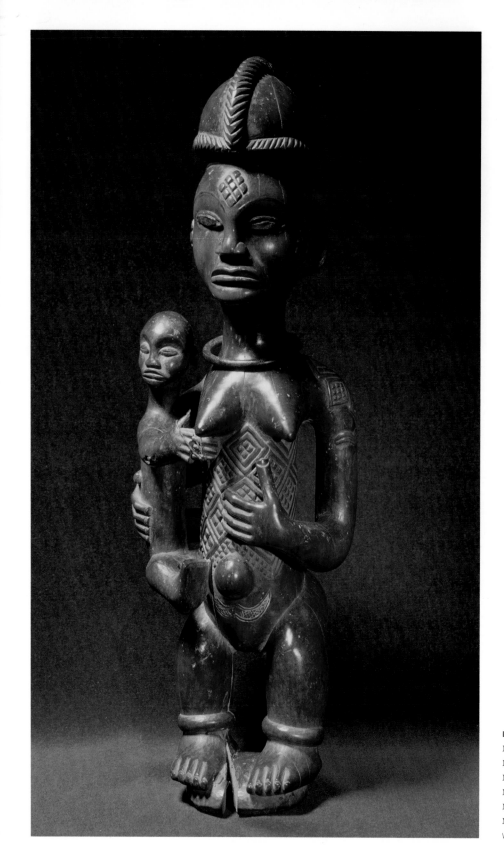

Lumbo

Mother with child
Mère et enfant
Mutter mit Kind
Mujer con hijo
Madre e figlio
Moeder met kind
Wood/Bois, 21 cm

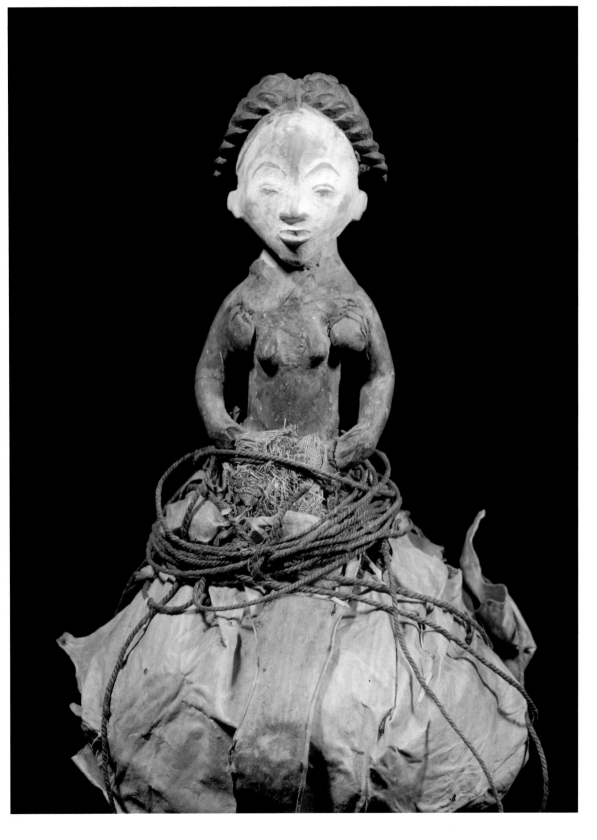

Lumbo

Reliquary with female
guard figurine

Reliquaire avec figure
de gardienne

Reliquiar mit weiblicher
Wächterfigur

Relicario con figura
de guardiana

Reliquiario con figura
di custode femminile

Reliek met vrouwelijke
wachter

Wood painted, leather,
plant fibres, string, organic
materials/Bois peint, cuir,
fibres végétales, corde,
matières organiques,
32 × 18 × 18 cm

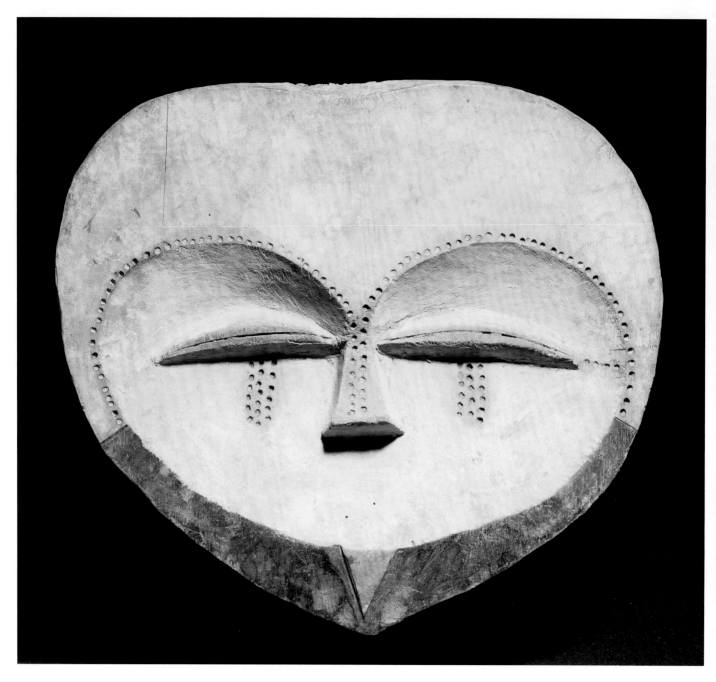

Kwele
Double mask
Masque double
Doppelmaske
Máscara doble
Maschera doppia
Dubbelmasker
tWood painted/Bois peint, 29 cm

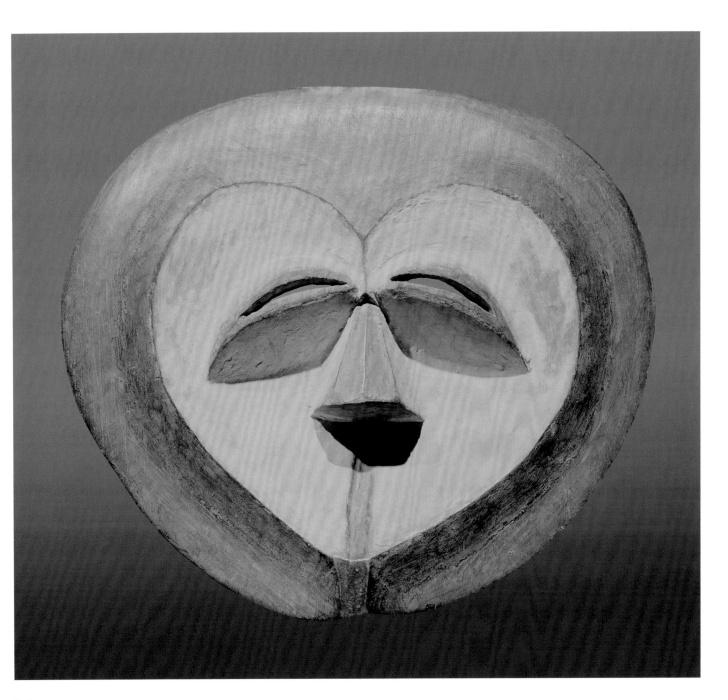

Kwele

Mask

Masque

Maske

Máscara

Maschera

Masker

Wood patinised, painted/Bois patiné, peint, 25,4 cm

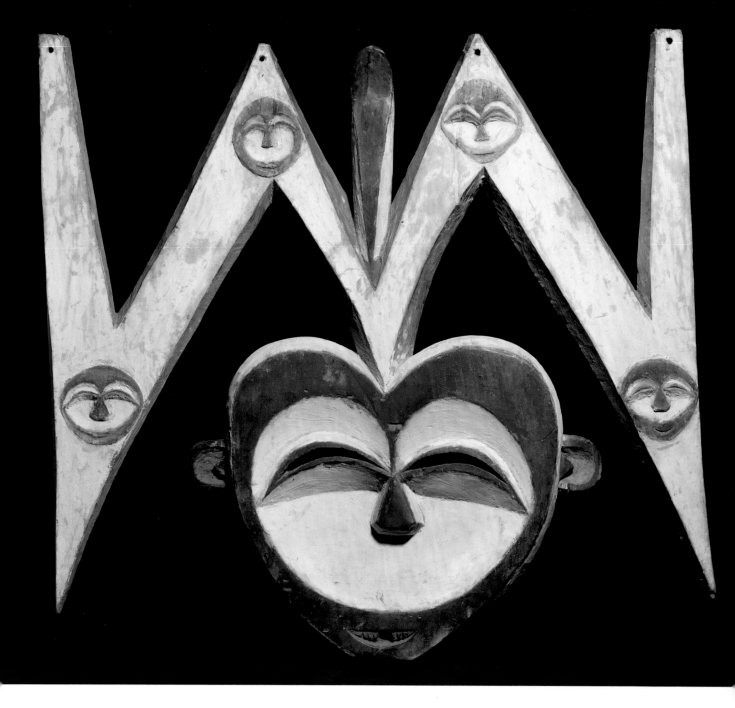

Kwele

Mask with extension in form of a letter

Masque avec cimier en forme de lettre

Maske mit Aufsatz in Form eines Buchstabens

Maske mit Aufsatz in Form eines Buchstabens

Maschera con copricapo a forma di lettera

Masker met hoofdtooi in de vorm van een letter

Wood painted/Bois peint, 61 cm

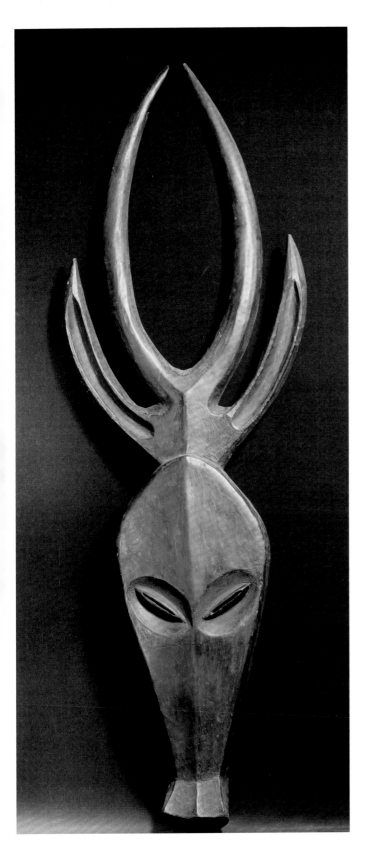

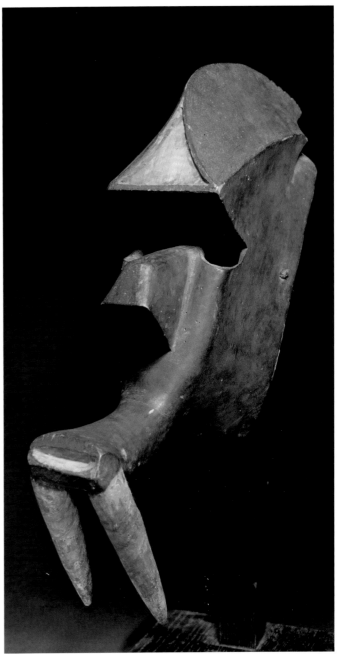

Kwele

Antelope mask

Masque d'antilope

Antilopenmaske

Máscara de antílope

Maschera a forma di antilope

Antilopenmasker

Wood/Bois, 95 cm

Kwele

Gorilla mask

Masque de gorille

Gorillamaske

Máscara de gorila

Maschera a forma di gorilla

Gorillamasker

Wood painted/Bois peint, 45 × 12 × 15 cm

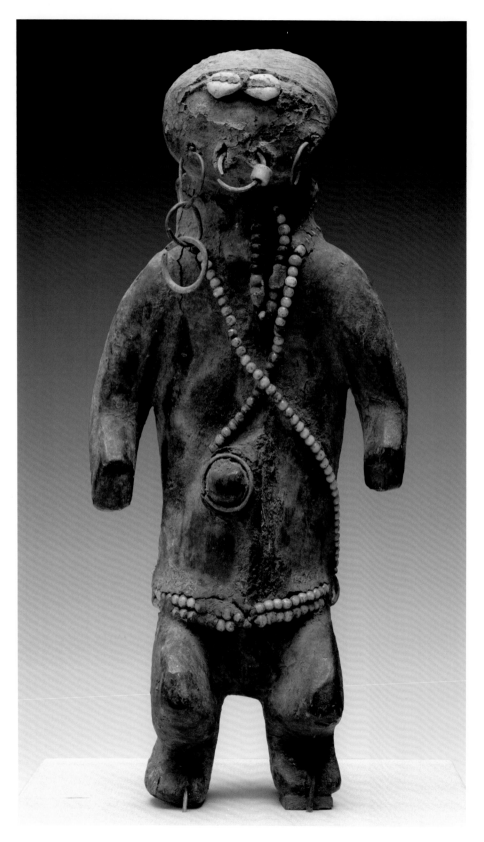

In Europe Azande were known under the alias "Niam-Niam" and were infamous as cannibals. This colonial stereotype did not resemble the truth: cannibalism is a global taboo. Its social acceptance can be proven neither in Africa nor in another location in modern times. A popular collector's item was the throwing knife and other weapons of the Azande. The expansion of the Azande Empire during the 18th century was mainly peaceful. The Yanda figurines were very popular; they were made in an abstract way and have a protective function. Only leaders of the Mani secret society may handle them.

En Europe, les Azandé étaient connus sous le nom de « Niam-Niam » et passaient pour des anthropophages sauvages notoires. Mais ce stéréotype colonial est erroné : le cannibalisme est un tabou mondial. À l'époque moderne, sa réalité sociale ne se vérifie ni en Afrique ni nulle part ailleurs. Le couteau de lancer et d'autres armes des Azandé étaient donc des objets de collection très prisés. L'expansion de l'Empire Azandé au cours du 18e siècle a été essentiellement pacifique. Les figurines Yanda étaient très populaires ; elles étaient pour la plupart abstraites et avaient une fonction de protection. Seuls les chefs de la société secrète Mani avaient le droit de les manipuler.

In Europa waren Azande unter dem Namen „Niam-Niam" bekannt und als wilde Kannibalen berüchtigt. Dieses koloniale Stereotyp entsprach jedoch nicht der Wahrheit: Kannibalismus ist ein globales Tabu. Seine gesellschaftliche Akzeptanz lässt sich weder in Afrika noch an einem anderen Ort in der Neuzeit nachweisen. Ein beliebter Sammelgegenstand waren daher Wurfmesser und andere Waffen der Azande. Die Expansion des Azande-Reiches im 18. Jahrhundert verlief allerdings weitgehend friedlich. Populär waren Yanda-Figuren, die meist abstrakt ausgeführt werden und eine Schutzfunktion haben. Nur Führungspersonen des Mani-Geheimbundes dürfen mit ihnen umgehen.

Azande

Figurine for use in a secret society

Figurine pour une utilisation dans une société secrète

Figur für den Gebrauch in einem Geheimbund

Figura para el uso en una sociedad secreta

Figura per l'uso in una società segreta

Figuur voor een geheim verbond

Wood, cowry shells, glass pearls, metal/
Bois, cauris, perles de verre, métal, 32 cm,
Koninklijk Museum voor Midden-Afrika, Tervuren

En Europa se conocía a los azande por el nombre "Niam-niam" (ñam-ñam en español) y se rumoreaba que eran caníbales. Este estereotipo colonial no era fiel a la verdad: el canibalismo es un tabú global. Su aceptación social no puede probarse ni en África ni en ningún otro lugar en la era moderna. Por ello, un objeto preciado por los coleccionistas eran los cuchillos arrojadizos y otras armas de los azande. La expansión del imperio azande en el siglo XVIII, sin embargo, se realizó de manera principalmente pacífica. Entre las figuras populares estaban las Yanda, que eran generalmente abstractas y tenían una función protectora. Solo los líderes de las organizaciones secretas Mani podían llevarlas.

In Europa gli azande erano conosciuti come "Niam-Niam" e noti per essere cannibali selvaggi. Tuttavia, questo stereotipo coloniale era infondato. Il cannibalismo è un tabù globale e la sua accettazione sociale nell'era moderna non può essere dimostrata né in Africa né in altri luoghi. Tuttavia, in virtù di questa credenza, erano oggetti da collezione molto richiesti i coltelli e altre armi degli azande, l'espansione del cui regno nel XVIII secolo fu invece in gran parte pacifica. Popolari erano poi le figure Yanda, di solito astratte e con una funzione protettiva, che potevano essere maneggiate solo dai leader della società segreta Mani.

In Europa waren de Azande onder de naam 'Niam Niam' berucht als woeste kannibalen. Dit koloniale stereotype kwam echter niet overeen met de werkelijkheid: kannibalisme is een wereldwijd taboe en de maatschappelijke acceptatie ervan kan noch in Afrika noch elders worden aangetoond. Geliefde verzamelobjecten waren in dit verband de werpmessen en andere wapens van de Azande. Maar de expansie van het Azanderijk in de achttiende eeuw verliep grotendeels vreedzaam. Populair waren de yanda-figuren, die doorgaans abstract werden uitgevoerd en een beschermende functie hadden. Alleen leidende figuren van de geheime Mani-genootschappen mogen ze hanteren.

Afrikanische Völker II.

Meyers Konv.-Lexikon, 6 Aufl. Bibliogr. Institut in Leipzig Zum Artikel „Afrika".

African Folk
Peuples africains
Afrikanische Völker
Pueblos africanos
Popoli africani
Afrikaanse volkeren
Meyers Konversationslexikon, Leipzig 1903

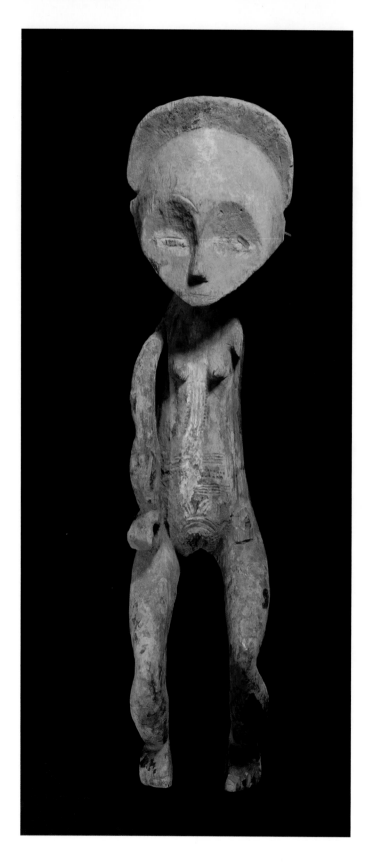

Mbole

Figurine for use in a secret society
(hanged female figurine)

Figurine en lien avec une société
secrète (figurine féminine
destinée à être suspendue)

Figur für den Gebrauch in einem
Geheimbund (erhängte weibliche Figur)

Figura colgante para el uso en una
sociedad secreta (femenina)

Figura per l'uso in una società segreta
(figura femminile impiccata)

Figuur voor een geheim verbond
(opgehangen vrouw)

Wood/Bois, 58,5 cm

Lega

Small mask

Petit masque

Kleine Maske

Pequeña máscara

Piccola maschera

Klein masker

ANGOLA
CONGO

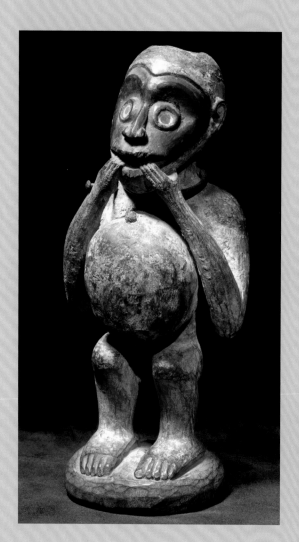

Kongo

Medical magic figurine

Figurine magique à usage médical

Medizinische Zauberfigur

Figura mágica medicinal

Figura medicinale magica

Helende toverfiguur

Wood/Bois, 25,5 cm

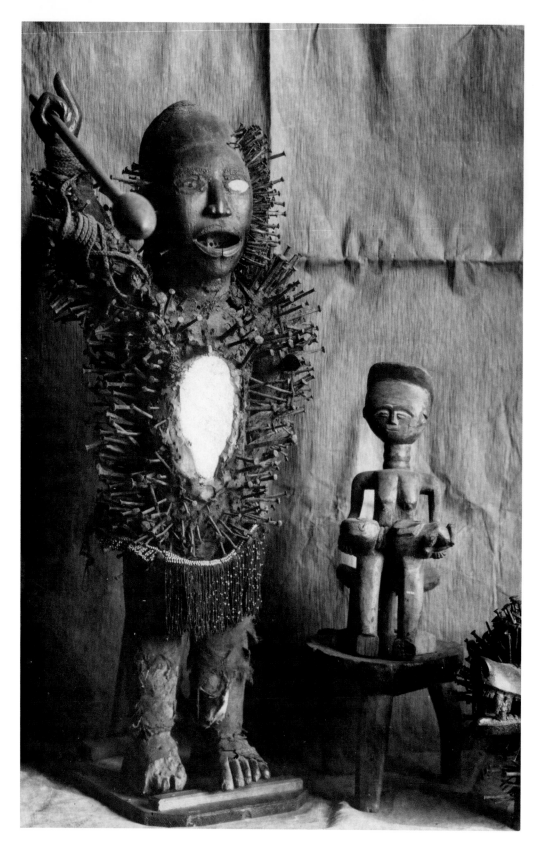

Kongo

"Fetishes" *(postcard)*

« Fétiches » *(carte postale)*

„Fetische" *(Postkarte)*

"Fetiche" *(postal)*

"Feticci" *(cartolina)*

"Fetisjen" *(ansichtkaart)*

The so-called nail and mirror fetishes, *nkisi,* are a special trait of the Congo area. Their function is similar to Christian protective and holy figurines reaching the region in the 16th century. A *nkisi* is a figurine gaining importance when filled with various substances. *Nkisi* change their appearance during a séance. They were very popular among merchants and collectors. Many pieces were called "fetishes", regardless of their purpose. These collector's habits strengthened the prejudice that Africans were obsessed with magic.

Une particularité de cette région du Congo est ce que l'on appelle les fétiches à clous ou à miroirs *minkisi.* Leur fonction est similaire à celle des figures saintes et protectrices chrétiennes qui arrivèrent dans la région au 16e siècle. Une *nkisi* est une statuette dont les pouvoirs s'activent lorsque le réceptacle dont elle est pourvue est rempli de diverses substances. Ainsi, les *minkisi* changent d'apparence au cours d'une même séance. Elles étaient très appréciées par les marchands et les collectionneurs. De nombreuses pièces ont cependant été qualifiées de « fétiches », indépendamment de leur finalité. Cet amalgame a renforcé le préjugé selon lequel des Africains étaient obsédés par la magie.

Eine Besonderheit des Kongo-Gebiets sind die sogenannten Nagel- und Spiegelfetische *minkisi.* Ihre Funktion ähnelt christlichen Schutz- und Heiligenfiguren, die im 16. Jahrhundert in die Region gelangten. Ein *nkisi* ist eine Figur mit einem Behältnis, das mit verschiedenen Substanzen gefüllt wird und dadurch bedeutungsvoll wird. So verändern *minkisi* während einer Séance ihr Aussehen. Sie waren bei Händlern und Sammlern sehr beliebt. Viele Stücke, ungeachtet ihres Zweckes, wurden allerdings als „Fetische" bezeichnet. Diese Sammelpraxis verstärkte das Vorurteil, Afrikaner seien geradezu von Magie besessen.

Los fetiches de espejos y de clavos *minkisi* son una particularidad de la zona del Congo. Su función es parecida a la de las figuras de santos y de protección del cristianismo, que llegaron a la región en el XVI. Un *nkisi* es una figura con un recipiente que se llena con diversas sustancias que le otorgan un significado. Así, las *minkisi* cambian de aspecto durante las sesiones de espiritismo. Eran extremadamente apreciadas por comerciantes y coleccionistas. Sin embargo, muchas obras, independientemente de su función, se catalogaron como "fetiches". La práctica del coleccionismo potenció el prejuicio de que los africanos estaban verdaderamente obsesionados con la magia.

Una peculiarità del territorio del Congo sono i cosiddetti *minkisi,* dei feticci recanti chiodi e uno specchio. La loro funzione è simile a quella delle figure dei santi e protettori cristiani che giunsero nella regione nel XVI secolo. Un *nkisi* è una figura che diventa significativa quando viene riempita di sostanze diverse. I *minkisi* cambiavano così il loro aspetto durante una seduta spiritica. Erano molto popolari tra i commercianti e i collezionisti. Molti pezzi, indipendentemente dal loro scopo, venivano tuttavia definiti "feticci". Il collezionismo di questi oggetti rafforzò il pregiudizio che gli africani fossero ossessionati con la magia.

Bijzonder aan het gebied van de Kongo zijn de zogenaamde nagel- en spiegelfetisjen, *nkisi* genaamd. Hun functie is vergelijkbaar met christelijke beschermheiligen, die in de zestiende eeuw in deze regio werden geïntroduceerd. Een *nkisi*-figuur is uitgerust met een houder, die met verschillende stoffen gevuld kan worden en daardoor betekenis krijgt. Zo veranderen *nkisi*'s tijdens een séance van uiterlijk. Ze waren bij handelaren en verzamelaars zeer geliefd, maar veel van deze kunstwerken werden ongeacht hun functie als 'fetisjen' aangeduid. Deze wijze van verzamelen versterkte het vooroordeel dat Afrikanen door magie bezeten waren.

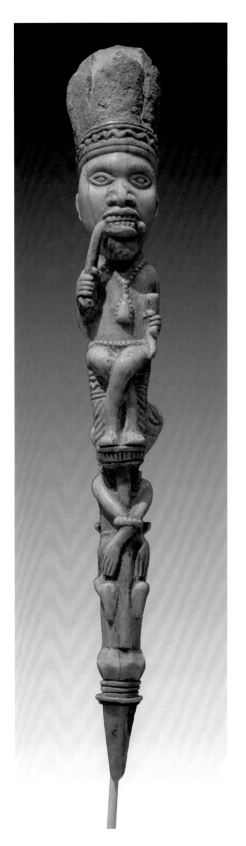

Kongo
Handle or sceptre displaying a chief
Poignée ou sceptre avec représentation d'un chef de tribu
Griff oder Zepter mit Darstellung eines Häuptlings
Mango o cetro con representación de un jefe
Impugnatura o scettro raffigurante un capotribù
Heft of scepter met uitbeelding van stamhoofd
Wood/Bois, 26 cm

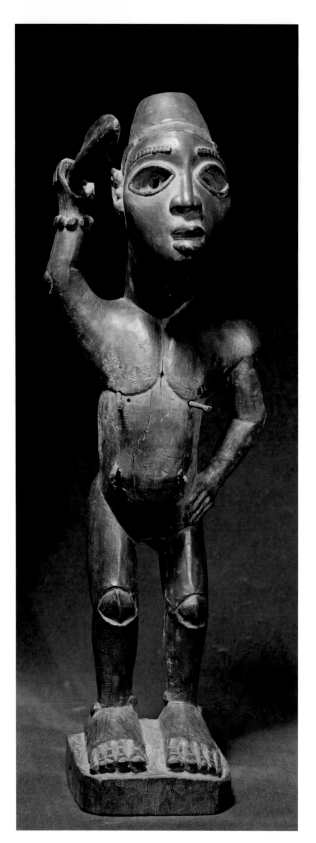

Kongo

Figurine of a
speer-waving man

Homme brandissant
une lance

Figur eines Speer
schwingenden
Mannes

Figura de un
hombre blandiendo
una lanza

Figura di un uomo
che impugna
una lancia

Mannenfiguur
met speer

Wood/Bois, 37 cm

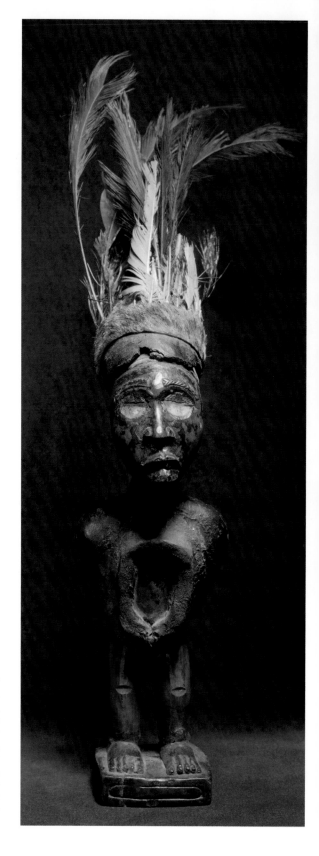

Kongo

Reliquary guard

Gardien du
reliquaire

Reliquiarwächter

Guardián de
relicario

Guardiano
delle reliquie

Reliekwachter

Wood, feathers/
Bois, plumes, 27 cm

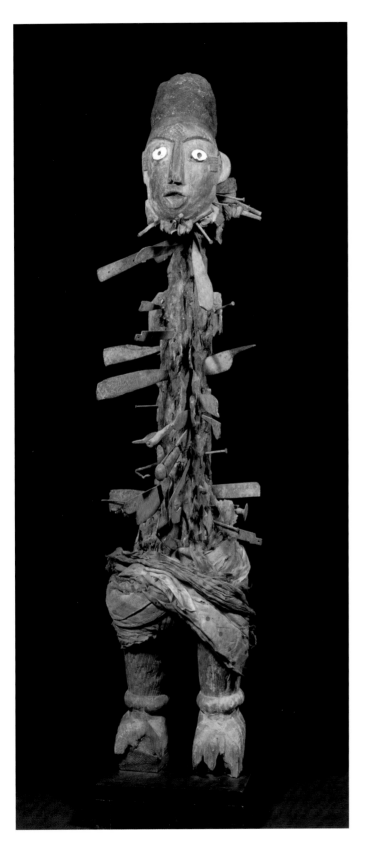

Kongo

Nkisi-figurine

Figurine Nkisi

Nkisi-Figur

Figura Nkisi

Figura Nkisi

Nkisi-figuur

Wood, iron, copper, cloth/
Bois, fer, cuivre, tissu, 86 cm

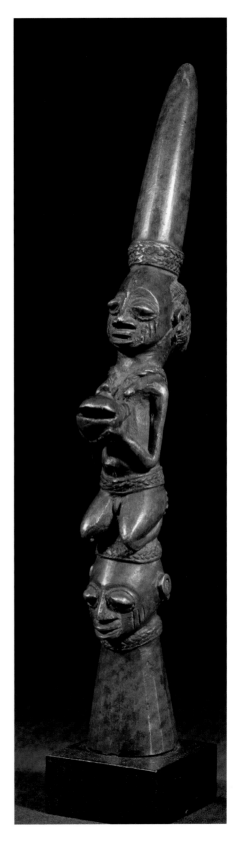

Kongo

Bell with figurines
and a horn

Cloche avec figurines
et un corne

Glocke mit Figuren
und einem Horn

Campana con
figuras y cuerno

Campana con figure
e un corno

Bel met figuren en hoorn

Bronze/Bronze, 28 cm

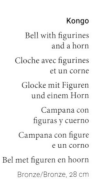

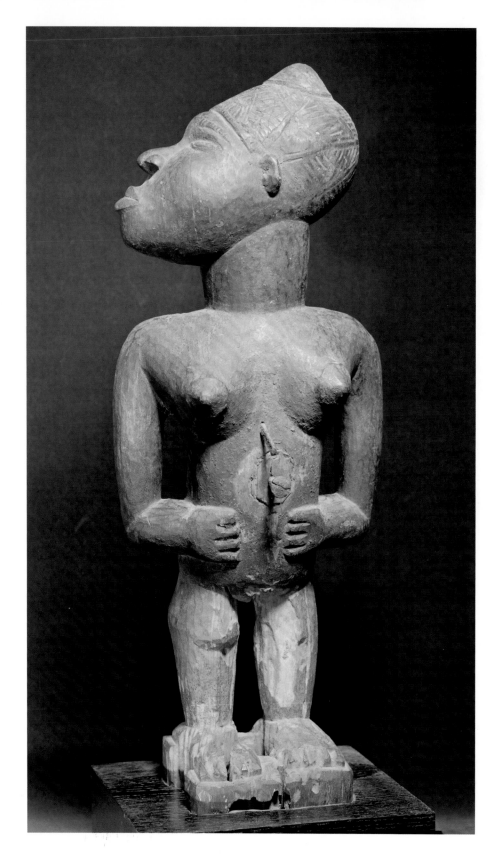

Kongo

Female figurine

Figure féminine

Weibliche Figur

Figura femenina

Figura femminile

Vrouwenfiguur

Wood/Bois, 50,5 cm

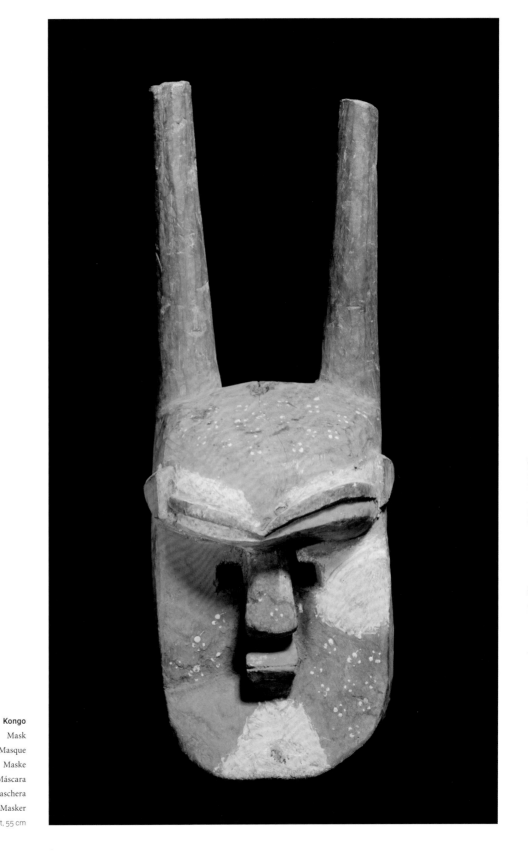

Kongo
Mask
Masque
Maske
Máscara
Maschera
Masker
Wood painted/Bois peint, 55 cm

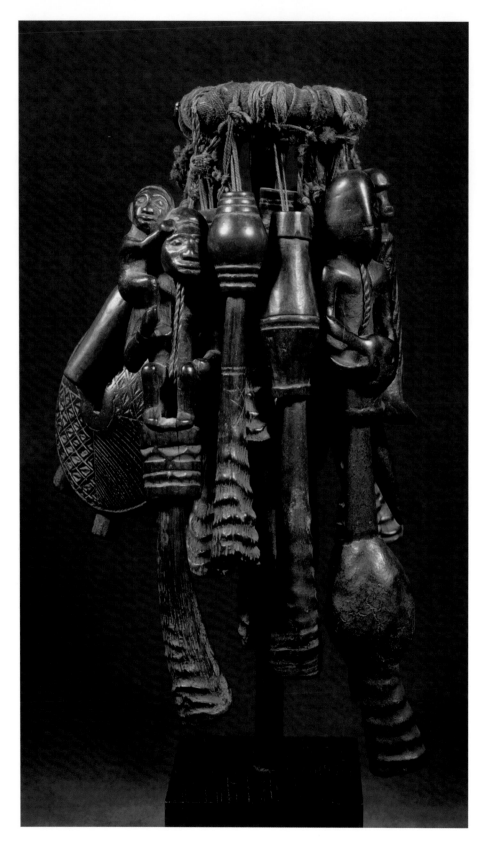

Kongo

Magic bracelet with anthropomorphic shapes

Amulettes magiques avec formes anthropomorphes

Zauberamulette mit anthropomorphen Formen

Amuleto mágico con formas antropomórficas

Amuleto magico con forme antropomorfe

Toveramuletten met antropomorfe vormen

Wood/Bois, 22 cm

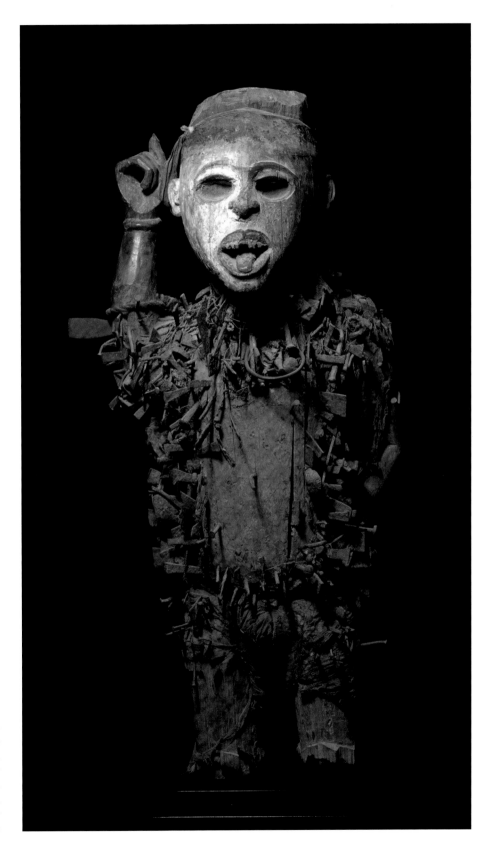

Kongo
Nkisi-figurine
Figurine Nkisi
Nkisi-Figur
Figura Nkisi
Figura Nkisi
Nkisi-figuur
Wood, string, iron, cloth/Bois, ficelle, fer, tissu, 77 cm

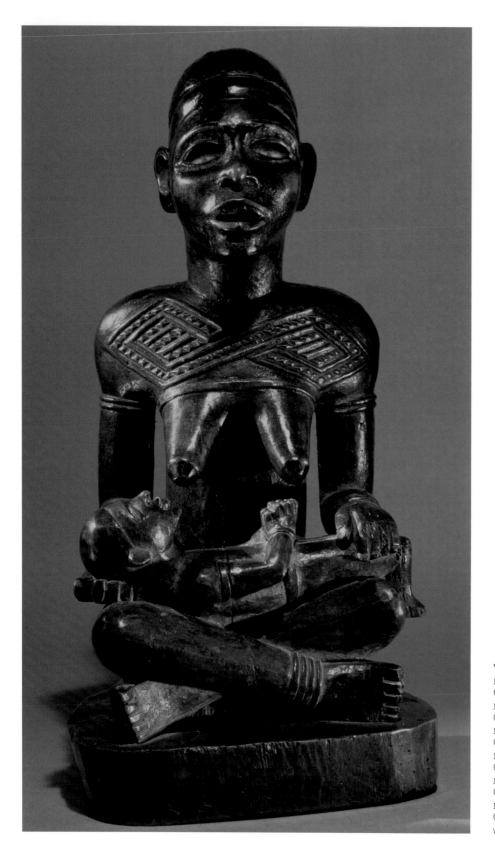

Yombe

Mother with child
(fertility goddess)

Mère avec enfant
(déesse de la fertilité)

Mutter mit Kind
(Fruchtbarkeitsgöttin)

Madre con hijo
(diosa de la fertilidad)

Madre e figlio
(dea della fertilità)

Moeder met kind
(vruchtbaarheidsgodin)

Wood/Bois, 29,5 cm

Yombe

Mask of a priest

Masque de prêtre

Maske eines Priesters

Máscara de sacerdote

Maschera di un sacerdote

Masker van priester

Wood painted/
Bois peint, 25 cm

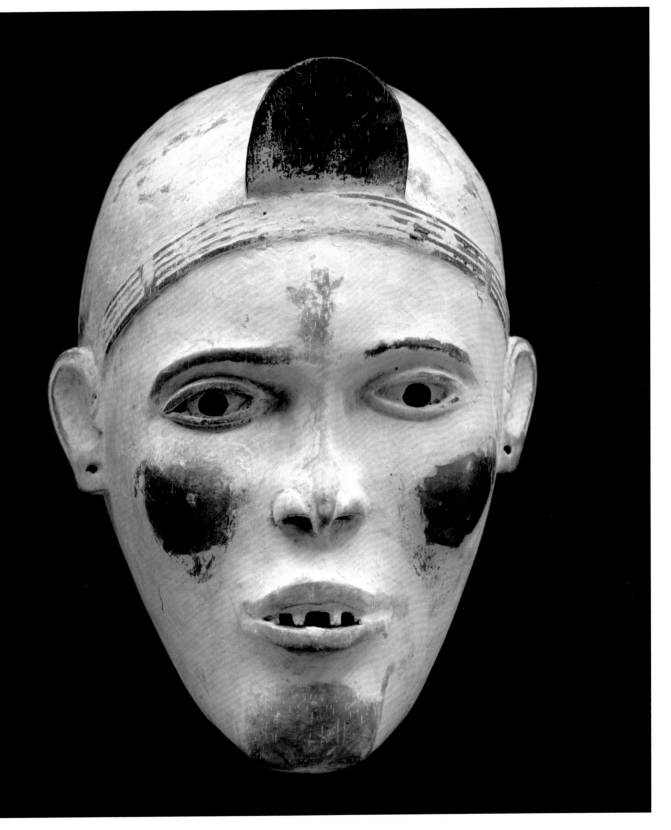

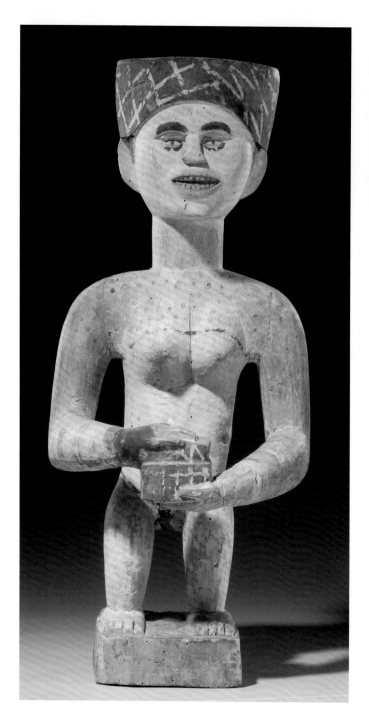

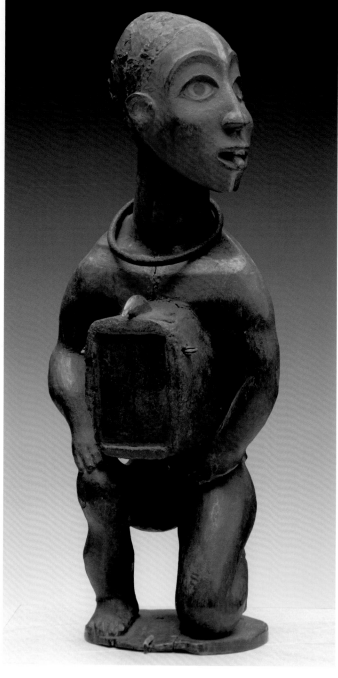

Sundi

Female ancestry figurine holding a vessel

Figurine d'ancêtre féminine tenant un récipient

Weibliche Ahnenfigur, ein Gefäß haltend

Figura de antepasado femenina, sosteniendo un recipiente

Figura di un'antenata che sostiene un vaso

Vrouwelijke voorouderfiguur met kom

Wood painted/Bois peint, 55 cm

Vili

Nkisi-figurine

Figurine Nkisi

Nkisi-Figur

Figura Nkisi

Figura Nkisi

Nkisi-figuur

Wood painted, mirror, leopard claw/Bois peint, miroir, griffe de léopard, 33 cm

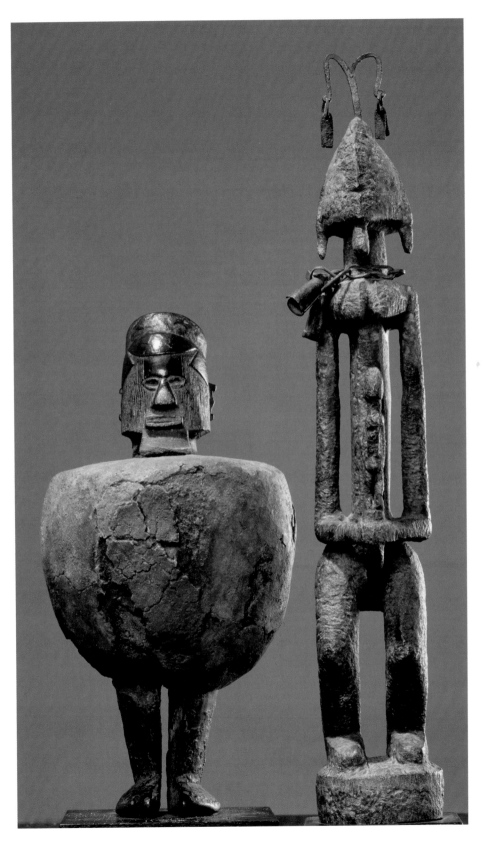

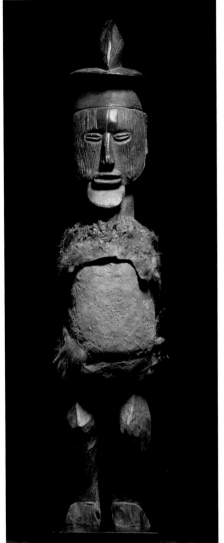

Teke
Reliquary guard
Gardien du reliquaire
Reliquiarwächter
Guardián de relicario
Guardiano delle reliquie
Reliekwachter
Wood, bark, leather/bois, écorce, cuir, 40 cm

Teke, Dogon
Reliquary guard (Teke), statue (Dogon)
Gardien de reliquaire (Teke), statue (Dogon)
Reliquiarwächter (Teke), Statue (Dogon)
Guardián de relicario (Teke), estatua (Dogón)
Guardiano delle reliquie (Teke), statua (Dogon)
Reliekwachter (Teke), beeldje (Dogon)
Wood, clay, metal/Bois, argile, métal, 33–48,5 cm

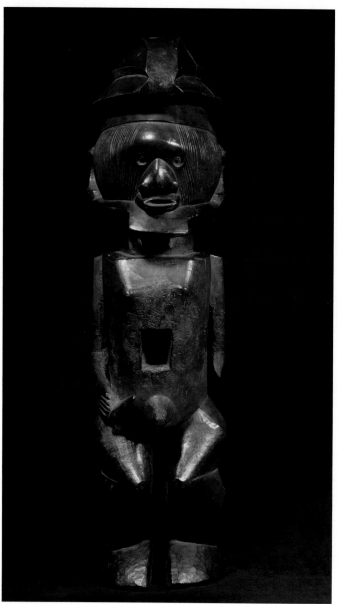

Teke

Ancestry figurine

Figurine d'ancêtre

Ahnenfigur

Figura de antepasado

Figura di antenato

Voorouderfiguur

Wood/Bois

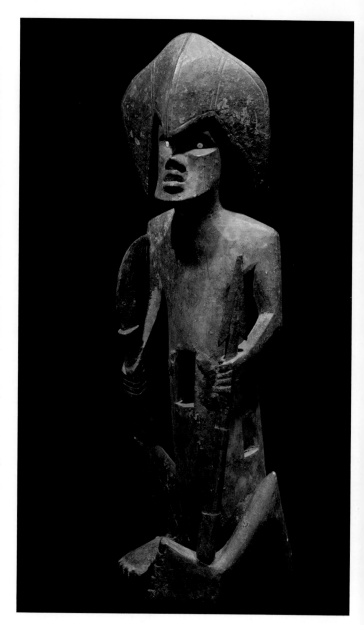

Teke

Soldier figurine

Figurine de guerrier

Kriegerfigur

Figura de guerrero

Figura di guerriero

Krijgersfiguur

Wood patinised/Bois patiné, 53,8 cm

Teke

Mask

Masque

Maske

Máscara

Maschera

Masker

Wood painted/
Bois peint, 34 cm

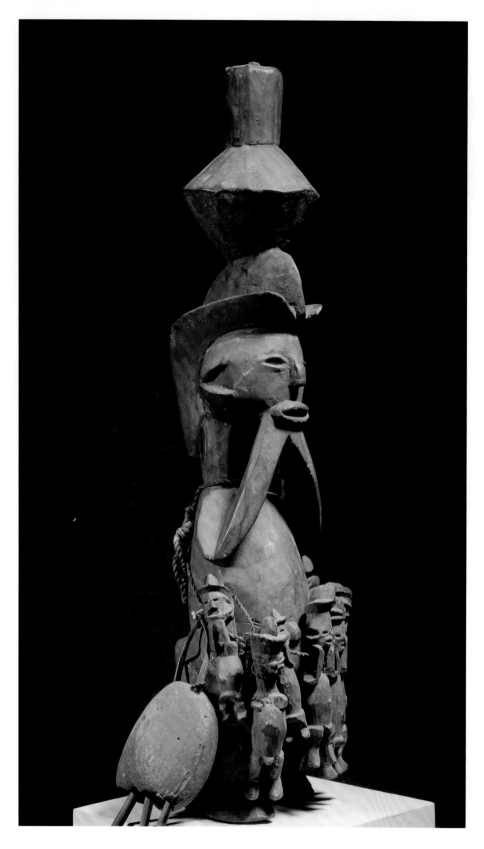

Hungana

Statuette

Statuette

Statuette

Estatuilla

Statuetta

Beeldje

Wood, horn, string/bois, corne, cordon, 47 cm

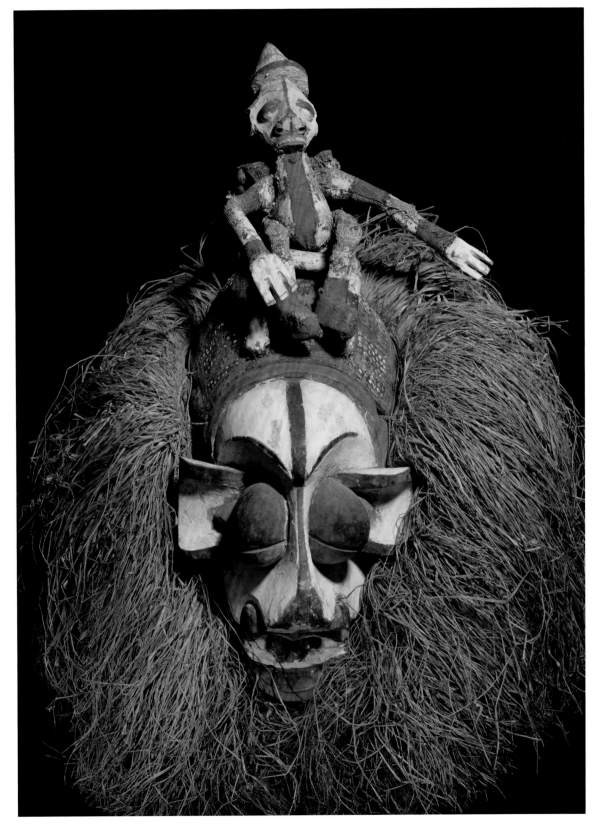

Yaka

Mask for boy's initiation

Masque pour l'initiation
des garçons

Maske für die Initation
der Jungen

Máscara para la
iniciación de jóvenes

Maschera per l'iniziazione
dei ragazzi

Initiatiemasker
voor jongens

Wood painted, bast/
Bois peint, raphia, 52,9 cm

219

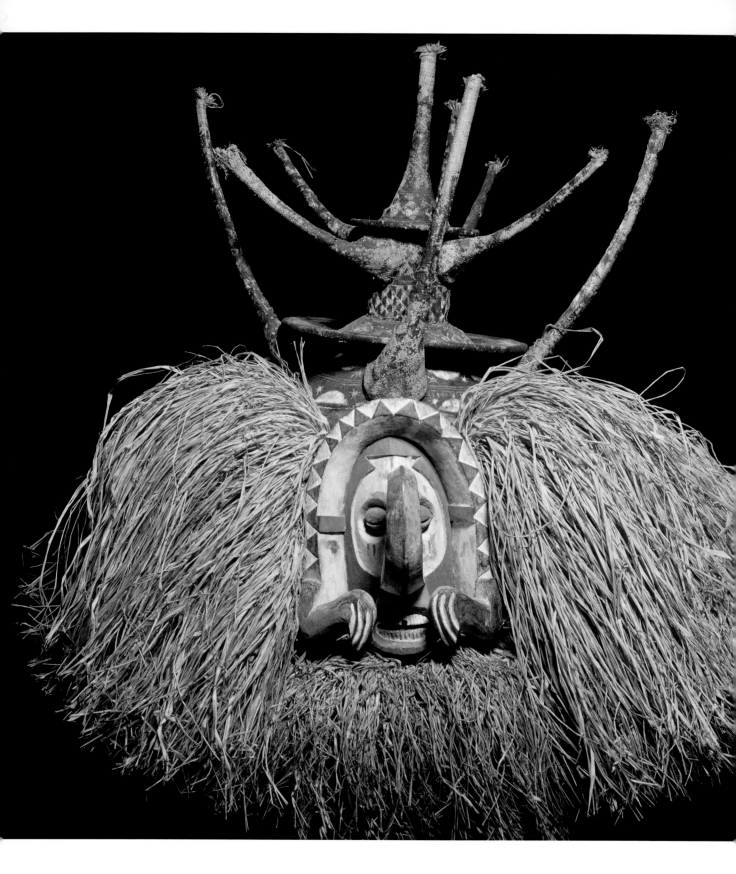

Yaka

Mask for boy's initiation

Masque pour l'initiation
des garçons

Maske für die Initation
der Jungen

Máscara para la
iniciación de jóvenes

Maschera per l'iniziazione
dei ragazzi

Initiatiemasker
voor jongens

Wood painted, bast/
Bois peint, raphia, 62,4 cm

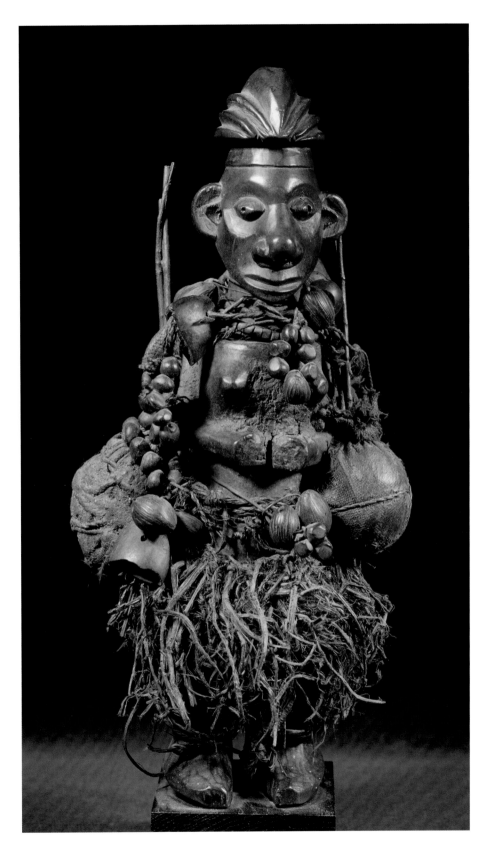

Yaka

Statuette

Statuette

Statuette

Estatuilla

Statuetta

Beeldje

Wood, metal, plant fibres/
Bois, métal, fibres
végétales, 30 cm

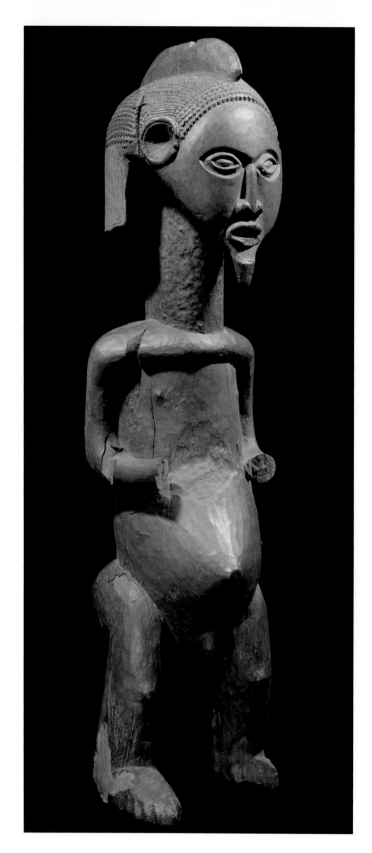

Suku

Ancestry figurine

Figurine d'ancêtre

Ahnenfigur

Figura de antepasado

Figura di antenato

Voorouderfiguur

Wood patinised/Bois patiné, 64 cm

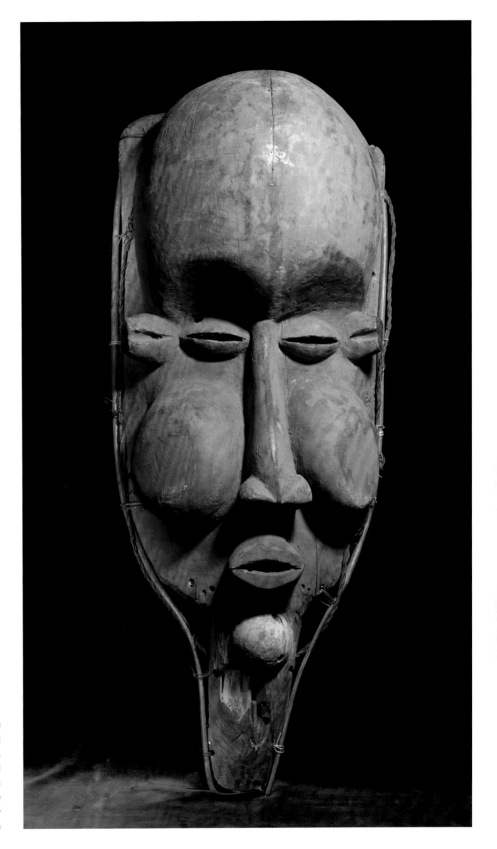

Suku

Mask for initiation ritual

Masque pour rituel d'initiation

Maske für Initationsritual

Máscara para ritual de iniciación

Maschera per rito di iniziazione

Initiatiemasker

Wood painted/Bois peint, 100,6 cm

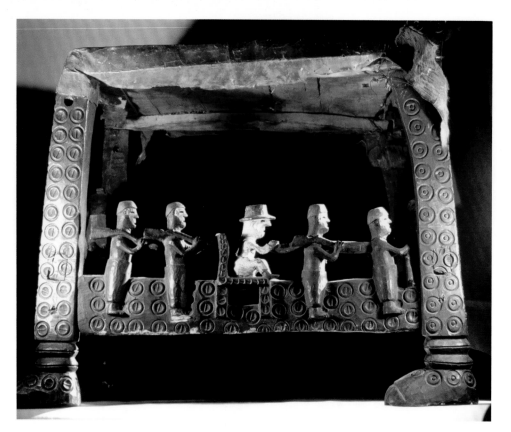

Chokwe

Chief chair: Belgian colonial administrator
with companion *(detail)*

Chaise de chef: administrateur colonial
belge accompagné *(détail)*

Häuptlingsstuhl: belgischer Kolonialbeamter
mit Begleitung *(Detail)*

Silla del jefe: funcionario colonial
belga y acompañantes *(detalle)*

Sedia di un capo: amministratore coloniale
belga con il suo seguito *(dettaglio)*

Stoel van stamhoofd: Belgische koloniale
functionaris en gevolg *(detail)*

Wood painted, leather/Bois peint, cuir,
Koninklijk Museum voor Midden-Afrika, Tervuren

Chokwe

Dancing mask

Masque de danse

Tanzmaske

Máscara de danza

Maschera di danza

Dansmasker

Wood, brass, fibres, pearls/Bois, laiton, fibres, perles

The Chokwe are one of the largest groups in the region. Their extraordinary tradition of decoration is obvious: objects of daily use were decorated with symbolic motives. Chokwe sculptures distinguish themselves by artistic solidity. Mainly leaders are portrayed. The wooden masks *mwana po* and *cihongo* visualise a female and a male ancestry spirit. They stand for fertility, power and riches. These masks were used for many social and political events such as tribute payments, initiations and festivities.

Les Tchokwés sont l'un des plus grands groupes ethniques de la région. Leur tradition du décor est extraordinaire et frappante. Même les objets usuels étaient décorés avec des motifs symboliques. Les sculptures Tchokwé se caractérisent par leur côté massif, majestueux et artistique. Elles représentent principalement des dirigeants. Les masques en bois *mwana po* et *cihongo* symbolisent l'esprit d'un ancêtre féminin et masculin. Ils servent à la fertilité, la puissance et la richesse. Ces masques étaient utilisés pour de nombreux événements sociaux et politiques, comme le paiement des impôts, les initiations et les fêtes du temps ordinaire.

Die Chokwe sind eine der größten Volksgruppen der Region. Auffällig ist ihre außerordentliche Dekortradition: Auch Gebrauchsgegenstände wurden mit symbolischen Motiven verziert. Skulpturen der Chokwe zeichnen sich durch eine kunstvolle Massivität aus. Dargestellt werden vor allem Führungspersönlichkeiten. Die Holzmasken *mwana po* und *cihongo* visualisieren einen weiblichen und einen männlichen Ahnengeist. Sie stehen für Fruchtbarkeit, Kraft und Reichtum. Im Einsatz waren diese Masken bei vielen gesellschaftlichen und politischen Anlässen wie Tributzahlungen, Initationen und Jahreskreisfesten.

Los Chokwe son unos de los mayores grupos de la región. Es particularmente reseñable su extraordinaria tradición de decoración: también los utensilios se decoran con motivos simbólicos. Las esculturas de los Chokwe se caracterizan por un tamaño artificialmente masivo. Representan sobre todo a líderes. Las máscaras de madera *mwana po* y *cihongo* reflejan un espíritu ancestral masculino y uno femenino; simbolizan fertilidad, fuerza y riqueza. Las máscaras se utilizaban en muchos eventos sociales y políticos, como el pago de impuestos, iniciaciones o festividades estacionales.

I Chokwe sono uno dei più grandi gruppi etnici della regione. Colpisce la loro straordinaria tradizione decorativa: anche gli oggetti di uso quotidiano erano decorati con motivi simbolici. Le sculture dei Chokwe, che raffigurano principalmente i leader della comunità, si caratterizzano per la loro mole artistica. Le maschere di legno *mwana po* e *cihongo* raffigurano uno spirito ancestrale femmine e uno maschile. Simboleggiano la fertilità, il potere e la ricchezza, e venivano usate in numerosi eventi sociali e politici, come il pagamento dei tributi, le iniziazioni e le festività ordinarie.

De Chokwe zijn een van de grotere bevolkingsgroepen in deze regio. Opvallend is hun buitengewone traditie in decoreren: ook gebruiksvoorwerpen werden met symbolische motieven versierd. De beeldhouwwerken van de Chokwe onderscheiden zich door hun artistieke soliditeit. Uitgebeeld worden vooral leiderspersoonlijkheden. Houten maskers die *mwana po* en *cihongo* worden genoemd, visualiseren de vrouwelijke en mannelijke vooroudergeest. Ze staan voor vruchtbaarheid, kracht en welvaart. Deze maskers werden in veel gemeenschappen en bij allerlei politieke gelegenheden gebruikt, zoals tribuutbetalingen, initiaties en kalenderfeesten.

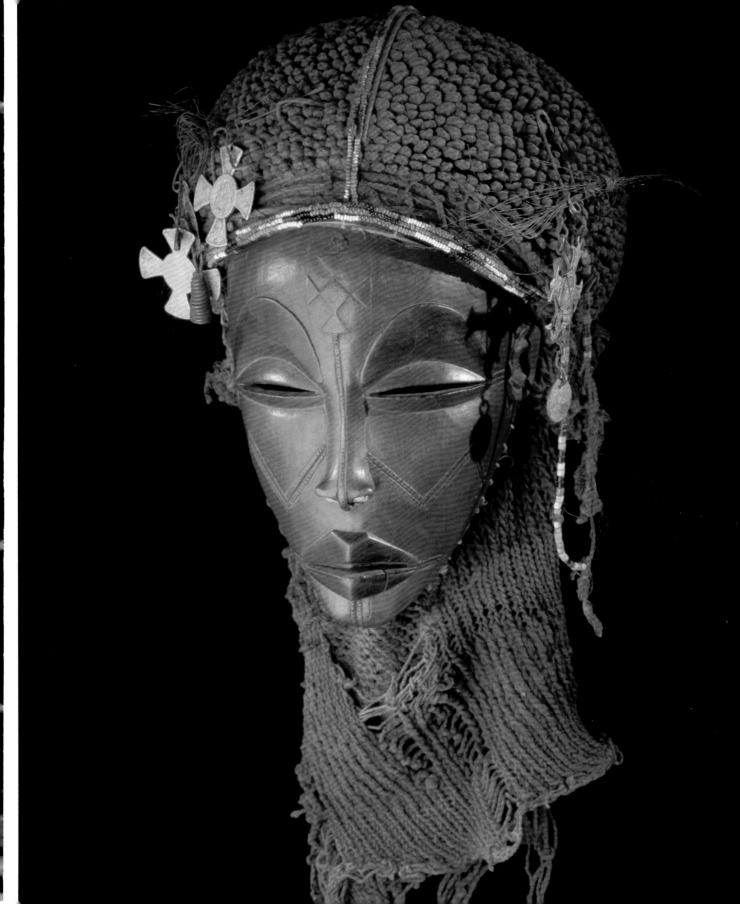

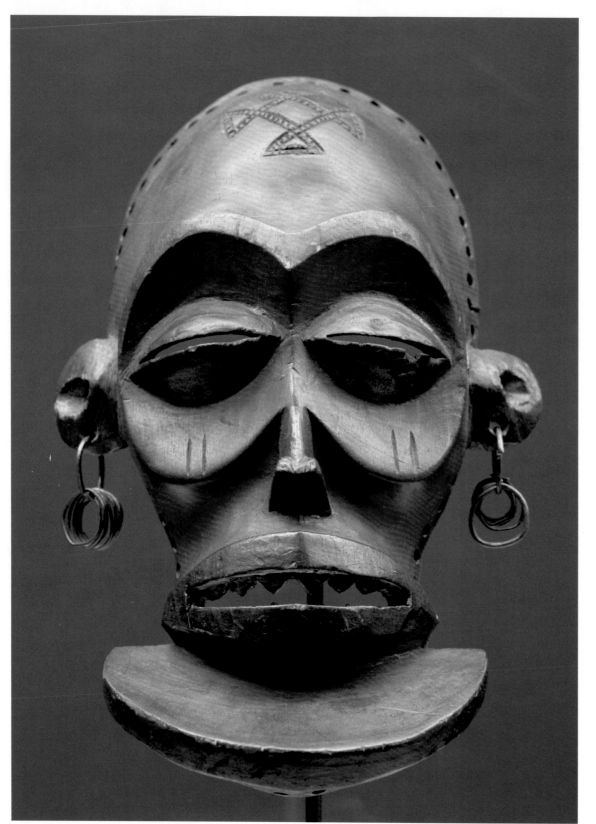

Chokwe

Mask

Masque

Maske

Máscara

Maschera

Masker

Wood, metal/Bois, métal,
24 cm, Koninklijk Museum
voor Midden-Afrika, Tervuren

Chokwe

Mask

Masque

Maske

Máscara

Maschera

Masker

Wood, metal/Bois, métal,
21 cm, Koninklijk Museum
voor Midden-Afrika, Tervuren

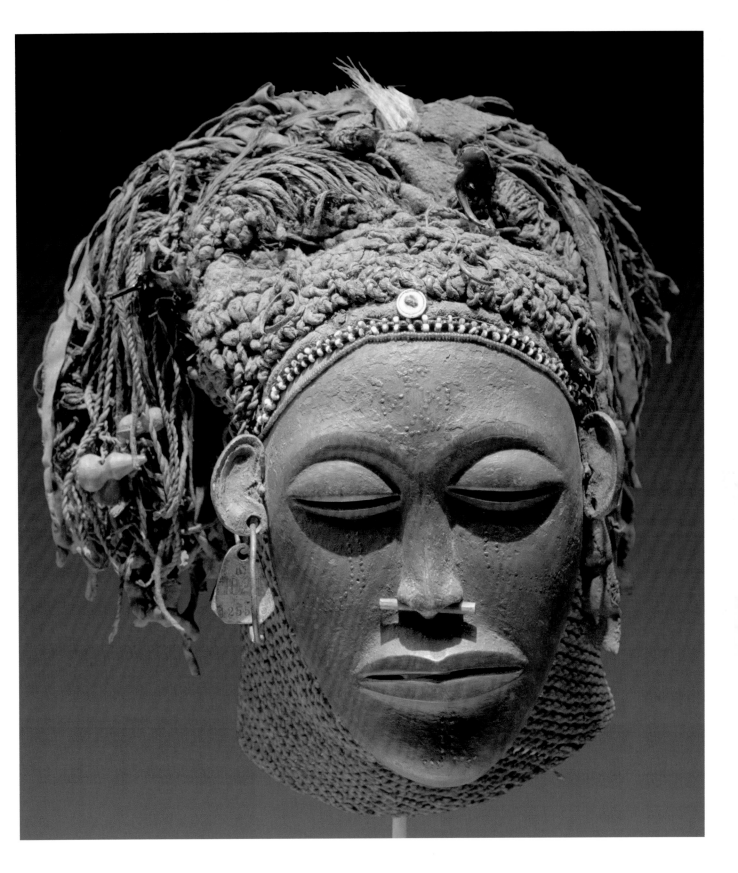

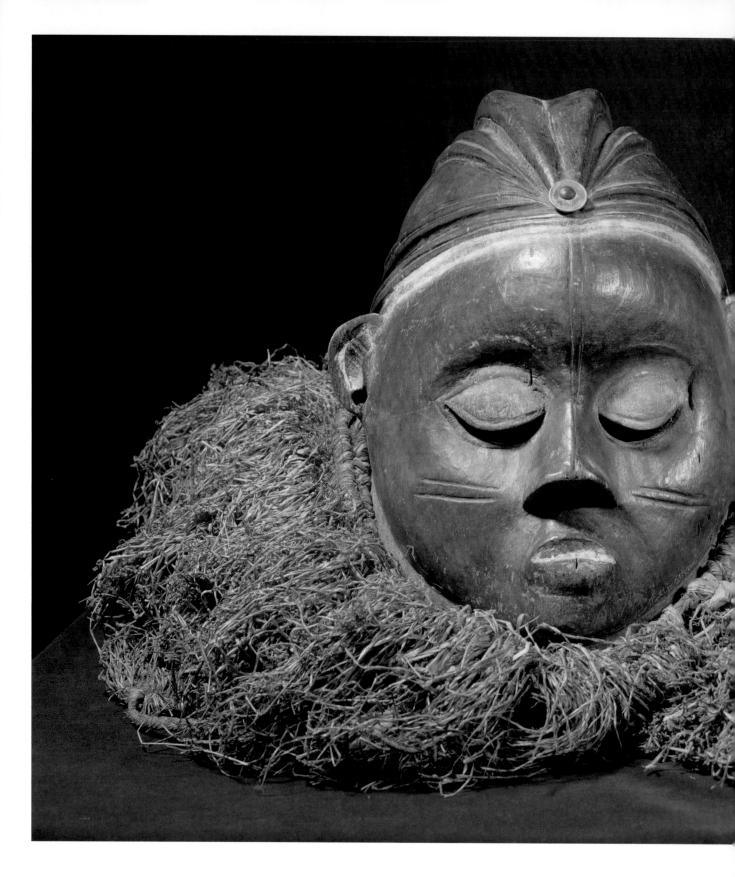

Pende/Suku

Helmet mask

Masque casque

Helmmaske

Máscara-casco

Maschera ad elmo

Gehelmd masker

Wood, bast, coin, nails/Bois, raphia, pièce de monnaie, clous, 26 × 23 cm

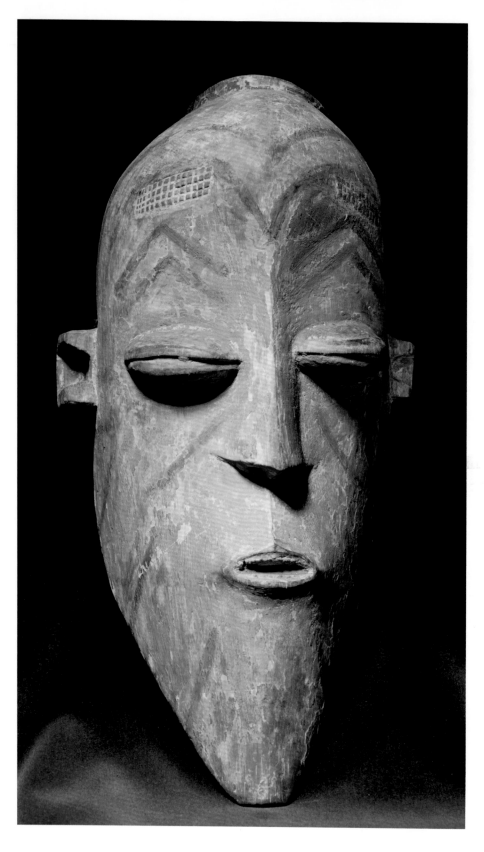

Pende
Mask
Masque
Maske
Máscara
Maschera
Masker
Wood painted/Bois peint, 41 cm

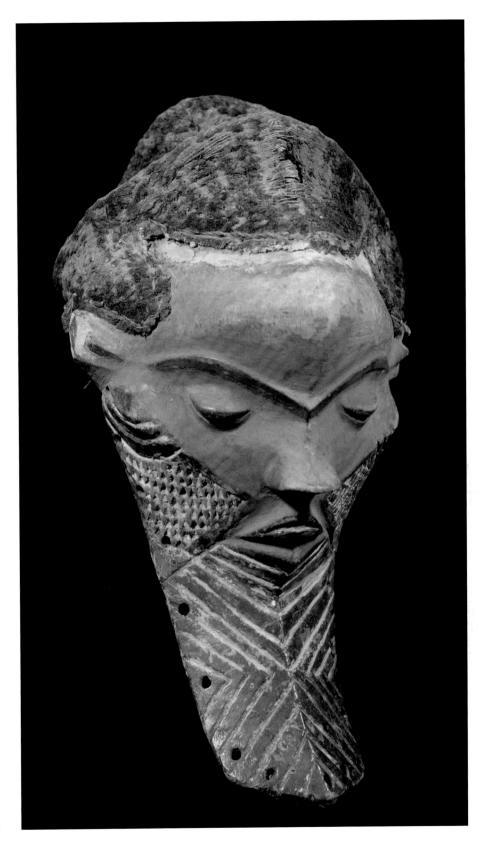

Pende

Mask

Masque

Maske

Máscara

Maschera

Masker

Wood, plant fibres, painted/Bois, fibres végétales, peint, 44 cm

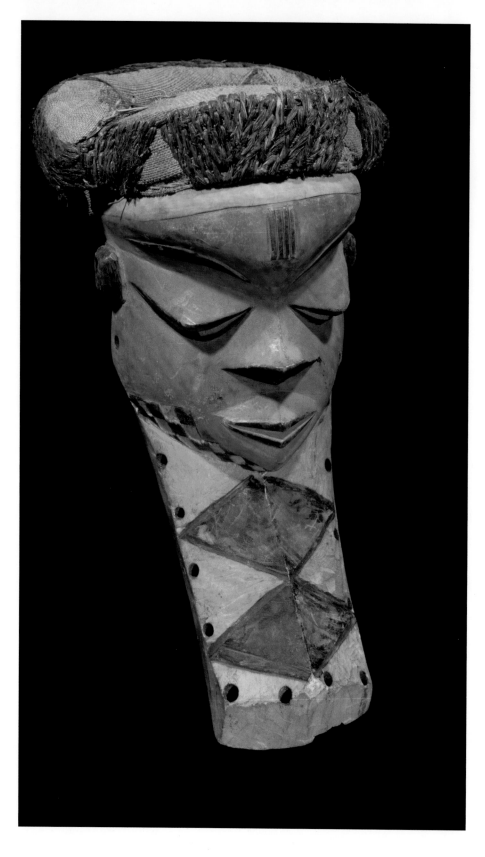

Pende

Mask

Masque

Maske

Máscara

Maschera

Masker

Wood painted, plant fibres/Bois peint, fibres végétales, 35,5 cm

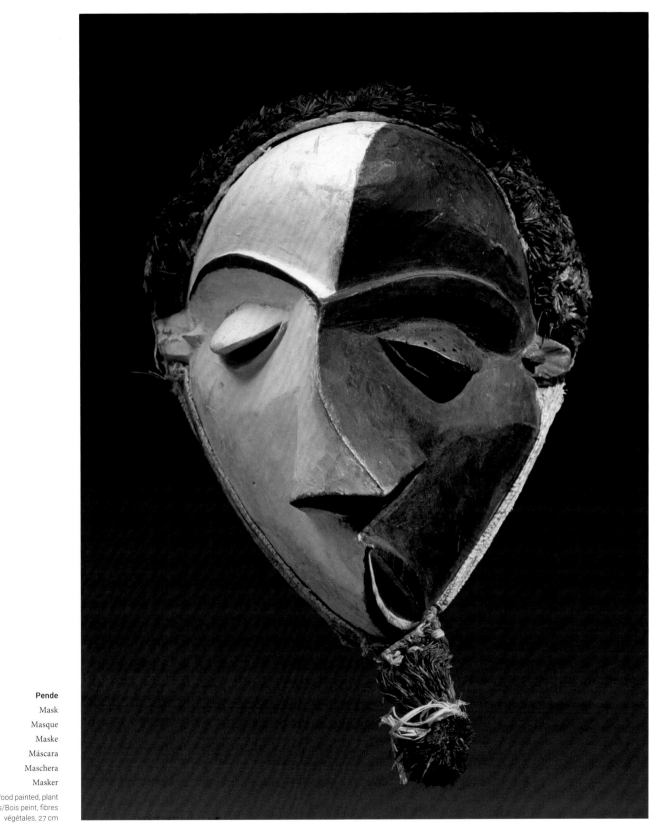

Pende

Mask

Masque

Maske

Máscara

Maschera

Masker

Wood painted, plant
fibres/Bois peint, fibres
végétales, 27 cm

233

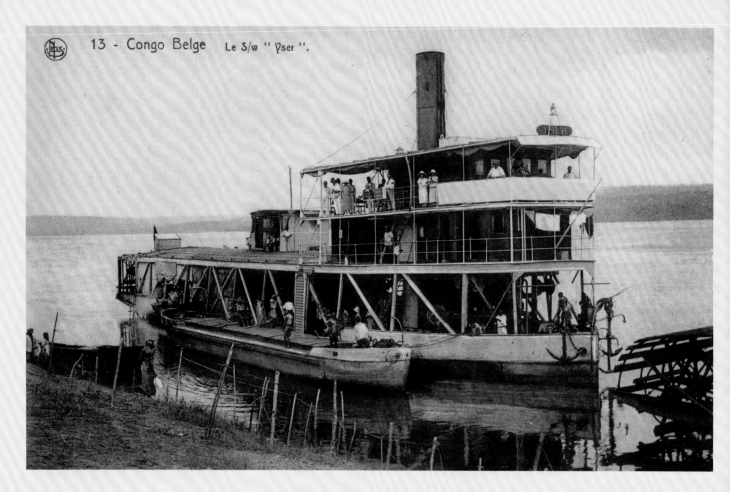

13 - Congo Belge Le S/w " Yser ".

Steam ship *(postcard)*
Bateau à vapeur *(carte postale)*
Dampfschiff *(Postkarte)*
Barco a vapor *(postal)*
Barca a vapore *(cartolina)*
Stoomschip *(ansichtkaart)*

Collecting

In earlier years, curiosities and rarities were collected in so-called chambers of art and wonders, including African art. Later, these objects reached museums, mainly ethnological and natural history collections; collectors and merchants started their own collections. Their acquisition was sometimes illegal. Ritual objects and objects of daily use were all catalogued as art objects. Most pieces shown here are listed in the museum archives without mentioning the artist. Person and name of the artist were unimportant for creation and use in many cultures; also Europeans had no sense for documentation.

Collecte

Autrefois, on collectionnait des curiosités et des raretés – dont des objets de l'art africain – que l'on exposait dans les biens nommés cabinets de curiosités. Puis les objets ont pris le chemin des musées, principalement des collections ethnographiques et d'histoire naturelle. Les collectionneurs et les marchands ont constitué leurs propres collections. Les acquisitions se faisaient en partie illégalement Les objets usuels et rituels étaient tous catalogués comme œuvres d'art, sans aucune distinction. La plupart des pièces présentées ici sont répertoriées dans les livres d'inventaires des musées sans mention de l'artiste. Dans de nombreuses cultures, le nom de l'artiste était sans importance pour la production et l'utilisation, et les Européens n'avaient de surcroît aucun sens de la documentation.

Sammeln

Früher sammelte man Kuriositäten und Raritäten in sogenannten Kunst- und Wunderkammern, darunter auch Kunst aus Afrika. Später kamen die Dinge in die Museen, zumeist völkerkundliche und naturhistorische Sammlungen; Sammler und Händler legten eigene Kollektionen an. Teilweise war der Erwerb unrechtmäßig. Alltags- und Ritualgegenstände wurden gemeinsam ohne Unterscheidung mit Kunstwerken erfasst. Die meisten der hier abgebildeten Stücke sind ohne Namen der Schöpfer in den Inventarbüchern der Museen verzeichnet. Person und Name des Künstlers war in vielen Kulturen unbedeutend für Herstellung und Gebrauch; Europäer hatten darüber hinaus keinen Sinn für eine Dokumentation.

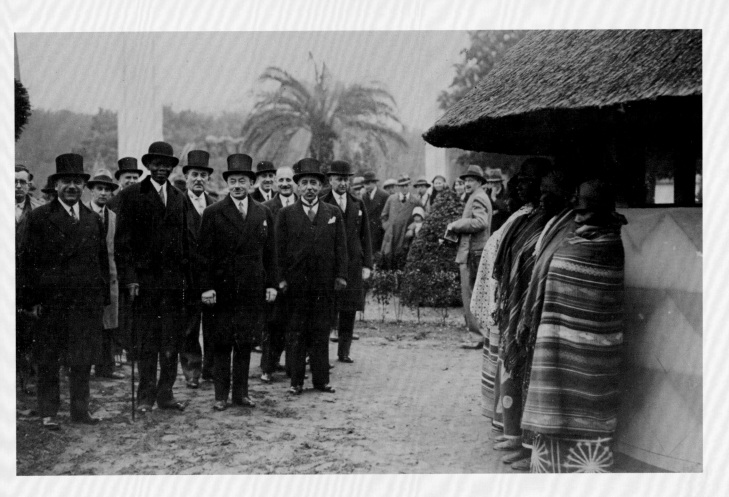

Colonial exhibition Paris
Exposition coloniale de Paris
Kolonialausstellung Paris
Exposición colonial París
Esposizione coloniale di Parigi
Expositie over de koloniën te Parijs
1931

Coleccionar

Antes se coleccionaban curiosidades y objetos peculiares en los llamados cuartos de maravillas y gabinetes de curiosidades, entre otros también el arte africano. Más tarde, los objetos llegaron a los museos, principalmente a colecciones etnológicas y de historia natural; coleccionistas y comerciantes crearon algunas de estas colecciones. Estas adquisiciones fueron parcialmente ilegítimas. Objetos cotidianos y rituales se registraron como obras de arte de manera conjunta y sin ningún tipo de distinción. La mayoría de las piezas aquí presentadas aparecen en los inventarios de los museos sin el nombre de su creador. El nombre y la persona del artista tenían, en muchas culturas, poca importancia para la creación y uso, y los europeos no tenían ningunaintención de documentarlo.

Collezionismo

Anticamente si collezionavano oggetti curiosi o rari, tra cui opere dell'arte africana, nelle cosiddette camere delle meraviglie. In seguito gli oggetti iniziarono ad essere esposti nei musei, per lo più in collezioni etnografiche e di storia naturale, e spesso i collezionisti e i commercianti esponevano le proprie collezioni. La loro acquisizione era a volte illegale. Nelle mostre venivano inclusi oggetti di uso quotidiano e rituale, senza alcuna distinzione delle opere d'arte. La maggior parte dei pezzi mostrati in questo libro è elencata negli inventari dei musei senza il nome dell'autore. In molte culture, la persona e il nome dell'artista era insignificante ai fini della produzione e dell'uso; inoltre, gli europei non avevano alcuno spirito di documentazione.

Verzamelaars

Vroeger werden curiosa en rariteiten verzameld in zogenaamde Wunderkammern, waaronder ook kunst uit Afrika. Later werden deze voorwerpen in musea tentoongesteld, vooral in volkenkundige en natuurhistorische collecties; verzamelaars en handelaars legden ook eigen collecties aan, deels van gestolen objecten. Alledaagse en rituele voorwerpen werden zonder onderscheid samen met kunstwerken getoond. De meeste van de hier afgebeelde stukken zijn dan ook zonder de naam van de kunstenaar in museumcatalogi opgenomen. In veel culturen waren de persoon en de naam van de kunstenaar onbelangrijk voor de vervaardiging en het gebruik van het kunstwerk; bovendien waren de Europeanen nog niet gericht op het documenteren van deze voorwerpen.

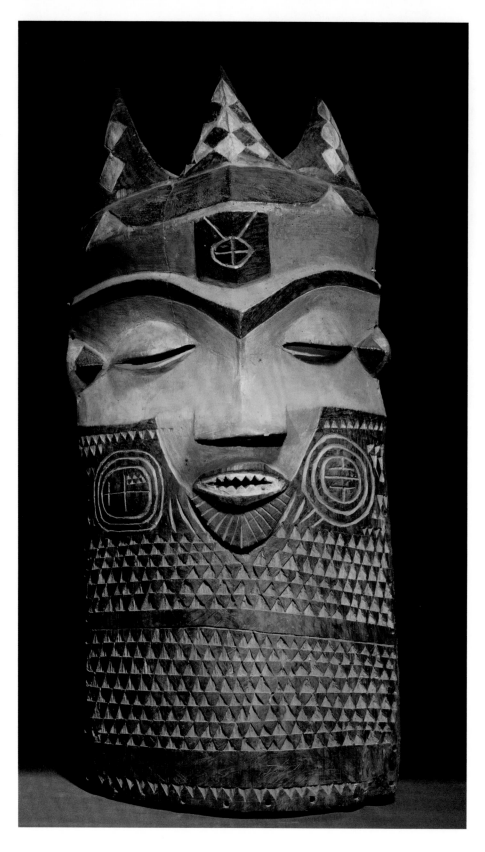

Pende

Mask

Masque

Maske

Máscara

Maschera

Masker

tWood painted/Bois peint, 95 cm

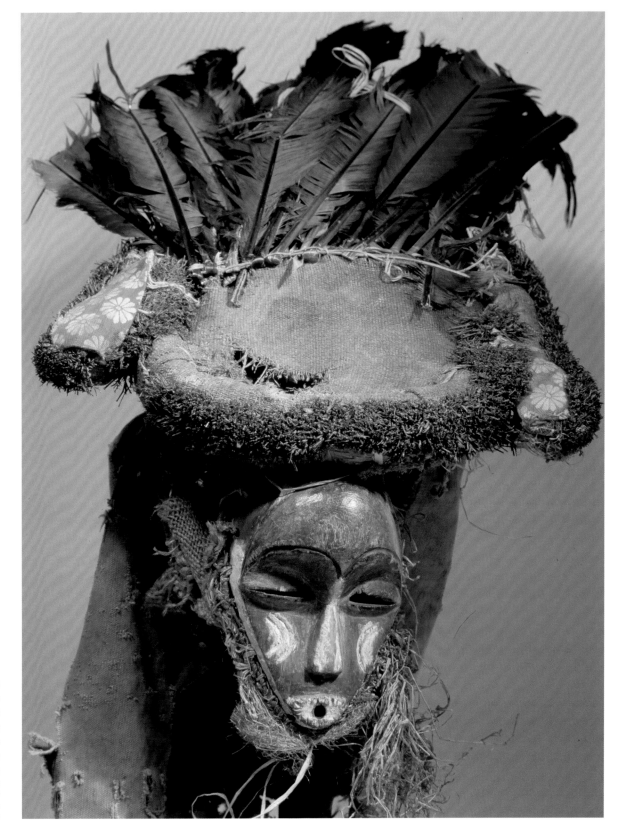

Pende

Mask

Masque

Maske

Máscara

Maschera

Masker

Wood painted, plant
fibres, feathers, cloth/
Bois peint, fibres
végétales, plumes, tissu

237

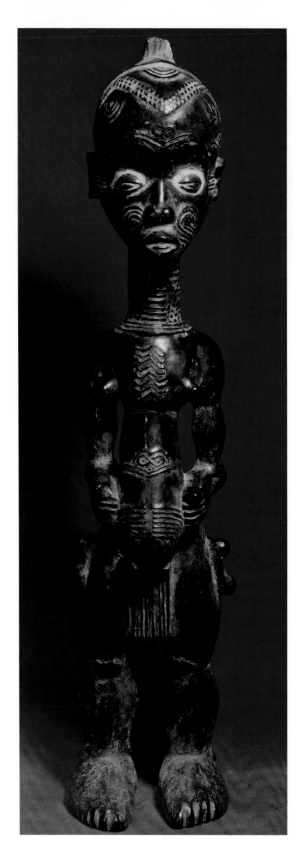

Luluwa

Female fertility figurine

Figure féminine de la fertilité

Weibliche
Fruchtbarkeitsfigur

Figura femenina
de la fertilidad

Figura femminile
della fertilità

Vrouwelijke
vruchtbaarheidsfiguur

Wood/Bois, 46,5 cm

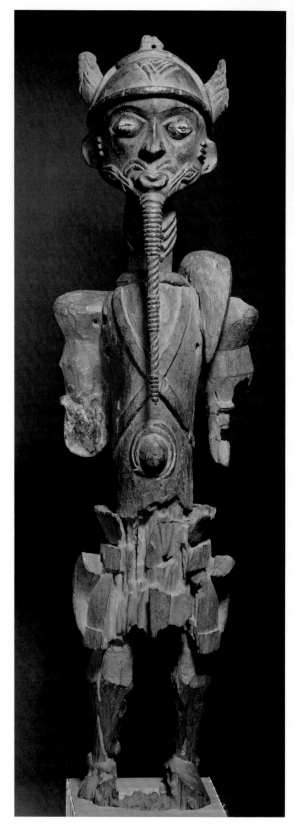

Luluwa

Male figurine

Figurine masculine

Männliche Figur

Figura masculina

Figura maschile

Mannenfiguur

Wood/Bois, 76,5 cm

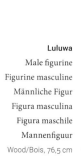

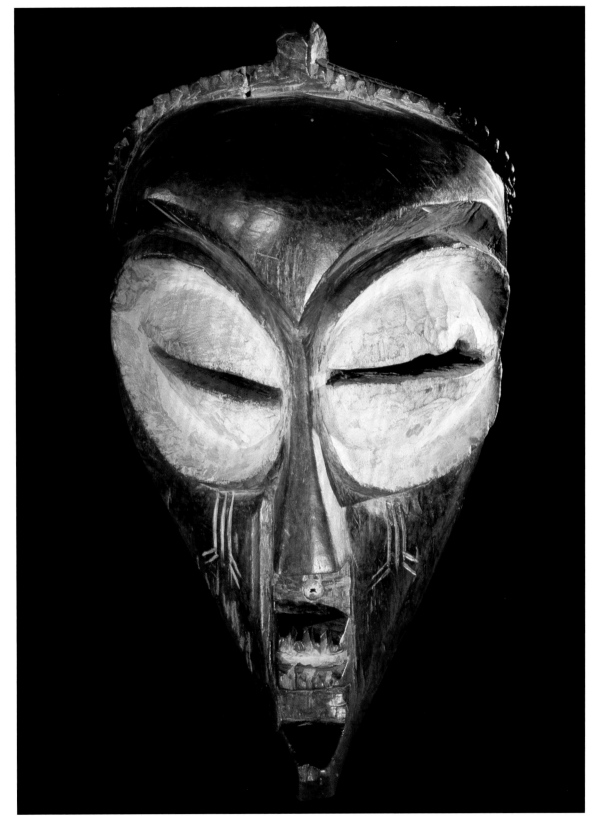

Mbagani
Mask
Masque
Maske
Máscara
Maschera
Masker
Wood/Bois

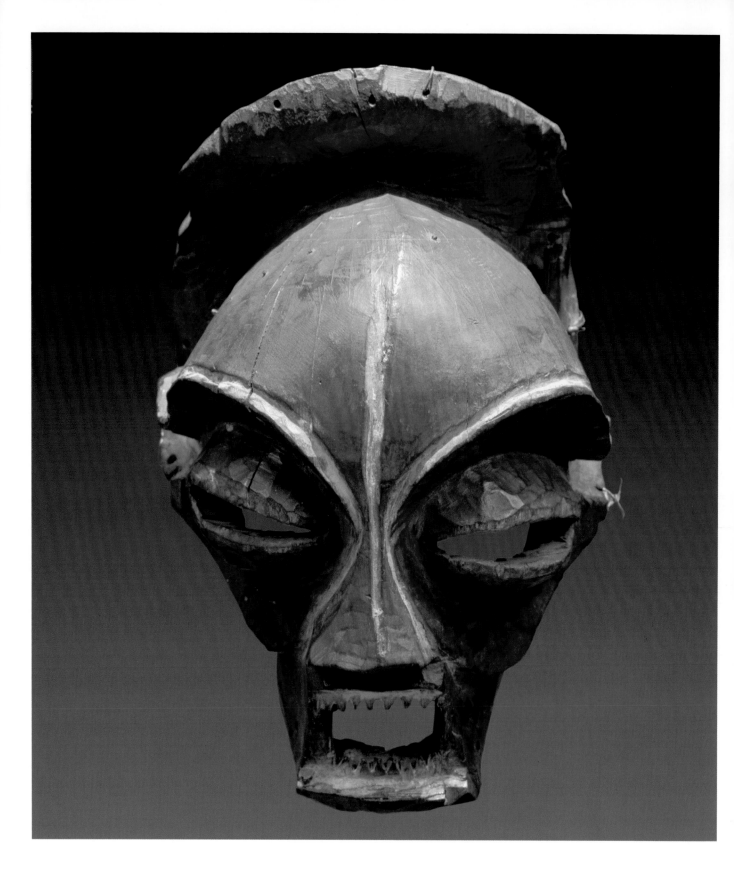

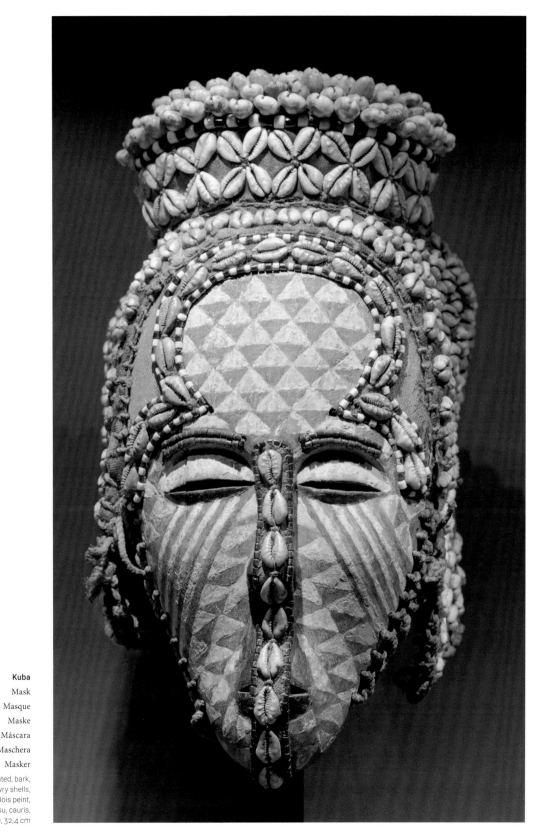

Bindji

Mask

Masque

Maske

Máscara

Maschera

Masker

Wood painted/
Bois peint, 30 cm

Kuba

Mask

Masque

Maske

Máscara

Maschera

Masker

Wood painted, bark,
cloth, string, cowry shells,
glass pearls/Bois peint,
écorce, tissu, cauris,
perles de verre, 32,4 cm

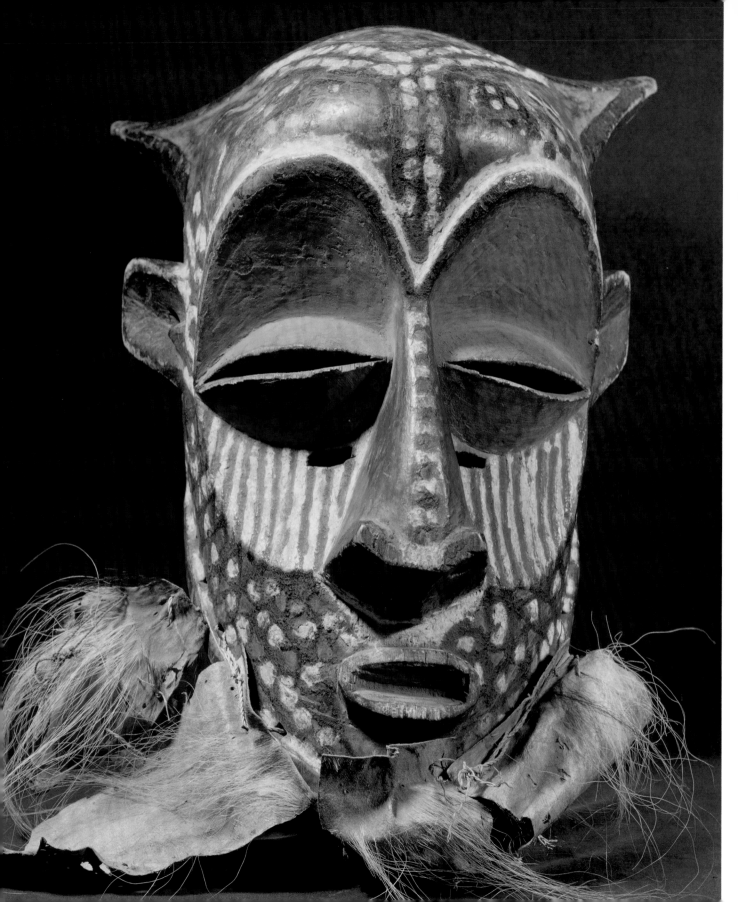

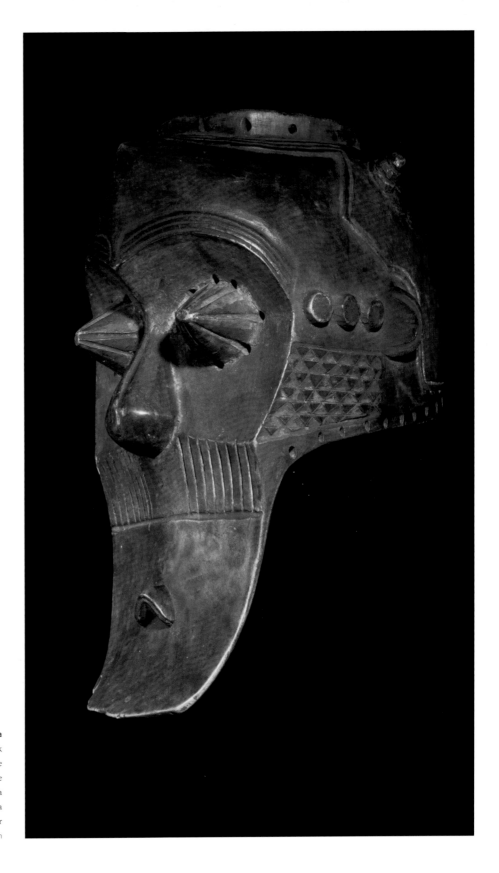

Kuba

Mask

Masque

Maske

Máscara

Maschera

Masker

Wood painted, leather/
Bois peint, cuir, 45,9 cm

Kuba

Mask

Masque

Maske

Máscara

Maschera

Masker

Wood/Bois, 38,5 cm

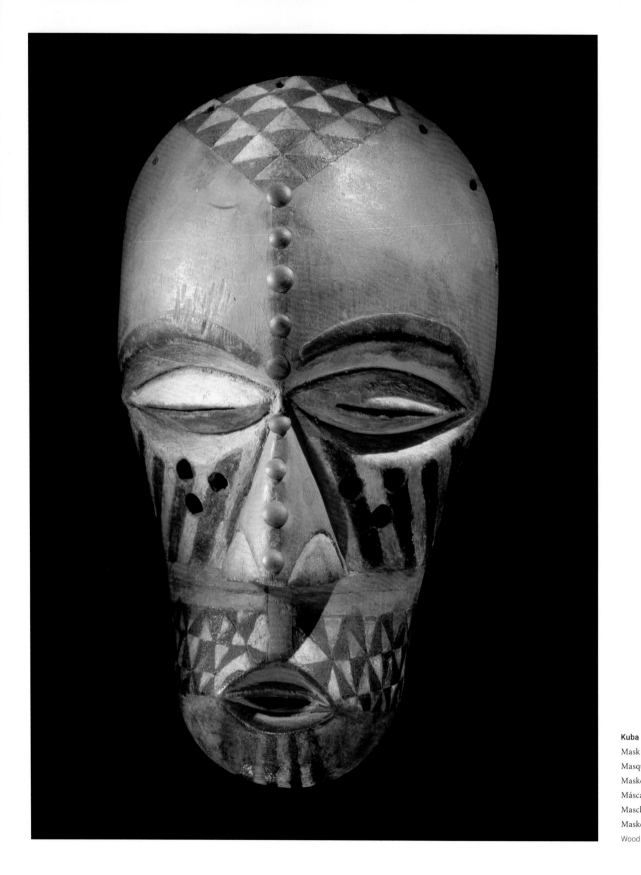

Kuba
Mask
Masque
Maske
Máscara
Maschera
Masker
Wood painted/Bois peint

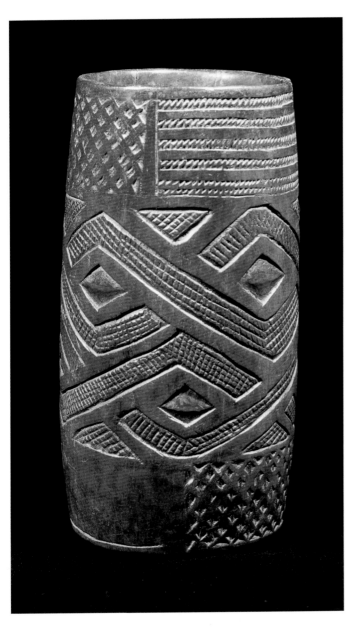

Kuba

Cup with geometrical design

Gobelet avec motif géométrique

Becher mit geometrischem Muster

Copa con motivos geométricos

Bicchiere con motivo geometrico

Beker met geometrisch patroon

Wood/Bois, 18,4 cm

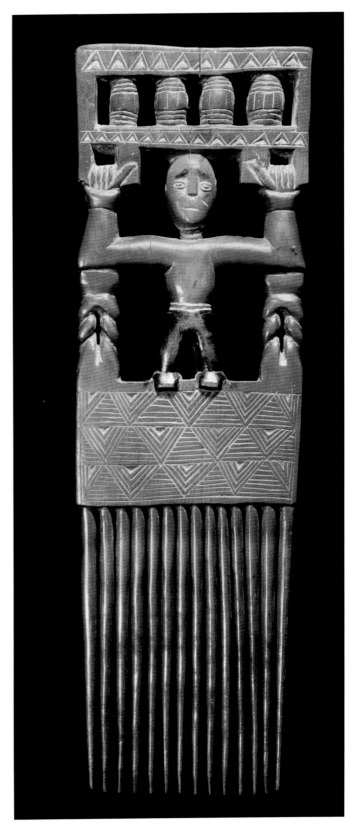

Kuba

Prestige comb

Peigne d'apparat

Prunkkamm

Peine

Pettinino

Pronkkam

Wood/Bois, 37,5 cm

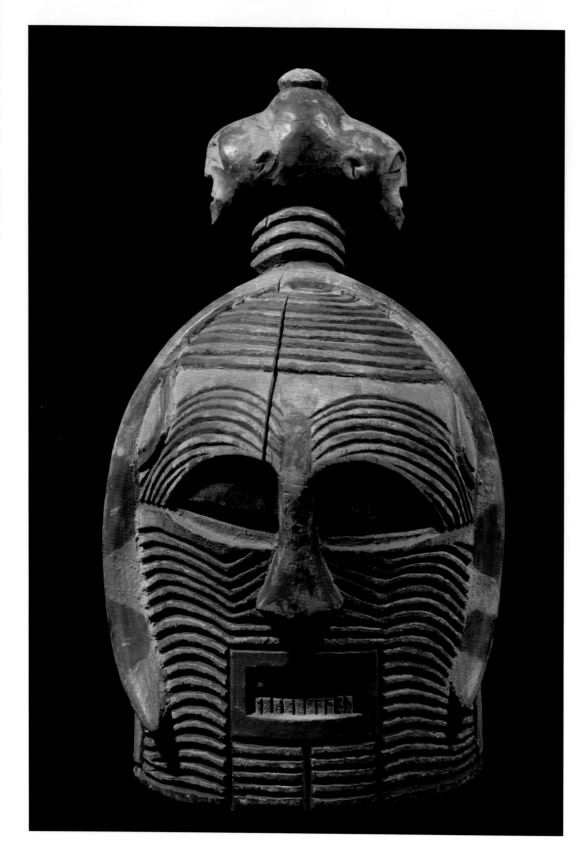

Tetela

Helmet mask

Masque casque

Helmmaske

Máscara-casco

Maschera ad elmo

Gehelmd masker

Wood/Bois, 48 cm

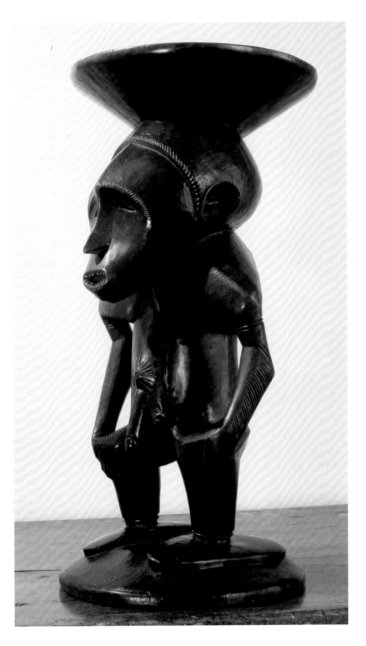

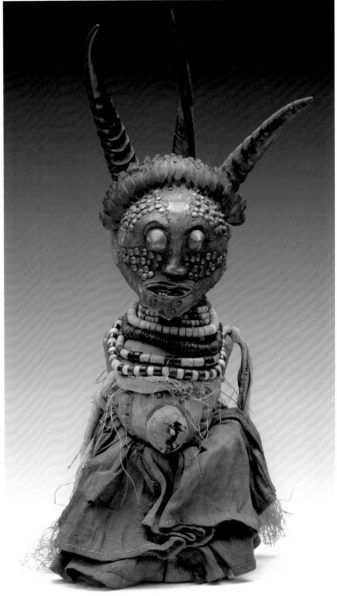

Zimba

Female carrying figurine

Figurine de femme porteuse

Weibliche Tragefigur

Cariátide

Figura femminile portante

Figuur van draagster

Songye

Nkisi-figurine

Figurine *Nkisi*

Nkisi-Figur

Figura *Nkisi*

Figura *Nkisi*

Nkisi-figuur

Wood, metal, pearls, leather, cloth, horn/Bois, métal, perles, cuir, tissu, corne, 65 cm

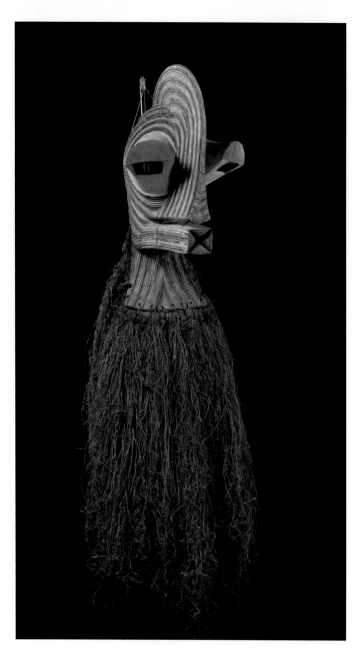

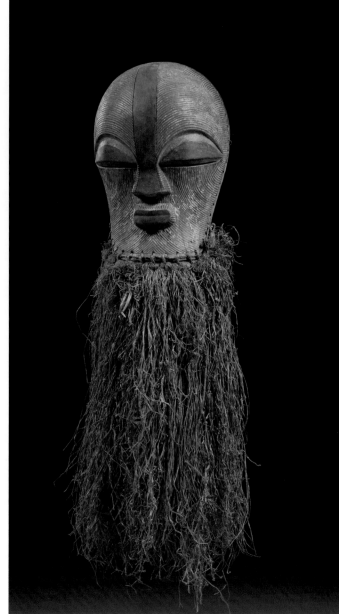

Songye

Male mask

Masque d'homme

Männermaske

Máscara de hombre

Maschera maschile

Mannenmasker

Wood painted, bast/Bois peint, raphia, 63 cm

Songye

Female mask

Masque de femme

Frauenmaske

Máscara de mujer

Maschera femminile

Vrouwenmasker

Wood painted, bast/Bois peint, raphia, 44 cm

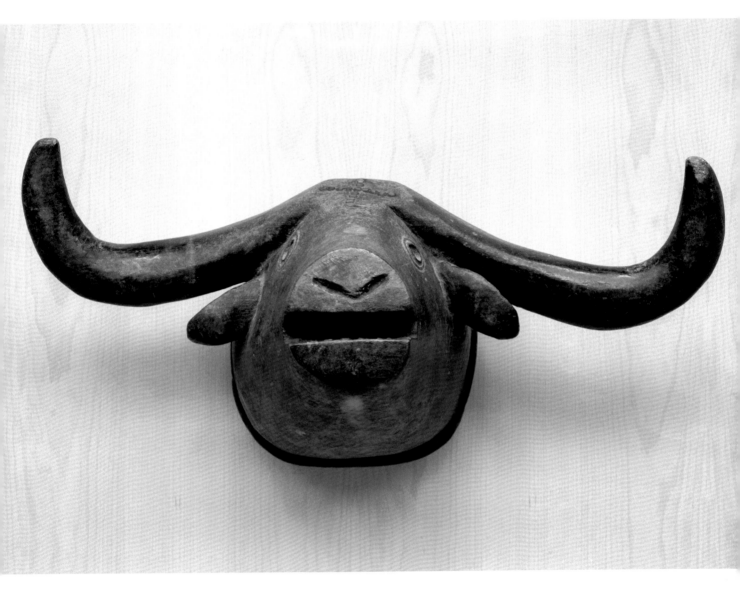

Tabwa
Buffalo mask
Masque de buffle
Büffelmaske
Máscara de búfalo
Maschera a forma di bufalo
Buffelmasker
Wood, nails/Bois, clous, 39 × 69 cm

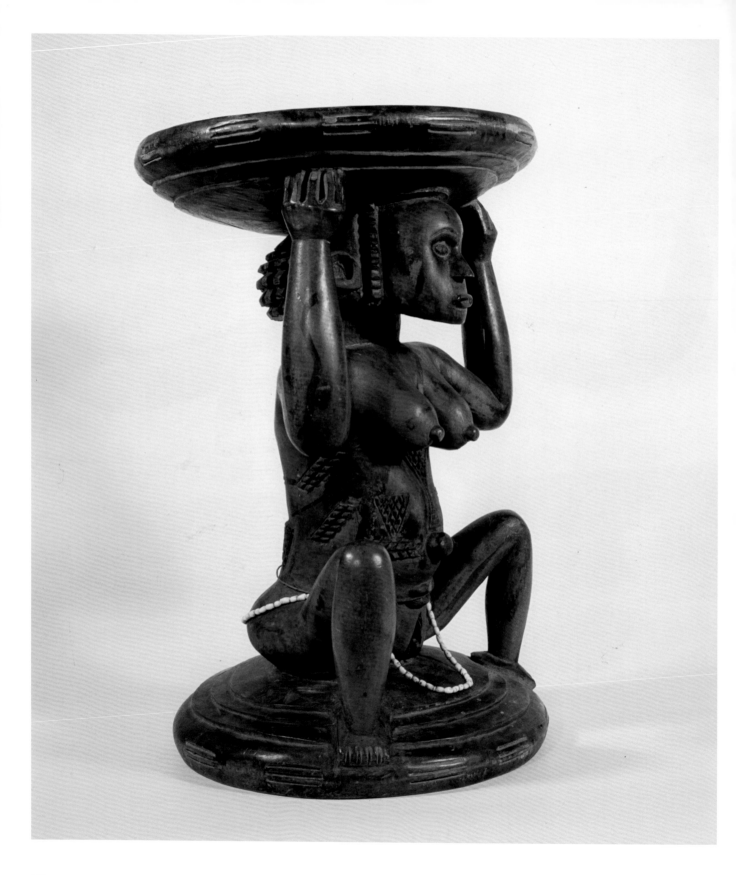

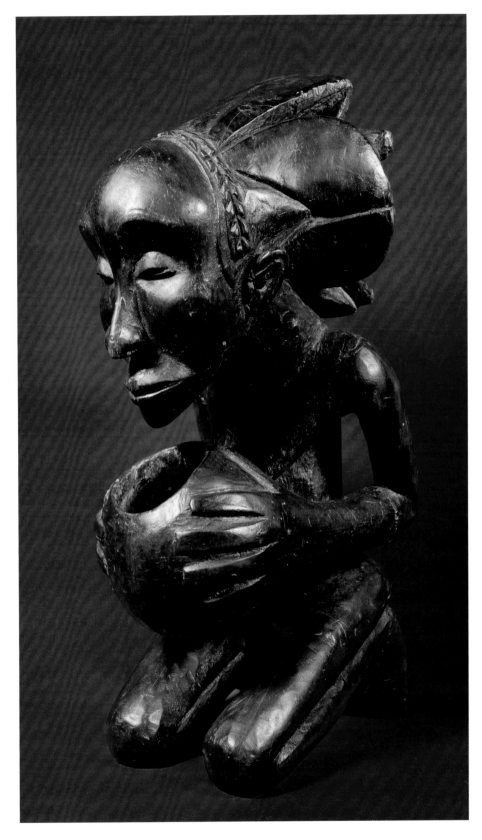

Luba

Meister von Buli

Seat with female figurine

Tabouret avec figure
de femme porteuse

Hocker mit weiblicher
Tragefigur

Taburete con cariátide

Sgabello con figura
femminile portante

Krukje met figuur
van draagster

Wood/Bois

Luba

Buli-Werkstatt

Vessel holder, female

Femme tenant un récipient

Gefäßhalterin

Sostenedora de recipiente

Figura femminile che
sorregge un vaso

Vrouwenfiguur met pot

Wood/Bois, 44 cm

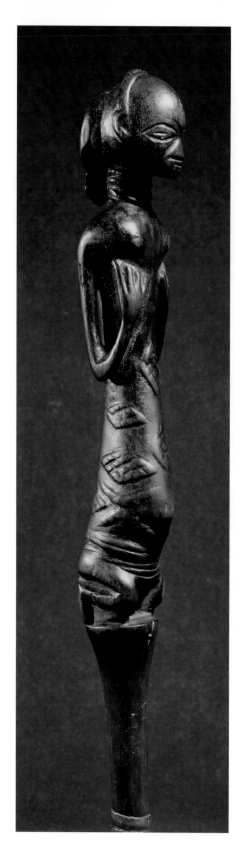

Luba

Cane with kneeling female

Canne avec figure de
femme agenouillée

Stabknauf mit knieender
Frauenfigur

Remate de bastón con
figura de mujer arrodillada

Impugnatura di un
bastone con figura
femminile inginocchiata

Stafknop met knielende
vrouwenfiguur

Wood/Bois, 46 cm

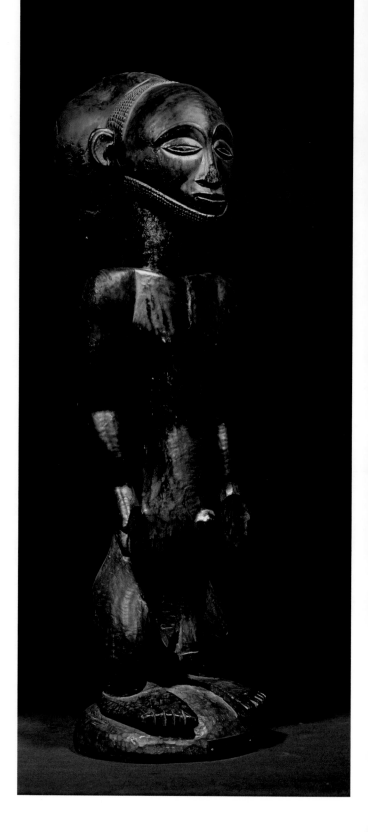

Luba

Ancestry figurine

Figurine d'ancêtre

Ahnenfigur

Figura de antepasado

Figura di antenato

Voorouderfiguur

Wood patinised/
Bois patiné, 70 cm

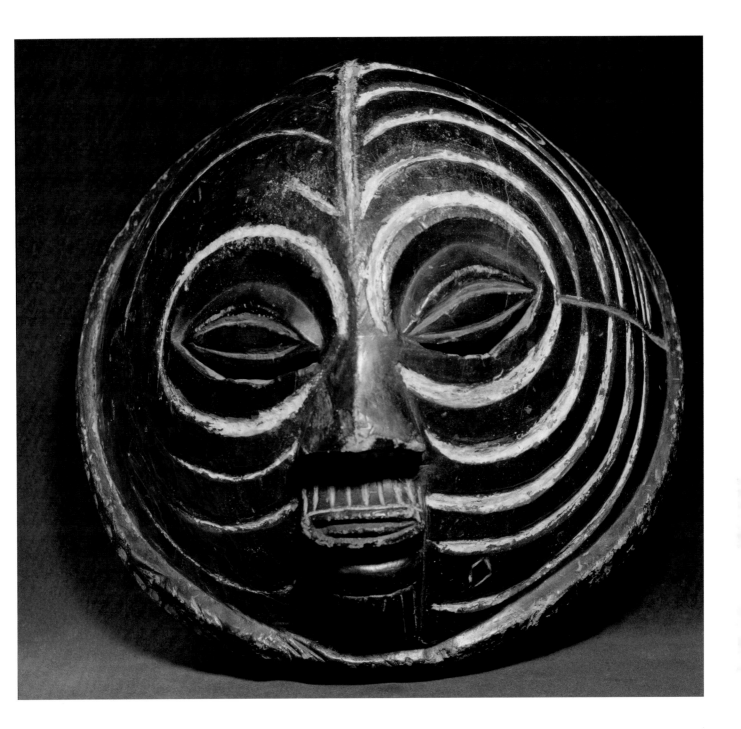

Luba

Mask

Masque

Maske

Máscara

Maschera

Masker

Wood/Bois, 37 cm

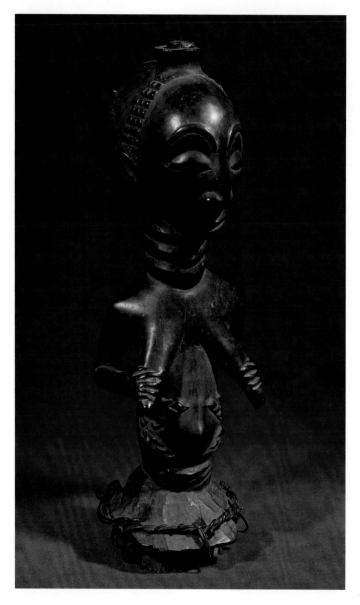

Hemba
Female ancestry figurine
Figurine d'ancêtre féminin
Weibliche Ahnenfigur
Figura de antepasado femenina
Figura femminile di antenata
Vrouwelijke voorouderfiguur
Wood patinised/Bois patiné, 27 cm

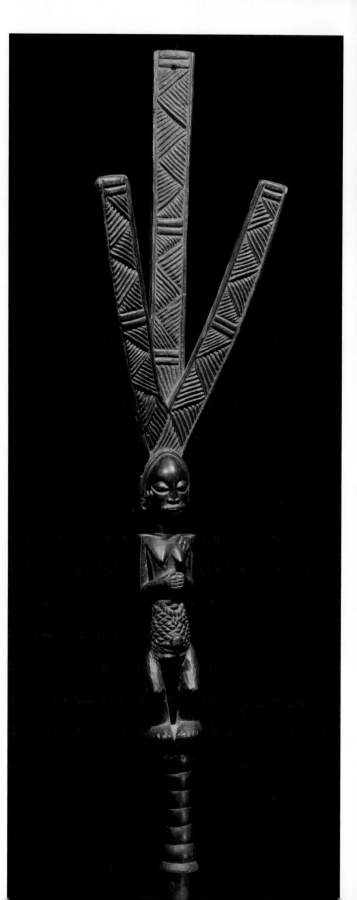

Hemba
Arrow holder
Carquois
Pfeilhalter
Soporte para pipa
Reggifreccia
Pijlhouder
Wood patinised/Bois patiné, 108,5 cm

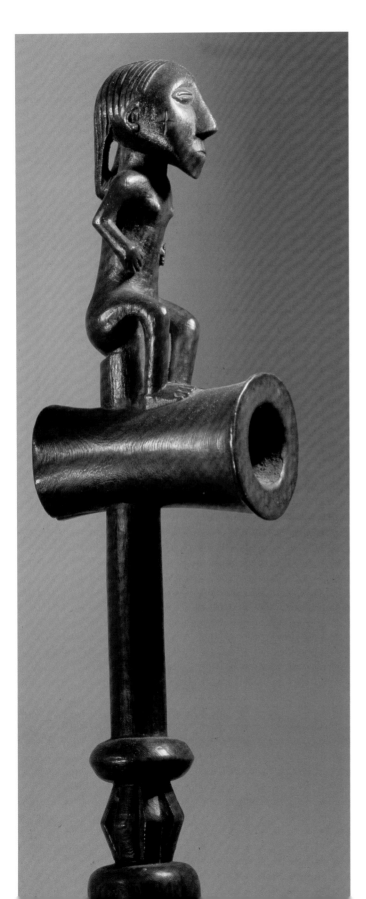

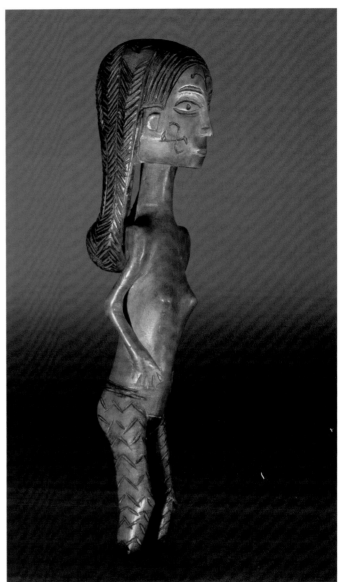

Mbundu

Pipe with female

Pipe avec figure de femme

Pfeife mit Frauenfigur

Silbato con figura de mujer

Pipa con figura femminile

Pijp met vrouwenfiguur

Wood, metal/Bois, métal

Ovimbundu

Female figurine (life cycle)

Figurine féminine (représentation
du cycle de vie)

Weibliche Figur (Darstellung
des Lebenszyklus)

Figura de mujer (representación
del ciclo vital)

Figura femminile (rappresentazione
del ciclo della vita)

Vrouwenfiguur (uitbeelding
van de levenscyclus)

Wood/Bois

KENYA
TANZANIA
MOÇAMBIQUE
SOUTH AFRICA

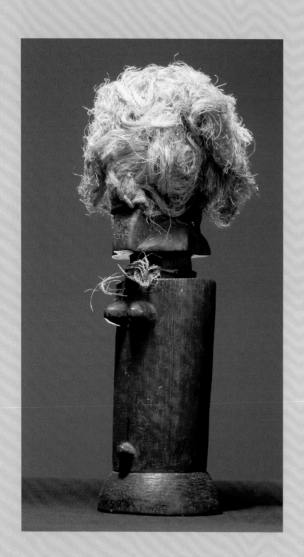

Zaramo
Figurine for girl's initiation
Figurine pour l'initiation des jeunes filles
Figur für die Initation der Mädchen
Figura para la iniciación de jóvenes
Figura per l'iniziazione delle ragazze
Initiatiefiguur voor meisjes

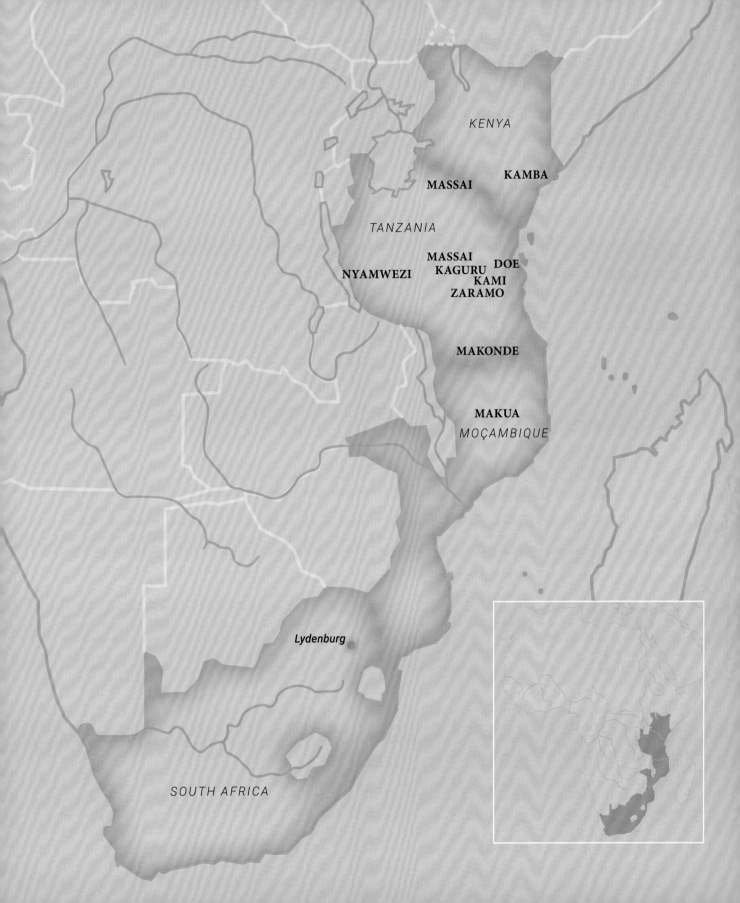

KENYA

KAMBA

MASSAI

TANZANIA

MASSAI
KAGURU DOE
NYAMWEZI KAMI
ZARAMO

MAKONDE

MAKUA
MOÇAMBIQUE

Lydenburg

SOUTH AFRICA

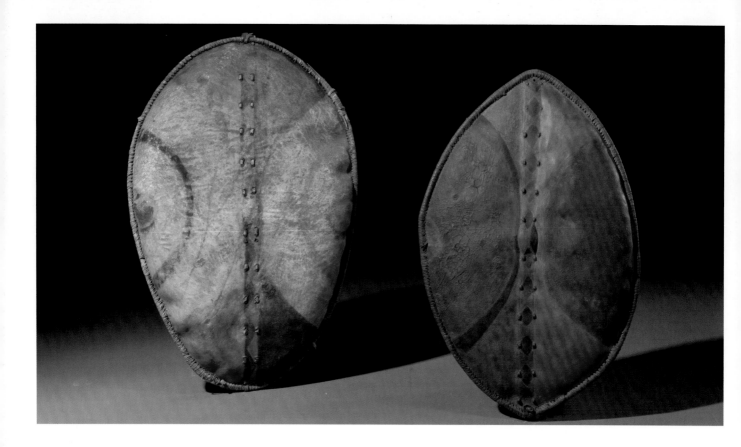

"Eastern Africa has no art". This incorrect perception was formed during colonial times. Compared to other regions there were hardly any courtly art or large sculptures, but rather artful objects of daily use. Especially the slave trade and the colonial times formed social structures in the 19th century. People lived in small communities. Relatively few Eastern African pieces have been documented and scientifically analysed until present times. Well known are the masks of the Makonde from Mozambique.

« Il n'y a pas d'art en Afrique de l'Est ». Ce malentendu est né pendant la période coloniale. Comparativement à d'autres régions, il n'y avait pas d'art courtois, ni de grandes sculptures, mais des objets usuels très astucieux. Au 19e siècle, c'est surtout la traite des esclaves et la domination coloniale qui ont façonné les structures sociales. Les gens vivaient dans de petites communautés. Il y a à ce jour relativement peu de pièces d'Afrique de l'Est documentées et étudiées scientifiquement. Les plus connues sont les masques des Makondés du Mozambique.

„Es gibt keine Kunst in Ostafrika." Diese falsche Wahrnehmung entstand in der Kolonialzeit. Im Vergleich zu anderen Regionen gab es kaum höfische Kunst oder große Skulpturen, dafür kunstvolle Alltagsgegenstände. Vor allem der Sklavenhandel und die Kolonialherrschaft prägten die gesellschaftlichen Strukturen im 19. Jahrhundert. Die Menschen lebten eher in kleineren Gemeinschaften zusammen. Bis heute sind verhältnismäßig wenige ostafrikanische Stücke dokumentiert und wissenschaftlich bearbeitet worden. Am bekanntesten sind die Masken der Makonde aus Mosambik.

"No hay arte en el África oriental". Esta percepción errónea proviene de los tiempos coloniales. Comparada con otras regiones, casi no hubo arte de la corte o grandes esculturas, pero sí que había objetos cotidianos artísticos. Las estructuras sociales del XIX estuvieron marcadas sobre todo por el comercio de esclavos y el poder colonial. Las personas vivían juntas en pequeñas comunidades. Todavía a día de hoy hay, en comparación, pocas obras del África oriental documentadas y trabajadas por investigadores. Las más conocidas son las máscaras de los Makonde en Mozambique.

"L'Africa orientale è priva d'arte." Questa errata percezione affonda le sue radici nel periodo coloniale. Rispetto ad altre regioni, mancano quasi completamente l'arte di corte e grandi sculture, ma gli oggetti di uso quotidiano di carattere artistico sono numerosi. Le strutture sociali furono create nel XIX secolo soprattutto a seguito della tratta degli schiavi e del dominio coloniale. Prima di ciò la gente viveva infatti insieme in comunità più piccole. Fino ad oggi, sono stati documentati e studiati scientificamente relativamente pochi pezzi dell'Africa orientale. I più noti sono le maschere dei Makonde del Mozambico.

"Oost-Afrika kent geen kunst." Deze onjuiste observatie ontstond in de koloniale tijd. In vergelijking tot andere regio's werden hier namelijk nauwelijks creaties van hofkunst of grotere beeldhouwwerken aangetroffen, maar wel veel kunstig vervaardigde gebruiksvoorwerpen. In de negentiende eeuw werden de sociale structuren vooral bepaald door de slavenhandel en het koloniale bestuur. De mensen woonden in kleinere gemeenschappen en tot op de dag van vandaag zijn er relatief weinig Oost-Afrikaanse kunstwerken gedocumenteerd en wetenschappelijk onderzocht. Het bekendst zijn de maskers van de Makonde van Mozambique.

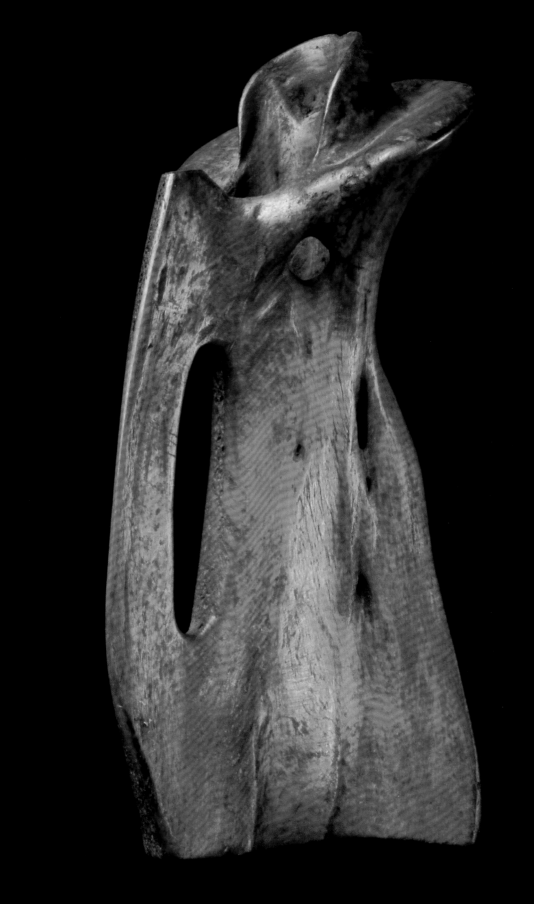

Massai

Shields

Boucliers

Schilde

Escudos

Scudi

Schilden

Leather, wood, painted/
Cuir, Bois, peint, 104 × 70 cm

Massai

Tobacco pipe

Pipe

Tabakpfeife

Pipa de tabaco

Pipa per tabacco

Tabakspijp

Bones/Os

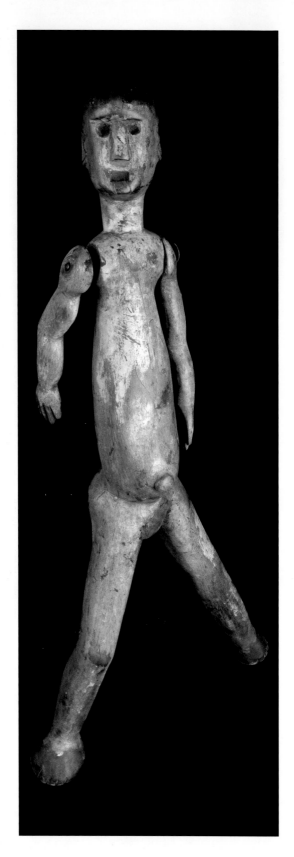

Nyamwezi

Anthropomorphic figurine

Figure anthropomorphe articulée

Anthropomorphe Gliederfigur

Figura antropomórfica con
extremidades móviles

Figura antropomorfa
di un membro

Antropomorfe pop

Wood painted/Bois peint

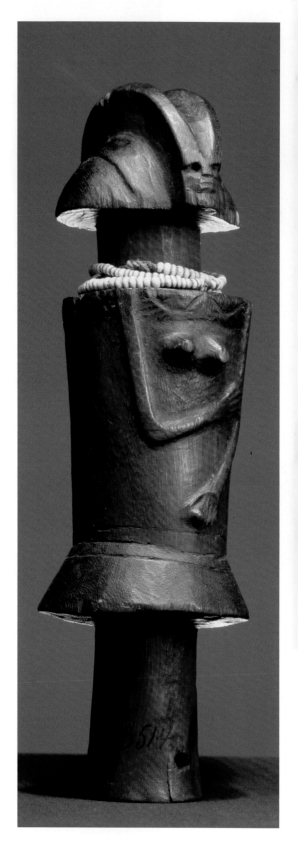

Zaramo

Figurine for girl's initiation

Figurine pour l'initiation
des jeunes filles

Figur für die Initation
der Mädchen

Figura para la iniciación
de jóvenes

Figura per l'iniziazione
delle ragazze

Initiatiefiguur voor meisjes

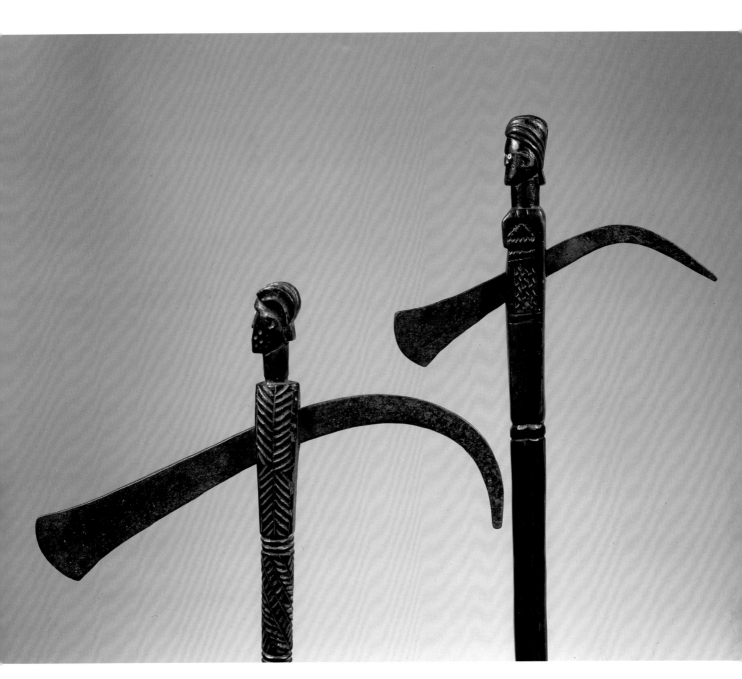

Zaramo

Axes

Haches

Äxte

Hachas

Asce

Bijlen

Wood/Bois

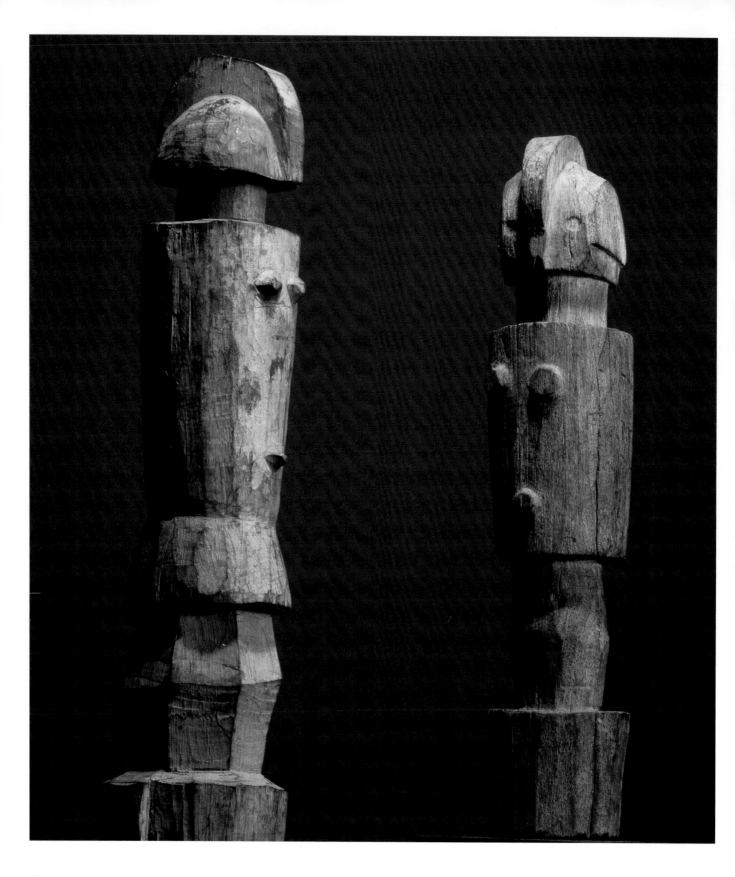

Zaramo

Reliquary guard

Gardien du reliquaire

Reliquiarwächter

Guardián de relicario

Guardiano delle reliquie

Reliekwachters

Wood/Bois, 29,8–35,3 cm,
Ethnologisches Museum,
Berlin

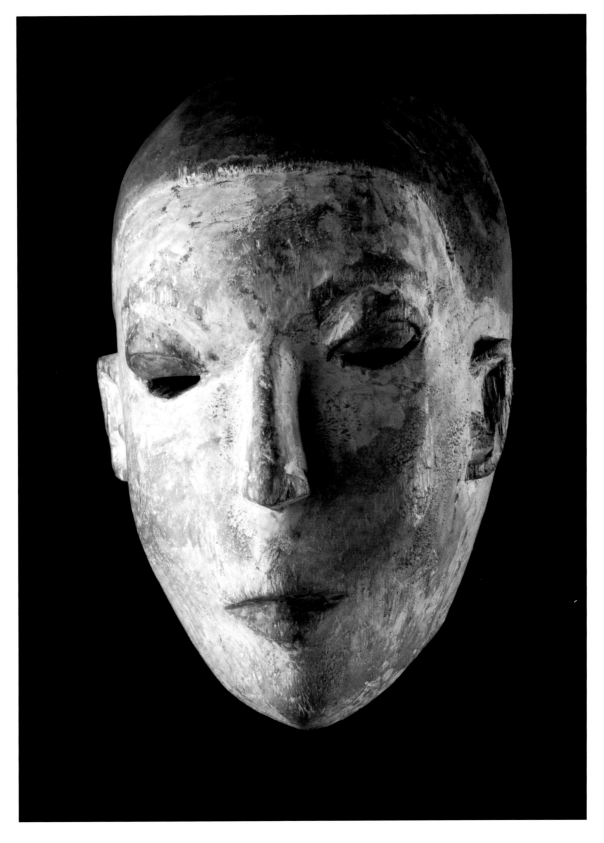

Makua

Mask

Masque

Maske

Máscara

Maschera

Masker

Wood/Bois

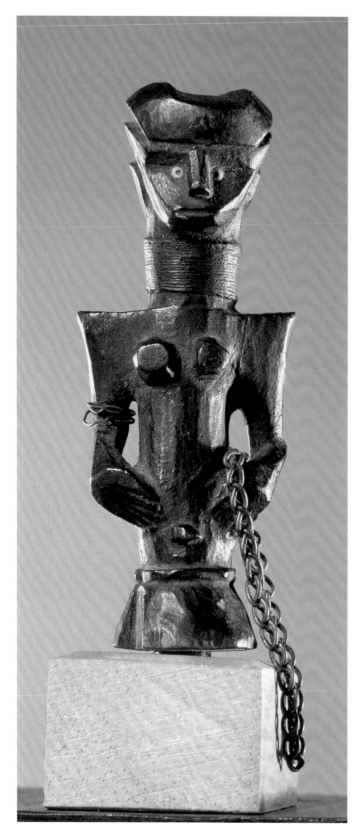

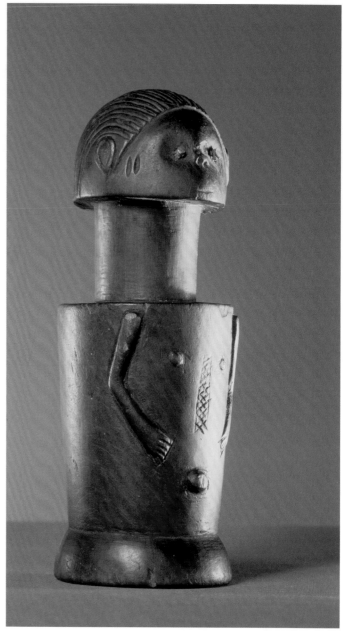

Kami

Figurine for girl's initiation

Figurine pour l'initiation des jeunes filles

Figur für die Initation der Mädchen

Figura para la iniciación de jóvenes

Figura per l'iniziazione delle ragazze

Initiatiefiguur voor meisjes

Wood/Bois, 19 cm, Ethnologisches Museum, Berlin

Doe

Figurine for girl's initiation

Figurine pour l'initiation des jeunes filles

Figur für die Initation der Mädchen

Figura para la iniciación de jóvenes

Figura per l'iniziazione delle ragazze

Initiatiefiguur voor meisjes

Wood, metal/Bois, métal, 7,6 cm,
Ethnologisches Museum, Berlin

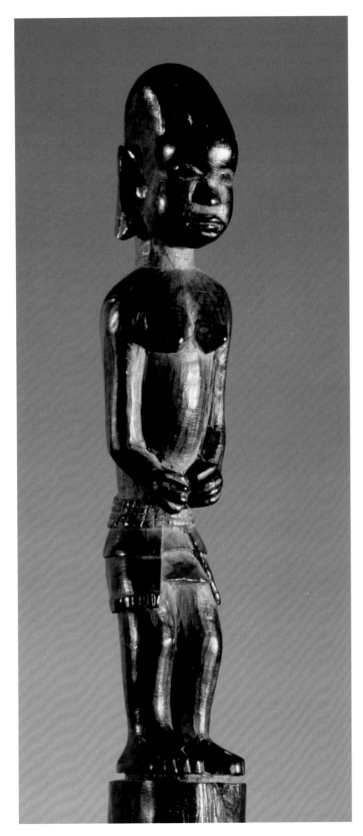

Makonde
Belly mask (pregnant)
Masque de ventre (femme enceinte)
Bauchmaske (Schwangere)
Máscara de tripa (embarazadas)
Maschera con pancione (incinta)
Buikmasker (zwangere vrouwen)
Wood painted/Bois peint, 68 cm

Kamba
Female figurine
Figure féminine
Weibliche Figur
Figura femenina
Figura femminile
Vrouwenfiguur
Wood/Bois, 12,7 cm

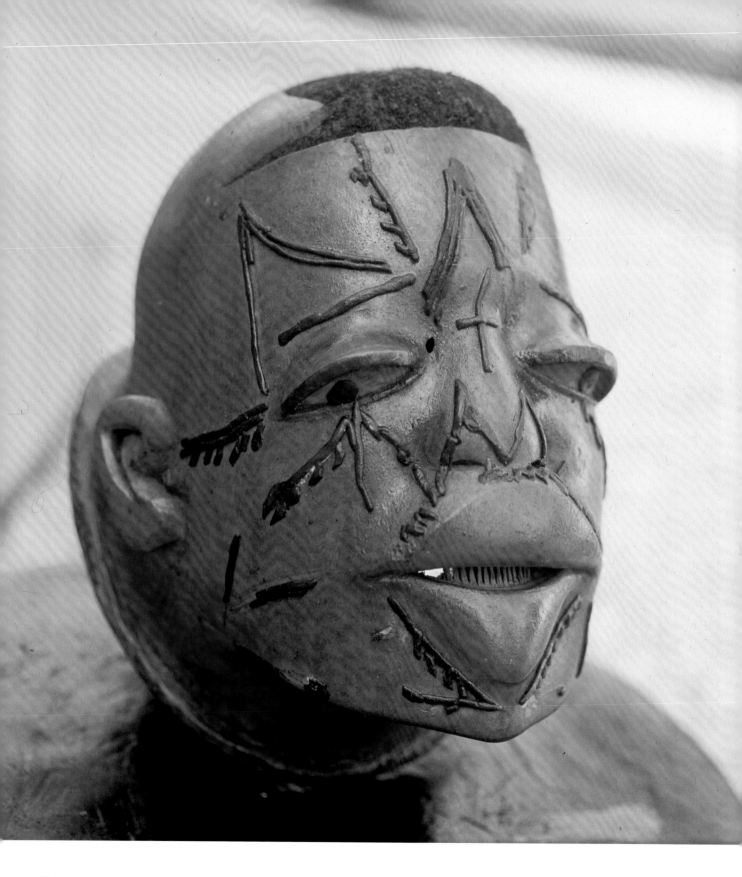

Makonde

Mask for boy's initiation

Masque pour l'initiation des garçons

Maske für die Initation der Jungen

Máscara para la iniciación de jóvenes

Maschera per l'iniziazione dei ragazzi

Initiatiemasker voor jongens

Wood, human hair/
Bois, cheveux humains, National Museum, Dar es Salaam

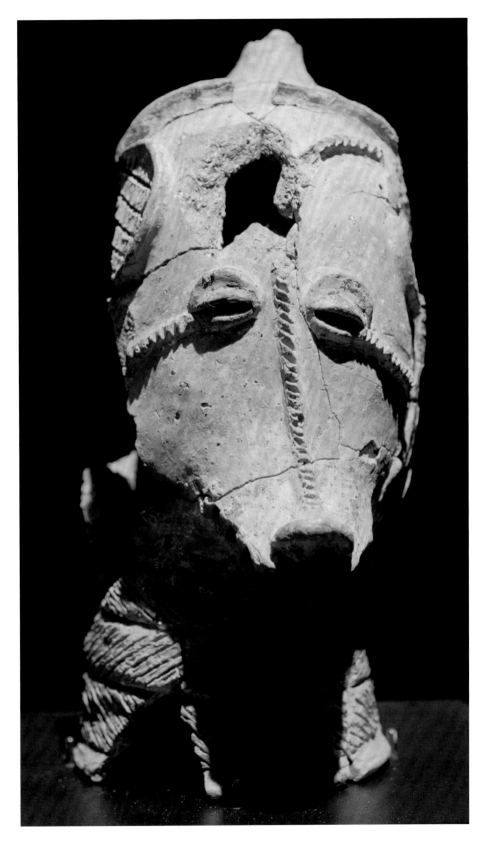

Lydenburg, Mpumalanga

Lydenburg Head

Tête Lydenburg

Lydenburg-Kopf

Cabeza de Lydenburg

Testa di Lydenburg

Lydenburg-kop

c. 500, Clay fired, coloured, iron/Terre cuite, couleur, fer,
24 × 12 × 18 cm, South African Museum, Cape Town

Bantu

Stone pictures

Pétroglyphes

Felsbilder

Petroglifos

Petroglifi

Rotstekeningen

C.2500 BC

Bamako, Mali

Outside ad of grill
restaurant

Publicité extérieure
d'un restaurant-grill

Außenwerbung eines
Grillrestaurants

Publicidad exterior
de un asador

Pubblicità esterna
di un ristorante con
specialità alla griglia

Buitenreclame van
een grillroom

2004

Painting

Painting is referred to as a "non-African" medium. There are, however, millennia-old stone and cave paintings in many locations on the continent. Many sculptures and objects of daily use were created in colour and painted. Wall paintings and shield decorative painting have a long tradition as well. In the 20th century and after decolonisation many artists changed to panel painting and worked on different subjects. George Lilanga is referred to as "African Picasso". He interprets traditional motives and rhythms of Makonde carvings in colourful stories of daily life.

Peinture

La peinture est considérée comme un médium « non africain ». On trouve pourtant sur tout le continent des peintures rupestres et sur bois vieilles de milliers d'années. De nombreuses sculptures et objets du quotidien étaient réalisés en couleur et peints de différentes couleurs. Les peintures murales et les panneaux décoratifs ont également une longue tradition. Au 20ᵉ siècle et après l'indépendance, de nombreux artistes se tournent vers la peinture de chevalet et traitent les sujets les plus variés. George Lilanga était surnommé le « Picasso d'Afrique ». Il a interprété les motifs traditionnels et les rythmes de la sculpture Makondé et mis en scène les histoires du quotidien dans des couleurs joyeuses.

Malerei

Malerei gilt als „unafrikanisches" Medium. Dabei finden sich an vielen Orten des Kontinents jahrtausendealte Fels- und Höhlenmalereien. Viele Skulpturen und Alltagsgegenstände wurden farbig gefasst und mit verschiedenen Farben bemalt. Wand- und Schildermalerei haben ebenso eine lange Tradition. Im 20. Jahrhundert und nach der Unabhängigkeit wenden sich viele Künstler der Tafelmalerei zu und bearbeiten unterschiedlichste Sujets. George Lilanga etwa wird der „Picasso Afrikas" genannt. Er interpretiert die traditionellen Motive und Rhythmen der Makonde-Schnitzerei in farbenfrohen Alltagsgeschichten.

Pintura

La pintura se considera un medio "no africano". Sin embargo, en muchos lugares del continente encontramos pinturas en cuevas y rocas con varios siglos de antigüedad. Muchas esculturas y objetos cotidianos se concibieron en color y se pintaron de diferentes tonos. La pintura mural o los rótulos tienen también una larga tradición. En el siglo XX, y tras la independencia, muchos artistas se dedicaron a la pintura en tabla y trataron los más diversos temas. George Lilanga, por ejemplo, es conocido como el "Picasso de África". Interpreta los motivos y ritmos tradicionales de las esculturas Makonde en historias cotidianas con vivos colores.

Pittura

La pittura è considerata un mezzo "non africano". Tuttavia, in molti angoli del continente possono essere ammirate pitture rupestri risalenti a migliaia di anni fa. Molte sculture e oggetti di uso quotidiano sono stati prodotti a colori e dipinti con colori diversi, e la pittura muraria e segnica vanta una tradizione altrettanto lunga. Nel XX secolo, dopo l'ottenimento dell'indipendenza, molti artisti iniziarono a dedicarsi alla pittura su cavalletto e a lavorare su soggetti diversi. George Lilanga, che ha reinterpretato i ritmi e i motivi tradizionali delle sculture Makonde in colorate storie quotidiane, è stato denominato il "Picasso d'Africa".

Schilderkunst

De schilderkunst wordt gezien als een 'on-Afrikaans' kunstmedium, hoewel er op talloze plekken op het continent duizenden jaren oude rotstekeningen en grotschilderingen zijn gevonden. Veel beeldhouwwerken en alledaagse voorwerpen werden in verschillende kleuren uitgevoerd en beschilderd. Ook muurschilderingen en schilderijen kennen een lange traditie. In de twintigste eeuw en na de dekolonisatie legden veel kunstenaars zich toe op paneelschilderingen en behandelden daarin zeer uiteenlopende onderwerpen. Zo wordt George Lilanga wel de 'Picasso van Afrika' genoemd; hij interpreteert traditionele motieven en ritmes uit de houtsnijkunst van de Makonde in kleurige genrestukken.

ARCHAEOLOGY
ARCHÉOLOGIE
ARCHÄOLOGIE
ARQUEOLOGÍA
ARCHEOLOGIA
ARCHEOLOGIE

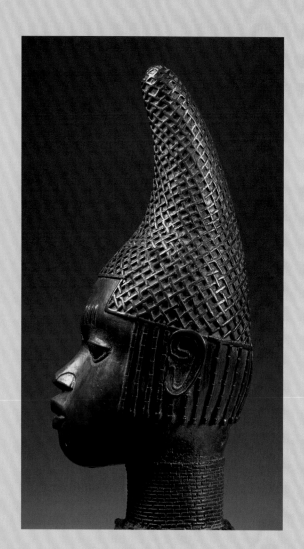

Benin

Head of a queen's mother

Tête d'une reine

Kopf einer Königinmutter

Cabeza de reina madre

Testa di una regina madre

Kop van een koningin-moeder

c.1515, Bronze, 52 cm, Nigerian National Museum, Lagos

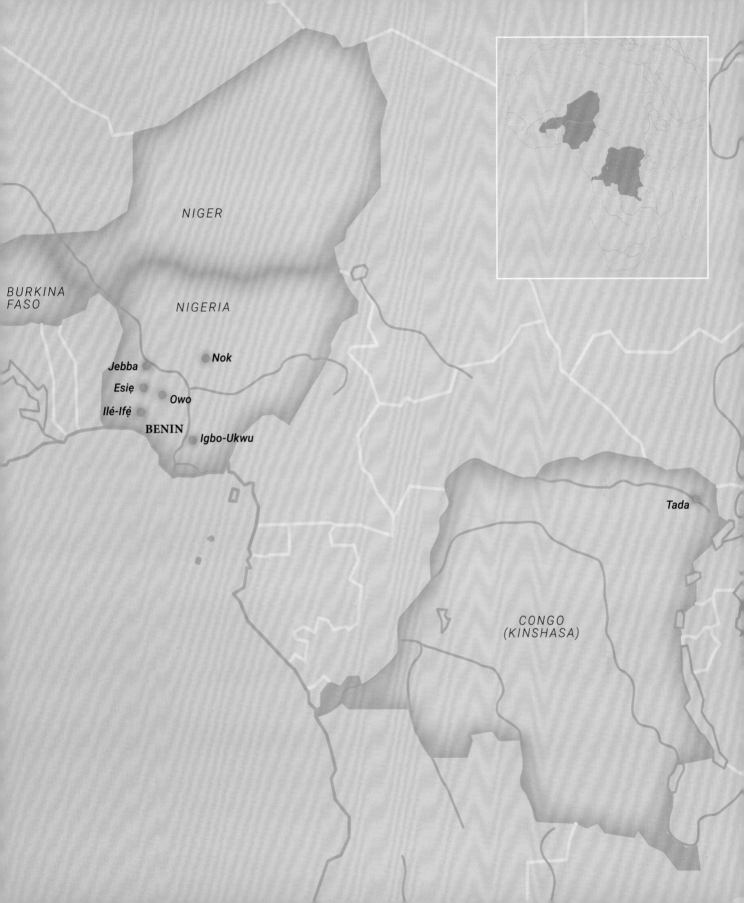

NIGER

BURKINA
FASO

NIGERIA

Nok

Jebba

Esię

Owo

Ilé-Ifè

BENIN

Igbo-Ukwu

Tada

CONGO
(KINSHASA)

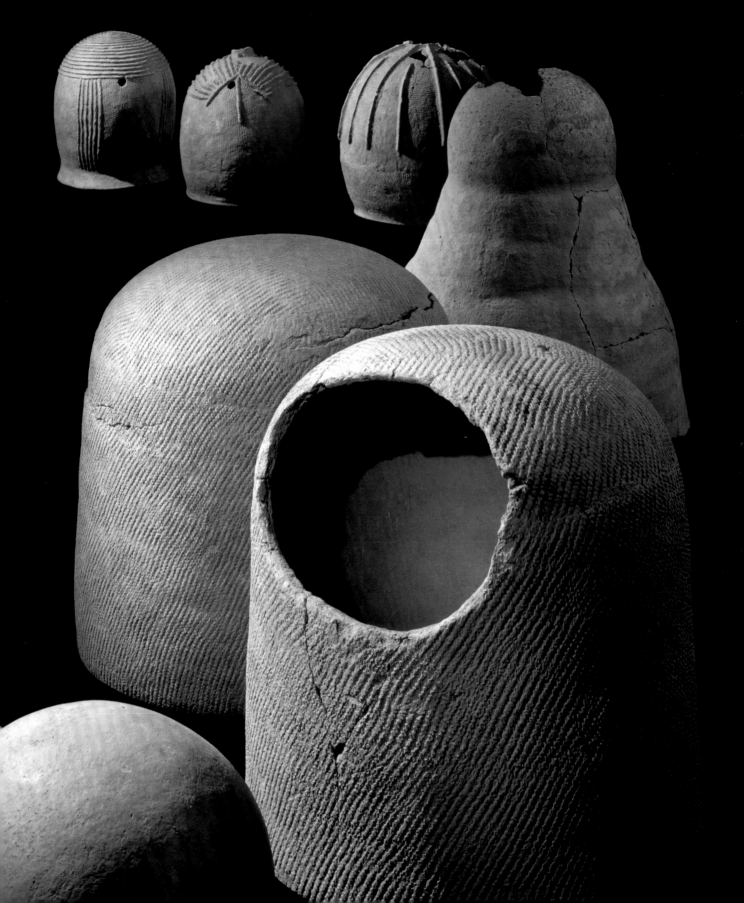

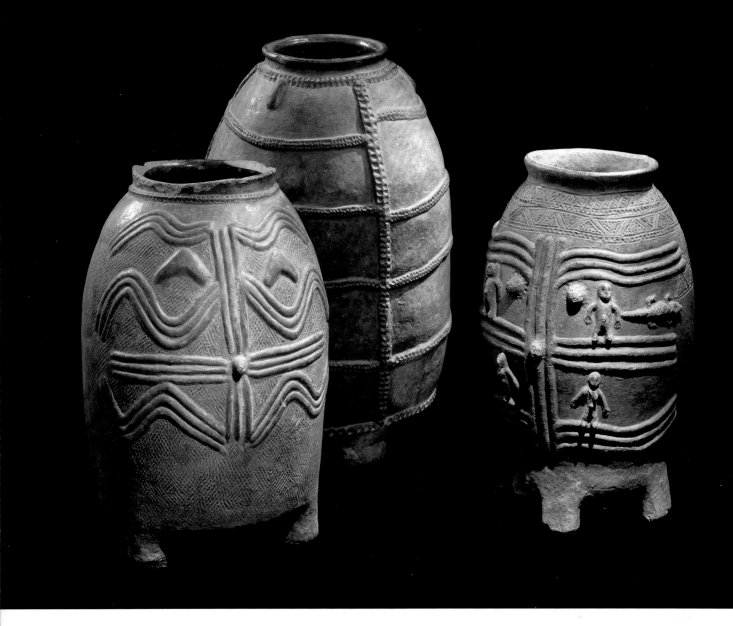

Burkina Faso

Jars

Cruches

Krüge

Vasijas

Brocche

Kruiken

Clay fired/Terre cuite, 54,5–78,7 cm

Burkina Faso, Niger

Urns, vessels

Urnes, récipients

Urnen, Gefäße

Urnas, recipientes

Urne, vasi

Urnen, vaten

Clay fired/Terre cuite, 40–79 cm

273

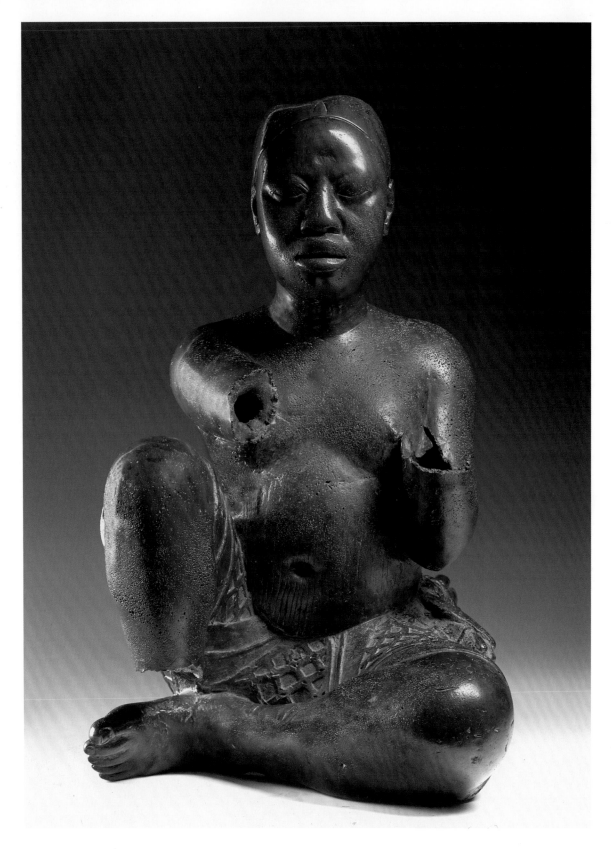

Tada

Sitting figurine

Personnage assis

Sitzende Figur

Figura sedente

Figura seduta

Zittende figuur

Nigerian National
Museum, Lagos

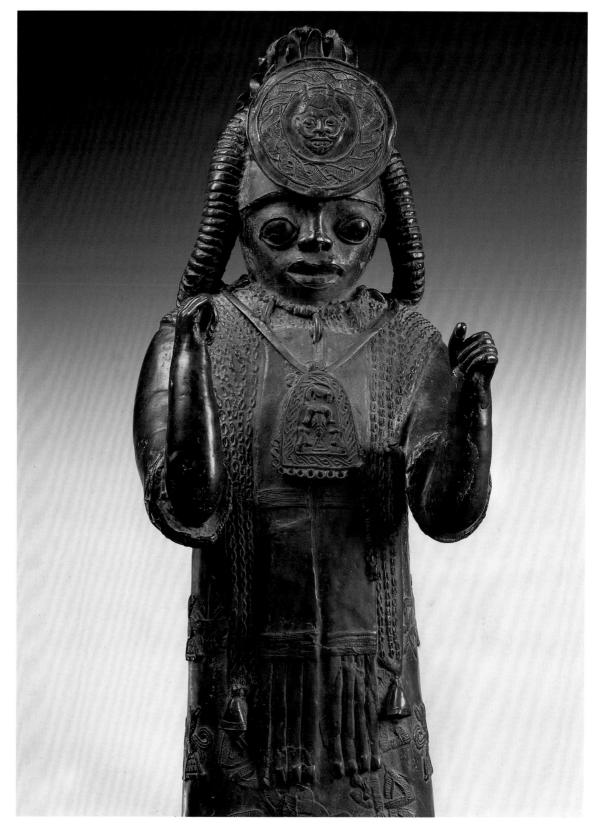

Jebba
Archer
Archer
Bogenschütze
Arquero
Arciere
Boogschutter
Bronze, Nigerian National
Museum, Lagos

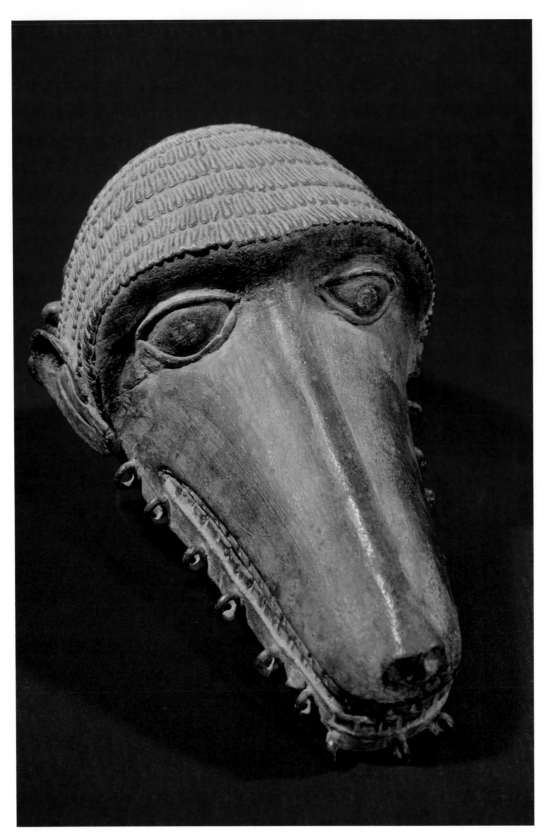

Owo
Pavian mask
Masque de babouin
Pavianmaske
Máscara de mandril
Maschera a forma di babbuino
Baviaanmasker
Bronze, 22,2 cm

Ilé-Ifẹ̀
Man's head
Tête d'homme
Kopf eines Mannes
Cabeza de hombre
Testa di un uomo
Mannenkop
Clay fired, painted/Terre cuite,
peinte, 15,5 × 11,5 × 12,3 cm

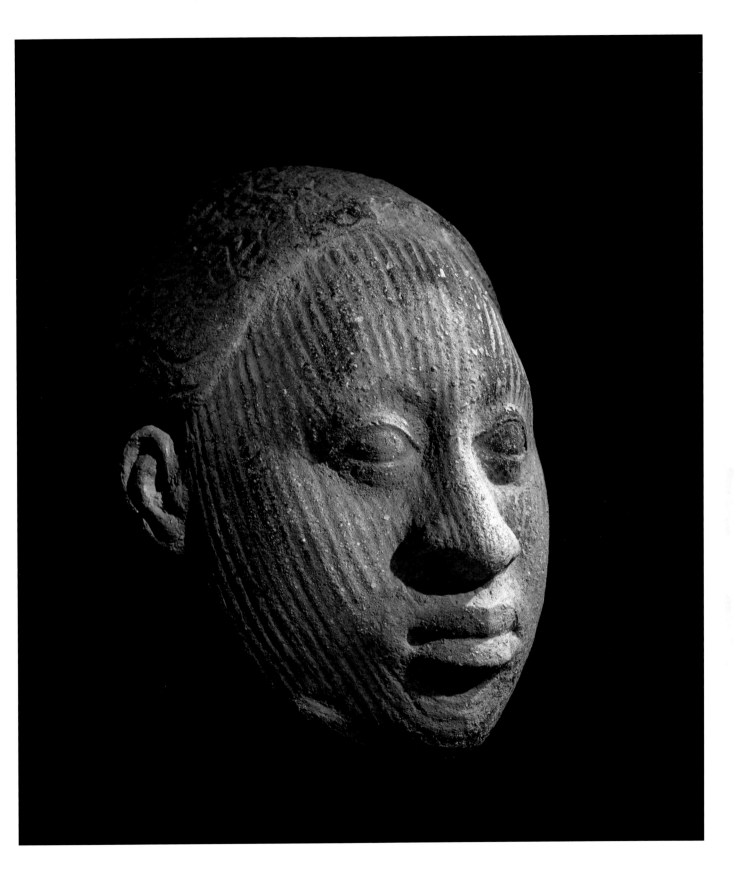

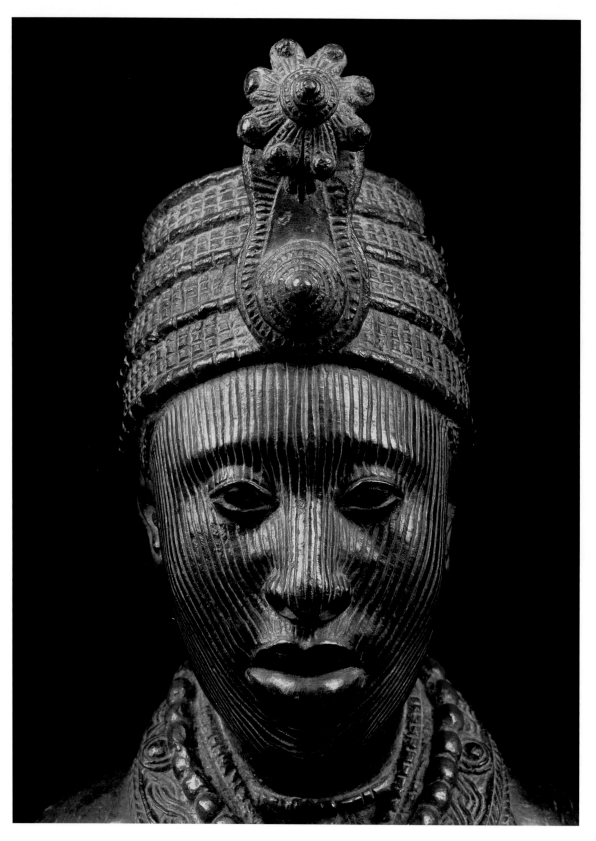

Ilé-Ifẹ̀
Memorial head
Tête de mémorial
Gedenkkopf
Cabeza conmemorativa
Testa commemorativa
Gedenkkop
Brass/Laiton

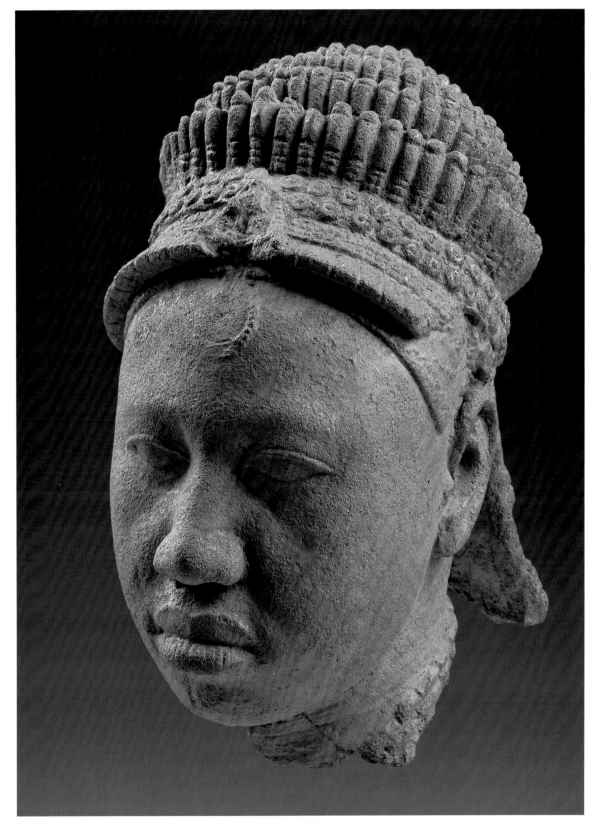

Ilé-Ifẹ̀

Queen's head

Tête d'une reine

Kopf einer Königin

Cabeza de reina

Testa di una regina

Koninginnenkop

Clay fired/ Terre cuite,
Museum of Ife
Antiquities, Ilé-Ifẹ̀

279

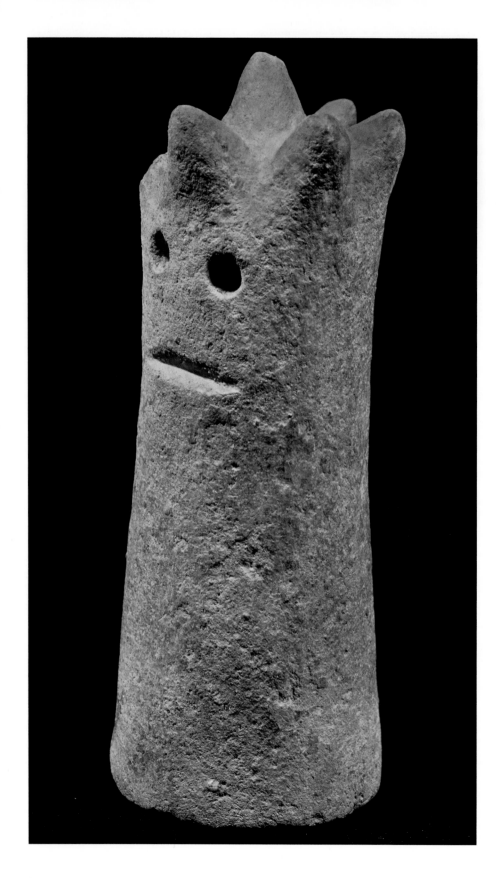

Ilé-Ifẹ̀

Cylindrical head

Tête cylindrique

Zylindrischer Kopf

Cabeza cilíndrica

Testa cilindrica

Cilindrische kop

Clay fired/Terre cuite, 19,2 cm

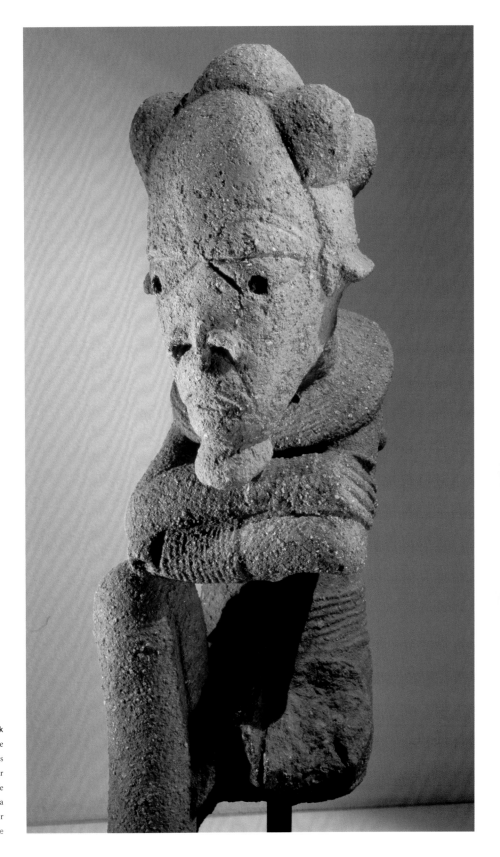

Nok
Sitting figurine
Personnage assis
Sitzende Figur
Figura sedente
Figura seduta
Zittende figuur
Clay fired/Terre cuite

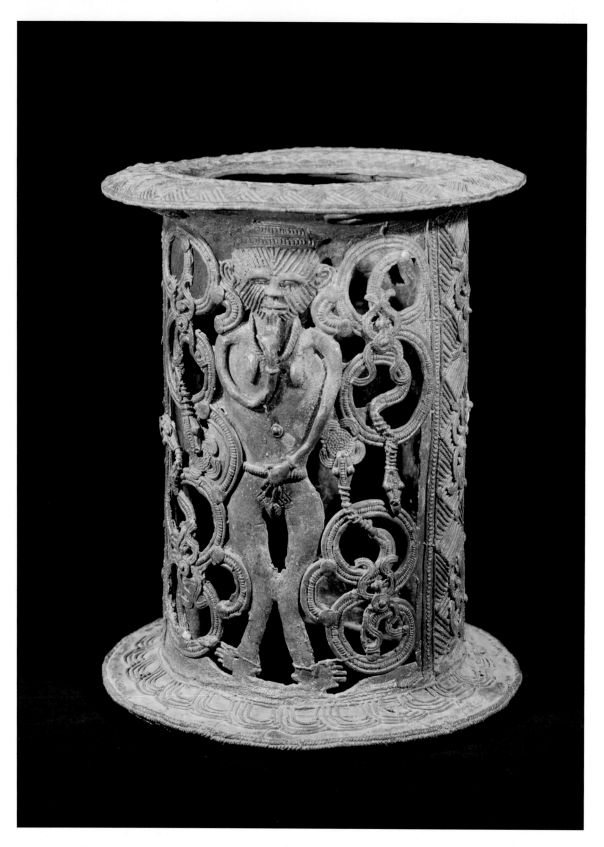

Igbo-Ukwu

Base or part of an altar

Socle ou partie d'un autel

Sockel oder Teil
eines Altars

Pedestal o parte de un altar

Base o parte di un altare

Sokkel of altaardeel

tBronze, 27,4 cm

Igbo-Ukwu

Vase with leopard
figurine as handle

Vase avec poignée en
forme de léopard

Vase mit Figur eines
Leoparden als Henkel

Vasija con figura de
leopardo como asa

Vaso con manico a forma
di figura di leopardo

Kan met luipaardfiguur
als handvat

Bronze

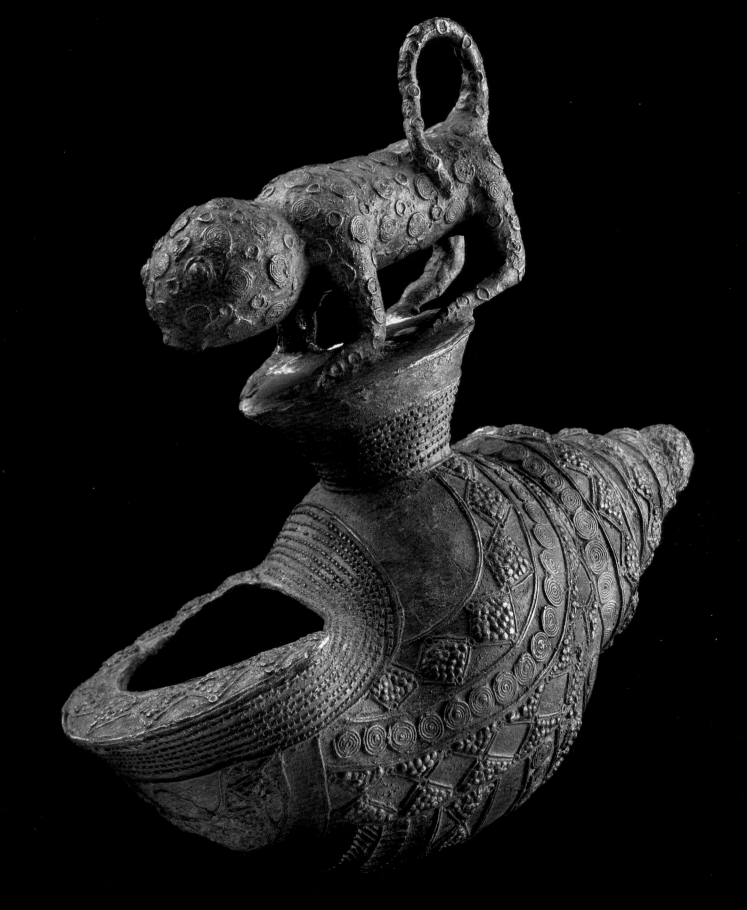

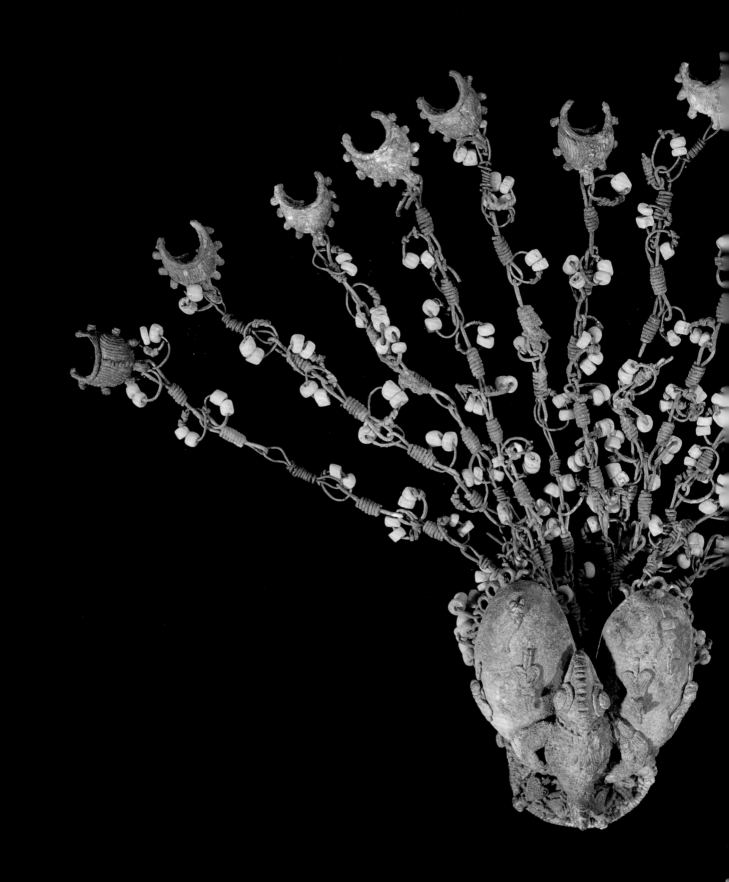

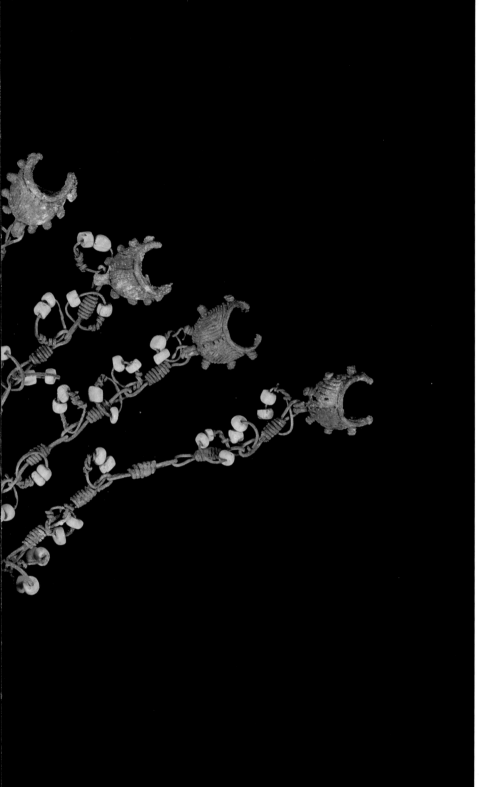

Igbo-Ukwu

Chameleon pendant

Pendentif avec caméléon

Anhänger mit Chamäleon

Pendiente con camaleón

Ciondolo con camaleonte

Hangsieraad met kameleon

Bronze, 21,6 cm

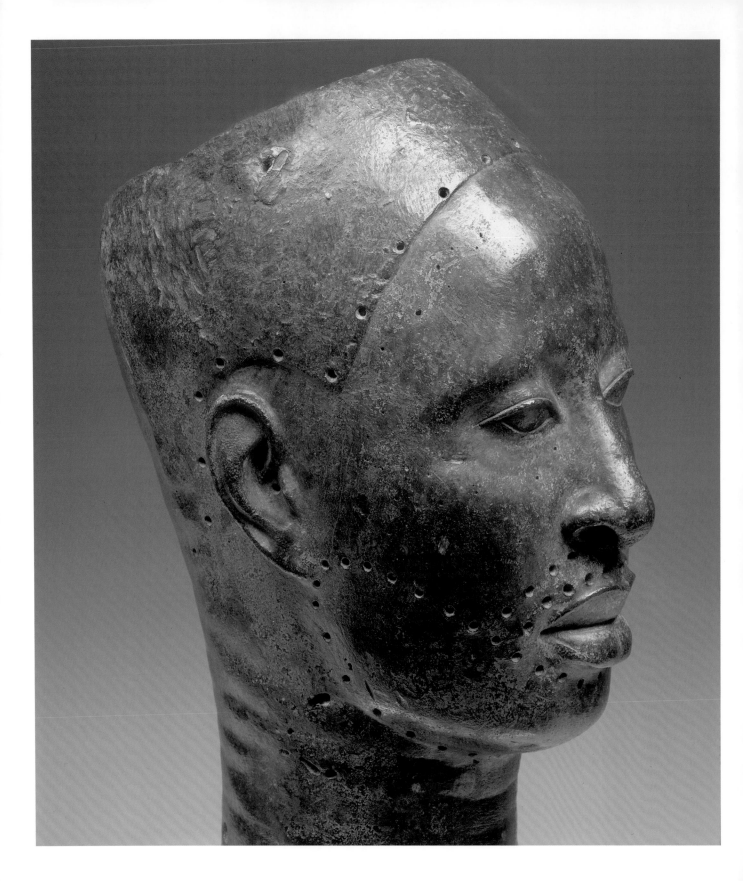

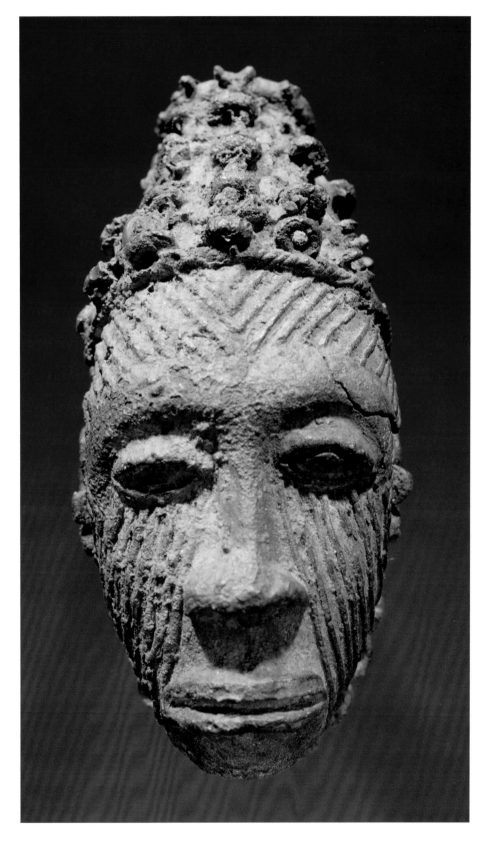

Igbo-Ukwu

Vessel in shape of
a man's head

Récipient en forme
de tête d'homme

Gefäß in Form eines
Männerkopfes

Recipiente en forma de
cabeza de hombre

Vaso a forma di
testa di un uomo

Vat in de vorm van
mannenkop

Nigerian National
Museum, Lagos

Igbo-Ukwu

Part of a pendant
in head shape

Partie d'un pendentif
en forme de tête

Teil eines Anhängers
in Form eines Kopfes

Parte de un pendiente
en forma de cabeza

Parte di un ciondolo
a forma di testa

Deel van een hangsieraad
in de vorm van een kop

Bronze, 7,6 cm

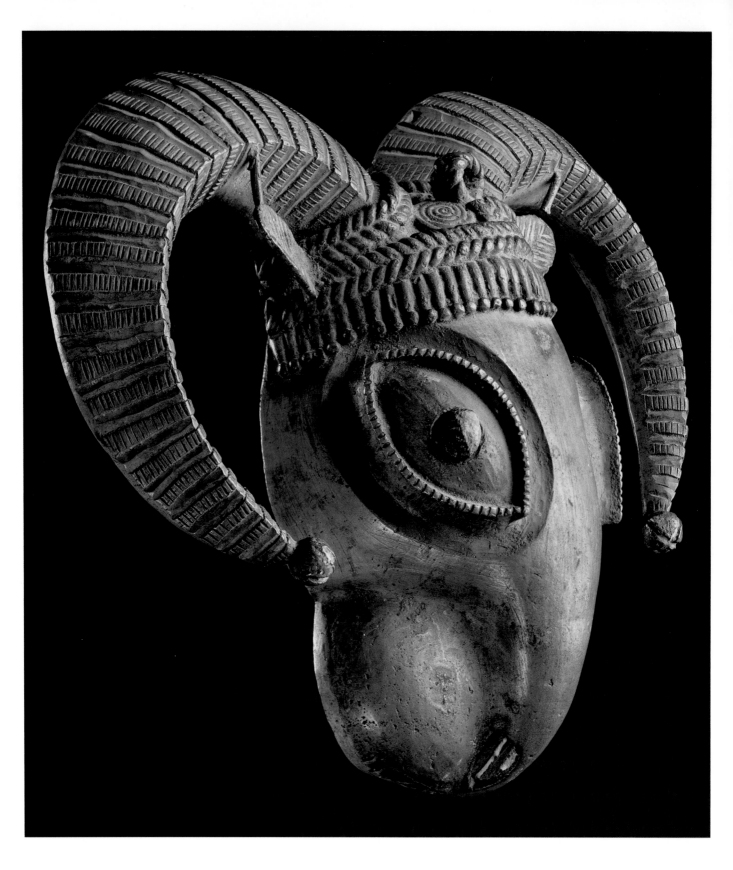

Ram head

Mask of a queen's mother

Tête de bélier

Masque d'une reine mère

Kopf eines Widders

Maske einer Königinmutter

Cabeza de carnero

Máscara de una reina madre

Testa di ariete

Maschera di una regina madre

Ramskop

Masker van een koningin-moeder

Bronze, Nigerian National Museum, Lagos

Ivory/Ivoire, 25 cm

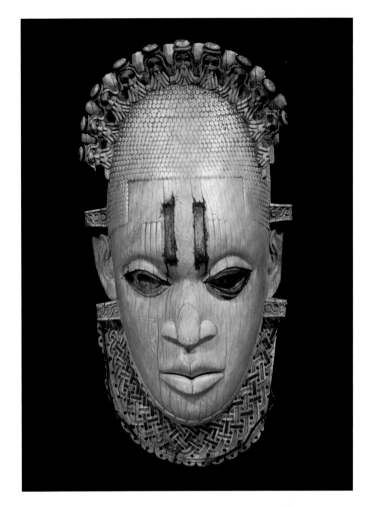

Archaeologists need to work with coincidental findings due to geographical conditions in Africa, such as the famous so-called BENIN-bronzes (they are however mainly made of a copper-zinc-alloy, making them brass work). The king introduced this technology for metal working at his court in the 14th century. Portuguese merchants later reported an astonishing wealth. During local conflicts the valuable pieces were hidden and buried. British colonialists conquered many memorial heads and relief plates. Europe was wondering: The technical and aesthetic quality contradicted the impression of the dark and primitive Africa.

En raison des conditions géologiques de l'Afrique, les archéologues doivent travailler avec des découvertes fortuites, comme les célèbres « bronzes » du BENIN (qui sont cependant principalement constitués d'un alliage cuivre-zinc et entrent donc dans la catégorie des ouvrages en laiton). Le roi introduisit cette technique à la cour pour le travail des métaux au 14ème siècle. Plus tard, des voyageurs de commerce portugais évoquèrent une richesse fabuleuse. Lors des conflits locaux, les précieuses pièces furent cachées et enterrées. Les colonialistes britanniques purent finalement s'approprier de nombreuses têtes commémoratives et plaques en relief. L'Europe fut alors stupéfaite, car la qualité technique et esthétique contredisait l'image d'un continent noir primitif.

Archäologen sind in Afrika aufgrund der geologischen Gegebenheiten auf Zufallsfunde angewiesen, wie die berühmten sogenannten Benin-Bronzen zeigen (sie bestehen allerdings in der Mehrzahl aus einer Kupfer-Zink-Legierung, sind also den Messingarbeiten zuzuordnen). Der König führte im 14. Jahrhundert diese Technik zur Metallverarbeitung am Hofe ein. Portugiesische Handelsreisende berichteten später von sagenhaftem Reichtum. Während lokaler Konflikte wurden die wertvollen Stücke versteckt und vergraben. Britische Kolonialisten eroberten schließlich zahllose Gedenkköpfe und Reliefplatten. In Europa geriet man ins Staunen: Die technische und ästhetische Qualität widersprach dem Bild vom dunklen, primitiven Afrika.

Los arqueólogos en África dependen, dadas las condiciones geológicas, de descubrimientos casuales como ilustra, por ejemplo, el caso de los famosos bronces de BENÍN (compuestos en su mayoría por una aleación de cobre y zinc, por lo que habrían de catalogarse como trabajos de metal). El yey introdujo esta técnica para el tratamiento del metal en la corte en el siglo XIV. Comerciantes portugueses informarían después de riquezas fabulosas. Durante una serie de conflictos locales, las valiosas piezas fueron escondidas y enterradas. Por último, los colonos británicos se hicieron con multitud de relieves y cabezas conmemorativas. El descubrimiento dejó a Europa asombrada: la calidad técnica y estética contradecían la imagen de una África oscura y primitiva.

In virtù delle condizioni geologiche locali, gli archeologi si sono imbattuti in Africa in scoperte casuali, come i famosi bronzi del BENIN (chiamati così anche se la maggior parte di essi è costituita da una lega di rame e zinco ed è quindi riconducibile alle opere di ottone). Nel XIV secolo, il re introdusse nella corte questa tecnica di lavorazione dei metalli, di cui in seguito i viaggiatori commerciali portoghesi riferivano la favolosa ricchezza. Durante i conflitti locali, i pezzi pregiati furono nascosti e sepolti. Alla fine, i colonialisti britannici entrarono in possesso di innumerevoli teste commemorative e piastre con rilievi. In Europa, la gente cominciò così a meravigliarsi di come la qualità tecnica ed estetica contraddicesse l'immagine che si aveva della cupa, primitiva Africa.

Gezien de geologische omstandigheden in Afrika zijn archeologen vaak op toevalstreffers aangewezen, zoals de beroemde BENIN-bronzen, die overigens grotendeels uit geelkoper – een legering van koper en zink – zijn vervaardigd, dus tot de dinanderie, dat wil zeggen kunstvoorwerpen van messing, gerekend moeten worden. De Ashanti-koning voerde deze techniek van metaalbewerking in de veertiende eeuw aan zijn hof in. Portugese kooplui berichtten later over legendarische rijkdom. Bij plaatselijke conflicten werden waardevolle voorwerpen verstopt en begraven. Britse kolonisten legden uiteindelijk beslag op talloze gedenkkoppen en reliëfplaten. In Europa baarde de technische en esthetische kwaliteit ervan opzien: die strookte niet met het gebruikelijke beeld van het donkere en primitieve Afrika.

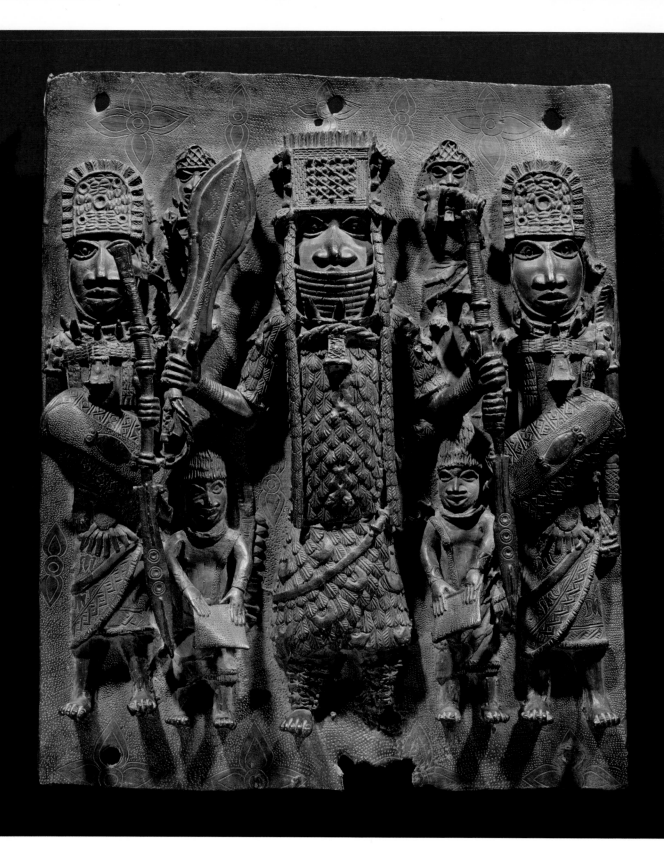

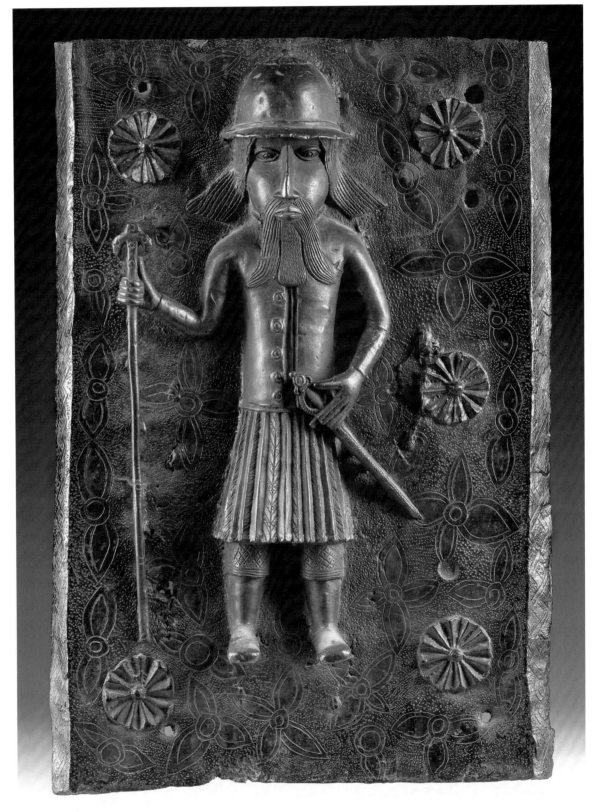

Benin

Relief with king
and entourage

Relief avec le roi et
son entourage

Relief mit König
und Gefolge

Relieve con rey y séquito

Rilievo con il re e
il suo seguito

Reliëf met koning en gevolg

Bronze, 44 cm

Benin

Relief with
Portuguese soldier

Relief avec soldat portugais

Relief mit
portugiesischem Soldaten

Relieve con
soldado portugués

Rilievo con
soldato portoghese

Reliëf met
Portugese soldaat

Bronze, Nigerian National
Museum, Lagos

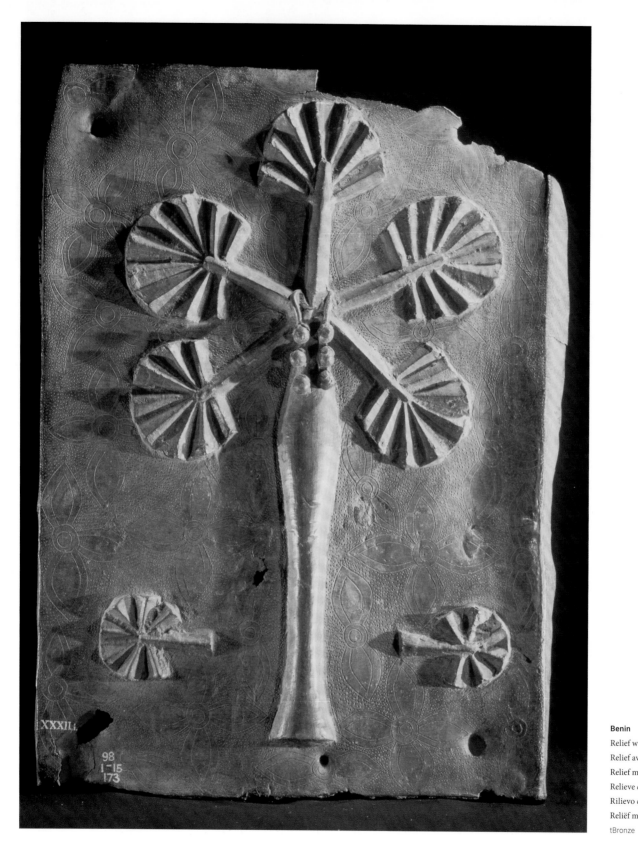

Benin

Relief with palmtree

Relief avec palmier

Relief mit Palme

Relieve con palmeras

Rilievo con palme

Reliëf met palm

tBronze

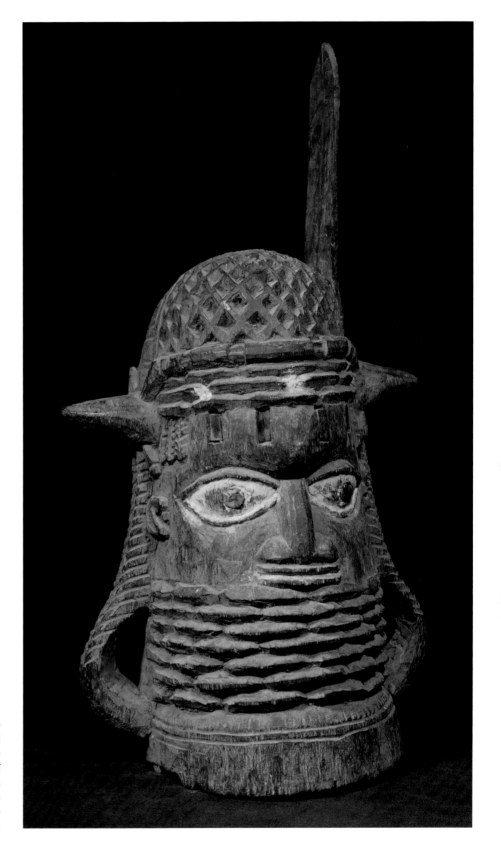

Benin
Memorial head
Tête commémorative
Gedenkkopf
Cabeza conmemorativa
Testa commemorativa
Gedenkkop
Wood/Bois, 50 cm

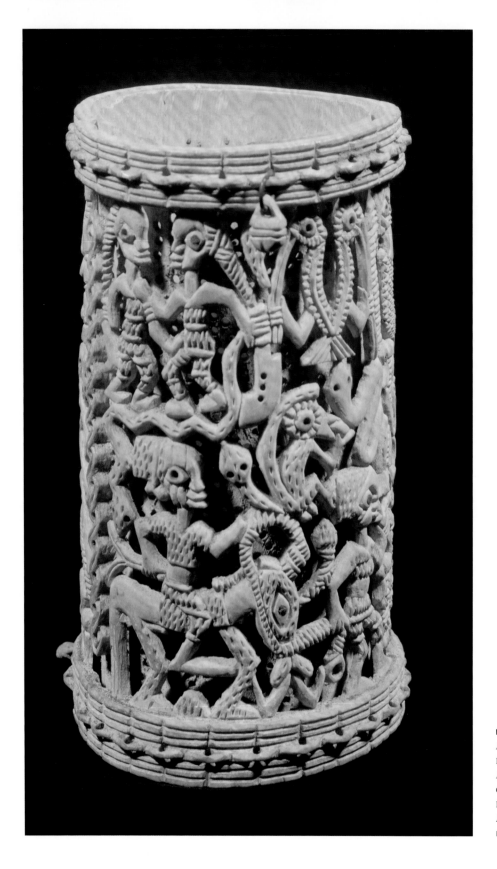

Benin

Arm cuff

Brassard

Armmanschette

Gemelos

Polsino

Armmanchet

Ivory/Ivoire, 15,7 cm

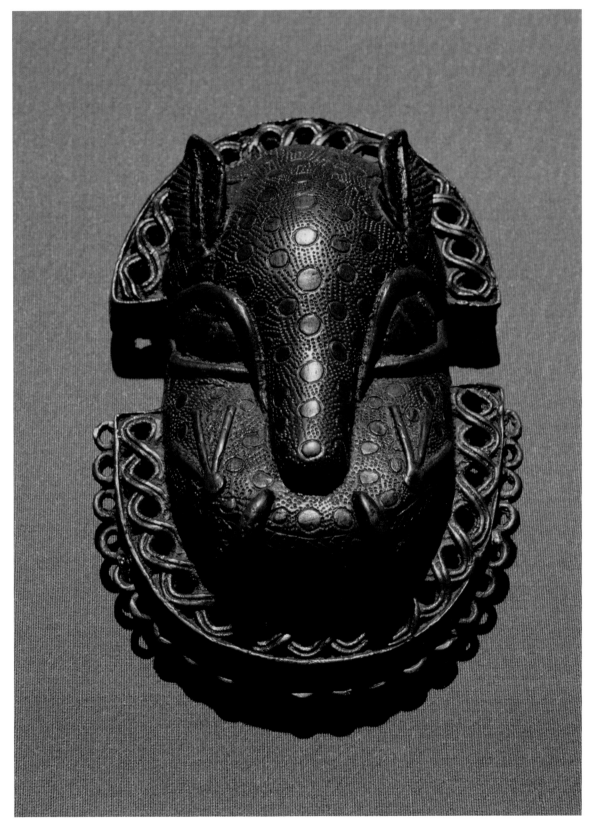

Benin

Hip mask with
leopard head

Masque de hanche
avec tête de léopard

Hüftmaske mit
Leopardenkopf

Máscara con cabeza
de leopardo

Maschera con testa
di leopardo

Heupmasker met
luipaardkop

Brass/Laiton,
14,5 × 10 × 5 cm

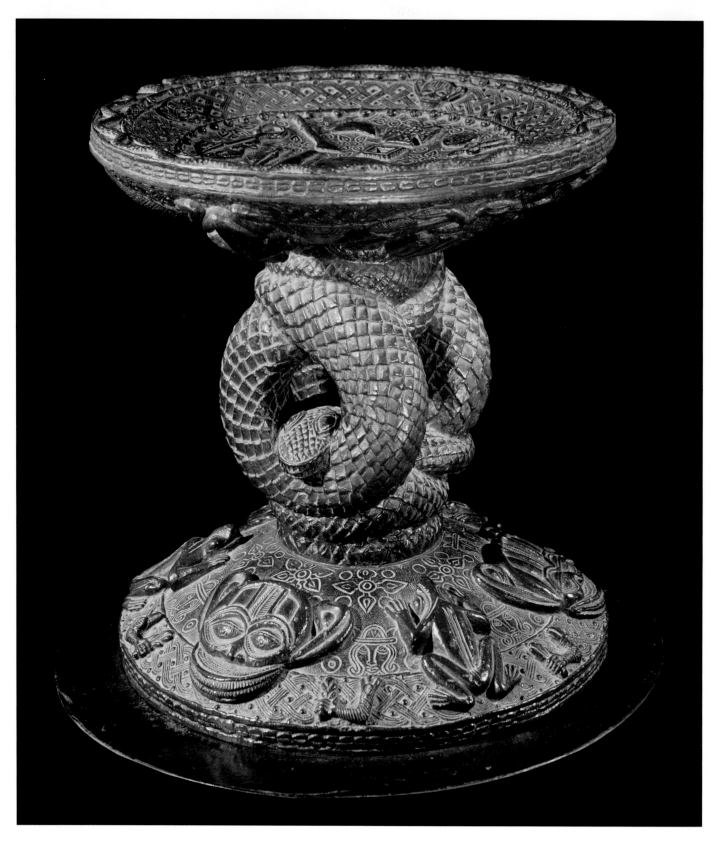

Benin

Seat

Tabouret

Hocker

Taburete

Sgabello

Krukje

Bronze, 39,5 cm

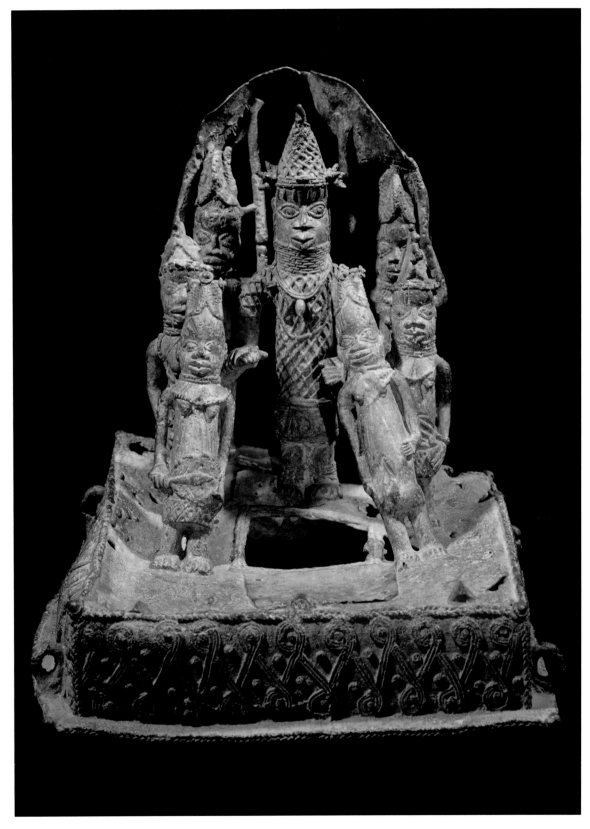

Benin

Altar sculpture with
king and entourage

Sculpture d'autel
avec roi et sa cour

Altarskulptur mit
König und Gefolge

Escultura de altar
con rey y séquito

Scultura d'altare con
il re e il suo seguito

Altaarsculptuur met
koning en gevolg

Bronze, 30,5 cm, National
Museum, Benin City

297

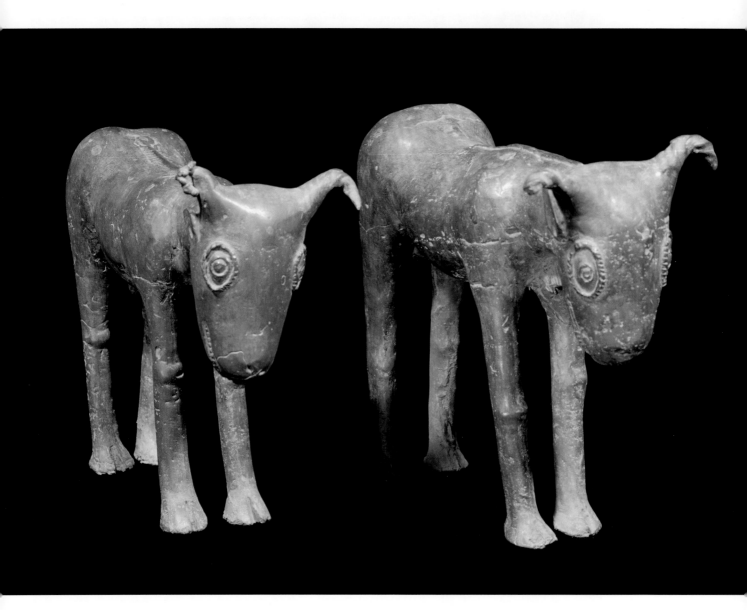

Benin
Rams
Béliers
Widder
Carneros
Montoni
Rammen
Bronze, 30,5–31,5 cm

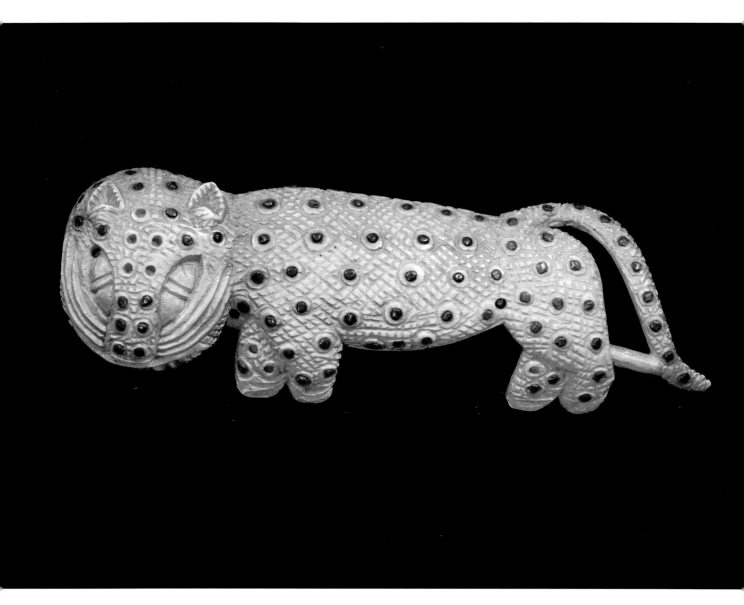

Benin

Arm jewelery as leopard

Bracelet en forme de léopard

Armschmuck in Form eines Leoparden

Alhajas para el brazo con forma de leopardo

Bracciale a forma di leopardo

Armband in de vorm van een luipaard

Ivory, copper/Ivoire, cuivre, 28 cm

Glossary	Glossaire	Glossar	Glosario	Glossario	Glossarium
aluminium	aluminium	Aluminium	aluminio	alluminio	aluminium
animal bones	os d'animaux	Tierknochen	hueso de animal	ossa di animali	dierenbotten
bark	écorce	Rinde	corteza	corteccia	schors
bast	raphia	Bast	líber	rafia	bast
blackened	noirci	geschwärzt	ennegrecido	annerito	gezwart
bones	os	Knochen	hueso	osso	beenderen
brass	laiton	Messing	latón	ottone	messing
bronze	bronze	Bronze	bronce	bronzo	brons
clamshells	moules	Muscheln	conchas	conchiglie	schelpen
clay	argile	Ton	arcilla	argila	klei
clay fired	terre cuite	gebrannter Ton	arcilla cocida	terracotta	gebrande klei
cloth	tissu	Gewebe	tela	tessuto	stof
coin	pièce de monnaie	Münze	moneda	moneta	munt
coloured	couleur	Farbe	pintura	colore	verf
copper	cuivre	Kupfer	cobre	rame	koper
cowry shells	cauris	Kaurischnecken	conchas cauri	cipree	kaurischelpen
feathers	plumes	Federn	plumas	piume	veren
fibres	fibres	Fasern	fibras	fibre	vezels
fur	fourrure	Fellhaar	pelaje	peli di animali	dierenvel
glass	verre	Glas	cristal	vetro	glas
glass pearls	perles de verre	Glasperlen	perlas de cristal	perle di vetro	glaskralen
gold	or	Gold	oro	oro	goud
grains	graines	Körner	granos	semi	graankorrels
hair	cheveux	Haare	pelo	peli	haar
horn	corne	Horn	cuerno	corno	hoorn
horse hair	crin de cheval	Pferdehaar	crin de caballo	crini di cavallo	paardenhaar
human hair	cheveux humains	Menschenhaar	pelo humano	capelli	mensenhaar
iron	fer	Eisen	hierro	ferro	ijzer
ivory	ivoire	Elfenbein	marfil	avorio	ivoor
leather	cuir	Leder	cuero	cuoio	leer
leopard claw	griffe de léopard	Leopardenkralle	garra de leopardo	artiglio di leopardo	luipaardklauw
metal	métal	Metall	metal	metallo	metaal
mirror	miroir	Spiegel	espejo	specchio	spiegelglas
mother of pearl	nacre	Perlmutt	nácar	madreperla	parelmoer
nails	clous	Nägel	clavos	chiodi	spijkers
natural fibres	fibres naturelles	Naturfasern	fibras naturales	fibre naturali	natuurvezels
oil on canvas	huile sur toile	Öl auf Leinwand	óleo	olio su tela	olieverf op doek
organic materials	matières organiques	organische Materialien	materiales orgánicos	materiali organici	organisch materiaal
painted	peint	bemalt	pintado	dipinto	beschilderd
painting	peinture	Malerei	pintura	pittura	schildering
patinised	patiné	patiniert	patinado	patinato	gepatineerd
pearls	perles	Perlen	perlas	perle	parels
pig's teeth	dents de porc	Schweinezähne	dientes de cerdo	denti di maiale	zwijnentanden
plant fibres	fibres végétales	Pflanzenfasern	fibras vegetales	fibre vegetali	plantenvezels
resin	résine	Harz	resina	resina	hars
snails	coquilles d'escargots	Schnecken	conchas de caracol	chiocciola	slakkenhuizen
soap stone	stéatite	Speckstein	esteatita	steatite	speksteen
string	corde	Schnur	cuerda	corda	koord
weaved	vannerie	Flechtwerk	mimbre	vimini	vlechtwerk
wood	bois	Holz	madera	legno	hout

Bibliography Bibliographie Bibliografía Bibliografia Bibliografie

Karl-Ferdinand Schaedler: *Afrikanische Kunst. Von der Frühzeit bis heute,* München 1997

Miklós Szalay (Hg.): *Der Sinn des Schönen. Ästhetik, Soziologie und Geschichte der afrikanischen Kunst,* München 1990

Peter Junge & Paola Ivanov (Hg.): *Kunst aus Afrika. Plastik, Performance, Design,* Berlin 2005

Valentin Yves Mudimbe: *The Invention of Africa. Gnosis, Philosophy, and the Order of Knowledge,* Bloomington 1988

Roy Richard Grinker, Stephen C. Lubkemann & Christopher Burghard Steiner (Ed.): *Perspectives on Africa. A Reader in Culture, History, and Representation,* Chichester and Malden 2010